Rembrandt Studies

Rembrandt Studies

❧

BY JULIUS S. HELD

PRINCETON, NEW JERSEY

PRINCETON UNIVERSITY PRESS

· MCMXCI ·

Library of Congress Cataloging-in-Publication Data

Held, Julius Samuel, 1905-

Rembrandt Studies / by Julius S. Held.

p. cm.

Includes index.

ISBN 0-691-04077-X (alk. paper)—ISBN 0-691-00282-7

(pbk. : alk. paper)

1. Rembrandt Harmenszoon van Rijn, 1606-1669—Criticism and interpretation. I. Title.

ND653.R4H377 1990

759.9492—dc20 90-8533 CIP

Printed in the United States of America by Princeton University Press,

Princeton, New Jersey

Princeton University Press books are printed on acid-free paper,

and meet the guidelines for permanence and durability

of the Committee on Production Guidelines

for Book Longevity of the Council on Library Resources

Printed in the United States of America by

Princeton University Press, Princeton, New Jersey

TO THE MEMORY OF MY WIFE,

INGRID-MÄRTA HELD

FOREWORD

THE PRESENT volume consists of five essays reprinted from the 1969 book *Rembrandt's* Aristotle *and Other Rembrandt Studies*. To these has been added an Introduction about some aspects of the current trends in Rembrandt research, and two additional essays which, like the original ones, were first delivered as public lectures. The one on the Spoken Word, first delivered in German on the occasion of a Rembrandt symposium in Berlin (1970), appears here for the first time in English. It seemed to me advisable, however, to take account, in several appendices, of researches concerning the works I had dealt with in the 1969 volume, either to amplify or, if necessary, to correct my text, but also on occasion, to restate my case in the face of differing opinions.

The foreword of the original volume was written in 1968: it reflected the thoughts and the apprehensions of that fateful year. Referring to the fact that I had dedicated the book "To my students" I spoke of the conflicts in which we, as teachers, no less than they—even though in a different manner—were then caught up. This is what I wrote in that foreword:

> When I dedicate this book to my students, it is done not only because some ideas may have been honed in the give and take of a seminar. The pressures of our age have created fearsome problems for all, but especially for our students. The very functions and goals of traditional scholarship are being questioned. What, they may ask, is the value of art history in a world where the social fabric is rent by bitter conflict, where a growing population seems to lead only to misery, violence, and destruction, and where the most urgent goals of education are to provide a minimum for the many rather than a maximum for a few. As a teacher I am not unaware of the doubts that plague some of the best of our students. Is it morally defensible to learn how to sharpen the tools of sophisticated scholarship when massive first aid appears to be the true need of the hour?
>
> It is a choice each one will have to make according to his own light and his own conscience. Speaking to our students from the other side of the gap of the generations, I hope, however, they will not forget that we are also the guardians of what is left of the creative efforts of men long dead. Much has been lost from natural causes and man-made disasters. What we still have is precious beyond words. We must protect this heritage. It consists only of dead matter if we cannot bring it to life; and we can't bring it to life if we do not study it with the most intense concentration we are capable of.

The alarums of 1968 have lost their urgency but not the validity of their concerns. If the methods of protest chosen by the students in 1968 aimed occasionally more at getting attention than at planning constructive action, the withdrawal of subsequent generations of students from the political arena in order to pursue their own special goals makes one almost yearn for the exuberance of the young men and women of '68.

In addition to the topical issues of those years, I also reflected in that foreword on the question whether, despite their evident diversity, the several studies responded, each in its own way, to my personal brand of curiosity. I concluded that in all of them (with the exception of the 1950 piece "Rembrandt: Truth and Legend") I was searching for more than the formal and intellectual organization of the works discussed. I evidently have also been trying to see if by analyzing these works, they could open up a path to the thoughts and emotions which—consciously or subconsciously—had guided the hand of their maker.

The new—unchanged—printing of the five essays of the 1969 volume, augmented by a new introductory chapter, two additional studies, and a critical appendix owes its appearance largely to two scholars: Professor David Rosand, erstwhile disciple and loyal friend whose encouragement helped me overcome some scruples, and Dr. Charles Scribner III, who with the enthusiasm of youth persuaded Princeton University Press to add this Rembrandt title again to its list. And having become part of the sudden notoriety of the Frick's *"Polish" Rider*, I am happy to yield to my young friend credit for using that picture on the cover. My thanks go also to Elizabeth Powers for polishing the rough edges of my prose and shepherding the book through the slow process of publication.

In the foreword of the original edition, I had expressed words of thanks to a considerable number of people who had helped me in various ways. I am still conscious of my debt, but see no need to repeat that list again. The only exception is she to whose memory this volume is dedicated.

Bennington, November 18, 1989

CONTENTS

CONTENTS

ILLUSTRATIONS

II. "POLISH" RIDER

III. JUNO

IV. TOBIT

VI. BEGGARS

Rembrandt Studies

REMBRANDT-*DÄMMERUNG*?

"If we are sure of so little we shall have to work harder."

WOLFGANG STECHOW, a universally admired scholar, wrote this line in a short article he contributed to a volume dedicated to the memory of Milton S. Fox.[1] When it appeared in 1975, Stechow himself had died (1974), but the warning it contained is as valid today as it was then. What triggered his fear, that the Rembrandt research was in a state of crisis, may have been Horst Gerson's revised edition of Bredius's catalogue of Rembrandt's paintings published in 1969.[2] Gerson's book was the first broadside against the ever growing number of attributions to Rembrandt, that left the oeuvre of the master bloated with works clearly unworthy of his genius. Stechow was too good a scholar not to be aware of the justification for such a retrenchment. What he objected to was the rather loose and highly subjective reasoning that lay behind some of Gerson's decisions and his casual floating of alternate attributions. He also realized that Gerson was not alone and that other Dutch scholars—he mentions B. Haak—were following a similar track. But Stechow called for a stricter critical methodology not only in matters of attribution (or its opposite), but also in regard to iconographic interpretation. He cites the Hermitage canvas of the *Dismissal of Haman* which, as he says in his opening paragraph, had been called *David's Departure from Saul and Abner* and *Joseph Turning Away from Judah and Reuben*. (Stechow overlooked another, equally untenable interpretation that has been proposed, *Uriah Sent to His Doom by David.*[3]) Most scholars retain the identification of the foremost figure with Haman, but there has been disagreement as to which moment of the Esther story has been depicted.[4] To top the irony, there have been voices claiming that the picture is either in part, or entirely, by the hand of one of Rembrandt's pupils. Nor is this the only case justifying Stechow's alarm over the "signs of increasing frustration and confusion." The gauntlet I had thrown down in 1944 with my paper on the "Polish" Rider (see pp. 59-98) has been picked up by not fewer than nine authors, each one offering a totally

[1] Wolfgang Stechow, "The Crisis in Rembrandt Research," *Art Studies for an Editor: 25 Essays in Memory of Milton S. Fox*, New York, 1975, pp. 235-39

[2] A. Bredius, *Rembrandt, The Complete Edition of the Paintings*, rev. H. Gerson, London, 1969.

[3] I. Linnik, "Sur le sujet du tableau de Rembrandt, dit 'La Disgrace d'Aman'," *Bulletin du musée de l'Ermitage*, Leningrad, xi, 1957, pp. 8-12

[4] Madlyn M. Kahr, "A Rembrandt Problem: Haman or Uriah?," *Journal of the Warburg and Courtauld Institutes*, xxviii, 1965, pp. 258-73.

[3]

different interpretation of the beautiful, if enigmatic, picture. And not enough that it has attracted the attention of eager and learned iconographers, that painting has also recently suffered the final indignity of being taken from Rembrandt's oeuvre and has been given, perhaps only tentatively, to Willem Drost, a Rembrandt follower whose dated works range from 1652 to 1663.[5] Though evidently prejudiced, I am not wavering in my conviction that it is Rembrandt to whom we owe this great and deservedly popular canvas.

In the fifteen years since Stechow sounded his warning, the controversies about Rembrandt have become even more intense than those he knew. Moreover, they have dealt with problems that had not played a significant role in the fears that made him speak of a crisis. Not that questions of authenticity or interpretation have ceased to be of interest to Rembrandt scholars. Yet there has been an unmistakable but also controversial trend to focus on biographical data; to reconstruct the social, economic, and intellectual climate in which Rembrandt lived and earned his living; to look into all the available evidence defining his working methods and conditions; and in the last analysis, to draw a new picture of the artist's personality. Much of the material for such studies has been provided in the dedicated researches of several archivists, above all the venerable dean of such studies, I. H. van Eeghen, as well as H. F. Wijnman and S.A.C. Dudok van Heel. Basic of course is still the collection of documents published by C. Hofstede de Groot (*Die Urkunden über Rembrandt*, 1906). This vast material has been made accessible in an English translation, accompanied by commentaries, by the late Walter Strauss and Marjon van der Meulen (1979).[6] Despite the severe, occasionally almost too sharp, criticism it has received from Ben Broos and L. de Vries,[7] it remains the only handy collection of the documentary material. Yet it is also clear that these documents are unevenly distributed over the master's lifetime and—even more regrettably—are virtually devoid of expressions of a personal nature. Most of them are legal records (wills, inventories, real estate and business transactions, and of course law suits). Some are passages from the writings of Dutch seventeenth-century historians and poets, above all the long and justly celebrated passage from Constantijn Huygens' autobiography of *ca.* 1630 (unfortunately with some inaccuracies of translation and, as Broos

[5] The attribution to Drost was first mentioned by Josua Bruyn in a review of W. Sumowski, Gemälde der Rembrandt-Schüler, i, *Oud Holland*, xcviii, 1984, p. 158.

[6] Walter L. Strauss and Marion van der Meulen, with the assistance of S.A.C. Dudok van Heel and P.J.M. de Baar, *The Rembrandt Documents*, New York, 1979.

[7] Ben Broos, *Simiolus* xii, 1981-82, pp. 245-62; *idem, De Kroniek van het Rembrandthuis*, 1983, nos. 1-2; Lyckle de Vries, *Kunstchronik*, xxxv, 1982, pp. 223-28.

correctly deplored, without commentary).[8] Even the seven letters—the only ones preserved in Rembrandt's own hand and all addressed to Huygens—valuable as they are for his handling of business contacts, illuminate only one particular commission. Still I find it worth noting that, though addressed to a person of rank, the tone of these letters is modest and respectful but never servile, the language not without a certain fanciful elegance.

The essay "Rembrandt: Truth and Legend," written about forty years ago and reprinted once more below, gives an idea of how much the attitude towards Rembrandt's art has fluctuated over the centuries, and shows that not infrequently it was seriously censured. Delacroix, who admired Rembrandt, realized that he was heretical when he wrote that one day Rembrandt might be considered as great as Raphael. That day indeed came towards the end of the nineteenth century. Today, however, we are faced with a new turn away from total admiration to a more discriminating view of Rembrandt's art and, quite unexpectedly, a highly critical view of his character. Svetlana Alpers is the author of a provocative book on Rembrandt published in 1988.[9] She sees in Rembrandt a typical proto-capitalist entrepreneur who as "the head of a large and productive workshop" organized an efficient method of producing art. Rembrandt, she says, was a *pictor economicus* whose entire output was consciously directed towards the marketplace and who even "commodified" his own self-portraits. Since she assumes that much of Rembrandt's oeuvre represents the output of a workshop where students and assistants presumably took part in the process of production, questions of connoisseurship are evidently only of minor concern for Alpers. Instead she is interested in those aspects of Rembrandt's art which he communicated to the artists working with him and under his direction. Thus she believes, for instance, that when preparing a narrative subject, Rembrandt practiced with his students a kind of play-acting to study gesture, movement, and expression in live situations. That practice, Arnold Houbraken (1660-1719) informs us he remembers having seen applied in the studio of *his* master, Samuel van Hoogstraten (1627-1678), a poet as well as a painter, and since Hoogstraten was a pupil of Rembrandt, Alpers concludes that he applied this "tool of teaching . . . after Rembrandt's example." This being an assumption unsupported by any evidence, the chapter entitled "The Theatrical Model" loses much of its persuasiveness.

[8] Huygens' autobiography, written in Latin, was published in a Dutch translation by A. H. Kan, *De Jeugd van Constantijn Huygens door hemzelf beschreven* Rotterdam, 1946. Both Walter Strauss's and the more complete and more faithful English version in Gary Schwartz's book on Rembrandt (see note 12) are based on this Dutch translation.

[9] Svetlana Alpers, *Rembrandt's Enterprise: The Studio and the Market*, Chicago, 1988.

Alpers also accepts a veritable *Leitmotif* of the Rembrandt literature, which may have begun with a scurrilous anecdote reported by the same Houbraken, according to which Rembrandt's students would paint coins on the floor or other places, to watch the master as he tried to pick them up. From this small "acorn" of a possibly apocryphal story (twice mentioned by Alpers) the large "oak" of Rembrandt's covetousness has grown. It found its first echo in Descamps' lapidary formulation ("Il n'aimoit que sa liberté, la Peinture et l'argent")[10] which provided Alpers with the title and the summing up of her last and longest chapter, "Freedom, Art, and Money." But the freedom which Rembrandt preferred to honor, according to another story reported by Houbraken (see pp. 56-57), Alpers interprets not as the artist's personal freedom from social constraints but, in keeping with her stress on Rembrandt's preoccupation with business affairs, as the freedom of the marketplace. This does not imply in any way a moral judgment on her part; it simply reinforces her aim to locate Rembrandt in the broad currents of a changing economic order. Even where she discusses certain technical characteristics, as for instance the heavy impasto of some of Rembrandt's paintings (taking a cue from Baldinucci, who based his commentary on hearsay)[11] and in that connection makes some astute observations about the function of the artist's "hand," she explains it not on artistic grounds but as the means he developed "to be distinguished, to stand apart." One wonders if, had he lived in our time, Rembrandt might have copyrighted his technique.

The Rembrandt who emerges from Alpers' book is an interesting though rather unattractive character, but the Rembrandt Gary Schwartz describes is downright repellent.[12] Schwartz's book ostensibly follows Rembrandt's career in an effort to define the circles in which he moved and the patrons for whom he worked. Much of this, as Dutch critics have already pointed out, is hypothetical, and Schwartz's efforts to provide new interpretations for several of Rembrandt's narrative subjects rest on pure (and untenable) speculation.[13] Nor has Schwartz been alone. In a review (*New York Times*, May 15,

[10] J. B. Descamps, *La Vie des Peintres Flamands, Allemands et Hollandais*, Paris, 1753-64, II, p. 90.

[11] Filippo Baldinucci, *Cominciamento e progresso dell'arte dell'intagliare in rame, colle vite de' più eccelenti Maestri della stessa Professione*, Florence, 1686.

[12] Gary Schwartz, *Rembrandt, his life, his paintings*, New York, 1985. According to Schwartz, Rembrandt was "underhanded," "untrustworthy," with a "nasty disposition," a "bitter and vindictive character" "without a grain of tact," "arrogant to his patrons," "ill-humored with his

apprentices," and motivated solely by a desire to increase his profits.

[13] The themes of several of Rembrandt's paintings, according to Schwartz, were inspired by plays performed on the Amsterdam stage. Two are plays by Vondel (*Palamedes* and *Gebroeders*); two by Serwouters (*Tamerlane* and *Hester, or the Salvation of the Jews*) and one a short dialogue-poem by Cats (*Masanissa and Sophonisba*). The *Danaë* in Leningrad (Rembrandt's "most succulent female nude") is reinterpreted as *Aegina visited by Jupiter* on the basis of an obscure Greek

1988) even Simon Schama states that "from a trail of documents" (?) Rembrandt appears to have been "an acquisitive property owner, hungry for status, greedy for cash, churlish to his patrons, and often |!| brutal in his relation to women." (Schama had been less harsh on the master in a lecture on "Rembrandt and Women" he gave April 10, 1985, at a meeting of the American Academy of Arts and Sciences in Cambridge.)[14] Summing up his survey of Rembrandt's relationship with Saskia, Geertje, and Hendrickje he says that the master "was no Prometheus, neither was he a moral pigmy, but an Amsterdammer ... who shared the foibles, prejudices, and weaknesses, especially where painful affairs of sex and money were concerned, with his fellow citizen." Can we forget that this ordinary Dutchman was also the supreme artist of his country? One could of course ask, as Gian Carlo Menotti did not long ago (*New York Times*, June 10, 1989) whether we should not be grateful to great artists for what they have given us with their works and forgive them their human failures. Such a question may indeed be justified where the evidence of such failures is incontrovertible. But is it really so with Rembrandt?

In order to turn Rembrandt into such an unsavory character, all the documentary evidence, as Alpers had already recognized when speaking about Schwartz's book, had to be interpreted *in malo*. But even for her, Rembrandt's obsessive (and, in the event, ruinous) accumulation of works of art and all kinds of curiosities is but the cultural sublimation of a basic avarice (p. 113). Scheller saw it as a means for Rembrandt to expand his artistic and intellectual horizon,[15] not an unworthy goal, as well as to raise his social status, but Schama's "hunger for status" twists the evidence in a mischievous way. Rembrandt's well-known practice of making changes in his etchings, even after he had begun printing them, is interpreted by his detractors as a calculated device to force collectors of his prints to buy also (as some indeed did) impressions of these later "states." That he may have had legitimate artistic reasons for the changes does not fit, of course, the notion of Rembrandt's avarice.

myth. None of these interpretations is convincing. In the Leningrad *David and Jonathan*—according to Schwartz the final scene of Vondel's *Gebroeders*—the crucial figure of Mephisobeth's small son Micha is missing, an omission most unlikely with an artist like Rembrandt. That many identifications are untenable has also been pointed out in the reviews of Schwartz's book by Peter C. Sutton (*The Burlington Magazine* cxx, 1986, pp. 681-82) and especially by Eric J. Sluijter (*Oud Holland* ci, 1987, pp. 287-301).

[14] Simon Schama, "Rembrandt and Women," *Bulletin, The American Academy of Arts and Sciences,* xxxviii, April 1985, No. 7, pp. 21-47. The report is "adapted from the text that accompanied Mr. Schama's slide presentation."

[15] R. W. Scheller, "Rembrandt en de encyclopedische verzameling," *Oud Holland,* lxxxiv, 1969, pp. 81-147. For a comparison of Rembrandt's collecting activity with that of Rubens, see Jeffrey M. Muller, *Rubens: The Artist as Collector*, Princeton, 1989, pp. 72-73.

We do know from various records that Rembrandt had a high opinion of the commercial value of what he painted or etched, and that he was not willing to accept less than what he was sure these works were worth. In that he acted precisely as did Rubens, of whom one agent reported that his prices were as firm as the laws of the Persians and the Medes. That same "greedy" Rembrandt, according to Baldinucci (who had his information from a reliable source), voluntarily paid above the market value for works by artists he esteemed, *per mettere in credito la professione.*

It is not my intention to replace a slanted characterization of Rembrandt with a bowdlerized one. The case of his controversy with the collector and money-lender Harmen Becker (see below pp. 100-103) shows that he was not always in the right. But what does this really mean in terms of moral behavior? Both men played games, and Becker just held the better cards. After all, what Becker really wanted was a picture by Rembrandt. He knew—and for this we have ample evidence—that they were hard to get. Yet at his death, Becker owned at least fourteen of the master's works.

Most shocking for a modern sensibility is the image of a Rembrandt "often brutal to women." What are the facts? Not counting his mother (of whom he painted some touching portraits) we know of only three women in Rembrandt's life: his wife, Saskia van Uylenburgh, whom he married in 1634 and who died, after four childbeds, in 1642; Hendrickje Stoffels, the daughter of an army sergeant who, still very young, entered his household around 1648 and lived with him as common-law wife until her death in 1663; and Geertje Dircx. There is no shred of evidence that he behaved brutally to either Saskia or Hendrickje. In the paintings, drawings, and etchings in which we have reason to recognize their features we can only see affection and tenderness.

That leaves the sad case of Geertje, a ship-bugler's widow who, at about thirty years of age, entered Rembrandt's house as a nurse for the infant Titus, Saskia's only surviving child. Geertje remained as his housekeeper and, eventually, his mistress. When and in what form, the parting came, we do not know, but Geertje apparently left Rembrandt's house and in September 1649, claiming that he had promised to marry her, sued for breach of promise. The ensuing wrangles ended in the long incarceration of Geertje in the *Spinhuis*, a penal institution, in Gouda. Most of the pertinent documents were discovered about twenty-five years ago.[16] It is astonishing with what alacrity mod-

[16] The documents, discovered by D. Vis, an artist, and published by him in 1965 were carefully analyzed by H. F. Wijnman ("Een Episode uit het Leven van Rembrandt: De Geschiedenis van Geertje Dircks," *Jaarboek Amstelodamum*, LX, 1968, pp. 103-18). The facts, as far as we can de-termine today, are these: Sometime during the 1640s Rembrandt had given Geertje a valuable ring and some additional jewelry (we hear later of other rings and some gold and silver coins); on January 24, 1648, she signed a will, leaving her personal belongings to her mother, but all the

ern scholars have concluded that Rembrandt behaved unfeelingly towards Geertje when all we have are the (notary-written) texts of various depositions and other legal instruments, with some crucial ones—descriptions of Geertje's behavior before being sentenced—still missing. Those we have are frequently obfuscated by "ambtenaren"

rest, including the jewelry, to Titus, the then six-year-old son of Rembrandt and Saskia. The terms were surely drawn up by Rembrandt who wanted to make sure that Saskia's jewelry remained in the family. We don't know when the actual estrangement began, but in June 1649, one and a half years later (and in the presence of Hendrickje, who by then was a member of the household) a contract was drafted, presumably by Rembrandt, to indemnify Geertje who was planning (we may assume not voluntarily) to leave Rembrandt's house. There were further negotiations in October when Geertje sued for breach of promise and thereby forced Rembrandt to increase his offer of an annual payment from 150 fl. to 200 fl. He insisted, however, on the condition that her earlier will remain in force. She apparently had already pawned some part of the jewelry and Rembrandt paid what was needed to redeem it. We hear of an ugly encounter in Rembrandt's kitchen when, according to a neighbor, Geertje shouted "very violently and unjustly" ("seer hevich ende onredelijk"), and refused even to listen to the contract. It was signed, however, on October 23, 1649. We know nothing about the next, crucial six months. On April 28, 1650, Geertje gave full power of attorney for the handling of her affairs to her brother Pieter Dircx, a ship-carpenter, and her nephew, Pieter Jacobsz., the latter presumably to act when her brother was at sea. She revoked the power of attorney on February 14, 1656, expressing thanks for the trouble her brother had taken on her behalf. It seems that in 1650 she had again borrowed money against some of the jewelry in her hands, and this time her brother had redeemed it. At any rate in the summer of 1650, possibly on Rembrandt's urging though there is no evidence for it, one or more of Geertje's relatives prevailed upon officer(s) of the "burgermeesterkamer" to place Geertje in a house of correction, since only that body could decree such a confinement. According to Wijnman this was a step, not uncom-

mon at the time, so to confine a person who "through his or her behavior had brought shame to the family." The statements about her behavior were made under oath by people of Rapenburg, Geertje's place of origin, but about the nature of these charges we again are in the dark. Would she have been sentenced to twelve years in the *Spinhuis* of Gouda by the office of the "burgermeesters" if there had not been some serious culpability? At any rate, friends of Geertje managed to get her free, over Rembrandt's protest, in 1655 after a similar attempt in 1652 had failed. In July 1656 she is named in Rembrandt's application for a grant of insolvency among seven persons to whom he owed money; this probably indicates that he was in arrears with his annual payment. Geertje's name appears for a last time in a deposition of September 19 of that year. It is not known when she died. In a lecture I gave at the Rembrandt symposium held at the Chicago Art Institute October 22-24, 1969 (published in a Dutch translation in *De Kroniek van het Rembrandthuis*, 1972, I, pp. 3-17 and II, pp. 32-41, and in the original version in *Rembrandt After Three Hundred Years, A Symposium*, Chicago 1973, pp. 49-66), I suggested that Geertje may have been the model for a painting in Edinburgh, then generally known as *Hendrickje in Bed*. Schwartz (p. 240), who cautiously accepted this identification, made it more likely by introducing a painting by Liotard in the Cleveland Museum of art which reproduced the Rembrandt painting together with a portrait of its then owner, François Tronchin; and the date 1647—precisely the time when Geertje Dircx was still with Rembrandt—according to Schwartz is clearly legible on the reproduction of the Edinburgh canvas. The subject of the painting is now generally interpreted as *Sarah Watching Tobias in the Wedding Night*, most convincingly argued by Christian Tümpel, *Nederlands Kunsthistorisch Jaarboek*, xx, 1969, pp. 176-78. See also below pp. 185-86.

(bureaucratic) jargon, as Scheller has pointed out. How can we really know, living as we do in a different society and under different moral and civic codes, what went on when the intimate relationship between Rembrandt and Geertje broke up? H. F. Wijnman, who gave the best *factual* report about the sequence of events, interpreted them in psychological terms that are astonishing in their primitive reasoning. Rembrandt's "love"(?) for Geertje changed into "burning hate" ("diens liefde voor Geertje was blijkbaar veranderd in een gloeiende haat"), he says at one time; Rembrandt was a "violent and passionate" man, "uncomplicated," who "once his fury was awakened . . . could act harshly and without restraint" ("fel en hartstochtelijk"; "ongecompliceerd"; "hoe fel en onbeheerst hij op kon treden als eenmal zijn woede was opgeweckt"). What is clear is that Rembrandt made an effort to keep a distraught woman, whose expectations to marry him had been disappointed, away from his house and his work. But might he not have had good reasons—an obligation to his son, his patrons, and his art—to protect himself from a disturbance he could not control in any other way? In 1655 he did try harshly, though unsuccessfully, to prevent Geertje's release from the Gouda *spinhuis*, but that was at a time when he was deep in financial difficulties which forced him a year later to declare insolvency and eventually to sell his collections and his house.

When he wrote his short philippic on some troublesome aspects of the (then) current Rembrandt research, Wolfgang Stechow argued not so much against the removal of dubious attributions from Rembrandt's oeuvre as for methodologically sound procedures in doing that job. Of considerable interest in that connection is the work of Werner Sumowski.[17] His task—to establish the oeuvres of those Rembrandt students who became identifiable masters in their own right—bears only indirectly on the question of whether or not a given work is by Rembrandt. Yet one could not unreasonably hope that, to the degree that the artistic "profile" of each of Rembrandt's students became recognizable, the works so established might act as magnets, attracting some of the products that have been peripheral to Rembrandt's art. This has been achieved in only a small number of cases.[18] Despite the fact that Sumowski catalogued and illustrated (often in color) the works of no fewer than forty-six "pupils" of the master, and occa-

[17] Werner Sumowski, *Gemälde der Rembrandt-Schüler*, vols. I-IV, Landau, 1983. Sumowski is also the author of nine volumes on the drawings of Rembrandt's followers: *Drawings of the Rembrandt School*, New York, 1979-1985.

[18] In a few cases the original signature was discovered under a superimposed Rembrandt signature: *The Landscape with an Obelisk*, Isabella Stuart Gardner Museum, Boston, signed by Govert Flinck; *St. Thomas*, Staatliche Kunstsammlungen, Kassel, signed by Nicolas Maes. Other artists identified as authors of works formerly given to Rembrandt are G. Dou, W. Drost, and J. Lievens.

sionally even the works of pupils of these pupils, he found himself forced at the end of Volume 4 to lump together as "anonymous works of the Rembrandt school" a large group of paintings that he in good conscience could not include in the oeuvres of any of these pupils. Among them, admittedly, are a good many pictures by "little" or "littlest" artists, to borrow one of his phrases, but there are also some works that would add distinction to any artist's name that could be connected with them. In fact, many of them had previously been attributed to Rembrandt himself.[19] Since they are quite different in style among themselves we are faced with the curious situation that several artists of rank—good enough to be confounded even with Rembrandt—are still "hiding" in the master's orbit.

Shrinking, or to put it more generously, cleansing Rembrandt's oeuvre has also been the chief aim of the authors of the *Corpus of Rembrandt Paintings*, the most ambitious undertaking in Rembrandt connoisseurship of recent years.[20] A combined effort of five Dutch scholars and the result of many years of study carried on with lavish financial support, the *Corpus* is presented in two volumes covering Rembrandt's activity as painter from 1625 to 1634.[21] (Since this was written, the third volume, extending to 1642 and including the *Nightwatch*, has been published |1989|.) It is to be expected that such a prodigious effort will make an important contribution, above all in collecting all the pertinent data for each work, including previous literature, no matter how scattered. Of the total of 195 paintings discussed in the first two volumes, only 105 are accepted as

[19] In Sumowski's "anonymous" group are some of the most admired paintings of Rembrandtesque character, and for virtually every one of them other painters' names have been suggested—unfortunately, several names for every one of them. I am listing a few: *The Beheading of St. John*, Rijksmuseum, Amsterdam; *The Adoration of the Magi*, Buckingham Palace, London; *Christ and the Disciples at Emaeus*, Louvre, Paris; *The Flagellation of Christ*, Museum, Darmstadt; *The Sacrifice of Manoah*, Staatliche Galerie, Dresden; *Quintus Fabius Maximus*, formerly Bucharest; *A Man with a Breast-plate* (Portrait of Rembrandt?), Fitzwilliam Museum, Cambridge; *The Return of Tobias* (see Tobit, Fig. 49); *The Centurion Cornelius*, Wallace Collection, London; and, needless to say, *The Man with the Gold Helmet*, Staatliche Sammlungen Preussischer Kulturbesitz, Berlin. Sumowski developed also an interesting group of categories, classifying these works

according to the degree of their dependence on Rembrandt. If nothing else, these analyses give an idea of the complexity, and controversial nature, of the impact Rembrandt's art had on his pupils.

[20] Stichting Foundation Rembrandt Research Project, *A Corpus of Rembrandt Paintings*, The Hague, Boston, London, ed. J. Bruyn, B. Haak, S. H. Levie, P.J.J. van Thiel, E. van de Wetering. I , 1982; II, 1986; III, 1989.

[21] The difficult problem of Rembrandt drawings—whether original, copy of an original, or a variation of a Rembrandt composition by a follower—has been attacked most assiduously by P. Schatborn, especially in his review of Otto Benesch, *The Drawings of Rembrandt: Complete Edition*, in *Simiolus* VIII, 1974-1975, pp. 34-39, and in *Tekeningen van Rembrandt, zijn onbekende leerlingen en navolgers, Catalogus van de Nederlandse Tekeningen in het Rijksprentenkabinet, Rijksmuseum*, Amsterdam, IV, The Hague, 1985.

authentic, 82 have been questioned or rejected, and eight—possibly because of differences of opinion among the collaborators—remain in a critical limbo. It is hardly surprising that the findings of the Dutch team have been questioned, particularly with regard to a number of portraits datable to Rembrandt's early Amsterdam years.[22] Rembrandt had settled there in 1632 and for some years appears to have worked in close contact with Hendrick Uylenburgh, a cousin of Saskia whom Rembrandt met through this acquaintance. Uylenburgh was an art-entrepreneur who "employed" young artists to work on commissions he obtained for them. Rembrandt was unquestionably the leading artist in this group but it is not clear to what extent he was established in these years as the "master" of a busy workshop. In the introduction to Volume 2 of the *Corpus* F. van de Wetering devotes many pages to discussing this problem, although we know little about the actual practices and the degree of participation of younger artists in the performance of the "workshop." As we have seen, the concept of a Rembrandt workshop occupies a central position in Alpers' discussion of Rembrandt's "enterprise" even though the distinction of hands, the central problem of connoisseurship, remains outside her interest. But the assumption that throughout his career Rembrandt headed and worked with the assistance of a studio has resulted in widespread unease as to what we can call a "Rembrandt." That state of affairs is unhappily reflected in a substantial, well-informed, and balanced book, so far available only in German, Christian Tümpel's *Rembrandt, Mythos und Methode* (1986).[23] One of Tümpel's merits, first seen in some of his articles, has been the demonstration of Rembrandt's familiarity with, and use of, the pictorial tradition available in sixteenth-century prints. This enabled him to identify correctly some of the biblical subjects in the master's work.[24] Yet in this sumptuously produced book, no fewer than 97 plates have captions such as "Rembrandt-Workshop," "Rembrandt-Follower," "Rembrandt-Pupil," or "Rembrandt-Circle," and with the mere addition of a question mark, Tümpel expresses doubts about the attribution of still others, among them the two stunning late portraits (from the Widener collection)

[22] For a spirited attack on the *Rembrandt Corpus* see Walter Liedtke, "Reconstructing Rembrandt," *Apollo*, May 1989, pp. 323-72. As a curator of the Metropolitan Museum in New York, Liedtke took a strong stand in favor of two portraits in his museum which the authors of the *Corpus* had questioned. Liedtke generously called attention to the fact that this writer fifty years ago (in *The Art Bulletin*, 1940) had defended the originality of these two portraits against doubts then expressed by Alan Burroughs. In a review of cur-

rent literature on "Northern Baroque Art," *The Art Bulletin*, LXIX, 1987, pp. 510-19, Egbert Haverkamp-Begemann reclaimed seven items for Rembrandt that had been rejected in the Rembrandt *Corpus*.

[23] Christian Tümpel, *Rembrandt, Mythos und Methode*. Mit Beiträgen von Astrid Tümpel, Königstein im Taunus, 1986.

[24] See also Ben Broos, *Rembrandt and his Sources*, an exhibition, with catalogue, Amsterdam, Rembrandthuis, 1985-1986.

in Washington, and the *Tobit and Sarah* in Rotterdam (see Tobit, Pl. 20), all of which I believe define Rembrandt at his best.[25]

The assault on Rembrandt's oeuvre, mounted from different directions, and with increasing severity, has resulted, not surprisingly, in a great deal of uncertainty and confusion. In this situation it might be useful to remember that even those works now banished to the no-man's land of anonymity must have shown qualities of form and expression which at a less critical age had enabled them to be taken for works of the master himself. And should we not keep in mind that even if they are now recognized as the achievements of some gifted followers, they, too, contribute to and enrich our image of the master's range?

For Rembrandt, as for all great masters, the question whether a work is or is not by him is of more than academic interest. Approval or rejection coming from authoritative bodies—such as the Amsterdam Rembrandt team—has dramatic consequences for the monetary value of the works. It is not only the private owner or dealer who is affected; even museums must take the verdict into consideration in their insurance valuations and in the increasingly common practice of relinquishing questionable items to make place for others unsullied by the shadow of critical doubt. In such cases one may well ask: how trustworthy is the opinion of the experts? what are the arguments on which they base their judgment? Horst Gerson, who started the process of winnowing out the painted oeuvre of Rembrandt, proceeded largely as experts had always done by applying a critical eye, sharpened by years of experience. His occasional references to X-ray evidence, flawed as they are by an incomplete understanding of how to read the X-ray image, were concessions to the growing trust in technology as a substitute for decisions inevitably based on subjective elements. Since then art experts have increasingly tried to support their opinions with scientific evidence, just as physicians feel compelled to reinforce their diagnosis with technological tests. In addition to X-ray photography, which was first applied to the examination of paintings around 1925,[26] paintings are

[25] Among the many works Tümpel questions or rejects (often with reference to other scholars) are *The Flight into Egypt*, Tours; *Bathsheba*, New York; *The Circumcision*, Washington; *the Adoration of the Shepherds*, London; *Christus at Emaeus*, Copenhagen; *Philemon and Baucis Visited by Jupiter and Mercury*, Washington. The continuous reduction in numbers of paintings accepted as by Rembrandt has been tracked in the exhibition catalogue *Art in the Making: Rembrandt,* National Gallery, London, 1988-1989, p. 9: Bredius's 1935

list had *ca.* 630 numbers; Bauch's, of 1966, *ca.* 560; Gerson's, of 1968, *ca.* 420; while the Rembrandt Research Project (*Corpus*) "seems set to reduce the artist's total oeuvre ... to fewer than 300 authentic paintings." (The authors charitably omitted giving the numbers Valentiner had accepted: 744!)

[26] In this country it was Alan Burroughs, then at Harvard University, who began systematically to make "shadowgraphs" of earlier painting, both here and abroad. He presented his findings in a

almost routinely examined with infra-red and ultra-violet light. Microchemistry (the chemical analysis of microscopic cross-sections of the paint-film), also practiced for many years, has been applied to a large number of Rembrandt paintings in the London National Gallery, and the results have been published in the excellent catalogue of the exhibition "Art in the Making."[27] (Two paintings, nos. 9 and 19, offer in addition data in infra-red photographs). Two new scientific devices have more recently been introduced into Rembrandt studies. One is dendrochronology which provides a *terminus post quem* for wood panels (chiefly oak), since it can now be determined, especially for central and north European panels, when the tree was felled.[28] The latest addition to the scientific armory of art criticism is autoradiography (more fully known as neutron-

book (*Art criticism from a Laboratory*, Boston, 1938). Similar campaigns to X-ray pictures were made in Germany, primarily by Christian Wolters for his doctoral dissertation (Munich, 1936), which appeared, like Burrough's book, in 1938: *Die Bedeutung der Gemäldedurchleuchtung mit Röntgenstrahlen für die Kunstgeschichte*, Frankfurt, 1938. Both volumes were reviewed by me (*The Art Bulletin*, 1940, pp. 37-43.) For the determination of Rembrandt's authorship much depends on the proper "reading" of the X-ray film, as shown by the case of the so-called *Self-portrait* of Rembrandt in Stuttgart, a work whose impossible attribution to Rembrandt was strongly seconded by C. Müller Hofstede ('Das Stuttgarter Selbstbildnis von Rembrandt," *Pantheon*, xxi, 1963, pp. 65-90), precisely on the basis of the X-ray image. It has been attributed (no more convincingly) to Aert de Gelder by J. Bruyn (*Oud Holland*, ci, 1987, p. 228). The chief value of X-ray photography consists in revealing major flaws in the state of preservation and above all changes the artist made in the course of execution. To mention some examples from Rembrandt's work: The X-ray picture of the Dresden *Self-portrait with Saskia* revealed that originally there was still another women in the composition, reinforcing the reading of the subject as *The Prodigal Son Carousing*; in the Kassel *Jacob Blessing the Children of Joseph*, Rembrandt had first given Joseph a position indicating his disapproval of Jacob's preference for the younger son; he changed it to stress the son's filial piety as he supports the old man's hand, but does not try to divert attention to the older child; in the painting of the *Syndics* in Amsterdam, Rembrandt apparently had great difficulties with the placing of the servant who had to be included; he had painted him in two different places until he settled for the central place that he now holds; and the figure which, in an early canvas in London, now depicts either Flora or an Arcadian shepherdess, had originally been planned to be Judith, accompanied by a maid who holds open a bag to receive Holofernes's head.

[27] David Bomford, Christopher Brown, Ashok Roy, *Art in the Making: Rembrandt*, with contributions from Jo Kirby and Raymond White, London, 1988.

[28] For dendrochronology see J. Bauch, D. Eckstein and M. Meier-Siem, "Dating the wood of panels by a dendrochronological analysis of the tree-rings," *Nederlands Kunsthistorisch Jaarboek*, xxiii, 1972, pp. 485-96. For autoradiography, see Maryan Wynn Ainsworth et al, *Art and Autoradiography: Insights into the Genesis of paintings by Rembrandt, van Dyck and Vermeer*, Metropolitan Museum of Art, New York, 1982. See also *Art in the Making* [26]. The painting of the *Tribute Money* in the National Gallery of Canada in Ottawa, signed and dated 1629, is painted on a panel taken from a tree supposedly cut after 1630 and has therefore been taken from Rembrandt's authentic oeuvre by the authors of the *Corpus* and been given to a pupil. Not having seen the evidence I reserve opinion on a picture well worthy of the master.

acceleration radiography) which has been hailed as an important breakthrough in de-
termining the authenticity of Rembrandt paintings. In fact, one of its first "victims" was
the *Man with the Gold Helmet*.[29]

Dazzled by the many possibilities of scientific examination at our disposal, many
people forget that none of these tests speak by themselves. They all must be interpreted
and inevitably some subjective elements enter into the process of interpretation.[30] What
seems to me certain is that unanimity of opinion about Rembrandt's authorship of
paintings, and perhaps even more of drawings, is unattainable. If the efforts lead to a

[29] For an account of how the *Man with the Gold
Helmet* was downgraded by the curator of the
Berlin museum where it is preserved, see Jan
Kelch at al, *Bilder im Blickpunkt: Der Mann mit
dem Goldhelm, eine Dokumentation der Gemälde-
galerie in Zusammenarbeit mit dem Rathgen-For-
schungslabor SMPK und dem Hahn-Meitner Insti-
tut*, Berlin. Staatliche Museen Preussischer
Kulturbesitz, Gemäldegalerie, Berlin, 1986. The
case against the *Man with the Gold Helmet* rests of
course not on autoradiography alone. Relying en-
tirely on stylistic arguments, B. A. Rifkin (*Art
News,* LXVIII, May 1969, p. 27) and Henry Adams
(*The Art Bulletin*, LXVI, 1984, p. 438) have sug-
gested Karel van der Pluym (c. 1625-1672), a pu-
pil as well as a relative of Rembrandt, as its au-
thor. C. Grimm (*Tableau*, v, No. 3, 1982-83, pp.
242-50) proposed Heyman Dullaert (1636-1684).
Jan Kelch (in *Bilder im Blickpunkt* [24]), quoting
additional critics who reject the attribution to
Rembrandt—K. Roberts, Christian Tümpel, and
Christopher Brown—concludes his study with
the statement that we are still far from a new (and
presumably acceptable) identification.

[30] On the second page of the lively opening
statement in her book on Rembrandt Alpers
wrote: "On the basis of a detailed study of the
way it was painted, and in particular on the evi-
dence of the substructure, that is, what is de-
scribed as the underlying drawing, which was re-
vealed by autoradiography, it has been concluded
that the painting is by a Rembrandt student, as-
sistant, or follower whose name is unknown."
What autoradiography actually reveals is some-
thing rather different. In this complicated, expen-
sive, and, like all radiological activity, risk-con-
nected method of examination, the painting is
bombarded with neutrons that activate the nuclei
of the various pigments and transform them into
radioactive isotopes. When the radioactivity has
declined to half-strength, it can be recorded on
special supersensitive X-ray films. Since the life-
times of the isotopes of individual pigments vary
greatly, from a few hours to days and even weeks,
the films provide information about where, and
in what quantity, specific colors, or color-groups,
have been applied by the artist. Yet with the pos-
sible exception of the first (ground) layer where
the design may be laid in in bone-black or brown,
the films do not allow reconstruction of the se-
quential process of the artist's work with any de-
gree of accuracy. Where the painter mixed his
pigments, the individual pigments will often ap-
pear on different films, films that provide artifi-
cial images of little value for the determination of
authorship. (Two of the most important pig-
ments, lead-white and lead-tin-yellow, actually
are recorded strikingly by standard X-ray pho-
tography.) One final caveat: the number of Rem-
brandt paintings so far examined by this difficult
and time-consuming method is still far short of
providing a sufficient range of data that would
permit us to exclude firmly nonconforming
works; nor have we been provided with what one
would expect in such scientific experiments—a
control group (works by pupils and imitators) ex-
amined in like manner. Nuclear science has its
place in many areas of this technological age; but
in the area of connoisseurship, the experienced
eye of the scholar armed with a good magnifying
glass will still have its place.

better understanding of the artist's work and working methods, they are welcome; if they only serve to establish commercial values, they are of no concern to the art historian.

Fortunately, and despite the fashionable deconstructionist trend in modern art history, the less fashionable conviction, that outstanding individuals are capable of playing decisive historical roles, has not yet disappeared from art-historical literature in general, and definitely not from that on Rembrandt. The title of an exhibition held in Amsterdam in 1983 proclaimed proudly: *Rembrandt, the Impact of a Genius*. It is beyond the limits of this introduction, however, to attempt a critical survey of the many specialized and often important contributions to the knowledge of our master made in recent years. They would doubtlessly help restore the Rembrandt image, distorted as it has become in some current writing.

When I accepted the invitation of Princeton University Press to have the essays, first gathered in the book of 1969, printed once more, augmented by two methodologically related pieces, I felt that they, too, might help to return to Rembrandt's oeuvre some of the luster an anti-elitist art history has tried to tarnish. Not that the artist whose position in art history is secure and whose fame is universal would need such help. But by always using—with one exception—the master's works rather than his personal history as the point of departure, these essays try to explore the reasons for the never-ending appeal Rembrandt's art has had through the centuries. They also permit me to repay a debt of gratitude incurred during the years when I was engaged in probing the meaning of those works and interpreting their human message.

I. REMBRANDT'S *Aristotle*

I. INTRODUCTION

L ONG FAMILIAR to scholars but hardly known outside their circles, Rembrandt's *Aristotle* (Fig. 1) was propelled into the blinding light of contemporary publicity at a New York auction on November 15, 1961.[1] When the late James J. Rorimer, with what became known as the most expensive "flick of an eyelid," made the winning bid—against the Cleveland Museum—he not only obtained for the Metropolitan Museum its most popular treasure but also delivered to the news media a sensational story: the highest price ever paid for a work of art, a cool $2,300,000. That sum has since been topped by one assumed to have been close to six million, paid by the National Gallery of Washington, for a languid, though only seemingly frosty Florentine lady painted by Leonardo da Vinci. Yet Rembrandt's *Aristotle* has retained some of the near magical fame which, like the tail of a comet, attaches itself to an extraordinary event. It is safe to say, however, that the picture owes this reputation less to the stratospheric price tag affixed to it on that memorable evening than to its own artistic merits. There is no danger that Rembrandt's *Aristotle* will ever cease to cast its spell on all who look upon it. Its aesthetic appeal has survived any number of jokes and puns, hundreds of cartoons, and countless words of spoken and printed appreciation. Anyone looking at the picture feels instinctively that he is in the presence of a great work of art. Surely Theodore Rousseau was perfectly justified when he wrote: "Whether or not we know what the picture represents, its mood is communicated to us with extraordinary and compelling force."[2]

Unfortunately, the majority of commentators have been satisfied with sensing the mood of the work without asking whether the picture has any meaning commensurate with this mood. A few scholars have tried to explain it more precisely but these efforts have rarely extended beyond generalities. According to one theory, Rembrandt's picture echoes the central theme of Raphael's *School of Athens* where Aristotle, however, is associated

[1] *The collection of Twenty-four Old Master Paintings formed by the late Mr. and Mrs. Alfred W. Erickson*, Parke-Bernet Galleries, Inc., New York, 1961, no. 7: "Aristotle Contemplating the Bust of Homer." (Canvas, 56½ x 53¾ inches.)

[2] Theodore Rousseau, "Aristotle Contemplating the Bust of Homer," *Bulletin, The Metro-* *politan Museum of Art*, 1962, pp. 149 ff., hereafter referred to as Rousseau, 1962. (Throughout this study literature frequently cited will be fully identified only once and later referred to by the author's name, the year of publication, and, in brackets, the number of the footnote where the title is first given.)

with Plato—not, as in the New York canvas, with Homer.[3] Another theory would like to explain the picture as an allegory, demonstrating the kinship of Philosophy, represented by Aristotle, and Poetry, "personified" by the bust of Homer.[4]

All such interpretations fail to do justice to the specific nature of the confrontation of the two figures. How little most people seem to be aware of the inadequacy or incompleteness of our understanding of the work is proved, for instance, by the general acceptance of the current title: "Aristotle Contemplating the Bust of Homer," a title first introduced into the literature by Bredius in 1936.[5] And yet, what does it really mean to say that Aristotle contemplates the bust of Homer? Is he admiring it as a fine piece of sculpture? Does he wonder if it is a good likeness? Is he pondering its date and place of origin? Or is he troubled by the thought that he may have paid too much for it?

Asking such waggish questions should make it clear that the current title is, to say the least, ambiguous. By seeming to formulate the theme of the picture precisely, it acts as a block to further inquiries. No one will deny that the bust must play an important role in Aristotle's thoughts, but that it is the main, let alone the sole, object of the philosopher's contemplation is unlikely, and, as we shall see, incorrect.

The thought that Aristotle must be preoccupied with the bust, and through it with the poet whose likeness it renders, has more than once affected the very description of the picture. Although it ought to be obvious that Aristotle is not looking at the bust, this is precisely what several scholars have said he was doing; this provides us with a good example of our tendency to perceive the expected. A characteristic commentary is Benesch's: "Aristotle holds a silent dialogue with this image of Homer."[6] Long before him Carl Neumann had introduced the concept of a "silent dialogue" (*stille Zwiesprache*), specifying the situation further by saying that Aristotle's "glance rests somberly on the bust of the old poet" (*dessen Blick so dumpf auf der Büste des alten Poeten ruht*).[7] And Schmidt-Degener, still thinking that the main figure was a poet, spoke of the "melancholy thoughts" of the epigone "as he looks into the eyes" of his marble Homer.[8]

[3] This view was presented by Theodore Rousseau in a paper read at the annual meeting of the College Art Association in New York, January 29, 1966.

[4] Fritz Saxl, "Rembrandt and Classical Antiquity," *Lectures*, London, 1957, pp. 298 ff., and Herbert von Einem, "Rembrandt und Homer," *Wallraf-Richartz-Jahrbuch*, XIV, 1952, pp. 182 ff.

[5] A. Bredius, *The Paintings of Rembrandt*, Vienna, 1936, fig. 478.

[6] Otto Benesch, "Rembrandt and Ancient History," *Art Quarterly*, XXII, 1959, pp. 309 ff. (328).

[7] Carl Neumann, *Rembrandt*, Munich, 1922, II, pp. 535. Emil Kieser, in his important but hard-to-find article "Über Rembrandts Verhältnis zur Antike," *Zeitschrift für Kunstgeschichte*, X, 1941-1942, pp. 129 ff., also says: "Die Augen richten sich in tiefem Sinnen auf eine Büste Homers."

[8] F. Schmidt-Degener, "Rembrandt en Homer-

2. THE HISTORY OF THE PAINTING

Painted in 1653 (or at least finished in that year), the *Aristotle* was sold to Antonio Ruffo, a wealthy Sicilian nobleman who in 1646 at the age of 36 had moved into a stately palace in Messina and by 1649 had already gathered a collection of 166 canvases, mostly by contemporary Italian painters.[9] At a time when Rembrandt's fortunes were declining at home, this young collector in far-off Sicily was willing to pay the extraordinarily high sum of 500 florins for a painting by the master. (We learn from a later correspondence that this was about eight times—not, as is sometimes said, four times—the amount an Italian painter would receive for this kind of picture.)[10] The painting arrived in Messina in the summer of 1654, after a trip lasting nearly three months, and appears to have pleased Ruffo greatly.

That Rembrandt enjoyed a considerable reputation in Italy emerges from a letter the Bolognese painter Guercino wrote to Ruffo on June 13, 1660.[11] Ruffo had asked Guercino to paint a companion piece to Rembrandt's picture, and to do it in his earlier vigorous manner[12] (we would probably say his Caravaggiesque style), so that it might better harmonize with Rembrandt's.[13]

us," *Feest-Bundel, Dr. Abraham Bredius aangeboden den achtienden April, 1915*, Amsterdam, 1915, p. 15: "Het zijn trieste reflexies die zulk een nakomer bekruipen, wanneer hij zijn marmeren Homerus in de oogen ziet."

[9] The basic literature for the reconstruction of the early history of the painting are 1) Marchese Vincenzo Ruffo, "Galleria Ruffo nel secolo XVII in Messina," *Bollettino d'Arte*, x, 1916, pp. 21, 95, 165, 237, 284, 369; 2) G. J. Hoogewerff, Rembrandt en een Italiaansche Maecenas, *Oud Holland*, xxxv, 1917, pp. 129 ff.; 3) Corrado Ricci, *Rembrandt in Italia*, Milan, 1918. (Ricci's book is important for certain additions to and corrections of the documents published by Marchese Ruffo.)

[10] Ruffo, 1916, p. 165 [9].

[11] *Ibid.*, p. 100.

[12] The phrase *della mia prima maniera gagliarda* is the phrase Guercino uses in describing his earlier style. The same formula was used by Giacinto Brandi in a letter of January 24, 1671, when he complained that had he known his pic-

ture was to be hung as a companion piece to one of Rembrandt's he would have painted it *di maniera gagliarda* rather than keeping it light (*chiaro*); see C. Ricci, 1918, p. 33 [9].

[13] It is of considerable importance for the history of art to know that a patron in the seventeenth century could ask an artist to produce a picture in a particular style, different from the one he was practicing at the moment, and that the artist would be perfectly agreeable to this request and confident that he could do as he was asked. This freedom to paint in one style or another should not be confused with the freedom of choice between different *modes* of representation, since in Guercino's case the theme and function of the painting remained the same (see Jan Bialostocki, "Das Modusproblem in den bildenden Künsten," *Zeitschrift für Kunstgeschichte*, xxiv, 1961, pp. 128 ff.). Nor should Guercino's willingness to paint his cosmographer in such a way that it would *harmonize* with Rembrandt's painting be compared to Goltzius' and Luca Giordano's practice of *imitating* the

Guercino answered that he knew Rembrandt's etchings, admired them greatly, and considered the Dutch master a true virtuoso. He asked for and received a drawn copy of Rembrandt's painting but his question as to what (or who) was represented was apparently never answered. Less than four months later, on October 6, 1660, he wrote that his picture was finished.[14] Assuming, as he says, that Rembrandt's work represented a physiognomist (*fisonomista*) he had painted a cosmographer as its pendant—balancing intelligently a student of the microcosm with one of the macrocosm. Guercino's painting is lost but Professor Jakob Rosenberg convincingly identified a Guercino drawing in Princeton (Fig. 2) as a study for that cosmographer.[15] (A picture Ruffo obtained in 1662 from the much-traveled Mattia Preti, then residing in Malta, is thought by some to have also been a companion piece to Rembrandt's *Aristotle*, but this is not the case, as Corrado Ricci pointed out long ago.)[16]

Like some modern observers, Guercino evidently assumed that the bearded scholar in Rembrandt's picture is examining the bust itself; we must not forget, however, that he judged on the basis of a third painter's sketch which had been sent to him, and the mis-

styles of other artists (see Goltzius' engravings in the manner of Dürer, Lucas van Leiden, and Barocci; for Luca Giordano see Andreina Griseri, "Luca Giordano 'alla maniera di' . . . ," *Arte antica et moderna*, XIII-XVI, 1961, pp. 417 ff.). In this connection it should be remembered that the two different versions of *St. Matthew* that Caravaggio painted for the Contarelli Chapel in San Luigi dei Francesi—paintings which all scholars had separated by a number of years because of their difference in style—were actually executed within a few months of each other. See Herwarth Röttgen, "Die Stellung der Contarelli-Kapelle in Caravaggios Werk," *Zeitschrift für Kunstgeschichte*, XXVIII, 1965, pp. 47 ff.

[14] Ruffo, 1916, p. 102 [9].

[15] Jakob Rosenberg, "Rembrandt and Guercino," *Art Quarterly*, VII, 1944, pp. 129 ff. See also the same author's *Rembrandt, Life and Work*, London-Greenwich, 1964, pp. 282 and 360, note 30. Guercino's finished painting differed from the Princeton drawing according to its description in Ruffo's inventory (Ruffo, 1916, p. 126): "Cosmografo con un turbante turchino in testa che considera un mappamondo tenuto con la mano sinistra sopra un tavolino e con la

destra va accennando." Instead of holding the globe with his left hand, Guercino's cosmographer in the Princeton drawing holds a pair of dividers as if to measure a distance on the globe. Seymour Slive (*Rembrandt and his Critics, 1630-1730*, The Hague, 1953, p. 62, note 1) also noticed these discrepancies. Admitting that the correspondence is far from perfect, I still believe that the Princeton drawing represents a stage in Guercino's preparation of the painting for Don Antonio Ruffo.

[16] Corrado Ricci, 1918, p. 11 [9]. Preti's picture represented Dionysius, tyrant of Syracuse, in half-length, teaching school in Corinth after having fallen from power. It measured 5 x 6 palmi and was oval (Ruffo, 1916, p. 287 [9]) and hence could not have been a companion piece to the *Aristotle*. As a half-length and slightly exotic figure ("che anche lega il torbante in testa come l'altri due," i.e., Rembrandt's Aristotle and Guercino's Cosmographer), it had of course a general similarity to them. See Preti's letters of September 18, 1661 (Ruffo, 1916, p. 241) and of October 30, 1662 (Ruffo, 1916, p. 244) announcing the completion of the picture.

understanding of the relationship between the philosopher and the bust may have to be blamed on that artist. Though clearly mistaken, Guercino was not so far off the mark as one might think. In the body of Aristotelian writings is indeed a treatise on physiognomy, though no longer accepted as his own work.[17] It was of the greatest influence when in the sixteenth century the problem of the relationship of intelligence and character to the appearance of the body was again studied. A book of vast popularity, Giovanni Battista Della Porta's *Physiognomy*[18] was built entirely around the Aristotelian comparison of animal and human appearance. Thus, it would have been quite legitimate to render Aristotle as a physiognomist.

It is somewhat peculiar that six years elapsed before Ruffo ordered a pendant to Rembrandt's *Aristotle* and that he then turned to Guercino. It is quite possible and even likely that Ruffo had first approached Rembrandt himself, although we have no evidence of it, to obtain one or two companion pieces for the *Aristotle* and that he sought out Guercino only when his patience had worn thin. Houbraken, writing about Rembrandt's relationship to his patrons, expressly mentions that they had to wait long for their pictures, and that to obtain anything from him they had—in the words of a proverb—"to beg him and still add money."[19] We know also of specific cases in which Rembrandt was slow in delivering. Two paintings for Frederik Hendrik of Orange, half-finished in 1636, according to Rembrandt's own words, were completed only in 1639, possibly because he then needed the money to pay for the purchase of his house. He only reluctantly finished the painting of *Juno*, and the tragedy of the *Claudius Civilis* picture may have resulted from procrastination due to his reluctance to bow to the wishes of the Amsterdam town fathers.[20] However that may be, Rembrandt shipped two more paintings to Ruffo shortly after Guercino had finished his *Cosmographer*, and he intended them to be companion pieces to his *Aristotle*. They arrived in Messina in the fall of 1661 and in the shipping bill were identified as portraits of *Alexander the Great* and of *Homer*.[21] About a year later

[17] T. Loveday and E. S. Forster, *Physiogno-monica*, Oxford, 1913 (The Works of Aristotle, VI).

[18] Giovanni Battista Della Porta, *De humana physiognomia*, Naples, 1586.

[19] Arnold Houbraken, *De Groote Schouburgh der Nederlantsche Konstschilders en Schilderes-sen*, I, The Hague, 1718, p. 269.

[20] For the paintings for Frederik Hendrik see Horst Gerson, *Seven Letters by Rembrandt*, The Hague, 1961, pp. 39 and 55; for the *Juno*, see below, p. 85; about the case of the Claudius

Civilis see, in addition to the standard literature, H. van de Waal, *Drie eeuwen vaderlandsche geschieduitbeelding, 1500-1800*, The Hague, 1952, pp. 217 ff.; idem, "The Iconological Background of Rembrandt's Civilis," *Konsthistorisk Tidskrift*, Stockholm, XXV, 1956, pp. 11 ff.; Carl Norden-falk, "Some Facts about Rembrandt's Claudius Civilis," *ibid.*, pp. 71 ff.

[21] The pictures were shipped from Amsterdam on July 30, 1661, see Ricci, 1918, p. 18, note 3 [9]. On p. 21 Ricci again mentions "la spedizi-one *simultanea* dell'Alessandro e dell'Omero."

Ruffo (as always, through a middleman) complained to the artist that the *Alexander* was unprofessionally made up of four pieces of canvas and that the seams were disturbingly visible. He suspected that Rembrandt simply had taken a head painted earlier and had enlarged it into a half-length figure by adding strips of canvas. Yet Ruffo said he would keep it if Rembrandt reduced the price by half (which, he claimed, was still much more than Italian masters would get).[22] Otherwise, Rembrandt ought to paint a replacement. There was no argument about the *Homer*, which Rembrandt had sent unfinished; Ruffo agreed to accept it if it were properly finished. The *Homer* thus was returned to Rembrandt and shipped again to Sicily in 1664. (It may well be that Rembrandt had sent the *Homer* unfinished not for the purpose of obtaining Ruffo's approval but in order not to lose the commission altogether.) Ruffo's complaint about the *Alexander* clearly riled the master, who answered curtly that there were apparently no good connoisseurs in Messina, and that the seams would not show if the picture were hung in the right light.[23] He was willing to paint a replacement if Ruffo was willing to pay 600 florins (100 more than for the first), and to return the first picture at his own cost and risk.

It is not known whether Ruffo kept the first canvas of the *Alexander* or decided to have it replaced. Faced with Rembrandt's intransigence and with the stiff charge for a new

It is difficult to understand why several authors assumed that only the Alexander was shipped in 1661, while the Homer followed the next year, unless they drew this conclusion from the fact that only the Alexander was billed at that time. The absence of the Homer from the original invoice, however, is easy to explain: the painting was shipped unfinished, and returned to the master in 1662 with some instructions, probably about the exact dimensions required. It left Messina on November 16, 1662, but is referred to earlier, on November 1, 1662: "inviò con il d.º quadro d'Alessandro un altro d'Homero *mezzofinito* sopra tela bella e nova . . . dentro una incirata" (Ricci, p. 26).

[22] Ruffo, 1916, p. 165 [9]. According to Preti's letter of December 17, 1661 (*Ibid*., p. 242), the pictures had greatly pleased the Italian patron when they first arrived.

[23] The original text of Rembrandt's letter is lost; it has been preserved only in an Italian translation. Since, except for a short autograph note (see below note 69), this letter is the only personal statement by Rembrandt concerned with this transaction, we include the full text: "Molto me maraviglio del modo che scrivono del Alexandro che è fatto tanto bene, credo che si sone pochi Amatori a Messina E poi che V.S. si lamenta tanto del prezzo quanto della tela, ma se V.S. comanda tornarlo sopra suoe spese e suo risico come ancora il schesso di Humeris, farò un altro Alexandro, poi in quanto alla Tela me ha mancato pingiende, che fu di bisognio alungarlo, ma però quando il quadro pende giusto sopra suo giorno non si vederà Niente. Si V.S. piagie il Alessandro cossì, va bene, se non a V.S. piacesse tener il detto Alexandro Il manco prezzo l'è f.ni 600- fiorini. e il Gumerio f.ni 500—et il costo della tela, le spese se intenda, doverle fare V.S. E piacendo haverlo fatto resterà servito di mandarmi la giusta misura quando le vole di grandezza.—E ne attende la resposta per mio governo." (Ricci, 1918, p. 30 [9]; for a slightly different reading see Ruffo, 1916, p. 166 [9]; Hoogewerff, 1917, pp. 146-47 [9]).

version, he may have decided to keep what he had. At present no painting that can be identified with certainty as Ruffo's *Alexander* is known to exist. Some scholars have suggested that it has been preserved in a beautiful painting of 1655 (Bauch no. 280) in Glasgow,[24] but this is far from certain. One argument against it—that the owl on the helmet fits only Pallas Athena—has recently been invalidated.[25] The presence of earrings can hardly be cited as sufficient reason to exclude a male character, in view of the fact that in the same year, 1665, Rembrandt painted the portrait of an elderly man (Stockholm) with similar earrings (Bauch no. 414). (Small earrings are worn by the Man with the Magnifying Glass in New York, and—last but not least—by Aristotle himself!) Moreover, the Glasgow picture, like Ruffo's "first" *Alexander*, is made up of several pieces of canvas. Yet it is precisely this technical detail which contradicts rather than supports the identification. The painting has been enlarged by four strips of canvas, none of them very large. The two lateral additions together measure 18 cm., these above and below together 21 cm. Besides being in all likelihood of much later date, and not by the hand of Rembrandt,[26] these additions are too insignificant to warrant Ruffo's complaint. Nor does their removal leave us with only a "head": it still would be a half-length figure. Moreover, in Ruffo's inventory the *Alexander* is described as "seated,"[27] and this can hardly be said of the Glasgow figure. There is, finally, the date of 1655: it is difficult to imagine that Rembrandt would have kept such a picture five years in his studio before shipping it on to Sicily.

In the museum of the Gulbenkian Foundation in Lisbon there is a similar picture (Fig. 3), which has generally been dated in the same year.[28] Here too the sex of the figure has

[24] For instance W. R. Valentiner, *Rembrandt's Paintings in America*, New York, 1931, under no. 115. Other names proposed for the painting are, besides Alexander: Pallas Athena, St. Michael, Achilles, Mars, Apollo, Erechtheus, Bellona. See Kurt Bauch, *Rembrandt, Gemälde*, Berlin, 1966, p. 15 of the notes, no. 280.

[25] Konrad Kraft, "Der behelmte Alexander der Grosse," *Jahrbuch für Numismatik und Geldgeschichte*, xv, 1965, pp. 7 ff., especially p. 20. I owe to Erwin Panofsky the reference to this study. The theory that the Glasgow picture represents Pallas Athena was expressed in the catalogue of the exhibition *Dutch Pictures, 1450-1750*, Royal Academy of Arts, London, 1952-1953, no. 201, and was again defended by Bauch, 1966, p. 15 of notes.

[26] C. Hofstede de Groot, *Beschreibendes und kritisches Verzeichnis der Werke der hervorragendsten holländischen Meister*, Esslingen-Paris, vi, 1915, p. 116, no. 208 ("in neuerer Zeit ringsum vergrössert"). These strips have justly been excluded in the reproduction of the picture in Bauch's book [24], fig. 280. See also the same author, "Einige Betrachtungen über die Ausstellung holländischer Kunst in London," *Repertorium für Kunstwissenschaft*, L, 1929, p. 135 (to no. 112), where Hofstede de Groot rejected the identification with Alexander the Great both for the Glasgow painting and the one in Lisbon (then still in Leningrad).

[27] "Alessandro Magno seduto, mezza figura, al naturale" (Ruffo, 1916, p. 318 [9]).

[28] Bredius, 1936, no. 479 [5]; Bauch, 1966, no.

been in doubt. To most scholars, the long hair, combined with an owl-crested helmet and a gorgon-head on the shield, suggested a Pallas Athena. None of these details, as Kraft has demonstrated, can be cited as proof that the painting represents Pallas Athena. The owl can be associated with Alexander as well, and gorgon-heads on shields are commonplace. As to long hair, it was actually characteristic of Renaissance renderings of Alexander, derived, as we shall see, from coin-images of Pallas Athena.

In fact, any study of the original makes it clear not only that Rembrandt painted the face of a man, but more specifically, that it was most likely his son Titus who modeled for him. The features are very similar to those found in the angel in the Paris *St. Matthew* (Fig. 4) and—somewhat earlier—in the painting in Vienna of Titus reading.[29] This raises the problem of the date of the Lisbon canvas. If Titus, as I firmly believe, was the model, the date cannot be "c. 1655," as has been generally assumed—simply by analogy with the Glasgow picture—but must be considerably later, most likely c. 1660-1661, or close to the Paris *St. Matthew*. This date is borne out also by the style of the picture, which is broader and bolder than that of the Glasgow canvas, and close to such pictures as the portrait of Hendrickje Stoffels of 1660 in New York (Juno, Fig. 7).[30] Thus, it was painted just about the time Rembrandt presumably was occupied with the "first" *Alexander*. Could the Gulbenkian picture, then, be Ruffo's painting? It certainly is not very difficult to imagine the figure seated. To sustain such a theory one would have to assume that the three additions (presumably added right, left, and below) that had been so disturbing to Ruffo, were removed at one time or another; the Gulbenkian picture, at any rate—as it appears now—could more justifiably be called a "head" than the one in Glasgow. Yet while it surely renders a man, and *could* be an Alexander, the identification of the Lisbon painting with Ruffo's picture, no matter how tempting, remains conjectural.[31]

281 [24]. Canvas, 118 x 91.1 cm. See also *Pinturas da Colecção da Fundação Gulbenkian*, Museu Nacional de arte Antiga, Lisbon, 1961, no. 37. The painting came from the Hermitage, Leningrad.

[29] See Bredius, 1936, fig. 122 [5]. That the youth in the Gulbenkian canvas bears Titus' features can hardly be denied. C. Hofstede de Groot, 1915, p. 117, no. 210 [26], failed to notice this obvious fact, presumably because he called the picture "Minerva," while the features of the Glasgow picture, which he called "Mars" (p. 116, no. 208) "strongly" reminded him of Rembrandt's son Titus! (In 1655, when Rembrandt painted the Glasgow picture, Titus was about 13 years old and not very likely to pose for such a martial theme.)

[30] Hoogewerff, 1917, p. 139 [9], also stated that the Lisbon picture (then still in the Hermitage) was painted more broadly than the Glasgow one but the subsequent literature on Rembrandt did not take any notice of this fact.

[31] The idea that the Gulbenkian picture might be the "lost" Alexander has of course already occurred to other scholars. Hoogewerff, 1917, p. 131 [9], was the first to come out in favor of this theory; he was followed by J.-F. Backer, *Gazette des Beaux-Arts*, 5th period, XI, 1925, pp. 54-55 who reproduced the picture and in his caption called it "Alexander" without any

The *Homer*, at any rate, is certainly the celebrated picture in the museum of the Mauritshuis in The Hague (Fig. 5), unfortunately preserved only as a fragment. It included originally two students recording the blind poet's words.[32]

Any careful reading of the documents must result in the conclusion that at the time

further qualification. Even before the discovery of the documents that established the fact that Rembrandt had painted an *Alexander*, J. Six had suggested that when Rembrandt painted what Six still called "Minerva," he had known imperial Alexander coins reflecting a type known from medallions found in Abukir; see Jan Six, "Apelleisches," *Jahrbuch des deutschen archaeologischen Instituts*, xxv, 1910, p. 147. The identification of the Gulbenkian canvas with Ruffo's *Alexander* was rejected by C. Hofstede de Groot, in the *Nieuwe Rotterdamsche Courant* of December 5, 1917, and by Hans Schneider, "Rembrandt in Italien," *Kunstchronik und Kunstmarkt*, xxx, 1918-1919, pp. 69 ff. Rosenberg also decided against it (1964, p. 283 [15]). Very little attention has been paid to a far from negligible circumstance: The picture actually was called "Alexander" at the time it entered the collection of Count Baudouin after its sale in Amsterdam on June 5, 1765, and continued to be known by that title even after entering the collection of Catherine II at the Hermitage; see C. Hofstede de Groot, 1915, no. 210 [26], and John Smith, *Catalogue Raisonné*, vii, London, 1836, p. 113, no. 309. The belief (Rousseau, 1962, pp. 154 f. [2]) that the existence of a second *Alexander* is vouchsafed by a letter of Mattia Preti, "in which Preti congratulates his patron on having received a second *Alexander* more to his taste than the first," unfortunately is based on a misunderstanding. Preti's letter was written in Malta on December 17, 1661 (Ruffo, 1916, p. 242 [9]), i.e., shortly after the arrival of the first *Alexander* and long before Ruffo had developed a dislike for the picture. When Preti speaks of "l'altra meza figura dell'Alessandro" which "sia stata di suo maggior gusto della prima," the word "prima" can only refer to the first picture Ruffo had received, that is, to the Amsterdam intermediary only on November 1, 1662. Thus, while Rousseau's thesis ac-

cording to which the Glasgow picture "could be" the first *Alexander* while the Gulbenkian canvas might be the second version, is not tenable, he deserves credit for having again defended the name Alexander for either of these pictures. A completely different solution was first proposed by W. R. Valentiner, *Rembrandt, Des Meisters Handzeichnungen*, ii, Stuttgart-Berlin, s.d., no. 740, p. 424. He suggested that a drawing in Rotterdam, depicting a young man sitting near a table on which stands a bust while a second man wearing a helmet sits behind it, might be a study for the lost Alexander painting; a head wearing a helmet crowned with an owl was sketched separately on the sheet. (See also the reproduction of this drawing in Seymour Slive, *Drawings of Rembrandt*, New York, 1965, ii, no. 414. Valentiner's thesis, rejected by von Einem (1952, p. 192, note 2 [4]), was abandoned by Valentiner himself (*Rembrandt and Spinoza*, London, 1957, p. 73). The drawing exists actually in two versions and opinions differ as to whether the one in Rotterdam or the one in the collection of Frits Lugt is the original. According to Benesch neither is by Rembrandt, but his attribution of the drawing to Johann Ulrich Mair, a pupil of Rembrandt, has found little credence. In view of the fact that the design is surrounded by a "framing" line, like the famous drawing of 1639 after Raphael's *Castiglione* (Ben. no. 451), one could consider the possibility that the drawing is not a sketch for a picture but of one already painted. At any rate, I see no way of connecting it with the project of the *Alexander*.

[32] Bredius, 1936, no. 483 [5]; Bauch, 1966, no. 244 [23]; Rosenberg, 1964, pp. 283 ff. [5]. See also Ruffo, 1916, p. 318 [9]: "Omero seduto che insegna a 2 discepoli, mezza figura al naturale, the *Aristotle*. His complaint was communicated 8 x 6 palmi." For a detailed and penetrating analysis, see von Einem, 1952, pp. 195 ff. [4].

Rembrandt began the *Aristotle* there was no plan for an enlarged program involving two other paintings. It is therefore justifiable to deal with the New York canvas alone. The other two pictures have no bearing on the genesis and specific meaning of the *Aristotle* although when Rembrandt later painted them, he surely had the *Aristotle* always in mind.

That the *Aristotle* is *in fact* the painting once owned by Ruffo, is supported by the date 1653 inscribed on it and by the way Ruffo's picture is listed in his inventories. In 1678 it was listed as "Aristotle with his right hand on a head" (*Aristotele con la mano diritta sopra una testa*), and another time "Aristotle in less than full length, who rests one hand on a statue" (*Aristotele a figura non intera che tiene una mano sopra una statua*).[33] (*Statua* was often used as a term for a bust.) There is, however, a discrepancy in the sizes: Ruffo's picture was 8 x 6 palmi (or c. 192 by 144 cm.), while the *Aristotle* of the Metropolitan Museum is much smaller, especially in height. We must conclude that at one time the picture lost about 53 cm. of its height, most of it, I would assume, at the bottom.

One of the strangest facts in the episode of this commission is that for some time Ruffo seems to have been in doubt regarding the subject of the painting. Far from ordering, as it is often said in the literature on Rembrandt, a picture of Aristotle,[34] he first registered the painting (on September 1, 1654) as "Half-length figure of a philosopher made in Amsterdam by the painter named Rembrandt (it seems to be an Aristotle or an Albertus Magnus)."[35] In an account book of January 8, 1657, we read: "Three ounces (using the word in its numismatic sense) for a frame for the painting of Albertus Magnus."[36] (Albertus Magnus was a thirteenth century Dominican, known for his strongly Aristotelian views; he was later nicknamed the ape of Aristotle.) Owing to Ruffo's ignorance of, and apparent indifference to, the actual subject of the work, Guercino in 1660 was forced to guess—and, as we have seen, to guess wrongly—at what was represented in Rembrandt's canvas.

The first clear identification of the picture as *Aristotle* is found in a copy written in November 1662 of the original shipping bill of 1654. The correct title, most likely, had emerged during the negotiations for the *Alexander* and *Homer*. It reads: "Copia del costo e spese del quadro dell'Aristotele."[37]

For the discussion of the meaning of Rembrandt's *Aristotle* it is of the highest importance to remember that Rembrandt, and not Ruffo, was responsible for the choice of the

[33] Corrado Ricci, 1918, p. 43 [9].

[34] See, for instance, W. R. Valentiner, 1957, p. 66 [30]: "The first order was for an Aristotle," or O. Benesch, "Rembrandt and Ancient History," *Art Quarterly*, XXII, 1959, p. 328.

[35] Corrado Ricci, 1918, p. 17, note 2 [9]:

"Mezza figura d'un filosofo qual si fece in Amsterdam dal pittore nominato Rembrant (pare Aristotele o Alberto Magno)."

[36] *Ibid.*: "Onze 3 per una cornice del quadro di Alberto Magno."

[37] *Ibid.*, p. 10.

subject. Whatever thoughts went into the creation of the work, they were not shaped by the wishes or instructions of the Italian collector. The picture was certainly not, as has been suggested, the result of "a collaboration between the Sicilian nobleman and the Dutch painter."[38] Rembrandt may have discussed the subject with some learned friends (or friend), but it is safe to assume that it is his work, in thought as well as in execution.

The later history of the painting of Aristotle is quickly told. It remained in the possession of the Ruffo family probably until some time in the late eighteenth century. It reappeared in an exhibition in London in 1815 and subsequently passed through some well-known English and French collections,[39] landing finally in the hands of Duveen, who sold it to Mrs. Collis P. Huntington. Mrs. Huntington's son Archer resold it to Duveen and it was purchased by Alfred W. Erickson, a New York advertising man. Erickson, who lost money in the crash of 1929 and later in copper investments, returned the picture three times to Duveen but took it back each time after repairing his fortune. It was finally at the sale of Mrs. Erickson's small but distinguished collection that the painting was acquired for the Metropolitan Museum of Art.

Knowledge of the actual theme of the work had been lost prior to its appearance in London in 1815, and various titles had been attached to it, if it was not simply called a savant or a poet.[40] Among the names suggested were Vergil (not at all unreasonable in

[38] See W. R. Valentiner, 1957, p. 67 [30] and Rousseau, 1962, p. 152 [2]. As far as I can see, it was only von Einem (1952, pp. 187-88 [4]), who stated unequivocally that Rembrandt alone was responsible for the choice of Aristotle. Others before him (among them Ricci, J.-F. Backer, E. Kieser, J. Rosenberg) had realized that the commission apparently called only for a "philosopher."

[39] Sir Abraham Hume, Bart., Ashridge Park, Herts.; Earl Brownlow, Hume's son-in-law; Rodolphe Kann, Paris. As the portrait of "Vander Hoof" it was listed by John Smith, *A Catalogue Raisonné of the Works of the Most eminent Dutch, Flemish, and French Painters,* . . . VII, London, 1836, no. 302, with the comment: "This capital portrait is of the highest excellence of the master's work." In 1835 Dr. G. F. Waagen saw the picture in Sir Abraham Hume's collection and warmly praised it in his *Kunstwerke und Künstler in England,* II, Berlin, 1838, p. 20: "Nicht oft hat Rembrandt sich zu einer so grandiosen und edlen Auffassung erhoben, als in dem Bildnisse eines stattlichen,

schon bejahrten Mannes, dessen rechte Hand auf einer Büste des Homer ruht, während er die linke gegen die Hüfte stemmt. Im Impasto und magischer Gewalt der Lichtwirkung giebt es keinem seiner Bilder nach, hat aber vor vielen eine gemässigtere Färbung des Fleisches voraus. Dieses Kniestück gilt für das Bildniss des grossen holländischen Historikers van Hooft. So gern man sich aber auch diesen Mann so denken möchte, spricht doch dagegen die Jahreszahl 1653, womit es bezeichnet ist, indem van Hooft schon 1647 starb." See also Rousseau, 1962, pp. 155-56 [2].

[40] See, for instance, C. J. Holmes, "Recent Acquisitions by Mrs. C. P. Huntington from the Kann Collection," *The Burlington Magazine,* XII, 1908, p. 197, "This weary man of letters"; Schmidt-Degener, 1915, p. 15, "The Poet." In the collection of R. Kann it was called "The Savant," and the same title appears in the catalogue of the *Dutch Masters Exhibition, Hudson-Fulton Celebration,* Metropolitan Museum of Art, 1909, no. 97.

view of the traditional association of Vergil and Homer); Torquato Tasso; and even Pieter Cornelisz. Hooft, a famous seventeenth century poet who in his time had been called the Dutch Homer.[41] Only when the Marchese Vincenzo Ruffo in 1916 published the records of his family's archives was it possible to establish the true title, a connection first made in 1917 by Dr. Hoogewerff.[42] Without the Ruffo documents it probably would have been impossible to name correctly the chief personage in the painting.

3. THE PERSONAGES

To this very day archaeologists are not certain which ancient portraits represent the historical Aristotle. Ancient authors painted a remarkably vivid word-image of him and it differs radically from the noble figure in Rembrandt's canvas. He is described as short, thin-legged, pot-bellied, with small eyes, sunken cheeks, and a slightly mocking expression around the mouth.[43] He also seems to have been somewhat of a dandy, and it is said that he wore rings (a fact not without interest as in our picture he wears them, one on his hand and one in his ear). At any rate, no portrait-bust or statue quite corresponds to that description. Antiquarians and scholars of the late sixteenth century tried to establish the facial features of Aristotle from busts and coins but never advanced beyond the question of whether he had a long beard, a short beard, or no beard at all.[44] A short-bearded sculpture in the collection of Fulvio Orsini in Rome was inscribed Aristoteles, but the inscription was suspect even then (Figs. 6, 7).[45] In the engraved publication of this collection Aristotle

[41] The identification with Vergil was proposed by W. R. Valentiner, *Rembrandt, des Meisters Gemälde*, Stuttgart-Berlin, 1908, pp. 426 and 562; that with Torquato Tasso (tentatively) by J. Six, *Oud Holland*, xv, 1897, pp. 4 ff.; and the name of "Pieter Cornelius van Hooft" (more correctly Pieter Cornelisz. Hooft) was first given to the picture when it was exhibited at the British Institution, London, 1815, no. 39.

[42] *Loc.cit.* [9].

[43] See Konrad Kraft, "Über die Bildnisse des Aristoteles und des Platon," *Jahrbuch für Numismatik und Geldgeschichte*, xiii, 1963, pp. 7 ff. The descriptions of Aristotle's appearance vary in some details. See also Gisela M. A. Richter, *The Portraits of the Greeks*, London, 1965, ii, p. 170: Aristotle is described as "small,

bald, stuttering, lustful, and with a hanging paunch."

[44] See Kraft, 1903, p. 20: "So lächerlich es auch klingen mag, in der Tat ist der Bart der Kernpunkt aller Diskussion für die Ermittlung des Aristotelesportraits."

[45] See J. H. Jongkees, "Fulvio Orsini's Imagines and the Portrait of Aristotle," *Archaeologica Traiectina*, iv, 1960, pp. 19-20, 28-36. The bust was drawn by Theodor Galle (Fig. 6) but was not used by him in the edition of classical portraits from Orsini's collection. Rubens also drew this bust in a small drawing (Fig. 7) now in the Louvre (Inv. 20359, see F. Lugt, *Musée du Louvre, Inventaire Général des Dessins des Ecoles du Nord, Ecole Flamande*, Paris, 1949, ii, no. 1086). Jongkees' statement that Rubens

is depicted beardless (Fig. 8),[46] and this type—generally called Menander—has again recently been proposed as an authentic representation of Aristotle. In this game of musical chairs in classical portraiture, the type that had been called Aristotle was now identified as Plato, and the traditional Plato type was christened Zeno.[47]

Rembrandt himself owned a bust of Aristotle, probably a copy of a well-known and entirely imaginary Renaissance sculpture rendering Aristotle with long hair and a flowing beard.[48] Jongkees wittily wrote that "long hair and beard went a long way toward creating the impression of being a second Aristotle."[49] At any rate, eminent scholars of the sixteenth and seventeenth centuries often appear to have cultivated a stately beard, preferably combined with a drooping moustache, in contrast to the popular tonsorial fashions for men (Fig. 9).[50]

Most unusual is Aristotle's dress. His gown, far from being Greek, does not, as far as we can tell, correspond to any costume worn at any time. The hat vaguely resembles a type of large beret Rembrandt used for portraits of old men, as may be seen in his portraits of 1654 (London, Bauch no. 210) and the somewhat later one in Dresden (Bauch no. 247). The sleeves are reminiscent of a kind found in costumes of both men and women in

copied Galle's drawing is, however, blatantly incorrect; Rubens certainly made his drawing from the bust itself, probably during his first stay in Rome (1601-1602). The bust itself is lost but until Jongkees' attack it had been accepted, on the strength of Galle's and Rubens' drawings and F. Studniczka's argument, as an authentic portrait of Aristotle.

[46] *Illustrium Imagines, Ex antiquis marmoribus . . . expressae. . . .* Editio altera, Antwerp, 1606, fig. 35. On p. 21 of his annotations to this edition (see below note 58), Dr. Johannes Faber of Bamberg strongly attacked the traditional view that Aristotle had long hair and beard.

[47] Kraft, 1963, pp. 34-38.

[48] See Leo Planiscig, "Leonardo's Porträte und Aristoteles," *Festschrift für Julius Schlosser,* Zürich-Leipzig-Vienna, 1927, p. 137. For the bust Rembrandt owned see C. Hofstede de Groot, *Die Urkunden über Rembrandt (1575-1721),* The Hague, 1906, no. 169. In the inventory of July 1656, three busts are listed: no. 162: Een Socrates; no. 163: Een Homerus; no.

164: Een Aristoteles. In the same year (1653) in which Rembrandt painted his *Aristotle,* a marble bust of Aristotle was listed in the inventory of Cardinal Mazarin (no. 82) as follows: "Une tête d'Aristote ayant une grande barbe et un bonnet avec son buste sans espaulles, couvert d'une robe et d'un capuchon" (Planiscig, *loc.cit.* 143).

[49] Jongkees, 1960, p. 18 [45].

[50] It is hardly accidental that the most prominent scholars appearing in Van Dyck's Iconography (Justus Lipsius, 1547-1606, Erycius Puteanus, 1547-1646, and Nicolas Claude Fabri de Peiresc, 1580-1637), all wear the long beard and moustache of the "philosopher." See Marie Mauquoy-Hendrickx, *L'Iconographie d'Antoine Van Dyck, Catalogue Raisonné,* Brussels, 1956, nos. 22, 36 and 89. When J. Six in 1897 (see note 41) rejected the identification of the main figure in Rembrandt's painting as P. C. Hooft, one of his arguments was that no one in mid-seventeenth century wore such a long beard.

Italy in the second quarter of the sixteenth century,[51] but the costume as a whole may be pure fantasy. This is hardly a surprise, coming from Rembrandt. While such theatrical freedom would be strange on the part of archaeologically oriented masters like Rubens and Poussin, it is obvious that Rembrandt's historical or mythological characters are dressed in the most outrageously anachronistic manner.[52] It has been suggested that by clothing him in such outlandish fashion, Rembrandt wanted to allude to Aristotle's mediaeval reputation as a necromancer and magician,[53] but there is nothing in the painting that favors such a theory. For the striking use of black as the color of the "apron" there is, as we shall see, a rational explanation. It might be mentioned in passing, however, that according to Ripa (citing Boethius as his source) the very gown of philosophy should be like a dark veil, symbolizing the obscurity of philosophers' thoughts; and he even mentions Aristotle in this connection, who "dressed" philosophy with dark terms and an obscure fabric of words.[54] It is equally interesting that Abraham Breughel, in a letter to Rembrandt's patron Ruffo, dated January 24, 1670, most assuredly had Rembrandt's *Aristotle* in mind when he wrote that a truly great artist paints beautiful nude bodies, whereas an ignorant one tries to hide them in dark and ridiculous gowns.[55]

Whatever reason Rembrandt had for painting the "apron" black, it makes a splendid pictorial foil for a heavy gold and jeweled chain draped across it. A medal, decorated with the head of a helmeted figure, is suspended from the chain (Fig. 10). Accepted by all scholars—and indeed most plausible—is the opinion that the medal depicts Alexander the Great.

Almost all classical portrayals of the Macedonian king (the majority on coins) show him bareheaded, but during the Renaissance there appeared many coins and woodcuts in books (Fig. 12) rendering him with a helmet. Perhaps the earliest, and undoubtedly the

[51] See, for instance, Moretto's *Portrait of a Man*, dated 1526, in London and Titian's *Portrait of Empress Isabella* of 1548 in Madrid. That Rembrandt was aware of the fact that both men and women could wear this kind of wide-sleeved gown can be seen from the fact that he used the very same garment (minus the "apron") for his picture of *Hendrickje as Flora*, also in the Metropolitan Museum. Flora's hat also resembles Aristotle's. As can be seen from X rays of the picture, Rembrandt had first painted the sleeve on Aristotle's left arm much narrower than it is now. The added section was painted more thinly and can readily be seen once the beholder's attention is alerted to this *pentimento*. I am indebted to Hubert F. von Sonnenburg for making the X-ray films accessible to me.

[52] For anachronism in Dutch painting of historical characters, see H. van de Waal, 1952, I, pp. 46 ff. [20].

[53] Herbert von Einem, 1952, pp. 182 ff. (esp. p. 189) [4].

[54] Cesare Ripa, *Iconologia of uytbeeldingen des Verstands*, Amsterdam, 1644, pp. 405 ff.

[55] Ricci, 1918, p. 32 [9]: ". . . un innoriante cherca di coprire de vestiti ouscuri goffi. . . ." See also Rosenberg, 1964, p. 285 [5], who translates the passage somewhat differently.

finest, of these portrayals of the helmeted Alexander is the marble relief attributed to Verrocchio in Washington (Fig. 11). We owe to K. Kraft the explanation for this popularity of the helmeted Alexander in Renaissance iconography.[56] A very common ancient Alexander-coin showed on one side the helmeted head of Pallas Athena. Since no inscription is found on this side of the coin, while Alexander's name appears on the reverse, the youthful if martial head of Athena, its long curls included, was accepted as a portrait of Alexander himself. In the sixteenth and seventeenth centuries the helmet (as well as long hair, see above p. 10) had become so much *de rigueur* in the Alexander iconography that he was shown wearing it even in situations where he would have been more comfortable without it, for instance, when taming Bucephalos or approaching bashful, if nude, Roxana, expectantly sitting on the nuptial bed.[57]

Some of the very rare classical renderings of a helmeted Alexander appear to have been known, however, by the seventeenth century; this at least can be seen from a drawing by Rubens of a gold coin in Fulvio Orsini's collection.[58]

The association of Aristotle and Alexander rests on safe historical grounds. At the age of 41, Aristotle responded to a call from Alexander's father, King Philip of Macedonia, to be the tutor of the young prince. For the next nine years the philosopher performed this service, thereby profoundly influencing the intellectual growth of the prince. But on Alexander's accession to the throne, Aristotle returned to Athens.

The third character in the picture, though like Alexander appearing only in the form of a "graven image," is Homer. Rembrandt's signature and the date 1653 are inscribed on this bust (Fig. 13). While we do not know what model Rembrandt used for his medal of Alexander, it is certain that his portrayal of Homer is based on a famous Hellenistic

[56] Kraft, 1965, p. 12 [25]. See also, Alfred R. Bellinger, *Essays on the Coinage of Alexander the Great*, New York, 1963.

[57] The most famous of the scenes in which the helmeted Alexander approaches Roxana appears to have been a composition by Raphael known only from contemporary and later copies. See R. Förster, "Die Hochzeit des Alexander und der Roxane in der Renaissance," *Jahrbuch der Preussischen Kunstsammlungen*, xv, 1894, pp. 182 ff. and A. E. Popham and Johannes Wilde, *The Italian Drawings of the XV and XVI centuries . . . at Windsor Castle*, London, 1949, p. 316, no. 809. One of the copies of this composition is by Rubens, see Frits Lugt, 1949, II, no. 1079, pl. XLVII [45], and Michael Jaffé,

"Rubens and Raphael," *Studies in Renaissance and Baroque Art Presented to Anthony Blunt*, London, 1967, p. 99. The same subject, showing also Alexander with a helmet, was treated in the circle of Parmigianino and by Niccolo dell'Abbate, see Förster, *loc.cit.*, and A. Pigler, *Barockthemen*, II, Budapest, 1956, p. 346.

[58] See Frits Lugt, 1949, II, no. 1086, pl. LI [45]. A reference to the coin drawn by Rubens is found in *Joannis Fabri . . . In Imagines Illustrium ex Fulvii Ursini Bibliotheca . . . Commentarius*, Antwerp, 1606, p. 8. An ancient coin with a helmeted Alexander is reproduced in Hubert Goltzius, *Graecia eiusque insularum et Asiae minoris Nomismata*, Antwerp, 1644, pl. XXXV.

bust of which he seems to have owned at least a plaster cast. According to the inventory of Rembrandt's collection (see note 48), the Homer stood next to the bust of Aristotle. Created about 600 years after Homer's time, this Hellenistic head brilliantly suffuses the physical blindness of the man with the visionary powers of the poet. It is known from a large number of copies, the most famous of which is in the Louvre.[59] One of the very finest, however, is in the Boston Museum (Fig. 14), and this Boston head, as far as I can see, is closer than any other to the bust in Rembrandt's painting, showing clearly the poet's ears, which are hidden in other versions. If the cast Rembrandt owned was indeed taken from the Boston head we would have to assume that that head either was then less damaged than it is today, or—what I consider more likely—had been restored and amplified by a later base.[60]

What then, we may ask, is the historical background prompting Rembrandt to combine Aristotle with Homer? Aristotle's philosophy, communicated to the West by Arabic and Jewish scholars, had exercised a powerful influence on the thought patterns of the later Middle Ages. He was the undisputed leader in the areas of logic, metaphysics, and moral philosophy. As late as c. 1510, when Raphael painted him in the School of Athens, he is introduced as the master of natural philosophy and of ethics; the book in his left hand is inscribed E T I C A. Although Aristotle's authority in these fields declined in the sixteenth century, his fame increased because of the discovery of his *Poetics*.[61] First printed in Venice in 1508, it was frequently reprinted and translated and soon was considered what we may call the last word on the rules of poetry. As Borinski put it: "From the ruins of his Logic and Metaphysics he [Aristotle] rose phoenix-like to be the ruler of the arts."

Nor is the confrontation with Homer based merely on Aristotle's interest in poetry as

[59] See Robert and Erich Boehringer, *Homer, Bildnisse und Nachweise*, 1, Breslau, 1939; see also Margarete Bieber, *The Sculpture of the Hellenistic Age*, 2d ed. 1961, p. 143, and the literature quoted in note 64.

[60] The Boston head came from an English private collection and was first exhibited in 1903. There is apparently no evidence as to where it was in the seventeenth century. That the shape of the bust, as it appears in Rembrandt's painting, is nonclassical in the form of the "body" has been confirmed by Professor O. Brendel of Columbia University.

[61] For this and the following section, see Georg Finsler, *Homer in der Neuzeit von Dante bis Goethe*, Leipzig-Berlin, 1912; K. Borinski, *Die Antike in Poetik und Kunsttheorie*, 1, Leipzig, 1914, especially pp. 219 ff.; F. Saxl, 1957, [4]; P.-O. Kristeller, *Renaissance Thought*, Harper Torchbooks, 1961, p. 44. It should be remembered in this connection that after its translation in 1570 Aristotle's *Rhetoric* exercised a growing influence and "during the Baroque dominated the minds of the artists in all of Europe" (Jan Bialostocki, " 'Barock': Stil, Epoche, Haltung" in *Stil und Ikonographie*, Dresden, 1965, pp. 77 ff., especially pp. 94-96).

such. One has only to read the *Poetics* to see that Aristotle considered Homer the incomparable master of all poetry. He mentions Homer in the *Poetics* no less than eleven times by name, and makes six additional references to the *Iliad* and *Odyssey*. At one point he speaks of Homer's *divine* superiority over other poets, which makes us understand the words of a modern commentator on the *Poetics* when he says: "Aristotle's admiration for Homer approaches nearer to idolatry than any other attitude we can discern in him towards a mortal."[62]

If the close association of Aristotle and Homer seen in Rembrandt's painting may be justified as the visual expression of the admiration the author of the *Poetics* had for the great bard, it should not be forgotten (in the context of the picture) that this admiration was shared by Alexander the Great. Alexander is known to have carried with him (and kept at night under his pillow) a copy of the *Iliad*, edited by Aristotle (Plutarch, *Alexander*, VIII). When a precious box or casket was offered to him from the booty of Darius, he used it as a container for this book. A legend, reported by Plutarch, tells that he chose a spot for the city of Pharos after a dream apparition had recited to him two lines from the *Odyssey*. He visited the tomb of Achilles and called him lucky because the story of his life had been told by Homer.

This boundless belief in Homer's eminence, already attacked in some quarters in antiquity, was not universally accepted in the periods of the Renaissance and Baroque. A considerable number of authors criticized Homer for what they felt were vulgar and base words and images, as when he likens Ajax to an ass about to be attacked by boys, or warriors to flies buzzing around a pail of fresh milk. Julius Caesar Scaliger, a sixteenth century scholar and one of the most violent anti-Homeric authors of the time, called the poet a liar, an ape of nature, a teller of old wives' tales, and one looking at gods and heroes from the vantage point of a swineherd.[63]

That Rembrandt had a very different attitude towards Homer is obvious and has often been stressed. In this connection it is of interest to know that it was precisely Flemish and Dutch seventeenth century authors who were among the strongest *defenders* of Homer. Justus Lipsius praised Homer, putting him above Vergil; Daniel Heinsius (1580-1665), Professor and Librarian of the University of Leiden and editor of Aristotle's

[62] Gerald F. Else, *Aristotle's Poetics: the Argument*, Cambridge 1957, p. 499. In Professor Else's rendering of the *Poetics*, the adjective "divine" as applied to Homer appears on pp. 500 and 580; in another passage (p. 594) Aristotle maintains that Homer "has surpassed all others in expression and thought."

[63] See Borinski, *op.cit.*, p. 231, and Finsler, *op.cit.*, p. 49, and pp. 133 ff. See also Eduard Brinkschulte, *Julius Caesar Scaligers kunsttheoretische Anschauungen und deren Hauptquellen*, Bonn, 1914.

Poetics (1611), was so convinced of Homer's greatness that he was sure that all passages offensive to seventeenth century taste were later interpolations or corruptions.[64] Gerhard Johann Vossius (1577-1649), professor of history at Amsterdam from 1633, in a book on poetics (1647) also rallied to Homer's defense,[65] and a new edition of Homer's works was published in Amsterdam in 1658 by Cornelis Schrevelius, rector of Rembrandt's old Latin school in Leiden. In a book on the University of Leiden published in 1614 (six years before Rembrandt was enrolled there as a student), several epigrams about famous men written by Jan Dousa were printed; among them was one "Ad Aristotelem," followed immediately by another "In Laudem Homeri":

Magnus Aristoteles, major Plato, Maximae Athenae
Omnibus at major magnus Homerus erit.[66]

As an introduction to his translation of Vergil, published in 1646, the poet Vondel devoted a lengthy treatise to the then fashionable question (treated also by Scaliger) whether Homer or Vergil had been the greatest poet of ancient times, calling the respective parties Homerists and Maronists (from Vergilius Maro)—as later French academicians were divided into Rubenists and Poussinists. Vondel came to the sensible conclusion that each one had been a superb poet.[67] All these references should make it clear that Rembrandt's own admiration for Homer, known from a drawing of 1652 for his friend Jan Six and from the late painting for Ruffo (not to mention various adaptations of the Homer physiognomy in other works), was certainly in harmony with a general climate of opinion in Holland at his time. I dare say that the very reproaches leveled against Homer by a classicizing literary theory might have endeared him to Rembrandt: like

[64] Finsler, *op.cit.*, p. 139. Constantijn Huygens tells that his father remembered hearing Philips Marnix of St. Aldegonde, his close friend, saying more than once that he suspected Homer of having been feebleminded (*fatuus*). Huygens goes on to say that this low opinion was surely exaggerated and greatly displeased his good friend Heinsius. See A. H. Kan, *De Jeugd van Constantijn Huygens door hemzelf beschreven*, Rotterdam-Antwerpen, 1946, p. 37, and J. A. Worp, "Fragment eener autobiographie van Constantijn Huygens," *Bijdragen en Mededeelingen der Historisch Genootschap te Utrecht*, XVIII, 1897, p. 36.

[65] Although following Scaliger in general, Vossius differs with him in regard to Homer,

whom he puts above Vergil. See Finsler, p. 139 [61].

[66] *Illustrium Hollandiae et Westfrisiae ordinum alma academia Leidensis contenta proxima pagina docebit*, Leiden, 1614, p. C 1.

[67] *De Werken van Vondel*, Amsterdam, VI, 1932, pp. 49-62. Vondel stresses the high opinion that Socrates, Plato, and Aristotle had of Homer —an opinion that was generally shared in Antiquity and even later by the church fathers. He ends by saying: "Let Homer have his well-earned honor, and Vergil his" (p. 62). See also Vondel's poem "Op de doorluchtige afbeeldinge van Homerus," (1665), *ibid.*, X, 1937, p. 185. Regrettably, this painting of Homer is not by Rembrandt but by "Joan den Ezel" (Jan Hals?).

Homer, he too was interested in the broad range of man's physical and emotional life, and he too, not surprisingly, was eventually criticized for his vulgarity and base naturalism.[68]

4. THE ICONOGRAPHIC TYPE

This, then, is the cast assembled in the picture: Aristotle, Alexander, and Homer. Yet knowing the identity of each "actor" and the historical basis for their association is only the beginning in the task of analyzing Rembrandt's painting. Before we proceed, it should be recalled that Rembrandt, commissioned to add two other canvases with "mezze figure" to the *Aristotle*, chose the very two characters who in the first picture had been present *in effigy* only—Alexander and Homer.[69] (It is, of course, possible, though immaterial in this context, that Ruffo himself had asked for an Alexander and a Homer.) In the *Aristotle* the three characters were combined, as we shall see, in a composition full of subtle tensions. In the final form of the project, the historical ties linking the three men with each other were once more strongly affirmed; yet the hidden drama of the *Aristotle* was now lost in the juxtaposition of three noble representatives of the ancient world, probably augmented by other celebrated figures of the past, to form a typical

[68] See below "Rembrandt: Truth and Legend," p. 130; see also Slive, 1953, pp. 83 ff. [15]. The idea that Rembrandt may have been attracted to Homer precisely by those qualities of his poetry that offended the classical taste, especially in France, was expressed by E. Kieser, 1941-1942 [7].

[69] That Rembrandt gave some thought to the question as to how the three pictures would harmonize with each other emerges from two documents. One is a brief note—the only autograph piece of writing that has come down concerning the whole commission—in which he speaks about the dimensions of the three pictures, assuring the agent of Ruffo at the same time that the price would be fair: "Als Ider stuck 6 palmen breedt is en 8 Hoogh sullent goede formaeten weesen en de prijs aengaende en sullen den Heer Niet overschatten." (If each piece is 6 palmi wide and 8 high, they will be of agreeable dimensions and as concerns the price, the gentleman will not be overcharged.) It is signed:

"u. e. Gheneegen dienaer Rembrandt van rhijn" (your honor's devoted servant Rembrandt van rhijn). This brief note, unfortunately, is not dated. It certainly cannot be used to support the theory that a project of three pictures rendering Aristotle, Alexander, and Homer existed from the very beginning. The second document is a note by the Amsterdam agent saying that the *Homer* still needs some work, and that when the three pictures were hung together, the *Alexander* ought to be placed in the middle (which would automatically put *Homer* at the left and *Aristotle* at the right facing toward the center). See Ricci, 1918, pp. 18-19 and 22 [9]: "In quel modo che fece una volta sopra la tela, mentre starebbe bene appresso l'altro per mettere Alexandro nel mezzo, se cosi comandano me lo avvisano." We do not know whether Ruffo continued to use Guercino's cosmographer as a pendant of the *Aristotle* or grouped the three Rembrandts together.

seventeenth century "Hall of Fame."[70] Insofar as Rembrandt's contribution to this "gallery" is concerned, the ultimate program was contained *in nuce* in the *Aristotle*. Yet it is precisely because both Homer and Alexander were already present in the *Aristotle* that at the time the *Aristotle* was conceived the plan for the later canvases could hardly have existed. It is one thing to reconcile—as we must—the finished *Aristotle* with the later two pictures. It is another to assume that when he included pictorial references to Homer and Alexander in his *Aristotle*, Rembrandt already knew that it was to be one of a set of three pictures, the other two containing the very same personages. Thus, what we concluded before from the examination of the documents (see pp. 25-26) is further supported by an examination of the picture's iconography: when Rembrandt painted the *Aristotle*, he painted it to be seen alone.

In our effort to understand Rembrandt's painting, we may begin by examining the setting he chose for the "confrontation" of its characters. Aristotle stands next to a table on which the bust has been placed. One or two small objects, difficult to identify, also lie on the table.[71] A pile of books, partly hidden by a curtain, is seen in the upper left. The books identify the setting as a study or library, and we know from other seventeenth century pictures, including some of Rembrandt's own, that bookshelves were often covered with curtains.[72]

From ancient authors we learn that Aristotle was believed to have been the first to form a library,[73] and that in Rome it was customary to decorate libraries with statues and

[70] The close connection between Homer, Aristotle, and Alexander as special favorites of *Fama* is visually expressed in an early sixteenth century French tapestry in Vienna, probably from Touraine, where these three figures march closest to the personified Fame (Renommée) standing on the chariot. (Also included are Charlemagne, Plato, Cicero, and Vergil.) See L. von Baldass, *Die Wiener Gobelinsammlung*, Vienna, 1920, pl. 4. A fragment, based on the same cartoon, is in the Metropolitan Museum in New York. See also Heinrich Göbel, *Wandteppiche I, Die Niederlande*, Leipzig, 1923, Band I, p. 105.

[71] The small boxlike item on top appears to be a pen-case, the most likely object to be found on the table of a writer. It seems to rest on a tray. F. Schmidt-Degener ("La double carrière de Rembrandt," *Gazette des Beaux-Arts*, 6e

période, xv, 1936, p. 49) expressed the opinion that there is only one object on the table and that it might be the gold casket in which Alexander is said to have kept Homer's *Iliad*, later known as the copy of the shrine (Plutarch 26 and Strabo 13. 27). This theory makes little sense. The casket was part of the booty Alexander obtained after his victory over Darius—long after Aristotle had left him. There is no earthly reason why Rembrandt should have thought that this casket eventually landed on Aristotle's desk. The object, besides, would seem to be much too small for such a container.

[72] See Rembrandt's portrait of Johannes Elison (1634) in the Boston Museum of Fine Arts (Bauch, 1966, no. 372) [23].

[73] See Ingemar Düring, *Aristotle in the Ancient Biographical Tradition*, Göteborg, 1957, p. 337.

busts of the great men of antiquity, above all of Homer. Pliny claims that Asinius Pollio, a writer, critic, patron of arts and literature, and a friend of Julius Caesar, started this custom. It was later adopted, among others, by Cicero and Terentius Varro.[74] No wonder that in the Renaissance and Baroque, periods deeply permeated by the spirit and traditions of the ancients, any man of learning or at least of intellectual pretensions equipped his library with busts.

This custom, in turn, gave rise to a category of portraiture in which one or more personages are rendered in the company of books and classical busts. We know this type above all from paintings by Rubens and his circle. It appears in the famous portrait group in the Palazzo Pitti where three humanist scholars (Lipsius, Woverius, and Philip Rubens, the artist's brother) and Rubens himself are assembled around a table on which books are placed, while a bust of Seneca (or at least then believed to be Seneca) adorns a niche behind them.[75]

It is axiomatic in this type of portraiture that a special bond links the living personages and the bust. The choice of Seneca in the painting at Florence was a logical one, since one of Lipsius' greatest achievements had been the edition of Seneca's works; Rubens himself was a great admirer of Seneca. The problem is more complicated in the portrait of Nicolaas Rockox, painted by Van Dyck before he departed for Italy on October 3, 1621 (Fig. 15). The marble bust on the table resembles a Hellenistic type of Zeus but may have been taken to be an actual portrait. At any rate, when Lucas Vorsterman engraved Van Dyck's painting, he substituted another bust acquired by Rockox early in 1622 and then believed to be Demosthenes, the great orator and worthy model for the burgomaster of Antwerp.[76] In Rubens' portrait of Dr. Ludovicus Nonnius, a physician and

[74] See K. Schefold, *Die Bildnisse der antiken Dichter, Redner und Denker*, Basel, 1943, and Thuri Lorenz, *Galerien von griechischen Philosophen und Dichterbildnissen bei den Römern*, Mainz, 1965, pp. 37-38.

[75] See M. Warnke, *Kommentare zu Rubens*, Berlin, 1965, pp. 33-34 and 91, note 131.

[76] See G. Glück, *Van Dyck, des Meisters Gemälde*, London, 1931, pp. 110 and 530, note. See also *Sammlung Stroganoff, Leningrad*, Sale Catalogue, Berlin (R. Lepke) 1931, no. 77, pp. 98-105 (notes by L. Burchard), and M. Varshavskaya, *Van Dyck Paintings in the Hermitage*, Leningrad, 1963, pp. 101-5, with a large detail reproduction of the bust (fig. 16). (Of the two versions, Baltimore and Leningrad, the painting in the Hermitage seems to be the better one.) That Rockox owned the bust depicted in Van Dyck's painting is substantiated by a painting depicting a room in Rockox's house (F. Francken, II, Bayerische Staatsgemäldesammlungen, see H. G. Evers, *Rubens und sein Werk, Neue Forschungen*, Brussels, 1943, pp. 154 ff., fig. 62) where it is the central one of five busts, standing on a shelf. For Rockox's purchase of the bust of Demosthenes, see Max Rooses, "Van Dijck's Leer- en Reisjaren," *Onze Kunst*, VI, 2, 1907, pp. 10-11. The bust, as we learn from letters sent by Peiresc to Rubens, rendered the ancient orator bald on one side, a fact which Rubens was able to explain with a reference to Plutarch, see Ch. Ruelens-M.

famous numismatist, we see, besides the obligatory books, appropriately enough a bust of Hippocrates, the patron saint, as it were, of physicians (Fig. 16).[77] The type is found once more in Rubens' portrait of Caspar Gevartius (1593-1666), a scholar and friend to whom Rubens entrusted the education of his eldest son. Gevartius sits at a table, pen poised over an open book; behind it, and below a shelf with more books, stands the bust of Marcus Aurelius, the most literate of Roman Emperors (Fig. 18).[78] Gevartius' portrait offers certain general formal analogies to Rembrandt's *Aristotle*: the vertical sequence of table, bust and books at the left, the placing of the living figure slightly to the right of center, the more active pose of the right hand and the fall of light from the left establish a connection possibly more than accidental. This must have been even more noticeable before Rembrandt's picture was cut off below. (Rembrandt could easily have known this composition, since it had been engraved around 1644, six or seven years before he painted the *Aristotle*.)

A portrait of the poet Jacob Cats (1577-1680) by Arnoldus van Ravesteyn (Fig. 17)[79] obviously belongs to this tradition of "Man + books + bust," furnishing proof that the type was known in Holland in the middle of the seventeenth century. (Ravesteyn's portrait also contains a curtain partly covering the library of the poet.) Another Dutch example is a rather amusing one of the Haarlem printer and publisher Abraham Casteleyn by Jan de Bray, of 1663; with his wife at his side, he is seated in front of a bust of the famous Lourens Coster of Haarlem, who some people (especially, of course, in Haarlem) thought had invented the art of printing before Gutenberg (Fig. 19). It is worth pointing out that the type survived into the eighteenth century. We meet it for instance in Angelica Kauffmann's portrait of Sir Joshua Reynolds (done in 1768).[80] Reynolds himself, with his well-known propensity for absorbing into his art many of the iconographic patterns of the past, gave to it a striking formulation in his self-portrait of

Rooses, *Correspondance de Rubens et Documents épistolaires*, Antwerp, 1887-1909, II, pp. 390, 435, 456, 460-61, 468; III, pp. 4, 6, 12-13, 292; IV, pp. 305-6. See also Van Dyck's *Portrait of Justus van Meerstraten* (Glück, *op.cit.*, p. 416) for a portrait with books and classical bust.

[77] See *A Loan Exhibition of Works by Peter Paul Rubens, Kt.*, London, Wildenstein & Co., Ltd., 1950, p. 46, no. 36, then owned by Lady Lucas. As L. Burchard points out in the catalogue, the bust of Hippocrates was engraved by Pontius in 1638.

[78] Koninklijk Museum voor Schone Kunsten,

Antwerp, no. 706.

[79] The Hague, Dienst voor 'sRijks Verspreide Kunstvoorwerpen, inv. no. AA 741; the painting was brought to my attention by Professor Egbert Haverkamp-Begemann, who also provided me with the photo. The picture is dated 1660 and is now on loan to the Catshuis (information provided by W. L. van de Watering).

[80] Coll: The Earl of Morley, Saltram Park (nr. Plymouth). Illustrated in Adeline Hartcup, *Angelica*, Melbourne-London-Toronto, 1954, facing p. 37.

c. 1773 in which a bust of Michaelangelo—the artist Reynolds admired more than any other—stands on the table.[81] And in a charming little print of the early eighteenth century, emblematically expressing the idea that the true scholar does not waste time with trifles, the study (for good measure) is equipped with three busts—all, like the scholar himself—anonymous (Fig. 20).[82]

It hardly needs stressing that Rembrandt's *Aristotle* differs from these works (except the last one) in many significant ways. They are portraits of contemporaries and the busts are mere antiquarian objects, a kind of attribute defining the intellectual range and personal predilections of the sitters. The busts are generally relegated to the background; no direct physical contact is introduced between the live model and his sculptured companion. This tradition does not account for one of the major themes of Rembrandt's painting, the placing of the hand on the marble bust.

Yet this motif, too, had a pictorial tradition. It is encountered in a famous woodcut by Hans Holbein the Younger (1535), portraying Erasmus of Rotterdam resting his hand on the head of a half-length figure of Terminus (Fig. 21). Schmidt Degener, indeed, cited that work as one of the sources for Rembrandt's *Aristotle*.[83] Although there may be a certain kinship relating the two works (see below p. 28), it is difficult to see a formal link between them. Much more obvious is the connection with a tradition to which H. von Einem has called attention.[84] We find the motif of a hand resting on a bust in Venetian and Venice-influenced portraiture, presumably of collectors and antiquarians, as for instance in Sebastiano Florigerio's *Portrait of Raffaele Grassi* in the Uffizi (894) where some ancient coins lie on the table next to the bust (Fig. 22).[85] While most of the Venetian examples (the majority from the studio of Tintoretto) are emotionally neutral, one finds occasionally an undercurrent of feeling between man and sculpture, as for instance in a picture of a young man with the bust of Lucretia (Munich); it reflects the veritable "cult of Lucretia" rampant in the early sixteenth century (Fig. 23).[86] In a full-length portrait of Duke Albrecht V of Bavaria the compositional pattern of Holbein's

[81] London, Royal Academy, see E. Waterhouse, *Reynolds*, London, 1950, p. 150.

[82] A. Houbraken, *Stichtelyke Zinnebeelden . . . verrykt met de Bygedichten van Juffr. Gezine Brit*, Amsterdam, 1723, p. 37.

[83] F. Schmidt-Degener, 1915 [8].

[84] H. von Einem, 1952 [4].

[85] See Bernard Berenson, *Italian Pictures of the Renaissance, Venetian School*, London, 1957,

pl. 887. E. Kieser, 1941-1942 [7], had been the first to refer to this painting in connection with Rembrandt's *Aristotle*. For the identification of the sitter see Carlo Gamba, *Bollettino d'Arte*, Pt. IV, I, 1924, p. 196 (information provided by E. Pillsbury).

[86] See Wolfgang Stechow, "Lucretiae Statua," *Essays in Honor of Georg Swarzenski*, Chicago, 1951, p. 114.

Erasmus woodcut was adopted to present the prince among the sculptures of his *antiquarium* (Fig. 24).[87] The collector whom Gonzales Coques portrayed surrounded by his family and the art treasures of his house also rests his hand on a classical bust.[88]

The theme of men touching classical busts[89] can again be followed into the eighteenth century. It can be seen in an anonymous late eighteenth century portrait of a young man putting his hand on the head of Homer,[90] and in a portrait of the painter Paul Christian Zinck (1687-1770), done in 1755 by Reinhold Christian Friedrich Lisiewsky (1725-1794), in Leipzig (Fig. 26).[91] Here the artist looks at a Roman bust while putting his hand on the marble, or plaster-cast, in a gesture surprisingly similar to Aristotle's. There is, finally, a curious analogy with Rembrandt's painting in a completely different subject, painted by Sebastiano Ricci (1659/60-1734) (Fig. 27): in a scene of a pagan sacrifice, the priest

[87] Dr. Justus Müller-Hofstede kindly called my attention to the portrait of Duke Albrecht.

[88] Mauritshuis, The Hague, no. 238 (see von Einem, 1952 [4], p. 192). Coques painted only the figures and accessories; the architecture has been attributed to W. Sch. von Ehrenberg, and the paintings standing and hanging around were painted, and signed, by different artists; according to the catalogue of the Mauritshuis, the man putting his hand on a bust is believed to be Coques himself. However, Mme. S. Speth-Holterhoff (*Les Peintres Flamands de Cabinets d'Amateurs au XVIIe siècle*, Brussels, 1957, pp. 175 ff.) tried to prove that he is Antoine van Leyen (1628-1686) a well-known collector. Tempting though this theory may be, it finds little support in the painting since van Leyen had only daughters except for a child born in the year when the picture was painted, while at least one and probably both children in the painting in The Hague are boys.

[89] Antiquarian interests of both collectors and artists account for the arrangement, fairly frequent in Van Dyck's portraiture, of men holding or touching sculptured heads; see, for instance, the sculptor Andreas Colyns de Nole (Fig. 25) in Mme. M. Mauquoy-Hendrickx, 1956, no. 34 [50]; the painter Hendrik van Balen (Mauquoy-Hendrickx, no. 42, and its preliminary drawing, in H. Vey, *Die Zeichnungen Anton van Dycks*, Brussels, 1962, no. 257,

pl. 310); and François Duquesnoy, Brussels (G. Glück, *Van Dyck, Des Meisters Gemälde*, London, 1931, fig. 158). Van Dyck also drew Nicolaas Rockox putting his hand on the head of a female bust (Windsor Castle, see Vey, no. 193, pl. 236) but the print based on this drawing renders only Rockox's head. An interesting but relatively little known example of this type of painting is Jean Daret's self-portrait in the Hermitage (Inv. 5704, Fig. 28). The theme, associated perhaps with the concept of the sense of touch, occurs also in the famous painting by Ribera in the Prado (no. 1112) traditionally identified with the blind sculptor Gambazo, but more recently said to represent the blind philosopher Carneades (see Delphine Fitz Darby, "Ribera and the Blind Men," *The Art Bulletin*, XXXIX, 1957, pp. 195 ff.).

[90] See Robert and Erich Boehringer, *Homer Bildnisse und Nachweise*, Breslau, 1939, p. 106, fig. 62. The painting, in the collection of the Duchessa Serra di Cassano in Rome, was formerly believed to have been painted by A. R. Mengs and to represent J. J. Winckelmann.

[91] The bust studied by Zinck may be a cast of the so-called "Hellenistic Ruler," in Naples, see Anton Hekler, *Greek and Roman Portraits*, London, 1912, pl. 73b. I am indebted to Professor Otto Brendel for this suggestion, and to Dr. Susanne Heiland who kindly provided me with the photograph.

rests his hand on the bust of the god (Pan?) as if this close contact gave added weight to his exhortations of the crowd of worshipers.[92]

The placing of a hand on a sculptured head is clearly a pictorial *topos*.[93] Our natural tendency to touch things we care for surely must have contributed to its genesis. In portraits of collectors, pride of ownership as well as intimacy is expressed in a gesture that is occasionally also met with in portraits of men accompanied by large dogs.[94] In a depiction of a sculptor, the gesture highlights the professional interest the sitter takes in works of masters of the past.[95] Yet the popularity of the theme may be due to associative factors of greater significance.

It is perhaps not accidental that the theme of the hand resting on a bust is curiously analogous to one found in portraits of the beginning of the sixteenth century both in the North and the South. In these paintings, the sitter puts his hand not on a bust, but on a skull, indicating his awareness of man's mortality.[96] Such paintings are known, as for instance by Dirck Jacobsz. (Fig. 30), dating from the fourth decade of the sixteenth century, and by Bernardino Licinio possibly slightly earlier (Fig. 31).[97] Since in some of these examples the skull rests on a parapet, the theme, if we follow William S. Heckscher, is imbued with the idea of the "triumph of Remembrance over Death."[98]

[92] Dresden, Gemälde Galerie, Catalogue 1908, no. 550. I owe the photo to the kindness of Dr. Anneliese Mayer-Meintschl.

[93] On pl. 124 in the publication of Fulvio Orsini's collection of antiquities [46], Pythagoras is rendered sitting on a chair and putting his extended hand on a sphere (Fig. 29). The Samian coins from which this print has been derived differ from it in that Pythagoras only *points at* the sphere; his hand never touches it. The artist who copied the ancient coin clearly drew not what was objectively there (though possibly less than sharply defined) but what he *expected* to find: a philosopher actually touching the object on which he concentrates in his thoughts. (The gesture is even reminiscent of Aristotle's in our painting, but as it occurs only in this print, one would have to assume Rembrandt's acquaintance with this very publication to give it a place in the formal genesis of the work.) See also Gisela M. A. Richter, *The Portraits of the Greeks*, London, 1965, I, fig. 302.

[94] See, for instance, Van Dyck's portrait of James Stuart, Duke of Lenox, and Murillo's

portrait of Don Andres de Andrade y la Col, both in the Metropolitan Museum in New York. The idea was probably derived from Titian's portrait of Charles V in Madrid, where the emperor's hand, however, rests on the neck of the animal, not on its head.

[95] For obvious reasons, the theme was used also in allegories of sculpture, see G. Delbanco, *Der Maler Abraham Bloemaert*, Strasbourg, 1928, fig. XXII, 2 (1616), and H. Voss, *Die Malerei des Barock in Rom*, Berlin [s.d.], fig. 146 (Renieri).

[96] See A. Pigler, *Barockthemen*, II, Budapest, 1956, pp. 577-78.

[97] See Max J. Friedländer, *Die Altniederländische Malerei*, XIII, Leiden, 1936, plates LXXXI and LXXXII, and Berenson, 1957, fig. 844 [85]. (The latter picture used to be known as "the portrait of a Lady Professor of Bologna, by Giorgione.")

[98] "Reflections on Seeing Holbein's portrait of Erasmus at Longford Castle," *Essays in the History of Art Presented to Rudolf Wittkower*, London, 1967, p. 128, especially pp. 144-45.

The theme of survival, however, is still more forcefully suggested where the sitter's hand touches a bust instead of a skull. Whereas the skulls were impersonal reminders of the inevitability of death, the classical heads were equally impersonal witnesses to a special kind of survival owing to the power invested in a work of art.[99] Writers of the Renaissance were very much aware of this power. Painting, according to Alberti, "has a divine power, being able not only to make the absent seem present . . . but even to make the dead seem almost alive after many centuries."[100] A similar statement is found in Albrecht Dürer, who defined the function of art as twofold—to serve religion and to preserve the likeness of men after their death.[101] A portrait painted while the sitter is still alive implies a time when it alone will be visible, preserving his features for the benefit of his immediate family, as well as for later generations and centuries.[102] Whatever else they may have connoted, classical busts—especially where they render specific individuals—give tangible proof of that person's preservation *in effigy* after many centuries. Given the preoccupation of many men during the Renaissance with the traces they would want to leave on this earth—stimulated surely by Horace's *exegi monumentum aere perennius* (carmina 3. 30. 1)—it makes good historical sense to assume that the busts included in portraiture were actually substituted for skulls, putting the symbol of survival in the place of that of extinction. It is not impossible that, seen in this light, there is a certain ambiguity in Holbein's woodcut portraying Erasmus with his hand on the statue of Terminus. Even though Terminus is the symbol of death, its rendering in the form of a sculptured torso may contain a hint of survival; if so, we may be sure that

[99] "The art work itself could be considered immortal because it went from generation to generation—'ars enim transfertur ab homine in hominem et propterea ars non moritur'" (Heckscher, 1967, p. 140, note 34)—a clever paraphrase of a formula distinguishing the immortality of the royal office from the mortality of the king, see Ernst K. Kantorowicz, *The King's Two Bodies*, Princeton, 1957, pp. 423 ff. For the power of art to survive see also Jan Bialostocki, "Kunst und Vanitas," in his *Stil und Ikonographie*, Dresden, 1965, p. 202 and pp. 216-17 and the same author's "The Power of Beauty," *Studien zur Toskanischen Kunst, Festschrift L. H. Heydenreich*, Munich, 1964, pp. 13 ff. The opposite view, holding that works of art are not exempt from deterioration and "death," was, of course, also defensible, see Robert Oertel, "Die Vergänglichkeit der Künste,"

Münchner Jahrbuch der Bildenden Kunst, XLV, 1963, p. 105.

[100] See E. G. Holt, *A Documentary History of Art*, New York, 1957, pp. 210-11. Mrs. M. Kahr reminded me of this passage.

[101] See Wolfgang Stechow, *Northern Renaissance Art, 1400-1600, Sources and Documents*, Englewood Cliffs, 1966, p. 112.

[102] A good example is Bernardino Licinio's *Portrait of a Woman*, wherein the subject holds a framed portrait, presumably of her deceased husband. This is in the Castello Sforzesco in Milan (Berenson, 1957, no. 853 [85]). Another example is Hans Eworth's *Portrait of Mary Nevill, Baroness Dacre*, in the National Gallery of Canada, Ottawa (see R. H. Hubbard, *European Paintings in Canadian Collections*, Toronto, 1956, p. 108), wherein the portrait of her late husband, painted in 1540, hangs on the wall.

Erasmus treasured this ambiguity as much as that contained in his motto *Concedo Nulli*.[103]

5. THE MELANCHOLY SAGE

It is appropriate in this context to remember that despite all its historical references, Rembrandt's *Aristotle* is a portrait of a living person as well (Fig. 33). For the features of the Greek philosopher, Rembrandt used a model whom he also painted in one of his most expressive portraits, now in the National Gallery of London (Fig. 32), and possibly in still other works.[104] Whoever this bearded man with his deep-set eyes was, he probably belonged to the artist's small circle of friends. Not knowing his identity, it is impossible to say whether there was something in the character, the intellectual capacity, or the activity of this man that qualified him for the role of the ancient sage. What matters here, at any rate, is the close identity of the two heads. Rembrandt adopted not only the external physiognomic details but the model's serious, if not actually tragic, expression as well.

This observation brings to the fore one aspect of Rembrandt's *Aristotle* which has been taken more or less for granted. As Rembrandt painted him, Aristotle is a gloomy figure. Schmidt-Degener called him a "melancholy dreamer" and—thinking that he was Vergil—accounted for his state of mind by "the sad reflections" natural for a late-

[103] See E. W. [Edgar Wind], "Aenigma Termini," *Journal of the Warburg Institute*, I, 1937-1938, pp. 66-69; see also J. Bialostocki, "Rembrandt's Terminus," *Wallraf-Richartz-Jahrbuch*, XXVIII, 1966, pp. 49-60. That death himself eventually could become the "guarantor of immortality" was pointed out by E. Panofsky, "Mors Vitae Testimonium," *Studien zur toskanischen Kunst, Festschrift L. H. Heydenreich*, Munich, 1964, p. 221.

[104] For this question see Neil Maclaren, *National Gallery Catalogues, The Dutch School*, London, 1960, pp. 316-17, no. 190. As Maclaren points out there is no valid reason for assuming that the model was a rabbi; it is not impossible, nevertheless, that he was a member of the Amsterdam Jewish community. It seems to me very likely that the same model posed for Rembrandt two years before the date of the *Aristotle* in the sensitive portrayal of a man wearing a white cap

(rather than a bandage, as is generally believed) under a broad-brimmed hat (Wanås, Sweden; see 1969 edition of this book, Fig. 34). It is equally possible, but by no means certain, that Rembrandt painted the same man again in the painting of 1657 in the San Francisco Palace of the Legion of Honor, Bauch 1966, no. 219 [23] and the portrait dated—less certainly—1661 in the Hermitage in Leningrad (*ibid.* no. 239). Maclaren rightly hesitates in recognizing his features also in the so-called *Falconer* in the museum in Göteborg (*ibid.* no. 242). The whole question involves the problem of commissioned portrait vs. portrait study in Rembrandt's later period, and the degree of artistic latitude Rembrandt permitted himself when painting from life. The London portrait is dated, but the last numeral is unclear; Maclaren prefers to read it as 1657; it could also be 1653.

born poet facing the image of the greatest poet of ancient times.[105] Now that we know that Rembrandt's subject is actually Aristotle, his strikingly melancholy expression is certainly in need of an explanation.

It is a commonplace to say that figures in Rembrandt's later works are apt to look *triste*. Even in his earlier works he had painted men and women with pensive expressions and in troubled states of mind. Yet the gloom seems to deepen progressively along with the spreading shadows in the chiaroscuro patterns of his compositions. Studying these later works attentively, one becomes aware of the recurrence, in ever new variations, of one pervasive theme: man's inevitable isolation, the ultimate loneliness of our entire existence. We find it, for instance, in the *Bathsheba* (Fig. 34) in Paris, painted soon after the *Aristotle*, where the young woman, having received and read David's letter, is alone with her thoughts, pondering a decision of far-reaching implications. In the painting of *Saul and David* in The Hague (Bauch no. 35), Saul is an old man whose tragic isolation is made more poignant by the splendor of his Oriental garb. We find it in the painting of the *Dismissal of Haman* in Leningrad (Bauch no. 39; Fig. 35) where the figures seem to brood about the meaning of the event, each one physically as well as spiritually alone.[106] Even the so-called *Jewish Bride* in Amsterdam, painted, to be sure, long after the *Aristotle*, is a painting with tragic overtones (Fig. 36). If I read it correctly, the picture is not only, as most people seem to think, a monument to the abiding beauty of a shared love. It also makes us aware that even in the closest relationship two human beings can establish, there remains forever an unbridgeable chasm between them. In a preliminary sketch Rembrandt had shown the couple smiling at each other.[107] In the finished work they tenderly touch, but they glance beyond each other. Each one is alone with private thoughts and sensations.[108]

[105] Schmidt-Degener, 1915 [7].

[106] I agree with Madlyn Kahr ("A Rembrandt Problem: Haman or Uriah?" *The Journal of the Warburg and Courtauld Institutes,* XXVIII, 1965, pp. 258 ff.), that the picture renders the moment (Esther 6:1-14) when Haman leaves the King after having been charged with the honoring, in the King's name, of Mordecai. The subsequent denial of this interpretation, by J. Nieuwstraten ("Haman, Rembrandt and Michelangelo," *Oud Holland,* LXXXII, 1967, pp. 61-63 has again been refuted by Mrs. Kahr ("Rembrandt's Meaning," *Oud Holland,* LXXXIII, 1968, pp. 63-68).

[107] New York, Collection S. Kramarsky (Ben. no. 988). For this composition (Fig. 37), see Jakob Rosenberg, 1964, pp. 128-30 [5].

[108] Considering the popularity of the work, and the pages of emotive description dedicated to it, it is surprising to see how little has been said about the precise nature of the action. The "groom" is not just touching the young woman's body, but drapes a golden chain over it, holding it with both hands. The gesture of the "bride," whose left hand gently holds his right to her body, surely indicates her willingness to be "bound" by that chain. The object she holds in her right hand seems to be a fruit. It might be a pomegranate, an appropriate symbol under the circumstances, but its color is too indefinite.

Aristotle, too, is a lonely figure, but there is perhaps a specific reason why he should be painted in a melancholy mood. Since the late fifteenth century, especially under the influence of Marsilio Ficino, it had become axiomatic that all great men of art and science had been melancholics. This went so far that, besides wearing a long beard, those who hoped to be taken for profound thinkers had to assume a melancholy expression—a faint echo of which still reverberates in Bunthorn's song from Gilbert and Sullivan's *Patience*.

Now this whole theory, studied thoroughly in a vast and learned body of modern literature,[109] took its beginning from none other than Aristotle himself, or rather from a text traditionally assumed to have come from his pen.[110] This is the so-called *Problema XXX* in the book known as *Problemata*, which begins with the blunt question: "Why is it that all those who have become eminent in philosophy or politics or poetry or the arts are clearly melancholics?"[111] For the context of our picture it is immaterial to know how this question is answered. What does matter is that Aristotle was forever credited with an observation widely held to be a self-evident truth. Now if it were true that all eminent men had been melancholics, then Aristotle, who had been the first to give expression to this thought and who had been one of the greatest thinkers of all time, would have been a melancholic himself.

to be dogmatic about it. W. Weisbach, generally a very perceptive observer, curiously misread the relationship of the two people when he spoke of "dem sich in sie einbohrenden Blick des Mannes" (the man's glance boring itself into the woman), see *Rembrandt*, Berlin-Leipzig, 1926, p. 592. A more penetrating interpretation of the picture was given by Charles Tolnay, "A propos de l'exposition d'Amsterdam, Contribution à la connaissance de Rembrandt, II, Interprétation de 'La Fiancée Juive,'" *L'Amour de l'Art*, XVI, 1935, pp. 277-78. Making reference to Ripa's prescription for the rendering of *Concordia Maritale*, Tolnay suggests that Ripa's externalization of the *concetto* (a chain put around the necks of *both* persons and an actual heart hanging from this chain, supported by one hand of each of the partners) was translated by Rembrandt into a genre action of symbolical significance. It is not impossible—despite the many discrepancies between the two images—that Ripa's description of *Concordia Maritale* played a role in Rembrandt's conception of the *Jewish Bride*. The mood of a slightly melancholy self-absorption of both figures, however, is surely still an essential part of the work. According to H. Kauffmann, "Die Fünfsinne in der niederländischen Malerei des 17. Jahrhunderts," *Festschrift für Dagobert Frey*, Breslau, 1943, pp. 147-48, the painting is related to the iconographic pattern of the sense of "feeling."

[109] The most complete discussion of this complex of questions is found in Raymond Klibansky, Erwin Panofsky, and Fritz Saxl, *Saturn and Melancholy*, London, 1964. See also Rudolf and Margot Wittkower, *Born under Saturn*, London, 1963, pp. 102-8.

[110] Its author is unknown, but Klibansky-Panofsky-Saxl (*op.cit.*, pp. 36-37) suggest that it may have been Theophrastus, Aristotle's successor in the Peripatetic school.

[111] *Opera omnia*, Paris, 1931, IV, pp. 265 ff.; for Aristotle's sources see W. Müri, "Melancholie und schwarze Galle," *Museum Helveticum*, X, 1953, pp. 21 f.

Some aspects of Rembrandt's picture may indeed support the contention that the artist wanted to represent the philosopher as a Saturnian melancholic. The sallow color of Aristotle's skin brings to mind the traditional view that melancholics are known for their dark complexion.[112] The large black area of the gown, to which we called attention before, is perhaps more convincingly explained as the traditional color of melancholy. According to one astrological theory a black garb draws upon the wearer "the beneficent influences of Saturn."[113] Above all, the very attitude of deep thought so beautifully rendered in Rembrandt's *Aristotle* is characteristic of a melancholy temperament.[114]

In the seventeenth century the theme of melancholy often coalesced with that of *Vanitas*. Hence it is not at all surprising that one of the most celebrated formulations of that subject, Georges de la Tour's *Magdalen with the Mirror* (Fig. 38) renders the saint in a state of silent meditation. The parallel with Rembrandt's *Aristotle* is reinforced by the similarity of her pose, as she touches with her hand a skull, very much as Aristotle touches Homer's bust. If it is true, as we suggested above, that in pictures of this kind the busts were substitutions for skulls (which in turn may have been transferred from images of St. Jerome meditating on the vanity of things)[115] both paintings share a common ancestry. The somber mood of the popular *vanitas* tradition, indeed, surely reverberates in Rembrandt's painting. It should not be forgotten that the books piled up in the background, in addition to characterizing the setting as the library of a learned man, strongly evoke the concept of *vanitas*. Books are among the most common symbols of the passing of all things and as such are standard items in Dutch *vanitas* still lifes.[116]

6. THE CHAIN

If nothing else, these remarks should make it clear that the state of gloomy introspection chosen by Rembrandt for his rendering of Aristotle is entirely appropriate in a por-

[112] See, for instance, Erwin Panofsky, *Albrecht Dürer*, Princeton, 1945, pp. 158 and 235.

[113] René Taylor, "Architecture and Magic," *Essays in the History of Architecture Presented to Rudolf Wittkower*, London, 1967, p. 87. Although the reference in this article is to Philip II's fondness for wearing black, it is possible that the same thought influenced Rembrandt in his choice of black for Aristotle's gown.

[114] For an early painting by Rembrandt which belonged to Frederik Hendrik of Orange and in an inventory of 1632 is described as an allegory of Melancholy, see J. G. van Gelder, "Rembrandt's Vroegste Ontwikkeling," *Mededelingen der Koninklijke Nederlandse Akademie van Wetenschappen, Afd. Letterkunde*, N.R. XVI, 1953, p. 294.

[115] See Jan Bialostocki, 1965, p. 198 [98].

[116] See Ingvar Bergström, *Dutch Still-Life Painting*, London, 1956, pp. 154 ff., and Charles Sterling, *Still Life Painting from Antiquity to the Present Time*, Paris, 1959, pp. 52-53.

trayal of this philosopher. The popular notion of the melancholy genius, nevertheless, is hardly sufficient to sustain the expressive weight of Rembrandt's picture. We can probe still more deeply into the fabric of the master's work and without turning into arbitrary mind-readers define its meaning more precisely. In doing so, we hope to reveal yet another dimension of the work.

At this point we must call attention to one clue the artist planted so conspicuously that —not unlike Edgar Allan Poe's purloined letter—it has been overlooked by almost all commentators. This is the golden chain worn by Aristotle (Fig. 39). With its almost barbaric splendor it forms a striking contrast to the modest ribbon around Homer's neck.[117]

It certainly will not do to account for its presence by saying that Rembrandt liked to paint sparkling jewels and golden chains, and here found pictorial delight (as he surely did!) in the coloristic effect the gold makes against the black; what may be sufficient reason in more casual pictures (see below, note 152) can hardly be enough in a work of the intellectual depth and complexity of Rembrandt's *Aristotle*. Only one author has given some thought to the presence of the chain, tentatively associating it with the *aurea catena Homeri* (the golden chain of Homer) though without going into this possibility more deeply.[118] The golden chain of Homer is a metaphor derived from a boastful speech of Zeus in which the god likened himself to the winner in a rope-pulling contest, with all the other gods on the opposite side (*Iliad* 8. 19). This golden rope, or golden chain, as it was known later on, became the subject of a great deal of allegorical interpretation, emerging finally as a celebrated cosmic symbol: it stands for the inner cohesion of the universe and the marvelous continuity—the concatenation of causes— of historical development.[119] As a literary metaphor, charged with historical and philosophical associations, the golden chain of Homer, stretching from heaven to earth, can hardly be associated with a chain actually worn by a human being and made even more concrete and specific by a portrait medal suspended from it.[120] For the discussion

[117] Emil Kieser, 1941-1942, p. 136 [7], clearly sensed this contrast when he spoke of the difference between "the age, poverty, and intellectual simplicity (*geistige Schlichtheit*) of the poet-ancestor" and the "sage, burdened equally with pomp and thought."

[118] H. von Einem, 1952 [4].

[119] See Emil Wolf, *Die goldene Kette; die Aurea Catena Homeri in der englischen Lite-* ratur von Chaucer bis Wordsworth, Heidelberg, 1947; Ludwig Edelstein, "The Golden Chain of Homer," *Studies in Intellectual History*, Baltimore, 1953, p. 48; A. Levèque, *Aurea Catena Homeri, Une étude sur l'allégorie grecque*, Ann. Litt. Univ. Besançon, Paris, 1959. See also A. O. Lovejoy, *The Great Chain of Being*, Cambridge, Mass., 1936.

[120] In his prescription for an allegorical render-

to follow, it should be remembered, however, that at least one sixteenth century my-thographer, Natale Conti (1520-1582) associated the *aurea catena* of Homer with the golden chain forged by avarice and ambition, the power of which draws many people from God's true religion to false beliefs.[121]

One might indeed ask why a philosopher should wear such a sumptuous piece of jewelry in the first place. As Ribera painted them, philosophers normally go in rags, in keeping with Petrarch's prescription that philosophy should go poor and naked (later repeated and paraphrased by Ripa).[122] We know, of course, that Aristotle was fairly well off, and that some ancient authors, as stated before, found it worthwhile to record that he liked wearing rings. Yet the chain in the New York canvas is too conspicuous to connote no more than Aristotle's vanity or economic affluence.

ing of *Pittura* Cesare Ripa (*Iconologia*, Venice, 1645, p. 490) stipulates that she be rendered as a beautiful woman who, besides being adorned with other attributes, should wear a golden chain from which a head of Momus is suspended. In a distant echo of the philosophical interpretations of the Homeric chain he explains the links of the chain to demonstrate "la conformità di una cosa con l'altra e la congiuntione," while the face of Momus signifies *Imitation*—a central aspect of the art of painting. In this sense the golden chain, carried by a Putto, was introduced in David Klöcker Ehrenstrahl's *Self-portrait* of 1691 in Stockholm (see Allan Ellenius, *Karolinska Bildidéer*, Uppsala, 1966, pp. 11 ff. and fig. 1). Ehrenstrahl himself explained in his book on the paintings he had executed for the royal palaces in Sweden (*Die vornehmste Schildereyen . . .*, Stockholm, 1694, p. 33) that just as identical links in a chain make a good chain, so divers parts of a picture, if in accord with each other, make for a good picture. It is obvious that chains worn by men who had no connec-tion with painting, and from which not a Momus-head but the portrait-medallion of an actual prince is suspended, cannot be related to Ripa's chain of *Pittura*. See also below, note 135.

[121] *Natalis Comitis Mythologiae . . . Libri X*, Venice, 1581, p. 93, lines 25 ff.: "Quod attinet ad auream cathenam, quod omnes Dii Iovem de coelo detrahere non possent, ego modo ava-ritiam, modo ambitionem esse auream cathenam crediderim; quae et si potentissima est, multos-que a vera Dei religione ad falsa dogmata re-traxit." Determined to give a moral interpreta-tion to Homer's chain, he uses metaphorically the inability of the Gods to pull Jupiter down: "For he who is a truly good man cannot be dis-lodged from any place by avarice nor ambition" (Qui enim vir bonus vere existit, ille neque avaritia neque ambitione ulla loco dimovetur). Wolff (*loc.cit.*) points out that Spenser (*Faerie Queene*, II.7.46) also connected the chain with ambition, but used the image differently. Here the chain, stretching from earth to heaven, is an instrument, as it were, for ambitious "climbing" —"thereby to climbe aloft, and others to excell." As we shall see, Rembrandt's innermost thoughts about the golden chain draped across Aristotle's body are fraught with similar moral associations, but we have no reason to assume that he con-nected the chain with the one known from the mythological contest. For Natale Conti see Jean Seznec, *The Survival of the Pagan Gods*, New York, 1953, *passim*.

[122] *Iconologia di Cesare Ripa, Perugino*, Ven-ice, 1645, pp. 245 and 266; Philosophy "ap-parisca la carne ignuda in molti luoghi . . ." quoting Petrarch: "Povera, e ignuda vai Filo-sofia."

While golden chains are not known to have been adornments of philosophers, they do carry with them a well-defined set of associations. As usual, Cesare Ripa relied on tradition and common knowledge when he listed the golden chain as one of the attributes of the personification of Honor (*Onore*). Honor, he says, may be represented by a man of venerable appearance, crowned with palm, with a chain of gold around his neck, and gold bracelets on his arms. The golden bracelets and the golden chain, he explains, "are ancient signs of Honor which were given by the Romans as rewards to those who had valorously fought in the wars, as Pliny said in the 33rd book of his Natural History."[123] Honor is here evidently not conceived as a quality of character inherent in the noble disposition of a given subject, but as the esteem in which the bearer is held by a higher authority. Though he may also be a "man of honor," the owner of a golden chain wears this valuable piece of jewelry as a token of the honor bestowed upon him by someone else, usually a prince, occasionally the civic authority in power.

The ancient custom of giving a special reward in the form of a golden chain was revived in the Renaissance and widely practiced in the seventeenth century. Being an object both of considerable material value and of noble connotations, the chain admirably fulfilled two functions: that of a very real financial reward, and of a rather spectacular demonstration of recognition in high quarters. Yet there are signs that it was soon recognized as something else: chains, after all, are symbols both of eminence and of servitude. Thus in the paradoxical world of Thomas More's *Utopia*—a world where false values are shunned—gold chains are signs of disgrace, and are also used to fetter slaves.[124] Likewise Alciati, in his Emblem "In Aulicos,"[125] speaks of the golden shackles by which courtiers are tied to their princes, and in this connection indeed mentions that Aristotle had been criticized for having left the Academy to become attached to King Philip's court. In the 1549 (French) edition of Alciati the word shackles (*compedes*) is actually replaced by chains: "Les courtisans qu'entretient vaines Court/ En chaines d'or les tient liez decourt."[126]

[123] The reference is probably to Pliny 33.8.37. If Ripa had been interested in the Bible as much as in ancient writers he could have referred also to Gen. 41:42: "And Pharaoh took off his ring from his hand, and put it upon Joseph's hand, . . . *and put a gold chain about his neck*. . . ."

[124] More's *Utopia*, ed. by E. Surty, S. J., New Haven, 1964, p. 86. I am indebted to Professor Rosalie L. Colie for this reference.

[125] *Emblemata D. A. Alciati . . .* , Lyons, 1551,

Emblema 86. 94, with the motto: "Vana Palatinos quos educat aula clientes/ Dicitur auratis nectere compedibus." Alciati also quotes Seneca as saying that it is foolish to love one's fetters even if made of gold.

[126] *Emblemes d'Alciat, de nouveau Tràslatez en Fràcois vers pour vers*, Lyons, 1549. I owe the reference to the Alciati passage to Dr. Peter Burke.

Numerous portraits of the sixteenth and seventeenth centuries render men honored by, and decorated with, a golden chain. The honor was compounded by the addition of a portrait medal of the donor to be worn suspended from the chain. This custom may have been derived from the insignia of chivalrous orders which were suspended from gold chains. To wear the portrait medal of a prince was as much a privilege as, say, the wearing of an image of St. George. Yet it was in a very special sense also an obligation; it made sure that the wearer would never forget to whom he was beholden for the honor bestowed. Jacopo de Strada (c. 1515-1588), for instance, as painted by Titian c. 1567-1568 (Fig. 40) wears a gold chain wound four times around his neck, with a portrait medal suspended from it.[127] A man of many talents and employed by a succession of three emperors (Ferdinand I [1503-1564], Maximilian II [1527-1576], and Rudolf II [1552-1612]), Strada evidently had been the recipient of such an award.

Since Rubens' portrait of Gevartius, as seen above, has general compositional similarities with Rembrandt's *Aristotle*, it is not without interest that the engraving of that portrait by Paulus Pontius (Fig. 41) differs from the painting in one respect. (It goes without saying that Rembrandt knew only this print.) While he is unadorned in the painting, Gevartius wears a golden chain in the print; the medal suspended from it bears the likeness of Emperor Ferdinand III. In the caption Gevartius is called "Counsellor and Historiographer" of this emperor—a dignity to which he was appointed on February 15, 1644. The print undoubtedly was made after this appointment, commemorating it by the inclusion of the chain and medal, objects that had accompanied the appointment.

In the context of Rembrandt's *Aristotle* it is important to realize that several well-known artists were among the recipients of such chains. While Titian may come to mind first, his is a special case: in 1533 Charles V appointed him Count Palatine and raised him to the rank of a Knight of the Golden Spur; as such he had the right to wear sword, chain, and spurs.[128] More important for us is the case of Paolo Veronese. After winning a competition with his allegory of Music in the Library of San Marco, Veronese received from the Signoria a golden chain in addition to his ordinary fee. Vasari calls it significantly a *premio d'onore* (a prize of honor).[129] A modern paradigm for the esteem in which the arts ought to be held, Veronese's decoration was mentioned not only in later Italian sources, such as Ridolfi, but also by van Mander and Samuel van Hoogstraten. Nor did Veronese remain an isolated case. Hoogstraten reports with almost audible pride that he himself had received a golden chain from Emperor Ferdinand

[127] Vienna, Kunsthistorisches Museum, no. 724, painted ca. 1567-1568.
[128] See Georg Gronau, *Titian*, London, 1904,

pp. 105-6.
[129] Giorgio Vasari, *Le Vite* (ed. Milanesi), VI, Florence, 1881, p. 373.

III, with an imperial "Genadenpenning" hanging from it.[130] Rubens is known to have received three golden chains. The first, worth 300 fl. was given to him in 1609 by Archduke Albert and his wife Isabella, along with his appointment as court painter. A medallion with the portraits of the princely couple was suspended from it.[131] In April 1639, Charles I of England gave him another chain, worth £300 as a sign of his satisfaction with the ceiling Rubens had painted for the Banqueting House at Whitehall.[132] Rubens also had received a gold chain from King Christian IV of Denmark; it is preserved and on display in the Rubenshuis in Antwerp.[133] On April 20, 1633, Van Dyck had received a golden chain worth £220 from Charles I; it, too, was accompanied by a medal with the portrait of the king.[134]

It may well be—although the painting has also been interpreted in a somewhat different manner—that Van Dyck alluded to this gift in one of his most famous self-portraits (Fig. 43). Proudly lifting the chain with his left hand, he points with his right at a sunflower, an emblem of a subject's unceasing devotion toward his prince.[135] The

[130] Samuel van Hoogstraten, *Inleyding tot de Hooge Schoole der Schilderkonst*, Rotterdam, 1678, p. 356.

[131] Max Rooses and Ch. Ruelens, *Correspondance de Rubens et Documents Epistolaires concernant sa vie et ses œuvres*, II, Antwerp, 1898, pp. 5-6. On August 8, 1609, the order was given by the Archduke for a payment of 300 florins to Robert Staes, a goldsmith, for a chain of gold with medallion of the likenesses of Albert and Isabella, to be given as a gift to Rubens. The patent as court painter was issued to Rubens on September 23, 1609.

[132] Rooses-Ruelens, *Correspondance*, VI, Antwerp, 1909, p. 229. The chain, weighing eighty-two and a half ounces, was handed over to Lionel Wake by Endymion Porter, to be conveyed to the artist "with all convenient speede."

[133] See *Herinneringen aan P. P. Rubens*, Tentoonstelling, Rubenshuis, Antwerp, 1958, no. 29. While there is no documentary evidence connected with this chain, it was given to the city of Antwerp by Burggraf R. Helman de Grimberghen, Paris, a descendant of Rubens; according to a family tradition, it had been given to Rubens around 1620.

[134] See Lionel Cust, *Anthony van Dyck, an historical Study of his Life and Work*, London, 1900, p. 88.

[135] For the interpretation of the sunflower as an emblem of devotion towards a prince see R. R. Wark, "A Note on van Dyck's Self-portrait with a Sunflower," *The Burlington Magazine*, XCVIII, 1956, pp. 52 ff. J. Bruyn and J. A. Emmens, "De zonnebloem als embleem in een schilderijlijst," *Bulletin van het Rijksmuseum*, Amsterdam, III, 1955, pp. 3 ff. and in a sequel "The Sunflower again," *The Burlington Magazine*, XCIX, 1957, pp. 96 f., call attention to the fact (hinted at before by Guy de Tervarent, "Van Dyck and the Sunflower," *Message, Belgian Review*, no. 23, 1943, pp. 35-36) that the sunflower may also signify the art of Painting (*Pittura*) which faithfully follows Nature. The golden chain in Van Dyck's picture, they believe, may then be connected with the chain *Pittura* wears, according to Ripa (see note 120). Admitting the plurality of emblematic meanings, they see no real conflict between their view and the one suggested here as well as by Wark. Since there is no medallion shown, either with the portrait of Charles I, or of Momus (as Ripa requires), a clear decision is obviously impossible; in view of Van Dyck's close connection with the court, however, Wark's view, I feel, still has the edge.

connection between chain and medal on the one hand and a sovereign's favor on the other is spelled out still more precisely in the self-portrait of David Beck (1621-1656), a pupil of Van Dyck, who from 1647 was court painter and valet de chambre to Queen Christina of Sweden. In the engraving of that picture by A. Cognet (Fig. 42) he points with his right hand to his portrait of the Queen, while his left hand holds up, for all to see, the Queen's portrait-medal, hanging from a chain. (The roll of paper in his right hand is presumably the patent of his appointment.)

No better illustration of the meaning of such gifts of golden chains could be found than a painting attributed to Paris Bordone (Fig. 44).[136] Identified by the objects on the table before him as a jeweler, a man dressed in a dark costume humbly receives into his right hand a golden chain tendered to him by a white eagle, balancing a small royal crown on its head and wearing the joined letters S A suspended from a slender chain around his neck. A medal with a profile portrait of King Sigismundus Augustus hangs from the chain. The reference is certainly to Sigismundus II Augustus (1520-1572), known to have been a passionate collector of jewelry. The personage represented in the painting was indeed the favored jeweler of this King, Gian Jacopo Caraglio, famous goldsmith, medalist, and engraver.[137] The expression on the face of Caraglio and the inclination of his body toward the royal eagle (aptly described by Campori as "un atto di somma riverenza") illustrate perfectly the subservience of the courtier. The chain brings honor and material reward, but the price is high.

Returning now to Rembrandt's *Aristotle*, we perceive clearly that the philosopher wears the golden chain as a sign of favor accorded to him by the monarch whose portrait medal is suspended from it. Once we have grasped the associations evoked by the golden

[136] Collection Dr. A. S. Ciechanowiecki, London.

[137] See Giuseppe Campori, *Raccolta di cataloghi ed inventarii inediti di quadri, statue, disegni, bronzi, dorerie, smalti, medaglie, avorii ecc. dal secolo XV al secolo XIX*, Modena, 1870, p. 190: Catalogo dei quadri dello studio Muselli di Verona, Archivio Palatino Modena: "Un ritratto d'un Gioielliere, sopra il banco vi sono diversi instrumenti per l'arte et un morione dorato, sopra il quale posa un'Aquila bianca con ali sparse, dalla bocca della quale pende una colonna [i.e. collana], a dalla colonna una medaglia d'oro con l'impronta d'un uomo armato, scrittovi intorno: SIGISMUNDUS AUGUSTUS POLONIAE REX: sostiene l'Aquila con un piede la colonna in atto di porgerla al ritratto, ed egli inchinandosi con un atto di somma riverenza stende le mani per riaverla. Vi e architettura e paese, e si vede dall'aria venir un fulmine, ma dall'ala dell'Aquila vien coperto. Quest'era un gioeilliere Veronese che fu condotto dal Re di Polonia, nel partirsi lo fece cavaliere: l'Aquila bianca e l'arma del Re di Polonia, con il finger che l'aquila li porge la colonna vuol alludere all'atto del Re in farlo Cavaliere, ponendo l'arma del Re per il Re medesimo; e tre braccia in altezza, in lunghezza due, de' più finiti a belli di Tiziano." I owe to the present owner the identification of the sitter and the reference to Campori's publication.

chain, we cannot help noticing that Aristotle, as portrayed by Rembrandt, is as much involved with the chain as with Homer's bust. Accepting, as I think we must, the notion that with a master like Rembrandt nothing is entirely accidental, and least of all in a work that was the product of much thought as well as feeling, we are obliged to pay attention to the placing of Aristotle's hands. One rests on Homer's head, while the other touches the chain, letting its several strands pass between index and middle finger (in this respect similar to Van Dyck's handling of the chain). The philosopher looks neither at Homer nor at the chain. Yet we cannot help feeling that his melancholic countenance and faraway glance are in some way linked to both these objects, as if subtle impulses were flowing to him from them while he touches them with his fingers. Rembrandt, however, also implied clearly that in the hierarchy of values there is a difference between the two objects. To show this, he followed age-old pictorial conventions. It surely is meaningful that Aristotle touches the bust of Homer with his *right* hand, favored in theology, symbolism, and ceremonial; it is his *left* that fingers the chain. His right hand is lifted up while the left hand is lowered. And it is a characteristic thought of an artist famous for his deliberate and meaningful use of light and dark that the right hand is in the full light, the left in the shade.[138] Though mindful of the function and the meaning of the chain, Aristotle turns in the direction of the bust. In the rivalry of two centers of attention, he seems instinctively to put one above the other. The diagonal draping of the chain may have been chosen precisely to permit the artist to connect it unobtrusively with the lowered left hand. That chains could be worn diagonally is shown by Rembrandt's portrait (of a poet?) formerly in the collection of J. Weitzner in London (Bauch no. 193) and by Van Dyck's portrait of Liberti (Fig. 45).[139]

At this point it is pertinent to remind ourselves of a biographical detail that so far has not been brought into the discussion of Rembrandt's picture. Aristotle had indeed been Alexander's tutor and had helped to shape the mind of the great king. Yet we have it on the authority of Plutarch (Alexander 54) that this relationship became strained later on. "[Alexander] admired Aristotle at first, and loved him, as he himself used to

[138] For a moral differentiation between light and shade, especially in Rembrandt's *Anatomy of Dr. Tulp*, see William S. Heckscher, *Rembrandt's Anatomy of Dr. Nicolaas Tulp*, New York, 1958, pp. 36-37, and p. 131, note 41. Heckscher acknowledges having been stimulated in his discussion by a lecture by H. van de Waal "Rembrandt and Chiaroscuro" which "drew attention to the iconographic function of chiaro-scuro in the work of the mature Rembrandt." As far as I know this lecture has not been published.

[139] Mauquoy-Hendrickx, 1955, p. 335, no. 172 [50]. Van Dyck's painting is in the Pinakothek in Munich (no. 375); another version was formerly in the collection of the Duke of Grafton.

say, more than he did his father, for the one had given him life, but the other had taught him a noble life. Later, however, he held him in more or less suspicion, not to the extent of doing him any harm, but his kindly attentions lacked their former ardor and affection towards him, and this was proof of estrangement." In another passage Plutarch (Alexander 55) quotes Alexander as saying: ". . . but the sophist" (a man named Callisthenes) "I will punish, together with those who sent him to me and those who harbor in their cities men who conspire against my life." Plutarch continues, "and in these words, he directly revealed a hostility to Aristotle, in whose house Callisthenes . . . had been reared." Callisthenes, who may actually have been a nephew of Aristotle, was indeed executed on suspicion of conspiracy, and Diogenes Laertius (V. 10) also reports that his death caused an estrangement between Alexander and Aristotle.

In the light of these accounts of the later phase of Aristotle's relationship with Alexander, contained as they were in a book probably more widely read than any other piece of ancient literature, it is conceivable that the melancholy reflections of Aristotle involve an awareness of the fickleness of princely favor. The prince who one day presents you with a chain of honor, may the next day look at you with suspicion and kill your friends or relatives. Erasmus expressed the same idea when he warned the ambitious against yearning for honors from those unworthy to bestow them: "They have the power to take away the honors they have given and to defame the one whom they have just honored."[140] A few years later Rembrandt drew another "example of the ingratitude of mighty rulers"[141] when he sketched blind Belisarius begging for alms (Tobit, Fig. 41).[142] Even if one might hesitate to reduce Aristotle's melancholy to such specific terms, it is hardly to be doubted that the picture is built upon the contrast between two sets of values, the more enduring ones symbolized by the bust of Homer, and the mere secular and transitory awards exemplified by the chain. That Rembrandt, as I mentioned before, put his signature on the bust, may well assume a special significance as an act of identification with a higher moral principle.

It should be obvious by now why the title "Aristotle contemplating the bust of Homer" is inadequate as a summing up of the picture's meaning. Aristotle's thoughts, if our reading is correct, are both more general—dealing with far-reaching human problems and moral choices—and more concrete—deriving from specific historical situations. The bust plays a most important part in these thoughts, but is not, in itself, the object of the sage's

[140] Desiderius Erasmus, *Enchiridion* (trans. W. Welzig) Graz-Cologne, 1961, p. 120 ("Against Ambition"). He continues with the equally pertinent phrase: "Remember that each honor is connected with a great burden."

[141] Otto Benesch, 1959, p. 315 [6].

[142] Kupferstichkabinett, Berlin, Benesch, no. 1053.

contemplation. Interpreted in this way, Rembrandt's *Aristotle* takes its place alongside other paintings by the master in which a troubled individual is caught in the center of conflicting forces, none more impressive than the great *Denial of St. Peter* in Amsterdam, where the apostle is revealed—in the light of the candle held up to his face—as a faltering mortal, standing undecided between the harsh threat of the secular powers, and the quiet voice calling him to his real duty.

7 · CONCLUSION

The interpretation of Rembrandt's *Aristotle* suggested here brings into focus a variety of themes and traditions conjoined in one of the most richly structured works of the master. Yet there is one more level on which it is of interest, one that might be called the psychological or subconscious one. It concerns both Rembrandt's interest in Homer and his attitude towards the value of secular honor, represented in the chain as a "premio d'onore." In his study "Rembrandt and Homer" von Einem laid stress on the spiritual significance Homer must have had for the aged and deeply religious Rembrandt. He expressed this thought when he said "Both Homer and Christ are mediators of the Divine" and again, "The ancient theme breathes a Christian spirit."[143] Yet Rembrandt's deep involvement with the image of the blind bard is also rooted in his lifelong concern with the theme of blindness. I have tried elsewhere to point out why the subject of blindness was of such enduring interest to Rembrandt.[144] One of the factors involved seems to have been Rembrandt's relationship to his own father who had died when the artist was still a young man. There is some evidence that, at least at the end of his life, Rembrandt's father had lost his sight. Could it be that Homer's appeal to Rembrandt was not only founded in the moving concept of a blind poet illuminated by inner visions but that subconsciously Rembrandt saw in Homer a transfigured image of his own father?

Art historians (rightly, I am sure), are wary of making excursions into fields in which they are not at home and where the evidence does not conform to the rules by which they are trained. Yet there are situations when even a believer in an aseptic kind of art history cannot help sensing a personal meaning underlying the apparent one. Rembrandt's painting of Aristotle, I believe, is such a case. For it is easy to see that the theme of a conflict between the two worlds, symbolized by the bust of Homer on the one hand and the golden chain as the token of secular honor on the other, must have had a more than academic significance for the master himself.

[143] Von Einem, 1952, p. 186 [4]. [144] See below, pp. 124 ff.

As he was an artist of international reputation, the possibility of following the example of other artists of his age, including some Dutch ones (such as Honthorst), and entering the service of a prince may well have crossed his mind or been suggested to him by others. In the 1630's Constantijn Huygens had made a strong effort to draw him into the service of the court at The Hague and to make his art over in the likeness of that of Rubens.[145] After the middle of the century other centers of power emerged as potential or actual patrons of artists, none of more immediate concern to Rembrandt than the city of Amsterdam herself. We know that he did receive commissions for the new Town Hall of Amsterdam, but it is equally known that for reasons which are not entirely clear, the path of these commissions was thorny and that they ended in failure.[146]

Among the anecdotes about Rembrandt which appear to have been current in the early eighteenth century there is one which I believe has bearing on this problem. It appeared first in Roger de Piles' *Abrégé de la Vie des Peintres*[147] and was soon thereafter taken up by Houbraken in his somewhat gossipy but highly valuable collection of artists' biographies (published 1718-1721).[148] It is no more than a sentence Rembrandt is supposed to have said, but this statement is so personal and differs so much from the standard anecdotes told about great artists that I consider it less *ben trovato* than actually true. This story tells that toward the end of his life Rembrandt associated a great deal with common people and plain artisans (implying that he failed to cultivate the rich and the noble).[149] Asked why he preferred the company of the lower classes, Rembrandt is supposed to have answered "When I want to relax my mind, it is not honor that I seek but freedom." (*Quand je veux délasser mon esprit . . . ce n'est pas l'honneur que je cherche, c'est la liberté.*)[150]

[145] See H. Gerson, *Seven Letters by Rembrandt*, The Hague, 1961, and the author's review, *Art Journal*, XXII, 1963, pp. 202-3. See also below, pp. 123-24 (note).

[146] See the literature quoted above, note 20.

[147] Paris, 1699 (here quoted from the second edition, Paris, 1715, pp. 423-24).

[148] *De Groote Schouburgh*, I, pp. 272 f. 1718 [19].

[149] Houbraken (*loc.cit.*): "Hy verkeerde in den herfst van zyn leven wel meest met gemeene luiden, en zulke die de Konst hanteerden." This notion had already been expressed by Sandrart when he criticized Rembrandt for failing to keep his station and associating with the "niedrigen Leute," see Slive, 1953, pp. 92-

93 and 141 [15].

[150] In Houbraken's formulation: "Als ik myn geest uitspanninge wil geven, dan is het niet eer die ik zoek, maar vryheid." Most scholars seem to have accepted, if not necessarily the precise formulation, at least the underlying idea as genuine. Without actually calling it an invention, Slive (1953, p. 126) considers de Piles' quotation "apocryphal" and seems to put little store in its veracity, saying that de Piles "wanted to imply that although the artist did not follow the ways of the Académie, and did not receive any of its honors, he had his freedom"(?) Within the year of the publication of de Piles' book his biography of Rembrandt was adapted by Florent le Comte (*Cabinet des Singularitez*

It is hardly accidental that the word honor, which had played such a central role in the interpretation of the *Aristotle,* appears also in this beautiful sentence.[151] In fact, the statement attributed to Rembrandt gains in significance in the light of the *Aristotle,* and in turn reinforces the meaning of the picture as it has been interpreted here. The golden chain, the symbol of honor, had been coveted by Rembrandt's contemporaries, including some of the greatest artists. But Rembrandt, who said that he valued freedom more than honor, must have seen that although golden, it was still a chain. Like Aristotle he may have known the risks involved in the acceptance of the symbols of honor. But unlike his *Aristotle,* in whom the conflict is charged with pathos since the philosopher wears—and in a way has become a "prisoner" of—the golden chain, Rembrandt himself never yielded his personal independence.[152] The greatness of his art, in the last analysis, is due to this

d'architecture, peinture, sculpture et graveure. Paris, 1699, see Slive, 1953, pp. 134 ff.). Le Comte paraphrased de Piles' quotation in the light of his own social standards; according to him, Rembrandt avoided associating with persons of standing because their rank would have "cramped his style" (*dont la qualité l'auroit mis dans une espèce de contrainte*); instead he "lived in liberty" (*il vivoit en liberté*) with people "of his own class."

Relaxation, to avoid mental fatigue, was strongly recommended to artists by Hoogstraten (see above note 130), pp. 199 ff. Citing Seneca, who had warned against a too intense or prolonged occupation with the same thing, Hoogstraten suggests to his fellow artists a variety of activities providing the desirable *uitspanning* (literally: unhitching). They include going for a walk, travel, drinking, reading, collecting prints, playing games (including drawing games) or even playing the fool. In a poem written in Vienna in July 1651, he praises travel as a way of gaining "freedom." Yet it was precisely on this trip that he accepted the golden chain of imperial honor (see above, pp. 36-37).

[151] In contrast to the statement attributed to Rembrandt, where it is interpreted negatively as opposed to freedom, "honor" was more often hailed as something praiseworthy in contrast to worldly riches. It takes the place of the "glory" which Alberti wanted artists to aspire to, rather than money (see Slive, 1953, p. 49 [15]) and

is found, for instance, in Goltzius' punning motto "Eer boven Golt.[ius]" (Honor above gold), see E. K. J. Reznicek, *Die Zeichnungen von Hendrik Goltzius,* Utrecht, 1961, 1, p. 315, no. 195 or Elsheimer's poem accompanying a drawing of *Fama:* "He who strives more for art and honors than for the riches of this world his praise will always be spread far and wide by Fame" (Der Mehr nach Kunst und Ehren stelt/ Dann nach dem Reichtumb dieser Weltt/ Desselben Lob wirdt aller Zeitt/ Von der Fama weit aussgebreitt), see H. Weizsäcker, *Adam Elsheimer, Der Maler von Frankfurt,* Berlin, 1936, 1, p. 47. The *topos* reverberates still in the rhymed motto the young Rembrandt inscribed in the friendship-album of Burchard Grossmann, a German merchant who visited Amsterdam in June 1634:

"Een vroom gemoet
Acht eer voor goet."

(A righteous soul prefers honor to wealth), see A. Hofstede de Groot, *Die Urkunden über Rembrandt (1575-1721),* The Hague, 1906, p. 32, No. 33.

[152] Among the fifty-odd self-portraits painted by Rembrandt there are about fifteen in which he used golden chains (sometimes doubling them) draping them either across his chest or on his fur-trimmed coat. These chains differ in appearance from each other; he used them occasionally also to decorate the costumes of his models, including the man often identified as his brother Adriaen, and Titus, his son. Thus, rather than

fact: that it is the work of a man who never compromised, who never permitted himself to be burdened with a chain of honor, and fiercely maintained both the integrity of his art and his freedom as a man.[153]

being records of actual honors bestowed upon the sitter, they are clearly studio properties, used to enrich the pictorial pattern and to "ennoble" the wearer. In his self-portraits, they are signs of prosperity as well as self-esteem. The proud painter honored himself with these sparkling pieces of jewelry—all the more so because he could wear them without being beholden to anyone. Still, it is worth remembering that they disappear from his late, and greatest, self-portraits. See also Kurt Bauch, "Ikonographischer Stil" *Studien zur Kunstgeschichte*, Berlin, 1967, p. 150: "with one exception, Rembrandt painted

himself only in Phantasietracht" (fantasy costume)!

[153] That his contemporaries were aware of, and impressed with Rembrandt's proud independence appears most clearly from Baldinucci's statement: "When he worked, he would not have granted an audience to the first monarch in the world, who would have had to return and return again until he had found him no longer engaged upon that work." (Trans. Ludwig Goldscheider, *Rembrandt*, London, 1960, p. 23). See also below, p. 87.

II. THE "POLISH" RIDER

I. INTRODUCTION

ANYONE dealing with Rembrandt's so-called *"Polish" Rider* (Fig. 1) at the Frick Collection cannot help remembering another famous rider of the art of the past: the rider of Bamberg Cathedral (Fig. 23). There are some tangible similarities. Both are youthful figures, apparently idealized in some measure, with long curly hair, sitting erect and proud on their horses, with their glances turned outward toward no clearly defined goal. What makes them suggestive of each other, however, beyond such general features, is a certain air of mystery that has surrounded them both. Like the Bamberg sculpture, Rembrandt's painting is enigmatic in many respects. Within Rembrandt's œuvre it is fairly isolated, and its origin and meaning are shrouded. No written source prior to the late eighteenth century is connected with it. No document tells when it was done or for what purpose. Its fragmentary signature, consisting of an R on a rock at the right, if genuine, proves only what need not be proved, Rembrandt's authorship. If there ever was a date on the picture, the accident which mutilated the artist's name deprived us also of this bit of contemporary evidence. Ever since it appeared unexpectedly in a remote collection in Galicia, and through its subsequent peregrinations and growing fame, the picture has been a puzzling and curiously intriguing problem. The following study does not deprive the work of this special fascination. It endeavors to collect and to examine critically the historical evidence as well as the scattered literature on the picture and to add some observations which may help to shed more light on the circumstances of its creation. Enough unanswered questions will remain to stir our curiosity, enough strangeness to provide material for our imagination; above all, the shining youth who himself seems to be in search of something distant, unmindful of things close and familiar, still withholds from us—another Lohengrin—the secret of his name.[1]

[1] The thought that there is something mysterious about the picture has been frequently expressed. I should like to mention the poem by F. Warre Cornish reprinted from the *Spectator* in the early guidebooks of the Frick Collection. Assuming that it is an actual portrait of a Polish officer, the author gave eloquent expression to feelings commonly shared.

"Does he ride to a bridal, a triumph, a dance or a fray

That he goes so alert, yet so careless, so stern and so gay?
Loose seat in the saddle, short stirrup, one hand on the mane
Of the light stepping pony he guides with so easy a rein.
What grace in his armor barbaric! sword, battleaxe, bow,
Full sheaf of long arrows, the leopard-skin flounting below.

[59]

2. "COSAQUE À CHEVAL"

The history of the painting, as far as it can be traced, offers some points of unusual interest. From its first recorded appearance in 1791 until 1910 when it was sold to H. C. Frick, it had been in various Polish collections and had been held in great esteem, as far as we can see. Yet its very existence became known to Western scholars only in 1883 when Bode mentioned it briefly and reported that "some time ago" it had been in Vienna for restoration.[2] A. Bredius was the first Rembrandt scholar to study the original. He saw the painting in Castle Dzików in Galicia in 1897 and reported this visit in great detail in a little known Dutch periodical.[3] Owing to his efforts, the painting was included in the Rembrandt exhibition at Amsterdam in 1898 where it was finally "discovered" by the art world at large. It was described and reproduced in the memorial volume of that

Heart-conqueror, surely—his own is not
 given, awhile,
Till she comes who shall win for herself that
 inscrutable smile.
What luck had his riding, I wonder,
 romantic and bold?
For he rides into darkness; the story shall
 never be told.
Did he charge at Vienna, and fall in a
 splendid campaign?
Did he fly from the Cossack, and perish
 ingloriously slain?
Ah, chivalrous Poland, forgotten, dishonored,
 a slave
To thyself and the stranger, fair, hapless,
 beloved of the brave!"

Similar sentiments were voiced by K. Madsen, who, in a review of the Rembrandt exhibition of 1898 at Amsterdam (*Tilskueren*, XVI, 1899, pp. 699 ff.) gave one of the finest and most circumstantial descriptions of the picture. Still reflecting the stirring impression of Nansen's polar expedition of 1893 to 1896, he wrote about the *"Polish" Rider*: "We do not know his name or who he was. In Rembrandt's representation he appears to be a young hero, somewhat like a Frithjof Nansen, about to proceed on a dangerous mission; in a mysterious world of adventure, on his way to conquer unknown realms by

virtue of his courage and his genius." It is interesting that Dehio (*Geschichte der deutschen Kunst*, Berlin-Leipzig, I, 1921, p. 333) used almost identical words for the Bamberg Rider when he spoke of an "eye that peers into the distance and dreams of adventure."

[2] W. Bode, *Studien zur Geschichte der holländischen Malerei*, Berlin, 1883, p. 499. A. v. Wurzbach (*Niederländisches Künstlerlexikon*, Vienna-Leipzig, I, 1906, p. 573) is more specific about the trip of the painting to Vienna. He says that it was offered for sale in that city in 1877 ("1877 in Wien, Handel"), a statement which, perhaps, is linked with his desire to detract from the general admiration for the picture. Wurzbach, indeed, alone of all scholars, as far as I can see, denied Rembrandt's authorship. He listed the painting as an Aert de Gelder (1645-1727).

[3] A. Bredius, "Onbekende Rembrandts in Polen, Galicie en Rusland," *De nederlandsche spectator*, 1897, p. 197. Bredius made the trip to Dzików in the company of Count Georges Mycielski, the nephew of Count Tarnowski, the owner of the picture. Count Mycielski was perhaps at that time already working on the catalogue of the collections of Stanislaus II Augustus (see below, note 8).

exhibition[4] and in a great many reviews in periodicals. Subsequently, it was included in Bode's catalogue of Rembrandt's paintings,[5] in Rosenberg's edition of the *Klassiker der Kunst*[6] and in Hofstede de Groot's critical catalogue,[7] and a crescendo of admiring voices has been swelling ever since. Yet, despite the numerous critical publications, there are still whole stretches in the earlier record of the picture of which so far only a few Polish writers seem to have been aware.[8]

Listed as *Cosaque à cheval*, the picture is mentioned in 1793 in an inventory of the paintings of the collection of Stanislaus II Augustus, King of Poland.[9] The purchase price according to the inventory had been 180 ducats. This list provided the basis for the final inventory compiled in 1795 by Bacciarelli, which was edited critically by Mańkowski from several preserved manuscripts.[10] At the time of the catalogue the picture was kept in the "antichambre en haut" of Lazienki Palace at Warsaw where Stanislaus II Augustus hung his favorite Dutch and Flemish masters. Its value was estimated to be 200 ducats

[4] Hofstede de Groot, *Die Rembrandt-Ausstellung in Amsterdam, 1898* (40 Photogravueren), Amsterdam, 1899, no. 28. The picture was no. 94 in the exhibition.

[5] W. Bode and C. Hofstede de Groot, *Rembrandt, Beschreibendes Verzeichnis seiner Gemälde mit den heliographischen Nachbildungen*, VI, Paris, 1901, no. 466, p. 165.

[6] A. Rosenberg, *Rembrandt, Des Meisters Gemälde*, Stuttgart, 1904.

[7] C. Hofstede de Groot, *Beschreibendes und kritisches Verzeichnis der Werke der hervorragendsten holländischen Maler des 17. Jahrhunderts*, Esslingen-Paris, VI, 1915, no. 268, p. 138.

[8] The Polish scholars who first occupied themselves with the problem of the picture by Rembrandt were B. Antoniewicz and Georges Mycielski; both of them delivered lectures on the history of the picture, which were summarized in the *Bulletin international de l'Académie polonaise des sciences et des lettres*, Année 1904, Krakow, 1905, p. 82 (Mycielski) and Année 1905, Krakow, 1906 (Antoniewicz). In 1910 S. Batowski published an article entitled "Z powodu sprzedazy Lisowszyka," *Lamus*, II, p. 189, and a slightly different version, entitled "Zum 'Polenreiter' von Rembrandt," *Neue Blätter für Gemäldekunde*, VI, 4, p. 65. More details were added by Th. Mańkowski, "Obrazy Rembrandta w Galerji Stanislawa Augusta," *Prace Komisji historji sztuki Polskiej*, Akademje Umicjctnosci, V, with a résumé in *Bulletin international*, Année 1928, Krakow, 1929, p. 171, no. 35, and by the same author in *Galerja Stanislawa Augusta*, Lvov, 1932. This fundamental work had been begun by G. Mycielski and was finished, after Mycielski's death, by Mańkowski who had assisted him from the beginning.

[9] The manuscript is preserved in the archives at Sucha, which at the time of Mańkowski's writing belonged to Count Tarnowski. It bears the title *Catalogue des tableaux app. à Sa Maj. le Roi de Pologne, 1793* (Mańkowski, *op.cit.*, p. 74). This catalogue was prepared by M. Tokarski, who was keeper of the gallery and its restorer. Chiefly responsible for this as for all the following catalogues, however, was Marcello Bacciarelli (1731-1818), court painter and intimate adviser of Stanislaus II Augustus, who in his function as "Directeur Général des Arts et Bâtimens" wielded almost dictatorial powers.

[10] The manuscripts consist of one preliminary draft preserved in the State Art Collection in Warsaw, and three copies of the final version. One of them, the least reliable, is in the library of the Ossolineum at Lvov, while the two most important ones are in the archives at Jablonna. One of the manuscripts at Jablonna is the king's own private copy.

and its measurements are given (in Polish cals) as 44 by 54 which corresponds to 109 by 133.9 cm.[11]

Stanislaus II Augustus (1732-1798) was one of the most avid collectors of his time. While weak and undecided ("toujours faible et pusillanime")[12] as a ruler in a critical period and unable to halt the impending doom of his country, he represented at the same time the typical gentleman of the eighteenth century, cultured, well-read, and interested in the arts. In the memoirs of the Polish diplomat and composer Michael Cleofas Ogiński there is a passage about a visit of the monarch to Ogiński's house at Sokolow, near Warsaw, in 1793, in the midst of mounting political troubles.[13] Although gloomy about the situation, the king was not averse to an animated conversation on the treasures of Ogiński's library which he admired with the keenness of the expert bibliophile. A tradition, based on the 1844 inventory of the collection at Dzików, actually credited Count Ogiński himself with the purchase of the picture while on a political mission to Holland and England in 1790-1791.[14] Andrew Ciechanowiecki, however, discovered that the painting had been acquired in Holland, probably in the spring of 1791, by another member of the Ogiński family, Michael Casimir Ogiński (1728-1800), grand hetman of Lithuania and the King's cousin by marriage.[15] Michael Casimir owned a fairly large collection of paintings and may originally have bought Rembrandt's painting for himself. In a light-hearted letter which the King received in the middle of August 1791, Ogiński offered the

[11] There is a discrepancy between these measurements and the present dimensions of the picture. While the width is practically the same (135.5 cm. against 134), its height today is an average of 7 cm. more than recorded in 1793/95 (there are slight variations of height if measured at the left or right margin). This difference seems to throw some light on the origin of the strip, which clearly has been added along the lower edge of the picture. It is true that Rembrandt himself occasionally added pieces of canvas to his pictures, as evidenced by his correspondence with Don Antonio Ruffo (see above, p. 8). The strip in the Frick canvas, however, is hardly original. A close examination shows that the character, quality, and condition of the pigments on it differ markedly from the rest of the work. This strip measures between 8 and 9 cm. in height (slanting from left to right), that is but slightly more than the discrepancy noted above between the measurements of 1795

and today. Thus it appears likely that it was added after that date, perhaps at the time of the restoration at Vienna (see note 2), and that 1-2 cm. of the old canvas were sacrificed in that process. The awkward profile of the horse's right hind hoof is thus due to a modern restoration; in Rembrandt's original version it surely had been properly foreshortened. We can of course no longer say why that lower part of the picture, which is now replaced by the modern strip, had disappeared by the end of the eighteenth century.

[12] Michel [Cleofas] Ogiński, *Mémoires sur la Pologne et les Polonais*, Paris, 1826-1827, I, p. 315.

[13] *Op.cit.*, I, p. 325.

[14] S. Batowski, *op.cit.* (Lamus), p. 190.

[15] Andrew S. Ciechanowiecki, "Notes on the Ownership of Rembrandt's Polish Rider," *The Art Bulletin*, XLII, 1960, pp. 294-96.

picture to the King in the hope of obtaining the equivalent of its value in orange trees from the royal orangery, most likely for his greenhouse at the castle of Helenów, near Warsaw. "Sire," he wrote, "I am sending Your Majesty a Cossack, whom Reinbrand had set on his horse. The horse has eaten during his stay with me for 420 German gulden. Your Majesty's justice and generosity allows me to expect that orange trees will flower in the same proportion." The King apparently accepted the proposal.

The subsequent history of the picture is tied up with the sorry fortunes of Stanislaus II Augustus and the grievous adversities of Poland. The King was not permitted to enjoy his collection for long. In 1795, he fled to Grodno, where, threatened with the possibility of exile, he made plans to take some of his most precious possessions with him as an insurance against penury. He actually played with the idea of spending his exile in Rome, like Queen Christina of Sweden. On November 14, 1795, he ordered Bacciarelli to put some of the more valuable pictures secretly into boxes to facilitate their removal.[16] Bacciarelli selected 172 works, representing a value of 13,000 ducats, and on December 30, sent a list of them to the King, asking for new orders. Rembrandt's "*Cosaque à Cheval*" was in that group of works. They were taken from Lazienki Palace and stored in the great chapel of the Royal Castle at Warsaw. During the following months more works were added to that group, which is described after March 1796 as contained in "13 caisses." As a result of the lack of planning and general confusion the thirteen crates were again taken back to Lazienki, where they were stored in a shed commonly used for housing the King's boats. All these arrangements were carried out with the greatest secrecy. The last time we hear about these "tableaux de reserve" is on December 30, 1796, when the King instructed Bacciarelli to add a few more pictures to the list.

The King's plans to move to Rome did not materialize. He went instead to St. Petersburg, where he died in 1798. The bulk of his collections remained behind in various castles —in what condition we cannot say.

The fate of Rembrandt's painting during the next eighteen years is obscure. A marginal note added later to the manuscript of the Ossolineum at Lvov (cf. note 10) tells cryptically that the painting was sold, without giving any further details. Mańkowski seems to accept this information, despite the fact that the Lvov manuscript is not always reliable. There is a good chance that the painting remained hidden under the care of Bacciarelli.

After the third partition of Poland a trilateral commission was established in 1797, charged with the dispersal of the art treasures found in the royal castles. This task was enormously complicated by the uncertainty of legal ownership (whether they belonged

[16] For this and the following see Mańkowski, *op.cit.*, pp. 109 ff.

to the office of the crown or to the King privately) and by the need of using some of these holdings to liquidate the staggering debts of the exiled monarch. After Stanislaus II Augustus' death, Josef Poniatowski, his nephew, laid claim to his private estate, and had these claims represented, as far as the art treasures were concerned, by the Prussian "Kammer-Assessor," Sartorius von Schwanenfeld, who was a member of the trilateral commission. The negotiations were cumbersome and long drawn out, especially as Bacciarelli seems to have hedged in delivering those works that were in his care. A final settlement with him was not reached until August 18, 1808. It is unlikely that Poniatowski had much time for his paintings, since he was too much preoccupied with political and military affairs.

When he died in the battle at Leipzig in 1813, his estate went to Countess Thérèse Tyszkiewicz, who lived in France and who entrusted her affairs to Alexander Linowski, later senator of the Kingdom of Poland. It was now decided to sell the art treasures. They were disposed of in several large sales at Warsaw. Rembrandt's painting which had remained with the Royal collection was sold on June 13, 1814, through mediation of Sartorius, to Prince F. Ksawery Drucki-Lubecki (1779-1846) for the sum of 150 ducats.[17] Lubecki was one of the most interesting figures of his time, a shrewd opportunist and skillful financier who is chiefly famous for founding the Bank of Poland in 1828. During the years 1813-1816 he was a member of the supreme council at Warsaw.[18] There is good reason to suspect that the purchase of Rembrandt's picture was for him no more than a financial speculation.[19] He was quick in taking his profit. Count Hieronym Stroynowski, who had been rector of the University of Wilna since 1799 and who was appointed bishop of that city in 1814,[20] paid Lubecki 500 ducats for the painting. This transaction must have been concluded very soon after Lubecki himself had purchased the canvas, since Count Stroynowski died the following year, in 1815, at the age of 63.[21]

According to Dr. Ciechanowiecki, Hieronym Stroynowski may have been persuaded to buy the picture by his niece Valérie Stroynowska, herself a gifted painter of miniatures,[22]

[17] Mańkowski, op.cit., p. 389.

[18] Encyklopedja Powszechna, Ultima Thule, VI, Warsaw, 1934, p. 594.

[19] Many of the Polish nobles were pretty much down at the heels at the end of the Napoleonic Wars. See Mańkowski, op.cit., p. 132.

[20] S. Orgelbrand, Encyklopedja Powszechna, XIV, Warsaw, 1903, p. 123.

[21] The inventory at Dzików (see Batowski, op.cit. [Lamus], p. 190) contains the information that Stroynowski bought the painting directly from Lazienki Palace. Batowski inferred from this that the sale took place in 1795 at the time of the abdication of Stanislaus II Augustus. While this obviously is incorrect, it is quite possible that the painting had actually remained in Lazienki until 1814 or 1815 and that Stroynowski had been the first to move it from that castle.

[22] See Batowski, op.cit., p. 191.

who had seen and coveted it when visiting the royal collections in 1810. After 24 years her wish came true. When Hieronym Stroynowski died, the picture came first to Valérie's father, Senator Valérien Stroynowski, who resided at castle Horochów in Volhynia, and after his death to Valérie herself, then married to Count Jan Amor Tarnowski, the founder of the gallery at Dzyków. It surely was the dominant piece in that collection.[23] Dr. Ciechanowiecki suggested also that the Stroynowski family may have had a special interest in acquiring Rembrandt's painting. During the Thirty Years War a distant forebear, Colonel Stroynowski, had been an officer in a regiment of Polish mercenaries originally led by Alexander Lisowski. It is not impossible that the nineteenth century Stroynowskis, if only wishfully, liked to think of the picture as a family portrait. What is certain is that in 1842, the first literary mention of the painting by Kajetan Koźmian (1771-1856), well-known Polish poet and patriot, identified the horseman as an officer of the Lisowski regiment.[24]

3. "LISOWCZEK"

Alexander Lisowski was a Polish condottiere, who as the leader of a motley outfit of fugitive Russian peasants and Cossacks participated in many European campaigns and died in 1616. Members of his regiment were still roving mercenaries during the earlier part of the Thirty Years War. They fought in the service of Emperor Ferdinand, participated in the battle of the White Mountain and, after engaging in campaigns all over Germany, are last found mentioned in payments of 1635 to 1636.[25]

The colorful history of Alexander Lisowski and his men exercised without doubt a strong appeal upon the romantic imagination of Polish patriots after the abortive revolution of 1830-1831, when the political fortunes of that much suffering nation were at a low ebb. It is significant that the standard works on Lisowski were published during that period.[26] Thus, the theory that Rembrandt's "*Cosaque à Cheval*" represented a member of the Lisowski regiment can be readily understood in the light of the interest in

[23] However, in 1933, when I had a chance to visit the gallery at Dzików, it still contained some fine works, especially an excellent portrait of a young woman by Jan Gossart. Hence it would appear that J. H. Bridge, *Portraits and Personalities*, New York, 1929, p. 215, exaggerated greatly when he wrote that in 1927 a fire "completely destroyed the remaining paintings in Count Tarnowski's collection."

[24] See Batowski, *op.cit.* (Lamus), p. 192. I have been unable to locate Koźmian's biography of Count Jan Feliks Tarnowski (*Zyciorys J. Tarnowskiego*, Lvov, 1843) which conceivably contains his views on the picture.

[25] *Encyklopedja Powszechna*, VI, Warsaw, 1934, pp. 515-17.

[26] They are M. Dzieduszycki, *Krótki rys dziejów i spraw Lisowczyków*, Lvov, 1843-1844, and K. W. Wójcicki, *Obrazy starodawne*, Warsaw, 1843.

Polish heroes of the past, revived among Polish patriots as a compensation for the national humiliation of their own time.[27] The identification, at any rate, became part of the tradition in Dzików. It was Hofstede de Groot who was the first to introduce the picture into the Rembrandt literature under the title "Polish Rider in the uniform of the regiment Lysowski." He spoke darkly of "experts on the history of Poland" who had identified the "uniform."[28] This formulation was repeated with a significant increase of finality by many modern scholars.[29] It is quite instructive for the stabilization of historic legends to see that the author of the article "Lisowski" in the most recent Polish Encyclopaedia used Rembrandt's painting as proof for the presence of a Lisowski officer in Amsterdam in 1636, a date which, based on the historic data of the Lisowski regiment, boldly antedates our painting by nearly twenty years. The illustration accompanying that text reproduces with nice consistency a "Lisowczyk after Rembrandt," not without changing Rembrandt's tender youth into a fierce-looking individual with short hair and a properly martial moustache. Rembrandt's somewhat shabby looking horse was replaced by an elegantly prancing Arabian thoroughbred (Fig. 2).[30]

Notwithstanding such "authority," the identification of Rembrandt's Rider with an officer of Lisowski's regiment or of his dress with a "uniform" of that regiment has no basis in fact. It has, indeed, been denied by the Polish scholars mentioned above but, owing to the comparative inaccessibility of their publications, the Rembrandt literature took no notice of their opinion. There is no doubt that whoever may have been the model, he was not a member of the Lisowski regiment. To begin with, there is every reason to assume that the Lisowski regiment ceased to exist about 1636. At that time its members were probably either too old or too few to continue as a fighting unit. Moreover there is no evidence that Lisowski troops—which fought, after all, on the Catholic side—even came to the Netherlands. In any case, at the time the last is heard of the Lisowski soldiers,

[27] It is interesting that Koźmian himself in 1856 wrote a poem about Stefan Czarniecki (1599-1665), one of the great Polish heroes of the seventeenth century. That F. Dülberg, speaking of Rembrandt's *"Polish" Rider (Das holländische Porträt des 17. Jahrhunderts*, Leipzig, 1923, p. 8) felt reminded of Chopin, takes on in this connection an amusing historical significance.

[28] In the publication on works in the exhibition at Amsterdam, see note 4. Bode, in 1883, had only spoken of a "young Polish nobleman in his national costume." E. Michel, *Rembrandt,* Paris, 1894, II, p. 54, misquoted Bode in speaking of an "Hungarian nobleman."

[29] W. R. Valentiner, *Rembrandt, K. d. K.,* 3d ed., Stuttgart and Berlin, 1908, p. 563: "The model wears the uniform of the Polish regiment of Lysowsky." Still more final, O. Benesch, *Rembrandt, Werk und Forschung*, Vienna, 1935, p. 53: "The Polish Rider, an officer of the regiment Lysowski." (The spelling of Lisowski varies in Western literature.)

[30] *Encyklopedja Powszechna, Ultima Thule,* VI, Warsaw, 1934, p. 516.

the youth seen in Rembrandt's picture was at best an infant. But even if there were not this chronological difficulty, the theory would be untenable for the reason that it is based upon two erroneous assumptions, namely, that the figure wears a distinctive uniform and that this uniform corresponds to one worn by a specific military body of the early seventeenth century. As we shall see below the "uniform" is so far from being distinct that there are even some doubts as to the nationality of the rider. Moreover, a superficial study of military history teaches that the fashion of giving definite uniforms to military units was developed only slowly during the seventeenth century, and chiefly in the national armies of the West, not in the European East, and never with mercenaries who changed their "color" often and easily.[31] We can be perfectly sure that a "uniform of the Lisowski regiment" is a historical impossibility and that any theory based on its existence is bound to be fallacious. We might just as well forget about Alexander Lisowski and his dubious followers in connection with the *"Polish" Rider*.

There is, however, another point in which the opinions of most Rembrandt experts of the West differ from that of the Polish scholars who have written about the painting. While Dutch and German authors in general have tended to believe that the person portrayed in the picture was a young Pole who had come to Amsterdam,[32] the Polish scholars are all of the opinion that he was a Dutchman, dressed up in a Polish costume. The student sampling these divergent opinions is in a situation comparable to that of the sleuth in Edgar Allan Poe's *Murders in the Rue Morgue*, whose witnesses agree only in so far as they describe the mysterious voice—that of the murderous ape—as speaking a tongue different from their own. Bode, who was the first to call the model "a Polish magnate," supported his opinion with a note saying that "Polish and other nobles of the half civilized East, when they were in Holland had themselves portrayed preferably by Rembrandt, as is shown by the so-called Sobieski of 1637 and the early portrait of G. Rákóczy preserved in an etching by Van Vliet."[33] Unfortunately for Bode's thesis neither of these

[31] *Encyclopaedia Britannica*, 11th ed., XXVII, 1911, p. 582. "The beginnings of uniform are to be found in truly national armies, in the In-delta of Gustavus (Adolphus)"—who used "scarfs of uniform color" and in "the English armies of the Great Rebellion." See also G. Liebe, *Der Soldat in der deutschen Vergangenheit*, Leipzig, 1899, pp. 72 f. "[Die Uniform] ist der Neuzeit so zum unterscheidenden Merkmal des Soldaten geworden, dass es merkwürdig

berührt, sie erst mit dem Ende des 17. Jahrhunderts allgemein eingeführt zu wissen."

[32] Bode, Bredius, Valentiner, and many others are of that opinion, while Hofstede de Groot (*op.cit.*; see note 4) agreed with it only after some hesitation. "He might be an Amsterdam model, dressed as a Pole but *more probably* a Polish nobleman who came to Amsterdam and had himself portrayed there."

[33] *Op.cit.*, 1883, p. 499.

pictures is an actual portrait.[34] Bredius, on the other hand, tried to substantiate his opinion with an historical reference which deserves more attention.[35] Besides stating categorically that "the type (of the model) is not Dutch,"[36] he recalls that Polish noblemen were frequent visitors in Holland where a good many of them studied at the University of Leiden. Indeed, if we go through the lists of students enrolled at Leiden, we meet fairly regularly with names of young Poles.[37] Some of them came with tutors and servants and surely attracted attention. That they attended classes in their national costume seems to be borne out by an engraving by A. J. Stock after Jacques II de Gheyn, showing the anatomical theater at Leiden where some Easterners can be distinguished in the large group of onlookers.[38] In view of these facts, Bredius' theory cannot be dismissed lightly. However,

[34] The "Sobieski," now in the National Gallery at Washington, belongs, like such pictures as the "Noble Slav" of the Metropolitan Museum, to the large group of works in which Rembrandt dressed up a Dutch model in a foreign costume. The same is surely true of Van Vliet's etching. The name "Georgius Ragozy Siculorum Comes" appears on it only in the fourth state which renders it most suspect as an addition by Hugo Allardt of Amsterdam, whose address appears on the impressions of this state. The most notorious case of such arbitrary "christenings" is that of the publisher F. L. D. Ciartres (Fr. Langlois, 1589-1647) who added the names of "Mahomet," "Philon le Juif," "Gasto Foisseius," "Doctor Faustos," "Democritus," "Heraclitus," and "L'Eunuque de la Reijne de Candaces" to other prints of Rembrandt or his school, and who, indeed, published a reversed copy of "Georgius Ragozy" as a portrait of "Scandrebec Roy d'Albanie" (cf. Hofstede de Groot, *Die Urkunden über Rembrandt*, The Hague, 1906, no. 17, pp. 12 f.). G. Rákóczy, the Protestant prince of Transylvania, gained European fame only in the years after 1631, the date of the print; nor is there any evidence of his having visited Western Europe at any time during his life. See also C. Neumann, *Rembrandt*, Munich, 1924, II, p. 414.

Since this article appeared, Otakar Odlozilik tried to demonstrate that the so-called Sobiesky in Washington represents Andrzej Rej of Naglowice, born in 1584, who as Polish ambassador visited England and Holland in 1637 ("Rembrandt's Polish Nobleman," *Polish Review*, VIII, 1963, pp. 3 ff.). The presence of a Polish nobleman with his retinue in Holland in the same year in which the picture was painted might indeed be more than coincidence; that the picture, however, is an actual portrait of the ambassador is, as Odlozilik himself was well aware, no more than an intriguing hypothesis. Kurt Bauch, at any rate (*Rembrandt, Gemälde*, Berlin, 1966, no. 174) again suggests that the model may have been Rembrandt's brother.

[35] A. Bredius, "Rembrandtiana," *Oud Holland*, XXVIII, 1910, p. 194.

[36] A similar passage is found in A. W. Sanders van Loo, "Naar anleiding van de Rembrandt-Tentoonstelling," *Dietsche warande*, 1899, pp. 24-25: "the face, clearly, is not that of a Hollander."

[37] See *Album studiosorum Academiae Lugduno Batavae, 1575-1875*, The Hague, 1875. I found nine Poles in 1652, four in 1653, eight in 1654, four in 1655, six in 1656 (including three from Kurland), none in 1657. The most prominent seems to have been a seventeen-year-old Count Martinus a Grudna Grudzinski, who was enrolled in 1654. He was accompanied by a tutor and two "famuli," all of whom were also enrolled as students. The records also mention, by the way, a fairly large number of Hungarian students. See also below, p. 144 (note).

[38] Reproduced in R. N. Wegner, *Das Anatomenbildnis*, Basel, 1939, p. 65.

there are several reasons that argue against this as well as against all other opinions which hold that the picture is an actual portrait of a Polish visitor to Holland. First there is the fact, as seen above, that the painting was still in Western Europe as late as 1791. If it had been an actual portrait it surely would have been taken to Poland by the man who commissioned it. It seems, indeed, as if the authors who held to the portrait theory took it for granted that the painting had always been in Poland, even though only one actually said so.[39] They might have revised their opinion if they had known more about the provenance of the picture. There is another though less tangible reason to abandon the idea that the painting was a commissioned portrait. It is found in the very appearance of the painting itself.

A few iconographic formulas of the "equestrian portrait" in the seventeenth century are fairly well established. One is represented by Rembrandt's portrait in the National Gallery in London (Fig. 3),[40] believed to be the Amsterdam merchant, Frederik Rihel (c. 1625-1681). Here the horse is rearing on its hind legs in a conventional pose (similar to the so-called "Pesade"),[41] while the rider looks squarely out of the picture toward the beholder. This type is obviously linked with a tradition, probably of classical origin, which can be traced from Titian's *Charles V at the Battle of Mühlberg* through some of the equestrian figures painted by Rubens, Van Dyck, and Velazquez, with their individual variations repeated in innumerable painted and engraved portraits of the seventeenth century. Although they are comparatively rare in Holland, being of a representational character incongruous with the social conditions in Holland, Rembrandt's *Rihel* is not the only example; almost contemporary with it is a portrait by Paul Potter of D. Tulp, in the Six Collection, dated 1653 (Fig. 4). The paintings belonging to this type are, like the *Rihel*, of large dimensions and render the group of horse and rider in life size.

Another type, of "cabinet" size, which is found quite frequently in Dutch seventeenth century painting, shows the rider comparatively small in a wide landscape setting. Dogs and other accompanying figures are often added to increase the impression of a natural

[39] K. Madsen, *Tilskueren*, XVI, 1899, p. 701: "The Polish Rider is presumably a distant ancestor of the Galician prince who owns the picture."

[40] A. Bredius, "Rembrandtiana," *Oud Holland*, XXVIII, 1910, p. 193, where the traditional identification of the model with Vicomte de Turenne (1611-1675) is replaced by the better founded one with the Amsterdam merchant Frederik Rihel. Another identification, with

Jacob de Graeff (1642-1690), proposed by R. van Luttervelt (Nederlands Kunsthistorisch Jaarboek, VIII, 1957, pp. 185 ff.), has not met with acceptance but Luttervelt's article is of considerable importance both for the interpretation of the picture and its dating (ca. 1660 rather than 1649).

[41] O. Grossmann, *Das Reiterbild*, Berlin, 1931, p. 24.

relationship between the rider and his environment. The best-known examples of this type are by Thomas de Keyser and Aelbert Cuyp.[42] As a rule, the rider, though moving to the side, turns his face, and his eyes meet those of the beholder. Special attention is always paid to the neatness and elegance of the costume; the riders appear in the finest clothes and the horses, trim and well groomed, step gracefully according to the rules of the riding academy (Fig. 5).

While Rembrandt's *Rihel* conformed clearly to the first of these established types of equestrian portraiture, the *"Polish" Rider* differs greatly from either one. It is not so much the unusual costume which sets it apart, nor its somewhat uncommon "in-between" dimensions,[43] but the absence of all the elements of portrait elegance and pose which we find in the other pictures, including the large canvas in London. The clothing of the rider is comparatively plain and suggests daily use. We shall see below that what the young man wears is anything but his Sunday best. The horse, likewise, is not a handsome creature in a conventional sense nor is it moving with appropriate dignity. With its quick pace, emphasized by the flying *ḳutâs* attached to its neck,[44] with the inward turn of its head and its open mouth, it gives the impression of nervous apprehension, quite unusual and unbecoming in a horse in a "normal" portrait likeness of the seventeenth century.

That any Eastern noble of that period could have had the independence of taste to ask for or agree to a portrayal of such strange and, according to contemporary standards, undignified character, seems highly improbable.[45]

In this connection, we remember that the few Polish scholars cited above insisted that the model was no Pole at all but most likely a Dutchman. As far as can be deduced from their brief texts, they did not think that the picture was done as a portrait commission

[42] All dated examples of that type are of 1660 or later. However, R. Oldenbourg, *Th. de Keysers Tätigkeit als Maler*, Leipzig, 1911, pp. 61 ff., believes that de Keyser's picture in Frankfurt was done in the 1630's.

[43] It is larger than the typical "intimate" portrait but considerably smaller than the "representational" type.

[44] The *ḳutâs* (or kutaz; see J. Szendrei, *Ungarische kriegsgeschichtliche Denkmäler*, Budapest, 1896, p. 604) was originally a Turkish decoration for suspension from the horse's neck. The Turks generally used curly yak-hair, but women's hair is also found. The *ḳutâs* was frequently used in Hungary but was not unknown in Poland. The example shown in Rembrandt's

painting is obviously made of horse's hair, which was in general use in these countries. Most Rembrandt scholars who mentioned the detail called it, curiously enough, a fox's brush; only Bredius (1897, see note 3) described it correctly.

[45] Although it would be rash to make generalizations, it ought to be mentioned that those Polish nobles who were formally portrayed by Flemish or Dutch artists seem to have preferred to be rendered dressed according to Western fashion. Cf. Rubens' portrait of Wladislas IV at the Metropolitan Museum and Goltzius' prints of two Polish princes of 1583, which C. van Mander described as "dressed in the French manner" (ed. H. Floerke, Munich and Leipzig, 1906, II, p. 256).

but as a "costume-study." To be sure, "fancy-dress" portraiture was not uncommon in Rembrandt's time, and in the second half of the seventeenth century it became something of a vogue with people who for one reason or another had contacts with foreign countries, either as ambassadors or colonial administrators or as merchants.[46] Children of such people also seem to have been dressed up occasionally in foreign dress, as is shown in the life size portrait by F. Bol of a boy of about eight years, dated 1656.[47] His costume consists of a *joupane* of yellow silk and a green cap. The author of the Rotterdam catalogue considers it to be Polish and, because of a still life of various weapons which appears in the background, believes the boy to have been the son of a military commander. The child holds a war hammer, which as a matter of fact has a marked resemblance to that held by the "Polish" Rider. Nevertheless, there is again the same difference which one always encounters between actual portraits and the painting of the Frick Collection. Bol's portrayal is clearly posed and the boy is "costumed"—masquerading in the foreign outfit which suits his type as poorly as the martial still life fits his age. By contrast, Rembrandt's picture shows a soldier who is at home in his costume and is appropriately mounted on a hardy if inelegant horse. Granted that in Rembrandt's work the boundary line between actual portraiture and purely imaginative creations is not always easy to draw, owing to his tendency to endow even his portraits with a certain poetic depth of expression, it is hard to find another instance in his work (except for the *Night Watch*, which is just as much a narrative action as a group portrait) in which he so thoroughly neglected the primary function of a portrait. The obviously important role played by the dark landscape in contrast to the light figure of the rider—a feature which will be discussed more in detail below—also helps to mark the picture as an imaginative creation of the artist.[48] The very face of the youth makes the assumption of actual portraiture neither necessary nor even likely. It is a face of very even and symmetrical forms, not exactly impersonal, but hardly very individual, the handsome face of an ideal hero,[49] transfigured by an inner

[46] Two interesting Flemish examples of comparatively early date are Van Dyck's portraits of the Persian Ambassador Sir Robert Shirley and his wife, of 1622, see G. Glück, *Van Dyck, Des Meisters Gemälde*, London, 1931, pp. 510-11. A good Dutch example is the portrait of Thomas Hees and his sons by M. van Musscher, of 1687, at The Hague, reproduced in F. Dülberg, *op.cit.*, pl. 20. The Metropolitan Museum in New York owns a painting by A. Cuyp in which members of a Dutch family are portrayed on horseback and in foreign dress.

[47] Rotterdam, Museum Boymans - van Beuningen, no. 48. Reproduced, F. Dülberg, *op.cit.*, pl. 14.

[48] W. Weisbach, who has devoted some thoughtful passages to the problem of "actual" *vs.* "imaginative" portrait (*Rembrandt*, Berlin-Leipzig, 1926, p. 279), considers the "*Polish*" *Rider* "phantasiemässig gehalten."

[49] A. M. Hind, *Rembrandt*, Cambridge, Mass., 1932, p. 91, speaks of the "remarkable beauty" of the young officer.

light of quiet determination. That he does not look straight at the beholder would in itself carry little weight in this connection, since there are enough definite portraits by Rembrandt which look sideways, although they are less frequent than those which look at us. But combined with the other features this observation tends also to support the argument against the portrait theory. That does not mean that Rembrandt did not make use of a definite model when he painted the *"Polish" Rider*. But there is every reason to believe that we owe the existence of the painting not to a portrait commission tendered to the master by his unknown model but to more complex circumstances.

From the published texts we can only conjecture on what grounds the Polish scholars denied the Polish nationality of the youth. They were, of course, aware of the fact that the painting had come to Poland not before the late eighteenth century. However, it seems that they based their opinions chiefly on physiognomical observations. Batowski, while not denying that the youth wore a costume "in the manner of that worn in Poland in the seventeenth century," thought that he was "neither a Pole nor a Cossack."[50] Antoniewicz considered the model to have belonged to Rembrandt's immediate environment,[51] and Mycielski declared outright that the image was "sans doute" that of Rembrandt's son Titus.[52] While the identification with Titus[53] is clearly untenable, there are indeed two features in the appearance of the young man which from our knowledge would be most exceptional for seventeenth century Poles (although they would by no means prove that he was Dutch): the presence of long hair and the absence of a moustache.[54] Short hair and long moustache, indeed, were so commonly associated with seventeenth century Poles, that the designer of the *"Lisowczyk"* (Fig. 2) promptly "corrected," as we saw, Rembrandt's picture in this respect, in order to give it the necessary authenticity. It may have been these characteristics or other less tangible ones, based on

[50] Batowski, *Neue Blätter f. Gemäldekunde,* VI, 4, 1910, p. 66.

[51] Antoniewicz, *Bull. internat. acad. polonaise,* Année 1905, p. 6.

[52] Mycielski, *Bull. internat. acad. polonaise,* Année 1904, p. 83. The same mistaken view was held by J. H. Bridge, *op.cit.,* p. 31. Since Titus was born in 1641, this would imply a date much later than generally—and probably correctly—given to the picture (see note 114).

[53] Batowski (see note 8) credits Antoniewicz with the hypothesis that Titus was the model. Since Mycielski's lecture, in which this statement was actually made, had been given within a

year of that of Antoniewicz (see note 8) we may assume that Batowski, writing five years later, had a pardonable *lapsus memoriae* when he ascribed the theory of one to the other. See also Postscript, below p. 141.

[54] Claude Jordan, *Der Curieusen und historischen Reisen durch EUROPA Andrer Haupt-Theil,* Leipzig, 1710 (trans. from the French ed. of 1699), p. 378: "Die Polen haben ihre Haare bis ueber die Ohren abgekuertzet. Sie nehmen ihren Bart ab und lassen allein einen grossen Stutz-Bart stehen." There are numerous seventeenth century prints which bear out this statement.

supposed racial features, which the Polish scholars could not reconcile with their conception of a "genuine" compatriot. They did not deny, at any rate, that the costume was Polish. On this point, Western and Polish scholars seem to be agreed. No matter how much they differ with regard to the nationality of the model, they all, by implication or direct statement, accept the costume as a Polish fashion, if not actually a "Polish uniform." It seems to be of sufficient interest to see whether the problem of the clothing and armament is as simple as it would appear from the literature.

4. THE COSTUME

The study of seventeenth century costume worn by nations other than those of the West is not an easy field to work in because of the dearth of easily accessible and reliably dated pictorial records and the lack of specialized literature. It is particularly difficult at this moment [1944] with certain European collections of material relative to the history of costume beyond reach. The following results are for these reasons presented with appropriate reservations.

We have to distinguish, in Rembrandt's picture, between the costume proper and the military equipment, including the horse's trappings. The chief article of clothing is an off-white coat of three-quarter length with ample sleeves that narrow toward the wrists. It is buttoned in front from neck to waist with a set of small, light buttons. A belt seems to hold it in at the waist. The upturned corner of the coat reveals a brown lining, possibly of fur. This piece of clothing is a *joupane*,[55] a garment which, originally from the Near East, had been adopted by many nations of Eastern Europe. It was common in Poland but was also worn just as frequently in other regions, as, for instance, Hungary.[56] There is no way of clearly differentiating between Hungarian and Polish examples of the seventeenth century.[57] The *joupane* could be made of all sorts of materials, according to require-

[55] A. Racinet, *Le costume historique*, Paris, 1888, vi, "Pologne," and F. Hottenroth, *Trachten, Haus- Feld- und Kriegsgeräthschaften . . .*, Stuttgart, 1884-1891, ii.

[56] In speaking of "Hungary" we follow the practice of combining under one name an area which, during much of the seventeenth century, was made up of three separate political units: Catholic Hungary, closely allied to the Austrian monarchy; Turkish (or central) Hungary; and Transylvania, the largest of the three, which was chiefly Calvinist and which managed, un-

der the able government of the Rákóczys, to follow a fairly independent course.

[57] The traditional view that the Hungarian *joupane* was to be distinguished from other *joupanes* by its horizontal bands of braid in front is not correct. Not only do braided examples also occur in Poland, but unbraided ones, closed with a plain row of ball buttons, are common enough in Hungary, where some are still preserved; see J. Hoellrigl, *Historic Hungarian Costumes*, Budapest, 1939, and Gyula Szekfü, *Magyar Történet*, Budapest [1930?-1934?], v,

ments of the season and the occasion. Those worn for special occasions were generally of silk. The *joupane* of the *"Polish" Rider* is obviously an ordinary garment, made of sturdy materials, able to stand hard wear. In official portraiture, and with people of high rank, the *joupane* never appeared alone, but was combined with a mantle which often was hung over one shoulder.[58] The absence of the mantle in Rembrandt's painting can be considered as an additional argument against the theory that the painting is a portrait of a Polish—or for that matter Hungarian—nobleman.

Besides the *joupane*, Rembrandt's rider wears tight-fitting red trousers and high yellow shoes. Both were common to Hungarians and Poles alike.[59] (The Cossacks, like the Russians, wore wide, loose pants which sagged down over the boots.) The cap which the young rider wears is a quite common Eastern form—worn even by Hollanders—with a cloth center and flaps of fur which can be pulled down over the ears. In addition to the basic shape there is a dark semicircular strip in front of the cap, suggestive of a separate piece of fur. While it gives to the cap a very individual and "smart" appearance, it is not only a most unorganic piece of decoration, but also tends to make the cap into a perfectly unique piece of headgear of which no other instance can be found anywhere in the costume of the seventeenth century. It would be just as foreign to Poland as to any other country.[60] This feature, fortunately, is less disturbing than it would appear. In a close examination of the original, made recently by Mr. William Suhr and the author,[61] it was found that the whole area in question is much rubbed and the dark color is part of a lower layer of pigment. The regular, semicircular shape is due either to accident or design on the part of a former restorer.

None of these parts of his dress is helpful for an exact identification of the nationality of the rider. It is not much better with his arms. He has two swords, one clearly of the

pp. 48, 64. See also H. Mützel, *Kostümkunde für Sammler*, Berlin, 1919, p. 119.

[58] See the two noble Poles in Rubens' *Cyrus and Tomyris*, Boston, Museum of Fine Arts. Antoniewicz (*op.cit.*, p. 16) suggested that the two men might be Dönhoff and Pac, two prominent Poles who had accompanied Wladislas IV to Brussels in 1624.

[59] See Hottenroth, *op.cit.*, II, p. 202.

[60] Hungarian caps often, though not always, extend the central part into a hanging pouch, somewhat like the cap in Rembrandt's drawing *Tobias and the Angel* (see Tobit, Fig. 10). Both

Poles and Hungarians commonly had clipped heron's feathers or similar decorations on their hats. The closest parallel in Rembrandt's oeuvre to the cap of the *"Polish" Rider* seems to be in a Berlin drawing of an old man, reproduced in E. Bock and J. Rosenberg, *Die Zeichnungen alter Meister im Kupferstichkabinett, Die niederländischen Meister*, II, Berlin, 1930, pl. 166, no. 5660 (Ben. no. 1080).

[61] I wish to thank Mr. Mortimer Clapp for having provided the opportunity for this examination and both him and Mr. Suhr for their kind assistance during it.

Karabela type,[62] a bow and arrows in quiver, and a war hammer. Of these, the war hammer is the least martial part as it was worn chiefly to indicate distinction; as such it is found all over the European East.[63] Boeheim mentions that in the seventeenth century it was still used as a weapon by Hungarian troops and served them also in defense against attacks by robbers.[64] The other weapons are of a generally Oriental character[65] although it seems difficult, from their rendering in the painting, to establish their place of origin exactly;[66] but even if their make could be identified, it would not help greatly in our problem since in the continual wars of the seventeenth century arms were constantly changing hands, by trade or by conquest, as the coveted spoils of victory.[67]

Thus, while the arms by themselves, even if properly identified, would be of little help, it is important to realize that their combination and the way they are borne are characteristic of a definite military type. Rembrandt's rider has one curved sword under his right thigh and the other, probably straighter one, at his left side. This seems to agree fairly well with Denison's description of Polish hussars.[68] "Two sabres, one slung on the side of the rider, the other under his *left* thigh, fastened to the saddle." However, we find the same thing confirmed also for Hungarian light cavalry. Szendrei[69] mentions that Hungarian hussars were armed with two swords, one of them pointed, which was worn under the *right* thigh. For this there is an important confirmation in a book published in Leiden in 1634.[70] Leopard skins used for saddle cloths, finally, and the decoration of horses with the *kutâs* (see note 44) are also common features with East European horsemen in general, the *kutâs* being particularly frequent again in Hungary.

It follows from these studies that, while no part of the costume or armament should be considered unusual for a Pole, there is nothing in the apparel of Rembrandt's rider which could not have been worn also by soldiers of other nationalities. While we agree

[62] The name comes from Karbela, near Baghdad, the home of famous swords.

[63] It is obviously used as such in Bol's portrait of 1656 of a boy (see note 47).

[64] W. Boeheim, *Handbuch der Waffenkunde*, Leipzig, 1890, p. 367.

[65] For the influence of Islamic art upon seventeenth century Polish workshops producing not only tissues and rugs but also "arms, harnesses, trappings and bridle-tackle for horses ... in one word all that had to do with cold steel and horses" see Th. Mańkowski, *Ars Islamica*, II, 1935, p. 113.

[66] That the sword in front has a chain on its

grip might point to Hungarian origin if Boeheim's contention (*op.cit.*, p. 277) is correct.

[67] See Szendrei, *op.cit.*, p. 319: "The best ... fight in the seventeenth century with weapons of oriental origin which they had taken on the battlefield. It was considered a special honor to wear war-loot as a common weapon."

[68] G. T. Denison, *A History of Cavalry*, London, 1877, p. 183.

[69] *Op.cit.*, p. 313.

[70] *Respublica et status Hungariae*, Leiden, 1634, p. 300: "Sagaris sive gladius Persicus, ad laevam sub dextro femore."

with Batowski's opinion that the costume was not unlike a Polish one of the seventeenth century, we must maintain that there is no part of it which was worn *only* in Poland and not also in some adjoining countries, especially in Hungary. Indeed, if there really was a difference between Hungarian hussars and Polish ones in that the first put one sword under the right thigh while the latter fastened it under the left, Rembrandt's rider clearly would belong to the Hungarian type. And while the long hair of the model was one of the reasons for denying that he was a Pole, the same feature could be used as argument in favor of a "Hungarian" thesis, for we know from pictures and contemporary sources that Hungarians wore long hair until after the middle of the seventeenth century.[71] One cannot help suspecting that the painting, had it been found by accident in a Hungarian castle instead of a Polish one,[72] might have become famous, with equal if not better right, as the *"Hungarian" Rider*.

In this connection, the title under which the picture appeared in the eighteenth century deserves some explanation. At its face value, *"Cosaque à Cheval"* has little justification, since Rembrandt's rider surely is not a member of the Cossack nations who lived along the lower Dnieper and Don regions, even though they played an important role in European history just about the middle of the century.[73] The costume of the Cossacks—wild hordes of soldiers dangerous to Poles and Turks alike—is always described as colorful in the extreme and of semibarbarian extravagance.[74] The old title, however, loses some of its mystifying nature if one realizes that the word "cossack" was not only applied to actual members of that mixed ethnic group, but also describes a type of light irregular Polish cavalry.[75] A Dutch mid-seventeenth century writer was already conscious of the loose usage of this word, for he writes, after a description of the actual Cossacks: "These are the true Cossacks from whose image so many serving in Poland in light arms, are called

[71] M. Meyer, *Ortelius redivivus et continuatus*, Frankfurt, 1665, I, 20: "[Die Ungarn] aber sind nicht so neugierig und aenderlich / als nur darinnen / dass sie *erst vor wenig Jahren angefangen* / ihre Haare / wie ihre Nachbaren die Türcken und die Moskowiter / scheeren zu lassen."

[72] Galicia, to be sure, where the painting was "discovered," was part of the Austro-Hungarian monarchy. Its people, however, particularly the nobility, were always Polish in language, tradition, and political sentiment.

[73] The Cossack revolts under Bogdan Chmielnicki in 1647-1649 and 1651 actually threatened the very existence of Poland.

[74] For a contemporary description see *Respub-lica, sive status regni Poloniae, Lituaniae, Prussiae, Livoniae*, Leiden, 1642, p. 385: "Eunt (Cosacchi) in bella pompose, ornati sagis et vestibus, quae auro, argento, milleque variis coloribus discriminantur. Ornant se quoque pennis et alis aquilarum, exuviis Leopardorum et usorum, vexillis labarisque multis variisque. . . ." The horsemen also used short whips, which hung from the wrist, and wore white baggy trousers (W. P. Cresson, *The Cossacks*, New York, 1919, p. 17).

[75] See F. Watson, *Wallenstein*, New York, 1938, p. 164, following Aladár Bellagi, *Wallensteins kroatische Arkebusiere*, Budapest, 1884.

Cossacks."[76] Thus, by calling the picture *"Cosaque à Cheval"* the authors of the catalogue of the collection of Stanislaus II Augustus (following Michael Casimir Ogiński's lead) did hardly more than apply to it a term customarily used to designate a lightly armed Polish horseman.

It might be questioned, to be sure, whether the whole investigation as to the "nationality" of the rider is not meaningless in view of the fact that Rembrandt generally made arbitrary use of foreign costumes which he collected for their exotic appearance and material beauty and which reappear constantly in his paintings in new combinations.[77] However, it is just in comparison with works which belong to the category of fantastic costume pieces that the *"Polish" Rider* impresses the beholder with its homogeneous character. Unlike those works, the Rider is surely not "overdressed" nor are there details such as jewels, pearls, or precious metal work which might be suspect as purely pictorial additions. The outfit is simple and convincingly functional. Some parts of the equipment admittedly may be found in similar form in earlier works of the master[78] or in contemporary paintings by followers.[79] Yet, the whole appearance of the young horseman is on the one hand so unified, so strikingly, "aus einem Guss" (out of one mold), to use Hofstede de Groot's happy expression,[80] and on the other hand agrees so well with the general outfit of Polish or Hungarian light cavalry that it is probably based upon an authentic experience.

Eastern cavalry, after all, was no unusual sight in Western Europe. The sumptuous pageants staged every now and then by exotic embassies would have been relatively unreliable as a source, since the costumes on such occasions were apt to be picturesquely elaborated. More important is the fact that foreign soldiers, especially on horseback, from

[76] A. Brachelius, *Historia nostri temporis, 1618-1854*, Rotterdam, 1656, pp. 144 f. "Dit zijn eygentlijck de Cosacken, naer welckers gelijckenis soo menigh alsser in Polen in lichte wapenen dienen, Cosacken genoemt worden."

[77] O. Goetz, "Oriental Types and Scenes in Renaissance and Baroque Painting," *Burlington Magazine*, LXXIII, 1938, p. 112: "We must confess" that Rembrandt "generally made the most arbitrary and queer use of his Eastern models, being only content on producing out of these elements new phantastic creations in harmony with his aesthetic ideas. . . . He contributed more than any other painter to its undoing [i.e. of the 'oriental tradition'] and to the destruction of all sense of its reality."

[78] Bow and arrows of similar forms and a similar sword appear in the etching of the *Baptism of the Eunuch* (1641) on the rider at the left (Fig. 15), a figure which has also other points in common with the *"Polish" Rider*, see below, note 101. The *kutás* occurs in the drawing of David and Abigail, see Otto Benesch, *The Drawings of Rembrandt*, London, 1954-1957, no. 1013. (Hereafter drawings reproduced by Benesch will be referred to as Ben. no.)

[79] See note 47.

[80] C. Hofstede de Groot, *op.cit.*, 1898. Similar remarks are found in comments by Grossmann (*op.cit.*, p. 87), W. Martin (*Rembrandt en zijn Tijd*, Amsterdam, 1935-1936, pp. 84 and 360) and others.

the seventeenth century on formed a common element in the mercenary armies of Western Europe. In contemporary records of the Thirty Years War constant mention is made, characteristically in one breath, of "Hungarians, Croats and Polacks" who served in the imperial armies.[81] Cardinal Richelieu, in 1635, formed a regiment of "Hungarian hussars" (consisting of Hungarians, Croats, and Germans),[82] and by 1640 there were, according to Merian, several regiments of "Frembde Reutterey" in the French army.[83] We find "Polacks" even in the Swedish army, after the death of Gustavus Adolphus.[84] We know that not infrequently recruiting agents of Western powers were permitted to raise troops in the East. In the tactical maneuvers of seventeenth century warfare the light cavalry of these Eastern regiments played an important role.

The discussion of the "nationality" of the rider and the study of his costume have been helpful, if for nothing else, to focus our attention on a fact which although quite clear has so often been lost sight of: that the picture represents a military man, a soldier. He is not covered with mail like the heavy cavalry of the time but he is nevertheless fully armed for combat, equipped like a special branch of the services, light "foreign" cavalry, often called hussars. It certainly is more than unlikely that a student at Leiden or a merchant visiting Amsterdam would have appeared in such an outfit, ready for combat, and there is just as little reason to assume that they would have desired to be portrayed in such a costume. No matter whether Rembrandt "made up" the costume, or based his picture—which is more likely—on an actual study of such a military figure, there should be no question about the proper classification of the theme.

5. THE PICTORIAL TRADITION

What may have prompted Rembrandt to paint a picture of such a soldier, if it was not a portrait commission, we shall try to discuss below. However, before approaching that problem, we have to realize that the "theme" of an armed foreign horseman was by no means a novel one in European art, even though Rembrandt's painting differs in many respects from what may be called its iconographic forerunners. As an iconographic type, the *"Polish" Rider* belongs to a tradition which can be traced back, chiefly in works of the graphic media, to the fifteenth century.

Pictures of foreign military types, like many other themes of a related character, made

[81] For instance M. Merian, *Theatrum Europaeum*, III, Frankfurt, 1639, pp. 309, 510.

[82] Szendrei, *op.cit.*, p. 316.

[83] *Op.cit.*, IV, 2d ed., 1648, p. 192.

[84] *Ibid.*, p. 906 (for the year 1642).

their appearance at a time when, owing to an increased interest in the variety of nature and human life, faithful pictorial records seemed to be a desirable complement of literary descriptions. Their chief function was not to tell a story but to bring home to those interested, in reliable and at the same time animated reproductions, images and peculiarities of the distant and unfamiliar. An excellent early example which states clearly, though in a rudimentary fashion, the "theme" of the *"Polish" Rider*, is found in a delightful drypoint by the Master of the Hausbuch (Fig. 6).[85] It shows a Turk on horseback, set out against a flat landscape in which knolls and trees form a frame for the figure. The horse, standing calmly, restrained by the reins, is seen from the side, while the rider, obviously a man of some rank, looks back over the right shoulder. The motif of the Oriental rider was chosen surely because he represented a foreign power whose growing strength gave cause for serious concern and lent a certain exciting news value to such representations. But aside from such journalistic considerations, it is plain that in most cases a simple curiosity about the foreign and colorful costumes was the chief *raison d'être* for these works. While the Master of the Hausbuch in a typically Northern elaboration combines the figure with a landscape and thus anticipates an idea which found such a poetic culmination in Rembrandt's painting, Italian artists of the fifteenth century, such as Gentile Bellini, created at the same time the "monumentally isolated costume-study."[86] It is this type which Dürer took over without, however, abandoning entirely the Northern tradition, familiar to him since his youth.

Among the equestrian representations, those of Turks as horsemen *par excellence* are particularly numerous, especially when they had advanced, in the early sixteenth century, to the strongholds of central Europe. Woodcuts of 1526 by Jan Swart van Groningen, and their German adaptations attributed to such artists as N. Stoer, E. Schoen, and H. S. Beham,[87] are good examples for the increasing interest in this theme. There are, however, also woodcuts of three Russian riders published in von Herberstein's *Rerum Moscouiticarum commentarij*[88] and the drawing of a Russian horseman from Dürer's studio, in

[85] M. Lehrs, *The Master of the Amsterdam Cabinet*, Paris, London, Berlin, New York, 1893-1894, no. 74.

[86] B. Degenhart, "Ein Beitrag zu den Zeichnungen Gentile und Giovanni Bellinis und Dürers erstem Aufenthalt in Venedig," *Jahrbuch der Preussischen Kunstsammlungen*, LXI, 1940, p. 37.

[87] W. Nijhoff, *Nederlandsche houtsneden 1500-1550*, The Hague, 1931-1936, nos. 25-29. M. Geisberg, *Der deutsche Einblattholzschnitt in der ersten Hälfte des sechzehnten Jahrhunderts*, Munich, 1923-1930, nos. 1239, 1240, 1241, 1242, 1245 (N. Stoer), 1382-1391 (E. Schoen), and 297-99 (H. S. Beham).

[88] Sigmund Freiherr von Herberstein, *Rerum Moscouiticarum commentarij . . .*, Basel [1556], p. 154.

the Ambrosiana, L. 632.[89] A typical seventeenth century example is found in a drawing by P. C. Verbeeck, showing a rider in Oriental dress moving forward diagonally in space, preceded by a boy and a dog.[90] Many of the later examples are on a low artistic level especially when they were produced by designers for cheap book illustrations and the like. One of these prints, done in Holland in or shortly before 1634 has a certain significance for our problem (Fig. 7).[91] In this modest engraving we find a horseman with bow, arrows, and curved sword, moving toward the right, while his face is turned toward the beholder. He has long hair and a plain cap and wears apparently a *joupane* on top of tight-fitting trousers. In a crude form we have again assembled in this print many of the *formal* elements and some of the sartorial details of the *"Polish" Rider*. There is perhaps a certain irony in the fact that the Leiden publisher used this horseman, obviously a hussar, to represent Hungary, while he chose two pedestrians, a knight in armor and a nobleman, for the title page of the companion book on Poland (Fig. 8).[92]

While the tradition of this type of work became artistically atrophied in the North, it was brilliantly revived in the etchings of an Italian artist who was attracted by its possibilities of subtle "color" and picturesque form. In Stefano della Bella's (1610-1664) large and varied œuvre there are several sets devoted to costume studies of military types. Their compositional arrangement generally follows a formula which Goltzius had used consistently for similar works, though he was by no means the innovator. It consists of the device of having one figure pose large in the foreground on slightly raised land and against a low horizon, while other figures of related character may be discerned small in the distance, in battle or camping scenes. This scheme remained the rule for such prints

[89] This drawing is generally discussed in connection with two others (Friedrich Lippmann, *Zeichnungen von Albrecht Dürer in Nachbildungen*, Berlin, 1883/1929, nos. 630 and 631) as a "Turkish" or "Oriental" rider. However, while the two latter drawings actually show Turks, the rider of Lippmann no. 632, on the evidence of his costume, is clearly a Muscovite. This might make questionable the theory, advanced by F. Winkler (*Die Zeichnungen Albrecht Dürers*, I, Berlin, 1936, p. 58) and taken up by Panofsky (*Albrecht Dürer*, Princeton, 1943, II, nos. 1251-1253) that the whole group of drawings was copied from drawings by Gentile Bellini even though it is likely that Bellini was Dürer's original inspiration in such works. For oriental riders in landscape see also H.

Tietze and E. Tietze-Conrat, *Kritisches Verzeichnis der Werke Albrecht Dürers*, Augsburg, 1928-1938, I, A 160, and II, A 234, and text p. 92.

[90] A. M. Hind, *Catalogue of Drawings by Dutch and Flemish Artists in the British Museum*, IV, London, 1931, pl. LI. The countermovement of the heads of horse and rider in this drawing is related in principle to that in Rembrandt's painting but it is used for a purely formal variation alone, without the expressive values with which this motif is endowed in the *"Polish" Rider*. Judging from its style, the drawing must date from around 1650 or slightly later.

[91] It is on the title page of *Respublica et status regni Hungariae*, Leiden, 1634.

[92] See note 74.

even after Goltzius' steely elasticity and graphic precision had been superseded by the capricious sketchiness of Callot and the sober objectivity of Wenzel Hollar.

Stefano della Bella seems to have been the first to design also a whole set of pictures of foreign cavalry according to this compositional formula, traditionally connected with figures on foot. His delightful series of eleven circular etchings of "Poles, Hungarians, Turks and Negroes" (rather "Moors")[93] shows in each case a single rider dominating the composition in the foreground while attendants or similar riders appear in the distance, on either side or between the horse's legs. The chief figures are sketched from various angles, with their horses at rest or in forceful motion. They provide a most vivid illustration for what Merian called "Frembde Reutterey."

These etchings share with Rembrandt's painting more than the dominant theme, that of an anonymous foreign soldier on horseback. There are also some surprising similarities of details. The Moorish rider (di Vesme 270) (Fig. 9), for instance, shows in his pose and in the lively trot of his horse a considerable similarity to Rembrandt's figure. The animal skin used as a saddle cloth forms an additional point of correspondence, as does the animated expression of the horse with its parted lips. One of the Polish riders (di Vesme 274) (Fig. 10) is dressed in a *joupane* and rather similar shoes with heels; he is armed with bow and arrows and a battle hammer and his right arm is bent with the hand in a position almost exactly like that of Rembrandt's figure. The battle hammer is also carried by two Hungarian hussars (di Vesme 276 and 278).

That there existed connections between Rembrandt and Stefano della Bella is a matter of common knowledge. The Italian is known to have bought etchings by Rembrandt as early as 1642 and di Vesme is convinced that his trip in 1647 from Paris to Amsterdam was undertaken chiefly to make the personal acquaintance of the Dutch artist whose graphic work he admired.[94] Rembrandt's influence on Stefano della Bella is evident in the technique and subject matter of several of the Florentine's etchings. It is perhaps because of this known dependence of Stefano della Bella on Rembrandt that the similarities between his circular etchings and the *"Polish" Rider* have not attracted the attention which they deserve.[95] There is no doubt that this case cannot be classified as another

[93] Baudi di Vesme, *Le peintre graveur italien*, Milan, 1905, nos. 270-80.

[94] Di Vesme, *op.cit.*, p. 75. The same view expressed by A. Pedrucci, *Stefano della Bella*, Rome, 1932.

[95] The only reference which I have come across is in the lecture by B. Antoniewicz (see note 8) in which he says "il est même vraisemblable que le tableau fut inspiré par les gravures de Stefano della Belli [*sic*], gravures où l'on voit fort souvent des cavaliers revêtus du costume polonais."

instance of Rembrandt's influence on the younger contemporary. At the time of Stefano's visit, the *Rider* had surely not yet been painted. Since the artist returned to Italy permanently in 1650, it is most likely that he never saw the picture at all. Moreover, his series of foreign horsemen is not an exceptional group in his œuvre. As early as 1633 he had etched on several plates the entry into Rome of the Polish Ambassador G. Ossilinski (di Vesme 44-49)[96] and according to di Vesme's careful chronology there are prints of Poles, Hungarians, and other exotic soldiers spread out over his entire career. The round etchings, indeed, according to di Vesme, are based on drawings made in Paris at the occasion of another Polish embassy, of October 29, 1645, when Wladislas IV asked for the hand of Louisa Maria de Gonzaga.[97] These drawings thus were made two years before Stefano's visit in Amsterdam. The round etchings themselves were dated 1651 by di Vesme and 1652 by Nasse,[98] all dates surely prior to the painting by Rembrandt.[99] If we are correct in thinking that the similarities between Stefano's etchings and Rembrandt's painting point to some sort of dependence, we are forced in this case to grant to the Italian etcher the honor of having been the donor. Rembrandt, who always followed with keen interest the developments of the contemporary art scene, can safely be assumed to have known the etchings of the Florentine. Nothing would be more likely than that they were sent to him directly by the Italian artist, as a modest enough homage. That does not mean that Rembrandt was inspired solely by his acquaintance with the comparatively small etchings. Yet, there seems little doubt that they contributed in some measure to the creation of the Frick painting.

In admitting this, we are conscious of the considerable differences which exist between Rembrandt's painting and the etchings by Stefano. The riders in the etchings are always in company. They are emphasized in scale but not isolated. Rembrandt's rider is alone. An Elsheimer-inspired watchfire glows in the distance and close to it huddle a few people barely recognizable. They are submerged in the setting and are a mere detail of the landscape. This landscape, with its powerful fortress on top of a steep and massive mountain, which shelters a few trees and buildings and at the left splits apart for a waterfall that feeds a rapid brook, adds an element quite foreign to Stefano's etchings with their wide plains and low horizon. In contrast to the plain daylight of Stefano's etchings, Rem-

[96] Reproduced: G. Hirth, *Kulturgeschichtliches Bilderbuch aus drei Jahrhunderten*, 2nd ed., Leipzig [1899-1901], IV, pp. 1242-43, 1246-47.
[97] Some of these drawings, according to di Vesme, are in the British Museum.
[98] H. Nasse, *Stefano della Bella*, Strasbourg, 1913.
[99] About the date of the *"Polish" Rider* see below, note 114.

brandt's mountain is enveloped in shadow, so that its forms, vaguely indicated as they are, seem to grow in bulk and mysteriousness while we look at them. Much of the painting's attraction is due to this richly suggestive landscape and its integration with the figure of the rider. It is easy to see, however, that this beautiful aesthetic theme on which the whole painting is built, is Rembrandt's own artistic property. It is foreshadowed in many works, as for instance in the *Rest on the Flight into Egypt* of 1647 at Dublin (Fig. 11), where the small figures nestle in the protection of the dark landscape behind them; in the drawing of *Tobias Frightened by the Fish* in the Albertina (dating about 1650), where a solid mass of rocky hills rises similarly behind a rolling foreground and equally culminate in low-flung, fortress-like buildings (Tobit, Fig. 14); in the etching with a square tower of 1650 (Münz no. 158) the chief feature of which reappears in the background of the *"Polish" Rider* (Figs. 12, 13); and particularly in the etching B.60 of 1654 (Fig. 14), where the Holy Family, returning from the Temple, is related to the mountainous background in a surprisingly similar way, embraced within the contour of the mountain and yet dominating it by virtue of the size of the figures; they also move past in the same slight diagonal as the rider in the painting.[100]

Nor is the theme of an exotic horseman foreign to Rembrandt's earlier work. Aside from the various Oriental riders in narrative pictures, etchings, and drawings, among which the rider in B.98 (Fig. 15) deserves our attention most,[101] there are two drawings with equestrian figures among his copies after Mughal miniatures (Ben. nos. 1197 and 1205) (Fig. 16).[102] There is little actual connection between these drawings and the *"Polish" Rider*,[103] but by their very existence these sketches show a certain direction toward and preoccupation with the rider theme, which came to a climax in the painting

[100] This motif appears also in a drawing of *Christ and the Disciples on the Way to Emmaus* (Dresden, Ben. no. C 70) which, according to Valentiner, is a copy of one done by Rembrandt in *ca.* 1655. For the coinciding of the head of the figure with the contour of the mountain see also Elisha (Ben. no. 1027).

[101] See note 78. The Rider, for whom Rembrandt utilized a somewhat earlier sketch which was formerly in Hofstede de Groot's collection (Ben. no. 363), anticipates the *"Polish" Rider* in the pose of his right arm and also in the contrast between the turn of his head and of that of the horse. This *contrapposto* motif within the group of horse and rider not only occurs else-

where in Rembrandt (for instance Ben. no. C 48) but also in the work of other artists, see note 90.

[102] For the question of Rembrandt's copies of Mughal miniatures see Benesch, v, nos. 1187-1206. Benesch dates the group of drawings 1654-1656, making them practically contemporary with the painting of the *"Polish" Rider*. The drawing reproduced here represents Shah Jahan (Ben. no. 1197).

[103] The similarities between these drawings and the *"Polish" Rider* include the horse's open mouth, found in both drawings (as well as in Ben. no. C 48) and the richly decorated head-strap.

in the Frick Collection. We might mention finally the drawings of costumed riders which Rembrandt had done somewhat earlier on the occasion of a costume procession.[104]

These observations present us, then, with the following situation. As an iconographic theme, the *"Polish" Rider* is related to a tradition from which, in the form of Stefano's etchings, Rembrandt very likely derived some inspiration for his work. On the other hand, the painting, by virtue of its symphonic richness of formal and chromatic elements, stands out from this iconographic background as a creation of special poetic and imaginative power and significance, whose "aesthetic theme" is rooted in and anticipated by other, earlier works of Rembrandt. None of these observations is sufficient to explain the origin of the picture. On the contrary, it is obvious that there must have been some special impetus which induced Rembrandt to occupy himself with this theme and to mold it into such an imposing and individual shape. By the same token, its pictorial beauty would seem hollow if it were not the visual correlation of a fuller, richer meaning. While it would be foolish to deny that Rembrandt often painted pictures which owe their existence essentially to the artist's delight in phenomena of purely aesthetic relevance, it is easy to see that the *"Polish" Rider* differs just as much from the many "Orientals," "Rabbis," and "Landsquenets" in the master's work as it does from his commissioned portraits. We may not be able to penetrate altogether to that last meaning, hidden in the realm which in the absence of better knowledge one likes to call an artist's creative fantasy or inspiration; yet, by approaching the problem from a different angle, it is possible to throw some additional light on the genesis of this work.

6. THE HORSE

In the passages devoted to the *"Polish" Rider* in the literature on Rembrandt, brief as they are, much of the comment is usually reserved for the horse. Almost every writer has felt more or less vaguely that this is an uncommon beast. But these impressions have only led the various authors to compare the animal with their conception of a successfully

[104] Ben. nos. 365, 367, 368. A. M. Hind (*Catalogue of Drawings . . . in the British Museum*, I, 1915, nos. 7, 8) interpreted them correctly as based upon some costume pageant. Of what such pageants consisted we can learn from the interesting description furnished by Merian (*op.cit.*, VIII, p. 448) of a pageant held in Frankfurt in 1658, at the occasion of the election of Leopold I as German Emperor. The parade was made up of the following groups: 1) Moors, 2) "Old" Germans in mediaeval costumes, 3) Muscovites, 4) Wild Men, 5) Romans, 6) Swiss, 7) Hungarians, 8) Amazons, 9) Free Knights. The Hungarians, by the way, had grooms who carried bows, arrows, and war-hammers!

rendered horse. In regard to this point, opinions vary greatly. While Martin states blandly that this horse "like Rembrandt's animals in general belongs to the best renderings of animals of all times and schools,"[105] Weisbach feels that it was "quite incorrectly and unnaturally drawn" and that "in none of his works did Rembrandt draw horses well."[106] Others mingle praise with censure. Even experts on horses are found to be at variance with each other. Grossmann is profoundly impressed with the "highbred horse somewhat reminiscent of the steppes" ("steppemaessig");[107] it moves, he says, "in a genuine trot" and like its rider "gives itself to the pace." Yet another horse expert, quoted by Weisbach without being named, described the movement of the horse as comparable to that of a common cart-horse starting to pull.[108]

The horse, certainly, has some unusual aspects. It is small in relation to the rider and strangely emaciated. Its rump is thin, especially if compared with the very long and bony legs. The general lack of flesh is most noticeable in the head (Fig. 17), the excessive "dryness" of which gives to it an almost cadaverous expression. Most of Rembrandt's horses, in contrast, except for those in some drawings of the same period or slightly later,[109] belong to the so-called "Spanish" type, with well-rounded bellies, flowing manes, and long, wavy tails. In comparison with this sort of horse, which was fashionable in the seventeenth century and which is familiar from innumerable reproductions, the creature of the Frick picture looks almost like a skeleton.

It is not by accident that we get this impression. The Darmstadt Museum owns a rather unusual drawing by Rembrandt which seems significant in this connection. It shows a skeleton rider on a skeleton horse which in turn is set up in such a way as to suggest a strong forward motion reminiscent of that commonly applied to equestrian monuments (Fig. 18). The rider, too, has been given a "live" pose. He holds the reins in his left hand and a bone, like a baton, in his right. Benesch thought that the drawing belonged to the

[105] W. Martin, *De hollandsche Schilderkunst in de zeventiende Eeuw*, Amsterdam, 1935-1936, II, p. 360.

[106] Weisbach, *Rembrandt*, p. 564.

[107] Fritz Grossmann, *Das Reiterbild*, p. 87.

[108] That Rembrandt used chiefly work horses for his models was said also by Valentiner, *Rembrandt und seine Umgebung*, Strasbourg, 1905, p. 152.

[109] A horse very closely resembling that of the *"Polish" Rider* is found in the drawing, Ben. no. 1013 (*Meeting of David and Abigail*,

sometimes also interpreted as *Coriolanus and the Roman Women*). It is emaciated in form like the horse of the painting and its head is turned toward the background in a similar way. That the *kutâs* which hangs from its neck connects it still more closely with the *"Polish" Rider* has been observed by H. Hell, "Die späten Handzeichnungen Rembrandts," *Repertorium für Kunstwissenschaft*, LI, 1930, p. 34. Hell dates the drawing *ca.* 1655, Benesch *ca.* 1656, while Valentiner assigns to it the date of 1660.

portrait of Rihel, which he assumed to have been painted in 1649.[110] Hind linked it cautiously with the *"Polish" Rider*.[111] Of the two opinions Hind's alone is tenable. There is no bond, stylistic or typological, between the portrait of *F. Rihel* and the Darmstadt drawing, but many striking similarities can be established between the drawing and the *"Polish" Rider*. In both, the group is seen from a low eye level. In the drawing, this is evident from the position of the feet of the rider and the relationship of his shoulder to his neck; it is equally obvious in the Frick canvas if we look at the relative position of the shoulders or notice the sole of the shoe. There are still closer similarities if we examine the horses. They have the same pace, although that of the skeleton horse is less rapid, closer to a walk. The hind legs are placed almost identically, even to the slight anomaly—which probably caused some of the adverse criticism—that the standing hoof is seen in profile while the lifted one is slightly foreshortened.[112] The cropped tail of the Frick picture, an uncommon feature at that time, exactly corresponds in length to the tail-bones seen in the drawing and thus makes a connection between the two works particularly likely. All this results in the feeling that the horse of the painting has literally been brought back from the dead but still betrays his macabre origin in his bony appearance and pale color. The broad, isolated brush strokes, especially about the legs, reveal the anatomical structure almost as clearly as do the corresponding pen lines in the drawing.

The style of the drawing, with its preference for planes and right angles, its general economy and absence of elaborate shading points clearly to a date in the 1650's. It has its closest stylistic analogies in drawings of the middle of the decade.[113] This date brings it close to the *"Polish" Rider*, provided that picture dates from the middle of the 1650's,[114] as is generally (and I think correctly) assumed.

Even apart from its connection with the *"Polish" Rider*, the drawing represents a work of special value for our knowledge of Rembrandt's interests and working methods. Nor has it received as yet the attention which it deserves. It is not even mentioned in de Lint's

[110] O. Benesch, Rembrandt, *Werk und Forschung*, Vienna, 1935, p. 43. Benesch re-affirmed the date of 1649 (Ben. IV, no. 728) but seems to have remained alone in placing the drawing so early. The Rihel, at any rate, is now generally dated much later, see above, Note 40.

[111] A. M. Hind, *Rembrandt*, Cambridge, 1932, p. 90: ". . . and a drawing of a skeleton of a horse [*sic*] at Darmstadt which might even have been done with a view to the Polish Rider."

[112] In the painting, the hoofs of both standing legs are on the canvas strip which has been added at the bottom (cf. above note 11). If this strip is a later addition, it surely replaces one which was very much like it.

[113] See H. Hell, *op.cit.*, *passim*.

[114] There has been a remarkable unanimity among authors with regard to the date of the *"Polish" Rider*. With the exception of Mycielski, who had to date it late in accordance with his theory that it was a portrait of Titus, no author seems to have dated it before 1653 or after 1656. I see no reason to suggest any other date.

book, in which Rembrandt's œuvre is discussed from the point of view of a man of the medical profession.[115] Yet just to scholars working in the field of the history of medicine it must be an illuminating document, for the reason that it was done in an anatomical theater.

The history and development of the anatomical theaters has been described by historians of medicine in such thorough fashion that we need not repeat it here.[116] It is well known that Holland played an outstanding role in this development. It was in the University of Leiden that the great anatomist Pieter Paaw exhibited skeletons of men and animals, starting the trend that has ended in the anatomical showcases of the modern museums of natural history. These skeletons were placed on top of the railing against which, during demonstrations of dissections, the numerous visitors leaned to observe. The appearance of the anatomical theater in Leiden is preserved in an engraving by Swanenburgh, which is based on a drawing by Woudanus (Fig. 19).[117] The various skeletons can be seen mounted in lifelike poses as representatives of the great principle of the animation of the dead, which had been so common since the fourteenth and fifteenth centuries as a manifestation of late medieval morbidity and pessimism. In the Titian-inspired woodcuts by Jan Stephan von Calcar for Vesalius' anatomical atlas,[118] the Gothic grotesqueness of these early works had given way to the balanced formal canons of classical statuary, in accordance with a corresponding shift toward a humanistically purified and tempered conception of death.[119] Yet the traces of a late mediaeval *memento mori* are still visible in the Leiden *Theater*, more so than in the illustrations of the Vesalius. Several of the skeletons hold flags inscribed with traditional warnings of death.[120] In the foreground, quite appropriately, appear Adam and Eve "signifying that through the sin of our progenitors death has come to all mankind."[121] The print, however, gives an impression that

[115] J. G. de Lint, *Rembrandt*, The Hague, n.d. (*Great Painters and Their Works as Seen by a Doctor*, 1).

[116] The most comprehensive study is by G. Richter, "Das Anatomische Theater," *Abhandlungen zur Geschichte der Medizin und Naturwissenschaften*, Berlin, 1936, Heft 16. I am indebted to Prof. A. Castiglione for this reference.

[117] There are actually two prints made from the design of Woudanus. One, very large, was engraved by B. Dolendo and published by J. Marcey in 1609; the other (Fig. 19) was engraved by W. Swanenburgh in 1610. Although they differ in details, they are alike with regard

to the general features of the room.

[118] On the authorship of these woodcuts see E. Tietze-Conrat, "Neglected Contemporary Sources relating to . . . Titian," *Art Bulletin*, xxv, 1943, p. 158.

[119] See also H. Schrade, "Rembrandts Anatomie des Dr. Tulp," *Die Welt des Künstlers*, I, 1939, p. 60.

[120] We read: MORS ULTIMA LINEA RERUM, NASCENTES MORIMUR, PRINCIPIUM MORIENDI NATALIS EST, MORS SCEPTRA LIGONIBUS AEQUAT, PULVIS ET UMBRA SUMUS, NOSCE TE IPSUM.

[121] I. I. Orlers, *Beschrijvinge der Stadt Leyden*, Leiden, 1641, pp. 209 f.

these symbols have lost their fateful meaning. We see a number of visitors, much like any group of sight-seers in a modern museum, curiously looking at and conversing about the exhibits. In the right foreground they examine a treated human skin which is known to have been a part of the collection.[122]

In the background of the print, at the right, we see a skeleton rider. Although he is reversed in the print, he exhibits great similarities to the Darmstadt drawing. The group is mounted on a single pole and the horse lifts its legs in a similar pattern. The rider is characterized as a military figure with sword, battle hammer, and feathered beret. This outfit links the figure of the *Anatomical Theater* not only with the Darmstadt drawing but in some measure, too, with the *"Polish" Rider*. For, scantily dressed as it is, the Leiden skeleton seems to have been meant to represent an Eastern European soldier as his cap and the battle hammer suggest. We shall see that there was a preference for dressing such skeletons in exotic garb.

That the Darmstadt drawing was done from a skeleton in an anatomical theater can be accepted as certain. Only this assumption satisfactorily explains the low eye level, for we can see from the print of the *Theater* that the beholders had to look up at the exhibits on the balustrades. Moreover, though the one in Leiden was not unique, elaborately mounted skeleton riders were by no means common. They were found only in anatomical theaters, where they appear to have been among the chief attractions.[123]

This raises the question whether Rembrandt did his drawing from the group in Leiden shown in Woudanus' print or from one exhibited elsewhere. That he knew the Leiden

[122] E. Holländer, *Die Medizin in der klassischen Malerei*, Stuttgart, 1923, p. 50, thought the human skin was used as a mantle by one of the visitors and called it a shocking example of the general "Verrohung der Sitten" in that period. It is actually a part of the collection and as such mentioned in early inventories. The content of the anatomical theater is described as follows: "disposita sunt apto et eleganti ordine . . . plurima diversorum animalium ossea cadavera (liceat ita vocare totam istam ossium compagem, quam Graeci Sceleton dixere) mirabili artificio inter se connexa; tam virorum et foeminorum manu sua vexilla insignioribus sententiis ornata tenentium, quam aliorum animalium quadrupedum et volucrium; ut Equi, Vaccae, Porci, Cervi, Lupi, Caprae, Aquilae, Cygni, Mustellae, Simiae, Baviani Felis Gliris Muris, Talpae ossa. *Visitur etiam praeparata pellis humana*, et intestinam." (*Illustrium Hollandiae et* *Westfrisiae ordinum alma academia Leidensis contenta proxima pagina docebit*, Leiden, 1614, p. 230. In the first printing of this study I erroneously cited G. Rollenhagen as the author of this publication). Orlers (*op.cit.*, p. 208) mentions a few more items which had been added in the meantime. But the chief figures and their arrangement were still the same as in 1614, which shows that once established the exhibition in such "theaters" was seldom changed. For the whole complex of questions connected with Dutch anatomical theaters and their meaning see now William S. Heckscher, *Rembrandt's Anatomy of Dr. Nicolaas Tulp*, New York, 1958, esp. pp. 97 ff.

[123] In the seventeenth century only experienced anatomists were able to assemble a skeleton and to do so was considered a great art, as the phrase "mirabili artificio inter se connexa" (see note 122) clearly indicates.

theater one can be certain. Born and raised in Leiden and even enrolled for a term at its university, he surely had gone more than once to see the famous cabinet of anatomical curios. Nor is it at all improbable that he visited Leiden again during the 1650's.

Yet there are some obvious differences between Rembrandt's drawing and the skeleton rider of Leiden. Rembrandt's figure holds a bone, not a hammer, and his skull is bare. He lacks the sword, and the horse has not the long tail so prominent in the print. Assuming that the print is accurate, these differences surely could be due to changes made during the forty odd years which elapsed before the drawing was done.

One must not forget, however, that by the 1650's there were at least two more anatomical theaters where Rembrandt could have made his drawing. One was in Delft. Its exhibits have been described by Bleyswijck.[124] It had been reconstructed in 1657, but Bleyswijck makes it clear that most of its anatomical showpieces had been taken over from the earlier anatomical theater which in part can be made out in Mierevelt's anatomy-painting of 1617.[125] According to Bleyswijck there were four standing skeletons: those of an English pirate, executed in 1614; of a woman who in 1615 had been put to death for committing adultery with her son-in-law; and of two men killed in 1616 and 1619. There was also "the skeleton of a whole horse, given by Mr. Jan de Geus, on which was mounted the skeleton of a famous criminal commonly called 'poor Jacob' who was dressed up with some Indian war-trappings."[126] We see that it was not uncommon to equip these skeletons with fancy dress. Yet, attired in such a manner, "poor Jacob" surely must have looked quite different from the rider in Rembrandt's drawing, not to mention the fact that we do not know how he was placed in the small Delft theater.[127] Therefore, there is little reason to regard him as Rembrandt's model rather than the figure in Leiden, which seems to have differed less.

One may ask, however, whether Rembrandt had to go to Delft or Leiden to do the drawing, since there was also an anatomical theater in Amsterdam. One thinks of the Amsterdam anatomical theater the more readily as Rembrandt's source since he was occupied around the middle of the 1650's with a commission which required him to visit the "snijburg," as the theater was popularly called, to make studies: the *Anatomy of Dr. Johannes Deyman* which was finished in 1656.[128] The painting, except for the famous

[124] D. van Bleyswijck, *Beschryvinge der Stadt Delft*, Delft, 1667, pp. 572 ff.

[125] The *Anatomy of Dr. W. van der Meer*, reproduced in G. Lafenestre, *La Hollande*, Paris, 1898, p. 50.

[126] Bleyswijck, *op.cit.*, p. 583: ". . . met eenigh Indiaens krijgstuyg voorsien." Another skeleton was draped with "een Indiaens kleed van gecoleurde vederen" (*ibid.*, p. 575).

[127] Delft had only four rows; Leiden had six.

[128] Dr. Johannes Deyman had been appointed successor of Dr. Tulp in 1653.

fragment in Amsterdam, was destroyed by fire in 1723. Its original appearance can be reconstructed from the well-known drawing in the Six Collection (Fig. 20).[129] The dissection takes place in a small room which seems to contain only two rows of benches and an instrument panel in the center.[130] There was hardly room for a large group like a skeleton rider. Unfortunately, it is hard to tell which room Rembrandt rendered in this painting, since the Amsterdam surgeons' guild used two rooms at that time, one in the St. Anthonis-Waag, one of the public weighing-houses of Amsterdam, another, after 1639, in the St. Margaret Chapel, an old convent-church.[131] The theoretical instructions were given in the former, which contained also the paintings owned by the guild, while public performances were held in the latter.[132]

[129] Ben. no. 1175. The drawing was probably done after the picture was finished to try out the design of the frame. For an analogous case see Ben. no. 969.

[130] The panel with the instruments which Weisbach (*op.cit.*, p. 582) interpreted as a "pillar-like piece of architecture" was very probably crowned with an allegorical sculpture which Rembrandt indicated with a few flourishes of the pen.

[131] The history of the Amsterdam Anatomical Theater is rather complicated. The surgeons' guild had performed dissections since 1550, first in the former St. Ursula convent, later, from 1578 on, in a room on the second floor of the small church of St. Margaret (see E. H. M. Thijssen, *Nicolaas Tulp*, Amsterdam, 1881, *passim*). It was, however, not before 1624 that a regular anatomical theater was established. This was at first in the St. Anthonis-Waag. In 1639 a new anatomical theater was opened on the upper floor of St. Margaret's, in a room which formerly had been occupied by the Rederijkers. It was moved once more in 1690, back to the St. Anthonis-Waag, which had been completely rebuilt to provide maximum space for the much enlarged theater.

There is a disturbing confusion in seventeenth century sources about the location of the theater of 1639. St. Margaret was one of two churches which had been converted, not to say degraded, into meat-markets. The other, standing nearby (see Fig. 21) had once been dedicated to St.

Peter. According to O. Dapper, *Historische beschryving der Stadt Amsterdam*, Amsterdam, 1663, pp. 451-52, the anatomical theater was in St. Peter's, "above the small meat-hall." Philip van Zesen (*Beschreibung der Stadt Amsterdam*, Amsterdam, 1664, p. 444) also locates it in St. Peter's but calls the meat-hall of the ground floor the "large one." This confusion is surely one of nomenclature alone, since both these authors knew quite well in which building the anatomical theater was actually placed. It can be explained if we assume that by the time of their writing some uncertainty existed about the names of the two churches which had been secularized for a long time (and have completely disappeared today). This confusion was abetted by the fact that the *larger* meat-market seems to have been in the *smaller* of the two churches. There fortunately is another source which, by virtue of its early date and its very explicit statements, carries more weight than either of these authors: J. I. Pontanus (*Rerum et urbis Amstelodamensium historia*, Amsterdam, 1611, pp. 118-21) clearly states that the larger meat-market was in St. Peter's, the smaller in St. Margaret's and that the room of the Rederijkers—which later gave way to the anatomical theater—was in St. Margaret's, where at his time the surgeons' guild already occupied a room.

[132] See M. W. Woerdema, in *Gedenkboek van het Atheneum en de universiteit van Amsterdam, 1632-1932*, Amsterdam, 1932, pp. 178 ff.

For the contents of the anatomical theater we have two sources. One is a list, reprinted by E.H.M. Thijssen from a manuscript in the Amsterdam municipal archives.[133] It mentions the skeleton of an English pirate of 1615,[134] a human skin,[135] and skeletons of a horse, a lion, and of many small animals. The second source is an account of a visit to Amsterdam in 1663 by the German traveler Christian Knorr von Rosenroth.[136] In the *binnenkamer* of the anatomical theater, Rosenroth indeed noticed "Sceleton Hominis in sceleto equi"—the skeleton of a man on that of a horse. Although this visit took place a number of years after Rembrandt had made his drawing, Amsterdam's skeleton rider may indeed have been in place for some time before that date. (Surprisingly enough, no skeleton rider is mentioned by Commelin in his description of the enlarged anatomical theater in 1690).[137] We must content ourselves with the possibility that Rembrandt's drawing may have been made either in Leiden or Amsterdam.

Rembrandt's drawing of the skeleton rider adds to the complexity of the genesis of the *"Polish" Rider*. It surely will not do to explain the drawing as a sketch made by the artist to "check" on the anatomy of horses when confronted, for some reason or other,

[133] *Op.cit.*, pp. 20-22. See also the poem of Kaspar van Baerle with which he celebrated the opening of the anatomical theater in 1639, and which implies the presence of anatomical exhibits (*Poemata*, Amsterdam, 1645-1646, II, p. 537: In Locum Anatomicum Recens AMSTELO-DAMI Exstructum):

Qui vivi nocuere, mali, post funera prosunt,
Et petit ex ipsa commoda morte Salus.
Exuviae sine voce docent. Et Mortua quamvis
Frusta, vetant ista nos ratione mori.

[134] This skeleton, in all likelihood, can be identified with the one Dr. Sebastian Egbertsz. is using for his demonstration in Thomas de Keyser's *Anatomy* of 1619 in Amsterdam.

[135] C. Commelin, *Beschryvinge van Amsterdam*, Amsterdam, 1694, p. 652, thought it was the skin of the first corpse ever dissected in Amsterdam, a criminal called "Suster Luyt." From an anonymous manuscript published by Thijssen (see note 131) which lists the contents, it appears that the skin came from a certain Gielis Calewaart, a criminal from Haarlem, who had been dissected by Dr. Johannes Fonteyn (1621-1628).

[136] See "Aus dem Itinerarium des Christian Knorr von Rosenroth (herausgegeben) von Prof. Dr. Fuchs. Met eene Inleiding en eene Hollandsche Vertaling van den Latijnschen tekst door Joh. C. Breen," *Jaarboek Amstelodamum*, XIV, 1916, pp. 201 ff., esp. p. 210. When the present study was first published I had been unaware of this source and had eliminated Amsterdam's anatomical theater as a setting for Rembrandt's drawing, assuming that it did not have a skeleton riding on a horse. Prof. van Regteren Altena subsequently called attention to von Rosenroth's itinerary, see *Rembrandt, Tentoonstelling, Tekeningen*, Rotterdam-Amsterdam, 1956, no. 225, p. 162. In this catalogue Prof. van Regteren Altena is quoted as also favoring a connection between the drawing of the skeleton-rider and Rembrandt's work for the *Anatomy of Dr. Deyman*, going even so far as to date the *"Polish" Rider*—precisely because of its use of the drawing—*after* Dr. Deyman's *Anatomy*. Since we do not know when Rembrandt began the large project, and how long it occupied him, no clear-cut evidence is contributed to the date of the *"Polish" Rider* by that of the *Anatomy of Dr. Deyman*.

[137] Commelin, *op.cit.*, p. 654.

with the problem of an equestrian theme. In the 1650's Rembrandt no longer was interested in that kind of naturalistic accuracy. One feels tempted, rather, to link the drawing more intimately with the imaginative processes, which one has to assume for the origin of the *"Polish" Rider*, as for any work of a great artist. Whatever thoughts he may have had about the picture that was to become his *"Polish" Rider*, the impressive sight of a "pale rider on a pale horse," still striking a martial pose, may have given them a definite direction. Stefano della Bella's etchings may have fused themselves with this vision. The "theme" of figures set against a mountainous landscape had occupied him before, and exotic arms and costumes had always been fascinating objects for study. This surely is but one of many possibilities. There is no way of uncovering the secret processes by which the artist welded new impressions and shreds of memory into indivisible works, nor can we tell from which point the whole process took its departure. We can try to bring to light the many "ingredients," the great variety of impressions and stimulations, but we must content ourselves with saying that somehow, under the compulsion of an auspicious constellation, they were merged into an organic formal and coloristic unit.

7. "MILES CHRISTIANUS"

Only by keeping in mind the various sources and components of the work are we equipped to approach the last question, which we have postponed once before: whether the painting is meant to convey a meaning appropriate to its stirring aesthetic appeal, the spell of which has been felt by all sensitive observers.

In order to answer this question we have to recall once more a few essential facts about the painting. The painting shows a youthful soldier on horseback, fully armed and dressed in a manner typical of East European light cavalry. Rembrandt very likely had seen this particular combination on an actual soldier although it is not impossible (yet quite immaterial for us) that for some of the properties he used pieces from his own collection. At any rate, the picture was not done as a commissioned portrait of a definite person, nor is it simply a costume-piece.

It is important, however, to realize that Rembrandt clearly desired to make the young horseman a sympathetic figure. He endowed him with all the personal charm and the endearing qualities of which his art was capable. He tempered the martial appearance with the tender appeal of youth. Rembrandt's rider is obviously an idealized figure, a glorified representative of a whole military group.

For this reason it is unthinkable that Rembrandt wanted his painting to be a monu-

ment to those Eastern mercenaries who had fought and were still fighting in Western armies, even if his presumed "model" may have come from their ranks. They were hardly a lot worthy of affection; one has only to think of a figure like Isolani and his Croats. On the other hand, for any seventeenth century person a figure of such an appearance was still associated with a specific historical situation. Eastern Europe, to everybody's common knowledge, was far from pacified. Constant warfare existed in the ill-defined border regions between the various nations. Turks and Tartars especially were still uncomfortably close and dangerous. Occasionally large-scale battles were fought in which all types of military bodies and equipment took part. More common, however, were raiding parties which struck unexpectedly and made quick escapes. Mobility was the chief asset and the burden of both attack and defense was carried by light cavalry of the type rendered in our picture.

This situation was well known everywhere. To people not too familiar with the actual details of the conflicts, this constant warfare appeared under the simplified and time-honored black-and-white pattern of Christians fighting infidels. No matter how much and how often the actual situation was characterized by shady compromises, bargaining and double-crossing of friend and foe, the sympathies of Western Europe were quite naturally with those groups which could be considered as defenders of Christianity against the "scourge" of Asiatic peoples, the "Erbfeind" of the Occident.

One must also remember that in the seventeenth century, as in centuries before, many military leaders of such East European armies had achieved great international fame. Several youthful warriors had captured the imagination of people of the Western countries with deeds of valor and high-minded intentions. Miklós Zrinyi (1620-1664), a member of a famous Croat-Hungarian family and author of one of the classical poems of Hungarian literature, was a European celebrity in the middle of the seventeenth century, praised everywhere for his courageous stand against the Turks.[138] The Transylvanian princes, Gábor Bethlen (1580-1629) and George I Rákóczy (1593-1648), gained fame as defenders of their Calvinist faith against Turks and Hapsburgs alike, and coreligionists everywhere sympathized with them.[139] One son of George I Rákóczy, Sigismund, whose intimate ties with Western civilization are attested by his interest in the educational

[138] See A. Markó, "Nicolas Zrinyi et la France," *Nouvelle revue de Hongrie*, 1937, xxx, p. 510. A contemporary description of Zrinyi mentioned by Markó comes from the *Dutch* physician Jacobus Tollius (1633-1696).

[139] The apocryphal inscription "Georgius Ragozy" on Van Vliet's etching (see note 34) is at least a sign that the Calvinist prince of Transylvania was a well-known personality in Holland.

reforms of Johan Amos Comenius,[140] had died very young, in 1652. He was followed by his brother, the brilliant though erratic George II Rákóczy (1621-1660), who broke with the Turks and made an alliance with Sweden.[141] In Poland, too, one finds historical figures in whom valor and youth are intimately linked. There was Marc Sobieski, the brother of Jan, who had fallen in 1652 in an unsuccessful battle against the Cossacks at Batowiz.[142] (The Cossacks were Greek Catholics but often made common cause with the Tartars.) Jan Sobieski himself was well known in Holland, where he had spent the winter of 1647-1648, as a youth of eighteen, and had been in contact with such prominent leaders as Admiral Tromp and Prince William of Orange.[143] Another famous soldier was Prince John Radziwill of Lithuania (1612-1655), who had defeated the Tartars in a widely celebrated battle. For centuries, indeed, Hungarians and Poles had furnished great leaders in the struggle against the Mohammedans, like the Hunyadis (Janos H., 1387-1456, whose son Laszlo, 1432-1456, is one of the great romantic figures of Hungarian history), or the "Great" Jan Tarnowski (1488-1561). Nor should we forget that other Balkan nations had produced such heroes; none was more famous, perhaps, than Giorgio Castriota (1412-1468), the Albanian prince who under the name of *Scanderbeg* had become an almost mythical figure. We know that the seventeenth century visualized him as a youthful figure because Ciartres published a copy of Van Vliet's etching of a young man as an ideal portrait of Scanderbeg (see note 34). From the early sixteenth century on, his exploits as a fighter against the Turks had been steadily romanticized in literature.[144] Spenser hails him as "The scourge of Turkes, and plague of infidels,"[145] and Lavardin, in the preface to his book on Scanderbeg, speaks of him in terms which seem to evoke a vision of a figure quite similar to the *"Polish" Rider*:[146]

". . . Scanderbeg: whose immortall name is worthie without all contradiction, to be consecrated to the temple of Memorie, farre above all other knights, and champions of the Leuant, whose honourable actes haue made them to be recommended for the defence of the faith of Christ against the detestable and cursed sect of *Mahomet*. For it seemeth

[140] See A. Gindely, *Über des Johann Amos Comenius Leben und Wirksamkeit*, Znaim, 1892.

[141] He died in 1660 after a catastrophic campaign against Poland.

[142] See N. A. de Salvandy, *Histoire du roi Jean Sobieski*, Paris, 1855.

[143] See J. B. Morton, *Sobieski, King of Poland*, London, 1932, p. 32.

[144] For a bibliography of the early literature on Scanderbeg see Fan S. Noli, *Storia di Scanderbeg*, Rome, 1924.

[145] Published in the English edition of Jacques de Lavardin, *The Histoire of George Castriot Surnamed Scanderbeg, King of Albanie*, London, 1596.

[146] Lavardin's book was first published in Paris in 1576. It was based chiefly on Marinus Barletius' *Historia de vita ed gestis Scanderbegi, Epirotarum principis*, Venice, 1504.

that God had a speciall will and purpose to marke him with all laudable qualities and prerogatiues: as faith, religion, strength of bodie, comelinesse of person [!], dexteritie of spirit, the practise and skill of armes: all which were accompanied with so wonderfull and unspeakable good fortune, that it may be iustly auerred, that his deedes did surmount his destinies."

Allied to the almost mythical figure of Charles Martel, the eighth century victor over invading Arabs, Scanderbeg's name is invoked in Joost van den Vondel's poem "Nootweer, Tegens den inbreuck van Turckyen," published in 1661.[147] Although later by a few years than Rembrandt's painting, this poem is eloquent proof of the assumption made here that people in Holland were very much aware at this time of the dangers coming from the East. Their threat is chiefly along the Danube:

> 24. De Donau onbewaert
> Roept hulp, verdaeght een' Scanderbeg,
> Een anderen Martel,
> Die't Sarazijnsch gewelt ontzegg.
> En heenstier naer de hel.

Practically calling for a new crusade, Vondel deplores the inactivity of the Christian leaders:

> 34. . . . zy staan
> Verstockt, hoe droef de grenswacht bidt,
> En schreit: de Turck treckt aen.

It is "de grenswacht"—the border-guards—that call out the warning: the Turk approaches![148] If Vondel had a visual image of such a border-guard, it may well have resembled Rembrandt's "Polish" Rider.

We do not mean to say that the picture ought to be interpreted as an homage to or a commemoration of any one of these historical figures or any other like them, although one cannot exclude such a possibility even if we find no actual physiognomical resemblances. One would have to make allowances for the obvious idealization on the one hand and Rembrandt's customary disregard for historical niceties on the other. Yet, no matter whether he did or did not think of an actual historical personality, it seems justi-

[147] De Wercken van Vondel, Amsterdam, IX, 1936, pp. 393-94.

[148] A.J.B. Barnouw (*Vondel*, New York, 1925, p. 203) goes so far as to say that "this Turkish menace was an obsession with Vondel. The European nations should sink all their dogmatic quarrels . . . and show a united front to the infidels." In his play Gysbrecht van Amstel (see below, p. 141) Vondel had hailed the miracle of St. Clara repulsing the Saracen, "zoo ras hy zich vertoonde" (no matter how furious he appeared) (vs. 981 ff.).

fiable to see in the picture an apotheosis of those soldiers of Eastern Europe who were still carrying on the traditions and ideals of Christian knighthood.

Understood in this manner, the picture assumes a meaning which is distinguished from the "neutral" costume studies of Stefano della Bella, just as much as it is related to works of a quite different category. The *"Polish" Rider* is indeed, as Hind with his keen understanding of the painting has said, "something of a naturalistic counterpart of Dürer's *Knight, Death and the Devil*."[149] Dürer's *"Reutter"* (Fig. 22), rigid in his armor and paying no heed to the powers of darkness which accompany him, was an expression of the idea of the *Miles Christianus*.[150] Rembrandt's figure is gentler but just as firm in his conviction of the worthiness of his mission.[151] He is no longer accompanied by actual monsters of spiritual and physical danger. For the seventeenth century painter such an explicit elaboration of his theme was not as meaningful as it had been for Dürer. All the more striking is the fact that in Rembrandt's picture the landscape fulfills a function similar to that of the engraving. Dürer's knight, calmly making his way *per aspera ad astra*, moves along a narrow, shadowy defile. A rocky slope looms up hostilely behind him and allows only a momentary glimpse of the rider's goal, the safe and bright castle on top of the mountain. Rembrandt gave his landscape a less precise allegorical relationship to the theme, but he, too, used the towering dark mass of a mountain which, with its shadowy crevasses, creates a mood of danger and latent violence, a feeling which is accentuated by the nervous excitement of the horse. In contrast to Dürer's print, however, the fortress on top of the mountain does not seem to beckon as a friendly refuge. Rembrandt's rider moves away from its inhospitably looming shapes. But Rembrandt, too, expressed the idea that his rider is charmed. As a typical seventeenth century artist, he did it with pictorial means, with a warm luminous glow enveloping rider and horse. Against this symbol of a good cause, the sinister forms which threatened to engulf the figure fade into the distance. Significantly, the outline of the mountain slopes down to the right, in the direction of the movement of the rider. In fact, the coinciding of the head of the rider with the upper border of the mountain is filled with a subtly dramatic tension; in a moment the rider will emerge from the dark background and his head will be outlined clearly against the open sky!

It is not only with the theme of Dürer's engraving that we sense an inner connection. Dim in the distance of centuries and yet truly related like a spiritual ancestor, there

[149] *Op.cit.*, p. 91.

[150] E. Panofsky, *Dürer*, Princeton, 1943, 1, pp. 151 f.

[151] Panofsky, *op.cit.*, p. 153, mentions that the view from below "strengthens the impression of tallness and superiority." The same is true of the *"Polish" Rider*.

appears once more that stone figure of a young horseman at Bamberg (Fig. 23). However divided opinions may be as to its exact meaning, it surely was basically an inspiring symbol of military prowess and moral righteousness, "noch umschwebt von dem romantischen Schimmer der . . . Kreuzfahrerzeit."[152] The spirit of the Crusades indeed still sheds a last gleam of light on the youth in Rembrandt's painting, whose Eastern costume identifies him with those national groups to whom the dangers of non-Christian powers were still a very real and constant concern.

That such subject matter seems to be without parallel in Rembrandt's work does not necessarily render this interpretation unlikely if one considers the fact that the picture as a formal unit is also unique in Rembrandt's work and has been a puzzling problem just for that reason. On the other hand, we are still far from being certain that other well-known works of the master do not also contain meanings more precise and more closely linked to definite historical situations and personalities than we as yet suspect. The Phoenix etching, which was done only slightly later than the *"Polish" Rider*, has been interpreted as an homage to Leopold I on the occasion of his coronation in 1656,[153] in contrast to Schmidt-Degener's suggestion that it was a personal document from Rembrandt's darkest years. Or, to give another example, without the accidental discovery of documentary evidence, it would have been impossible to interpret correctly a picture like the *Aristotle with the Bust of Homer*. The difficulties are plainly due to the fact that the more specific meanings in Rembrandt's work are suffused, especially in his later career, with expressive elements of a far wider and truly timeless nature. Every action and human relationship is lifted from its individual and well-defined significance and given a more general appeal and a universal validity.

In so far as he is a glorification of youthful courage and dedication to a worthy end, the *"Polish" Rider* stands in a most interesting relationship to the general trend discernible in Rembrandt's later works. In the center of the aging master's interest and foremost among the actors of his figure compositions are old people, either troubled by human weakness and uncertainty (as for instance Tobit, Bathsheba, Saul), or torn by moral conflicts (for instance Abraham, Peter, Aristotle), or carrying gravely the heavy burden of great gifts and visions (like Homer or the Apostles). They reflect a reality which Rembrandt knew from personal experience. Against this constant dominant he plays occasionally, as if to sharpen its significance, the theme of youth. Youth is the foil from which

[152] G. Dehio, *Geschichte der deutschen Kunst,* Berlin, 1921, 1 (Text), p. 333.

[153] J.D.M. Cornelissen, "Twee allegorische etsen van Rembrandt," *Oud Holland,* LVIII, 1941, p. 111.

stand out the complex psychological types of his old people. Youth represents certainty, sureness, and physical beauty, where age is doubting and reflective, fraught with mental conflicts and marked physically by the hand of time. Youth contains the promise of the future (*Blessing of Joseph's Children*[154]). There is perhaps no more striking rendering of this contrast of old age with youth than in the *St. Matthew* of the Louvre (Aristotle, Fig. 4). The inspiring angel represents the bright certainty of youth against the troubled, hesitant, slackening mental processes of the aged Evangelist. It is significant that Rembrandt gave to this angel the image of his son Titus, whom he so often painted as a typical representative of "youth as such" and whose features Antoniewicz thought he recognized in the *"Polish" Rider*. This is surely an error, but as we see now, not without some remote justification. The young and handsome rider of the Frick canvas is indeed the perfect counterpart of the old poets, patriarchs, and prophets, who were the proper spokesmen for Rembrandt's own thoughts.

Rembrandt may have called him by a definite name. There is little hope that we will ever know it. But it is possible to see that this figure of a young warrior, still shining in the light of Erasmus' *"Miles Christianus"* was to Rembrandt a symbol of youth, a symbol all the more beautiful and moving for being in part derived, in a creative process which is beyond our power of analysis, from the bare bones of a rigid skeleton.

[154] See W. Stechow's analysis of this picture in *Gazette des beaux-arts*, ser. VI, XXIII, 1943, pp. 193 ff. See also below, p. 125.

III. JUNO

1. HARMEN BECKER

Although Rembrandt's picture of Aristotle dominates the gallery in which it is displayed in the Metropolitan Museum of Art, the visitor cannot help noticing another painting by the master exhibited in the same room. The *Juno* (Fig. 1) indeed forms a striking contrast to the *Aristotle*. Whereas the *Aristotle* presents us with the figure of a thoughtful sage, caught in a moment of deep and melancholy introspection, we are confronted in the *Juno* by a large though still youthful woman, turning boldly outward, and displaying her ample form and regal attire with obvious, if good-natured, pride.

There have been times, in the not too distant past, when Rembrandt's authorship of this painting was questioned. The doubting voices, however, have been stilled and there is no need today to vindicate the attribution of the *Juno* to the master. What we propose to examine is the history of the painting and its meaning. On both counts a few new observations can be added to the existing body of literature.[1]

Like the *Aristotle*, Rembrandt's *Juno* belongs to that handful of pictures by the master which can be connected with a document involving Rembrandt himself. Its history begins with a deposition made before J. Hellerus, notary public, on August 29, 1665, by Abraham Francen (also spelled Franssen) on behalf, and in the interest of the painter.[2] An apothecary, art dealer, and friend of Rembrandt, Francen, whose appearance is known from Rembrandt's etching of c. 1658 (Fig. 2),[3] states that he is fifty years of age[4] and declares

[1] Besides various certificates written at the time of its rediscovery by Max J. Friedländer, A. Bredius, W. R. Valentiner, and others, the picture was published in quick succession by A. Bredius, "Ein wiedergefundener Rembrandt," *Pantheon*, XVIII, 1936, p. 277; J.L.A.A.M. van Ryckevorsel, "De Teruggevonden Schilderij van Rembrandt: De Juno," *Oud Holland*, LIII, 1936, pp. 271 ff.; George Isarlo, "La Junon de Rembrandt est retrouvée," *Beaux-Arts*, October 9, 1936; Julius Held, "Two Rembrandts," *Parnassus*, IV, 1937, pp. 36 ff.; Martin Weinberger, *American Magazine of Art*, XXX, 1937, p. 312. *The Connoisseur*, XCIX, 1937, p. 3, printed Bredius' and Valentiner's certificates, accompanied by an editorial note.

[2] C. Hofstede de Groot, *Die Urkunden über*

Rembrandt (1575-1721), The Hague, 1906, pp. 337-38, no. 278 (quoted hereafter as Hofstede de Groot).

[3] Francen was also one of two guardians of Cornelia van Rijn, Hendrickje's daughter, see Hofstede de Groot, p. 370, no. 311 (December 9, 1669). See L. Münz, *The Etchings of Rembrandt*, London, 1952, I, figs. 90-91; II, no. 79.

[4] There is a discrepancy about Francen's age between this document of August 29, 1665, and another one of December 31, 1664 (Hofstede de Groot, p. 323, no. 265). In that document he had given his age as 51; eight months *later* he claimed to be 50. Unless there is an error in the transcriptions of the documents, we must conclude that the age given in such situations was only approximate. (See also note 33.)

that about a year and a half earlier, that is, in the spring of 1664, he had called on Harmen Becker (1617-1678), a rich merchant, to pay both capital and interest of two loans Becker had made to Rembrandt. Showing him his own receipt, he had requested that Becker return to Rembrandt nine paintings and two volumes of prints and drawings given to him as security for the loans. On that occasion, Becker is said to have answered: "Let Rembrandt first finish the *Juno*." (Laet Rembrandt eerst de Juno opmaken.) He also wanted Rembrandt to do him an additional service, but the artist denied being obliged to do any such thing. The negotiations had been broken off when Becker persisted in refusing to accept the offered payment.

The debt referred to in this document originated in a loan of 537 guilders made at five percent interest on December 7, 1662, and one of 450 guilders made without interest on March 28, 1663.[5] Francen's deposition was obviously a preliminary to a suit Rembrandt intended bringing against Becker to force him to accept the payment. On September 12, 1665, Becker indeed gave power of attorney to Jan Keyser, a lawyer at The Hague, to represent him two days later in the action brought against him by Rembrandt.[6] It is not known what happened when the case was brought before Aelbrecht Nierop, ordinary counselor at the Court of Holland; at any rate, it was settled on October 6, 1665, when both Becker and Rembrandt declared themselves satisfied.[7] Rembrandt still owed Becker a sizable sum derived from another transaction, which, however, has no direct bearing on the story of the *Juno*.[8] Whether or not Rembrandt had indeed finished the *Juno* by October 6, it is certain that Becker owned it later, as it figured in the inventory of his estate, drawn up between October 19 and November 23, 1678.[9] There were actually two paintings of Juno in Becker's collection. One was described as "een Juno van Rembrandt van Ryn"; the other simply as "een Juno levensgroote" (a *Juno* in life-size). Most scholars assume that our picture is identical with the *Juno* identified as Rembrandt's work, though this is not certain.[10] If the New York painting is the picture listed as a *Juno* in life-size, we would of course have to assume that Becker owned two *Junos*, both painted by Rembrandt.

[5] Hofstede de Groot, p. 304, no. 255 (Dec. 7, 1662) and p. 316, no. 258 (March 28, 1663).

[6] *Ibid.*, p. 340, no. 280.

[7] *Ibid.*, p. 341, no. 281.

[8] See below, note 16.

[9] See A. Bredius, "Rembrandtiana," 11. "De Nalatenschap van Harmen Becker," *Oud Hol-land*, XXVIII, 1910, pp. 195 ff.

[10] In my article of 1937 [1] I had expressed the opinion that it was the anonymous Juno in life-size, a view which apparently was also taken by the cataloguer of the Christie's sale of April 1, 1960 (no. 38).

It is a hazardous task to distill from the dry language of legal documents the complex character and volatile behavior of human beings. Our natural sympathy with a great artist predisposes us to take his part in every controversy, especially when his troubles seem to be based on financial difficulties. Harmen Becker hence has often been characterized as a harsh money-lender who tried to take advantage of a poor, defenseless artist. The rather numerous documents we have of Rembrandt's life could permit another interpretation. Profoundly independent as Rembrandt was, both in his life and his art, he was hardly the man to let others trifle with him, and he knew how to take care of himself. To call him a man of litigious nature may be going too far, but he never hesitated to assert his rights even if it meant going to court.[11] Becker, on the other hand, may have been a stubborn man, but when he asked for the completion of the *Juno*, he may have been within his rights. Of the two loans he made to Rembrandt one carried, as we have seen, five percent interest; by the day of the settlement, October 5, 1665, this amounted to 73 guilders and 15 stuivers. The second loan had been made "without interest"—surely a very unusual thing. Why should Becker—no personal friend of the artist, and a money-lender by profession—agree to lend a sizable sum without interest? As soon as we realize this peculiar aspect of the transaction, Becker's insistence on obtaining the *Juno* before accepting the money and releasing the works of art given as security appears in a new light. We come to the almost inescapable conclusion that Becker had renounced interest on the loan on the condition that Rembrandt would finish the *Juno* and deliver the picture to him.[12] Rembrandt, for his part, may have agreed to reduce the price by whatever the amount of interest (presumably at five percent) would come to. (Given the size and importance of the picture, it is not likely that it would have been ceded for nothing *but* the interest on the loan.)

Becker, it should be remembered, was not only a money-lender but a collector of art as well. As we read the distinguished list of names represented in his collection, we may even ask which he coveted more—money or art. He owned paintings by Tintoretto, Rubens, and Claude Lorrain, besides many works by Dutch painters. He also owned

[11] See Hofstede de Groot, p. 189, no. 167. That he answered sharply when his professional competence was questioned may be seen from document no. 154, p. 173, in Hofstede de Groot's publication, and from his reaction to Ruffo's criticism, see above, p. 8.

[12] Only Hofstede de Groot, p. 342, as far as I can see, raised this point, though only hypothetically: "War diese Leistung vielleicht Ersatz für die Zinsen?." On August 28, 1662, Rembrandt agreed to paint a picture for L. van Ludick to make up "for time lost *and interest*" (see Hofstede de Groot, p. 298, no. 253).

fourteen, or possibly sixteen, paintings by Rembrandt.[13] At a time when the official taste in Holland veered increasingly towards an art molded by Flemish and French influences, Rembrandt's paintings were hardly promising objects for financial speculation.[14] Nor was five percent interest unduly harsh; in fact, Becker himself had charged five and a half percent on a loan he made to the Six family, and six percent on another loan, to an unnamed nobleman and collector.[15]

There is another document that ought to be considered if one wants to judge Becker's relationship to Rembrandt without prejudice. We have seen that Rembrandt owed Becker another sum of money originating in a loan made to Rembrandt by Jan Six. Six ceded this debt to a certain Gerbrandt Ornia, who, at the time of Rembrandt's insolvency, forced one of the guarantors of that loan, Lodewyck van Ludick, a painter and art dealer, to take it over. Ludick, in turn, sold this claim to Becker in a transaction of June 4, 1664 —shortly after Becker had refused, until Rembrandt finished the *Juno*, to accept the payment for the loans he had made directly to Rembrandt. Four years later, on July 24, 1668, Rembrandt acknowledged that he owed Becker 1,082 guilders on this old obligation, and he agreed to pay two-thirds in cash and one-third in pictures *by his own hand*. The interest rate was fixed at the exceptionally low figure of four percent. Becker on his part declared his willingness to wait six months for the pictures, and, if necessary, also for the cash. Moreover, Becker agreed that the paintings, when finished, should be evaluated by independent appraisers, and if it was found that their value exceeded one-third of the

[13] See Bredius, 1910 [9].

[14] Although no precise study has been devoted as yet to the fluctuations of prices paid for Rembrandt's works in the seventeenth and eighteenth centuries, we are told by Wybrant de Geest II (1702) that soon after the artist's death one of his portraits could be bought for a pittance (six stuivers). Yet prices began to rise again rather steeply so that, according to the same author, this kind of picture was sold soon thereafter for eleven guilders and at the time of his writing several hundred guilders would be paid for it (see S. Slive, *Rembrandt and his Critics 1630-1730*, The Hague, 1953, p. 166). Indeed in the same year, 1702, Rembrandt's grisaille sketch of *St. John Preaching* (Berlin) was sold at public auction for 710 guilders (Hofstede de Groot, no. 386). Thus, speaking purely from a speculator's point of view, Becker's confidence in Rembrandt was justified—though on the basis of a long-term investment.

[15] See Bredius, *ibid.*, p. 201. Becker, a native of Riga, was a self-made man. Until his twenty-fourth year he had worked as a servant for the merchant Jeronimus Heesters. Once established as an independent merchant he is known to have dealt in anything that promised gain, among them things as different as jewelry, marble floor-tiles, linen, and licorice. The house he lived in was valued at 15.000 florins, see N. de Roever, "Harmen Becker, Koopman en Kunstkenner," *Uit onze oude Amstelstad*, [2nd edition], Amsterdam, 1902, p. 185. (Professor Robert Scheller kindly provided me with a copy of the text of this brief sketch).

debts, he was willing to pay cash for the balance. (When Rembrandt died on October 8, 1669, he still owed money to Becker.)[16]

Becker clearly was always willing to wait, provided he would get more paintings by the master. At no time did he threaten the painter, and the unpleasantness of 1665 was brought about solely because Rembrandt was anxious to lay his hands on the pictures and prints he had turned over as security to Becker.

All this leads to only one conclusion. Whatever else Harmen Becker was, he was a persistent admirer of Rembrandt's art even when it was clearly out of fashion. Being a businessman, and seeing that Rembrandt needed money, he struck a bargain with him as a means of obtaining some of the works he wanted to own. Modern historians are unjustified when they reproach Becker for lack of charity toward a genius beset by financial troubles. Nor is it fair to blame him for the device of forcing Rembrandt's hand by becoming his creditor. He surely knew what we know from other sources (see above p. 7), that it was difficult to obtain works from Rembrandt by simply ordering them; rightly or wrongly he may have calculated that binding him by a loan was a surer way to induce the artist to "deliver."

The paintings, prints, and drawings accepted by Becker in 1663 as security for the loan were certainly not works by Rembrandt himself. Except for commissioned portraits, Rembrandt's output in these years was hardly large enough to have nine of his own paintings available for such a transaction—not to mention the fact that nine paintings and two portfolios of prints probably would have been worth considerably more than the amount of the loan. If the objects given as security were not his own works, Rembrandt's transaction with Becker is of additional interest. In the sales that followed the *cessio bonorum* of 1656 all of Rembrandt's collections had been sold.[17] It is noteworthy that by 1663 (surely acting independently behind the transparent shield of a "firm," run officially by Titus and the loving but illiterate Hendrickje) Rembrandt had again accumulated a large enough collection to enable him to give security for a sizable loan, and that in 1664 he was able to redeem these works of art with a cash payment of about 1,000 guilders.[18]

[16] For the complicated transactions concerning the Jan Six loan (which had been 1,000 guilders to begin with but had grown through interest) see Hofstede de Groot, documents nos. 178, 213, 225, 253, 263, 265.

[17] For the financial difficulties and transactions during the years of Rembrandt's insolvency see Jonkheer J.-F. Backer, "Les Tracas Judiciaires de Rembrandt," *Gazette des Beaux-Arts*, 5th période, IX, 1924, p. 237; X, pp. 219 and 361 ff.; XI, 1925, pp. 50 ff. See also Carl Neumann, *Rembrandt*, Munich, 1922, II, pp. 695 ff.

[18] Since in 1664, Rembrandt had received 500 guilders for his painting of Homer (see above, p. 8), it may have been the very money paid to him by Don Antonio Ruffo that enabled him

2. OTTO WESENDONCK

What happened to Rembrandt's *Juno* after Becker's death is not known. For over 200 years the picture disappeared from historical records. It made its reappearance in 1888 in a printed catalogue of the collection of paintings owned by Otto Wesendonck of Berlin.[19] The picture was listed as No. 240, and the entry reads (in translation) as follows:

> 240. Juno. Three-quarter length, life-size, completely 'en face,' in glimmering light; her plentiful chestnut-brown hair, which falls on her neck, is coiled in rows of pearls and she is adorned with a lavish crown; around her neck and over her breast is draped, on a small double chain, a flower made of jewels, half of which is tucked away in her bosom. An ermine cloak, lined with blue velvet, set with pearls, falls from her shoulders. A wide sash, decorated with precious stones and framed on the outside with a double string of pearls, supporting a large order made of diamonds, drops from her shoulders and on the breast of her rich brownish dress of brocade. Her right hand rests on a scepter at the foot of which the head and neck of a peacock become visible. The left hand, hanging down, holds the cloak.
>
> 124 cm high, 103 cm wide. Canvas.
> From the collection of J. Tho. Stanley, Palmerston House
> —Turnbridge near Sheffield.
> On the scepter Rembrandt's initials.[20]

"J. Tho. Stanley," mentioned as the previous owner of the picture, must have been Sir John Thomas Stanley, First Baron Stanley of Alderley (1766-1850).[21] Although no "Turnbridge" is known in the British Isles, there is a "Tunbridge" near Sheffield, Yorkshire, and it may be significant that Lady Stanley (Maria Josepha Holroyd Stanley, 1771-1863) was the eldest daughter of the First Earl of Sheffield (1735-1821). Whether John

to make the offer of repayment of his debt to Becker.

[19] Written by the collector himself, it was published as "Katalog A" in Berlin in 1888.

[20] These initials are no longer discernible; they may have been later additions which were removed in one of the several cleanings of the picture. The Wesendonck catalogue included another "Rembrandt" for which the same provenance was given. It was no. 238 of the catalogue and represented the Departure of the Angel from the Family of Tobit. This was, most likely, the painting listed in John Smith's *Catalogue Raisonné*, VII, no. 54, as having been previously in the collection of Mr. Hone and J. P. Cook. It probably was an old copy of the painting in the Louvre (see Tobit, Fig. 26).

[21] I owe this suggestion to investigations made by Harry S. Middendorf.

Thomas Stanley inherited the pictures or acquired them in the art market cannot be answered at this moment. However, it is worth mentioning that in 1790, at the age of 24, he had taken a trip to Holland, where he stayed in The Hague. It is likely that Lady Stanley, who was 79 years old at the death of her husband, disposed of some property when, according to custom, she prepared to move to the dower house.

Nor is it known when or where Otto Wesendonck acquired the painting. But it may well have been in London, which he had visited on his travels. Otto Friedrich Ludwig Wesendonck was born in Elberfeld, March 16, 1815, and died in Berlin September 18, 1896. As a young man he had been to America and by 1851 was the European partner of an important New York silk firm, Loesching, Wesendonck & Company. The firm still existed in 1905 under the name of Kutter, Luckemeyer & Company; Luckemeyer had been the maiden name of Mathilde Wesendonck, whom Otto had married in 1848. After 1852, both Otto and Mathilde Wesendonck were close friends of the composer Richard Wagner, who for some time (1857-1858) lived near them in Zürich, Switzerland, in a house put at his disposal by the Wesendoncks. The composer's infatuation with Mrs. Wesendonck and the well-known role of the Wesendoncks in Wagner's musical development have no bearing on the history of the *Juno*, though it is tempting to think that Rembrandt's painting may have been a silent witness to some intimate conversations between Wagner and his adoring Mathilde.[22] Leaving Switzerland after the Franco-Prussian War, the Wesendoncks moved to Dresden in 1872, and, after a brief stay in Cairo, Egypt, settled in Berlin, where their house was a well-known center of art and music.

In 1906, three years after Mathilde Wesendonck's death, about 200 paintings of the Wesendonck collection were offered by the heirs (Dr. Karl von Wesendonck, Berlin, and Dr. Freiherr von Bissing, Munich) to the Bonn Provinzialmuseum as a long-term loan, and another 26 followed in 1909.[23] Bonn was probably chosen because Dr. von Bissing had been a student at Bonn University and had taken his degree there. Six paintings remained in Berlin and were exhibited at the Kaiser-Friedrich-Museum.

In the catalogs of the Wesendonck loan, edited by W. Cohen, the *Juno* appears in a

[22] For Wagner's relationship to the Wesendoncks, see Robert W. Gutman, *Richard Wagner: The Man, His Mind, and His Music*, New York, 1968, *passim*. In one of Wagner's most famous works, *Tristan and Isolde*, the characters of "Tristan," "Isolde," and "King Marke" in poetic form reflect the relationships among Wagner, Mathilde, and Otto Wesendonck.

[23] See Walter Cohen, "Die Sammlung Wesendonck," *Zeitschrift für Bildende Kunst*, N. F. XXI, 1909, pp. 57 ff.

one-line entry among the pictures kept in storage.[24] Wesendonck's original attribution of it as the work of Rembrandt, perfectly correct in the light of our present-day knowledge, had been changed to "Rembrandt, Nachahmer" (Rembrandt, Imitator), and Dr. Cohen complained that no work of Rembrandt's was in the Wesendonck loan ("That we do not own a Rembrandt is bitter"). It is difficult to understand how this negative judgment of the *Juno* had come about. To be sure, its appearance may have been somewhat disfigured by overpaintings, only recently fully removed.[25] Nevertheless, it must have been seen in Berlin by connoisseurs such as Wilhelm von Bode. The renowned Dutch specialist, C. Hofstede de Groot, who himself had published the crucial document of 1665, had been charged by the Bonn Museum with the examination of all of Wesendonck's Dutch paintings. The failure of these men to recognize the true worth of the *Juno* remains one of the real mysteries in the history of the painting.

In 1925 the Rheinische Provinzialverband (Provincial Council of the Rhineland), in cooperation with the City of Bonn, decided to take possession of the Wesendonck Collection by purchase. The Wesendonck heirs[26] agreed to the sale and to payment in long-

[24] Walter Cohen, *Katalog der Sammlung Wesendonck*, Bonn, 1914, p. 156, no. 230. (The *Katalog* was printed in a revised edition in 1927, but the entry for the *Juno* remained unchanged.)

[25] In Wesendonck's description of the painting, cited above, Juno was said to hold her gown with her left hand. This impression must have been the result of some repaint applied, perhaps, to hide the fact that the painting had suffered damages along the lower edge. According to a report submitted to the present owner by Mr. Daan Cevat, the painting was cleaned in Amsterdam in 1935; when owing to some "overcleaning" a red area appeared in the lower right corner, it was "used to make a table for Juno to rest her left hand on." Cevat also suggested that this red area was a remainder of a "balustrade covered with red cloth" which Rembrandt originally had painted all across the lower edge. "At the same time," Cevat asserts, "large areas of the costume and much of the jewelry were 'finished' and Juno's left hand extensively repainted." Some, though not all of the repaint was removed after the unsuccessful sale at Christie's in April 1, 1960. The picture was still further cleaned and restored by William Suhr in

1966. A strip of two and a half inches "cut from a landscape of later date" was found to have been added at the top. It was left there though toned down to accord with the rest of the background. Most problematical is the condition of a five-inch strip across the bottom. It is not an addition to, but part of, the main canvas. "This strip," in Mr. Suhr's words, "even without the repaint does not permit clear reading." A few pentimenti were also observed, the most striking on Juno's bare bosom where a "pearl-studded ribbon, similar to those used in the hair" ran across it in a downward slant from left to right. Although aware of the vicissitudes of the picture's history and its imperfect preservation, Mr. Suhr believes that at least the left arm and hand ("splendid reminiscences of Titian") had never been finished.

[26] Otto Wesendonck had had two children: Myrrha, who died in 1888 after having been married for sixteen years to Freiherr Moritz Ferdinand von Bissing. The von Bissings had one son, Dr. Freiherr Friedrich Wilhelm von Bissing, an Egyptologist and for some time professor at the University of Munich. Karl, Otto Wesendonck's other child, was ennobled in 1899

term installments. In 1934, however, at the beginning of the Nazi era, in keeping with the stress on local and national traditions, a complete reorganization of the Bonn Museum was undertaken with the goal of emphasizing the local Rhenish traditions. The unpaid-for part of the Wesendonck collection was returned to the heirs, while the works owned by the Museum but no longer considered pertinent to the aims of the institution were sold at auction. The selection of the works to be auctioned was entrusted to Professor Karl Koetschau, then Director of the Kaiser-Friedrich-Museum in Berlin. The *Juno* was among these works and was sold at Lempertz in Cologne on November 27, 1935, as "Style of Rembrandt, Dutch 17th Century" (no. 87). It fetched 900 marks—about $214.00.

Now, however, *Juno*'s fortune changed. When the two Dutch dealers W. Paech and A. J. Schrender, who bought the painting, submitted it to the foremost experts on Dutch painting of the day, it was hailed as an authentic work of Rembrandt and indeed as the very picture he had painted for Harmen Becker. Acquired by D. Katz of Dieren, Holland, it was sold at an unknown date to Dr. C.J.K. Van Aalst of Huis te Hoevelaken, Holland. It was exhibited at the Rijksmuseum in 1936, at the World's Fair in New York in 1939, and later in St. Louis, Minneapolis, Los Angeles, Newark, Toledo, Springfield, and Detroit. During the war years it was deposited in the Detroit Art Museum, but was exhibited again in Los Angeles in 1947. After having been kept for some time in a bank vault in London, it was once more offered at auction with the Van Aalst collection at London (Christie's April 1, 1960, no. 38), but was not sold. In 1966 it passed into the hands of Hans M. Cramer of The Hague and from him was bought by J. William Middendorf, II, who entrusted it to the Metropolitan Museum on an indefinite loan.[27]

3. DATE AND STYLE

As we return from its strange career to the picture itself, we are still faced with a number of questions. The first is the actual date of the work. We know that in the spring of 1664—in Harmen Becker's view—it was not finished. Since we also postulate a connection

and thereafter dropped the "c" from his name. A lecturer in physics at the University of Berlin, he was married to Countess Evaline von Hessenstein, by whom he had two children, Otto-Günther von Wesendonk and Inge von Wesendonk. The agreement of 1925 was made, for the Wesendonck heirs, by Freiherr Friedrich Wilhelm von Bissing and Dr. Otto-Günther von Wesendonk.

[27] I am indebted to the owner for providing me with some of the evidence on which this brief account of Juno's modern peregrinations is based, and for his permission to publish the picture in this book.

between the *Juno* and the loan without interest of March 28, 1663, we propose as a plausible hypothesis that the painting had been begun before that date. Besides being painted quite thinly, the picture shows few pentimenti and certainly no major revision; to one modern technical observer (W. Suhr, see note 25) it still gives the impression of being in part unfinished. Thus, it is likely that despite Becker's insistence that Rembrandt "finish" the *Juno*, the artist actually did very little to the picture during 1664 and 1665. (If anything, Rembrandt may have given some attention to Juno's left arm and hand which, as several critics have pointed out, is more freely painted than other parts of the picture, particularly the right hand). We should perhaps also keep in mind that we have only Becker's word for it that in the spring of 1664 the picture still needed "finishing." Rembrandt, whom Houbraken quotes as saying that "a picture is finished when the master has achieved his intentions" (*dat een stuk voldaan is als de meester zyn voornemen daar in bereikt heeft*),[28] may have felt satisfied with it. Thus, his difficulties with Becker may have been a question of aesthetics rather than of fact, and in the end Becker may have decided to accept Rembrandt's judgment (or, for that matter, to settle for "half a loaf").

If we try to place the painting chronologically on stylistic grounds, we clearly come to the early 1660's. Its most striking features are the frontality and monumentality of the figure of Juno. In the earlier phases of his development Rembrandt had avoided this kind of arrangement. A portrait with a perfectly frontal head like the one formerly in the Lanckoronski collection (Bauch no. 265) is exceptional—and even here the body is slightly turned to the side; in the Chicago picture of a girl in a door-frame (Bauch no. 507) where the pose indeed anticipates to a degree that of Juno, the eyes studiously, and coyly, look away from the beholder. It is only in the 1650's that we find a marked increase in frontal and symmetrical arrangements, both in portraits and narrative subjects. The *Ecce Homo* etching of 1655 (Münz no. 235),[29] the *Anatomy of Dr. Deyman* of 1656 (Bauch

[28] Arnold Houbraken, *De Groote Schouburgh der Nederlantsche Konstschilders en Schilderessen*, I, The Hague, 1718, p. 259.

[29] One of the sources—perhaps the most significant—of this great etching has apparently not yet been pointed out, probably because the subject itself is very different. I refer to Claes Jansz. Visscher's etching of an outdoor performance by the "Oude Camer" of the Rederijkers of Amsterdam in celebration of the truce of 1609 (K. Bauch, *Der frühe Rembrandt und seine Zeit*, Berlin, 1960, fig. 40). Visscher's print depicts a stage erected on the *Dam*; a large crowd of spec-

tators is assembled below to listen to an actor, who has emerged from between the drawn curtains. The print has not only the same frontal and symmetrical arrangement as Rembrandt's etching, but anticipates it in many other ways. As in Rembrandt's work, strongly marked architectural elements, topped by sculpture, flank the stage-opening, and other buildings are seen on either side. Although the opening in Rembrandt's etching is much narrower than the one of Visscher's print, it also has a shallowly arched top. Indeed, the striking "stage-like" arrangement of Rembrandt's etching becomes dramati-

no. 538), and the *Phoenix* etching of 1658 (Münz no. 279) are the most striking manifestations of this trend. It is safe to say that the *Juno* could have been conceived only after the master had reached this stage. Yet if we consider the hugeness of the figure in relationship to the shape of the canvas, and the broad if economical technique of applying paint, we can associate the picture only with works done around 1660 and soon thereafter. Indeed, there is no denying the similarity, regularly pointed out by scholars, between the *Juno* and Rembrandt's *Lucretia*, dated 1664, in Washington (Figs. 3, 4, 5).[30] The strict frontality recalls also the "historical" portrait of *Count Floris of Holland*, now in Göteborg, Sweden (Bauch no. 242),[31] and the drawing of a young man, of c. 1662, in the Six Collection, Amsterdam (Ben. no. 1181, fig. 1407). Thus, taking into consideration all the historical and stylistic factors, a date of c. 1663-1664 for the *Juno* is the most satisfactory.

This date, however, creates a certain difficulty with one thesis concerning the picture. All scholars who have written about the *Juno* (this writer included) have agreed in stating that the model posing for Rembrandt as the classical goddess was Hendrickje Stoffels,[32] his common-law wife. Hendrickje came into Rembrandt's house in the 1640's; she is first mentioned in 1649. She appears in a number of pictures by the master (though opinions may vary from case to case whether the model was indeed Hendrickje), and one

cally clear in the comparison of these two works. The main difference, of course, is found in the reversal of the roles: in Rembrandt's etching it is the audience that "acts," whereas the "actors" almost form a *tableau vivant*. Yet it was precisely in the "performance" of the celebration commemorated by Visscher's print that after each announcement a *tableau vivant* (of the story of Tarquinius and Lucretia) was shown. Rembrandt's later transformation of the *Ecce Homo* has as its chief result the forceful confrontation of the beholder himself with the group of Christ: it is not a picturesque and unruly crowd of anonymous people but we ourselves who are face to face with the figure of Christ presented to us on a stage. From a rendering of a theatrical performance the print was changed to provide a haunting personal experience. See Dagobert Frey, "Die Pietà-Rondanini und Rembrandts 'Drei Kreuze,'" *Kunstgeschichtliche Studien für Hans Kauffmann*, Berlin, 1956, p. 222.

[30] The Washington painting appears to have suffered from later "restorations" in the face. The action of Lucretia accords with a time-honored theme in the rendering of heroic suicide: the address to the chosen weapon. The material of this tradition has been collected by Erica Tietze-Conrat in an unpublished book: *Patterns of Suicide in Literature and Art*. In his later painting in Minneapolis (Bauch, no. 286), Rembrandt painted the moment after Lucretia has given herself the fatal wound.

[31] The identification of this knight with Count Floris of Holland, as he appeared shortly before his murder, appears to me completely convincing; it was first proposed by W. R. Valentiner, "Rembrandt's Conception of Historical Portraiture," *Art Quarterly*, XI, 1948, pp. 117 ff. See below, p. 141.

[32] Stoffels is a patronymic; Hendrickje's father was Stoffel (Christopher) Jeger (Jagher), and in documents she occasionally appears indeed as Hendrickje Jaghers.

can trace the rapid maturing and premature aging of this sympathetic and warmly devoted peasant girl. The last generally accepted portrait of Hendrickje is in the Metropolitan Museum, dated 1660, possibly painted as a companion piece to Rembrandt's self-portrait of the same museum (Figs. 7, 8). In that picture, Hendrickje looks tired, perhaps even ill. Being very sick, she made her will in August 1661. She died, not yet 40 years old, in July 1663.[33]

Since both on stylistic and historical grounds the *Juno*, even in a first conception, cannot be dated as early as 1660 (the date of the Metropolitan painting), let alone earlier, it is highly questionable that Hendrickje literally posed for the painting. Juno's features (Fig. 9) undeniably have a certain similarity with those of Hendrickje, but this similarity is closer to the lovely portrait in Berlin from the late 1650's (Fig. 6) than to the portrait nearer in date. Even in the Berlin portrait Hendrickje looks "older" than the radiant, youthful *Juno*.

Once we give up the theory that Hendrickje actually modelled for Rembrandt as he painted the *Juno*, we are able to see the picture as a free creation in which Rembrandt used some of the features—the broad face, the large dark eyes, the short nose—of the woman who had sustained him with her love.[34] "Had"—for if we are correct in dating the picture 1663-1664, we must seriously consider the possibility that it was painted after Hendrickje's death. The very idealization of her features might in fact be used to sustain the assumption of a posthumous "portrayal."[35] When Saskia died, Rembrandt also had rendered her features in an "ideal" portrait (Berlin, 1643, Bauch no. 509).

As a painting stressing frontality and symmetry, and largely eschewing foreshortening, the *Juno* represents a trend that was not restricted to Rembrandt alone. Dutch painting of the second half of the seventeenth century showed clear signs of preferring "classic" patterns to "baroque" ones. And while it is true that Rembrandt was at all times aware

[33] Hendrickje was buried on July 24, 1663, see I. H. van Eeghen, *Amstelodamum*, 1956, pp. 115-16. Her age at the time of her death is uncertain. On October 1, 1649, she declared herself to be 23 years of age, but 12 years later, on October 20, 1661, she gave her age as 38 (see C. Hofstede de Groot, p. 146, no. 120 and p. 290, no. 244). (For another such discrepancy, see note 4.)

[34] According to Neil Maclaren (*National Gallery Catalogues, The Dutch School*, London,

1960, p. 313), there are only *four* sure portraits of Hendrickje—one of them being the *Juno*!

[35] This view is evidently not compatible with a rather sentimental theory, first, I believe, expressed by van Rijckevorsel and occasionally repeated after him, that the painting had been started before Hendrickje's death, and that it remained "unfinished" owing to Rembrandt's attachment to the beloved woman, making it difficult for him to touch the picture after her death.

of the great masters of the Renaissance,[36] he obviously saw them with different eyes in the 1650's and 1660's than he had done before. As for the *Juno*, she is a striking example of Rembrandt's interest during the late period of his life in the normative aspects of Venetian portraiture. The picture brings to mind Titian's celebrated portrait (Fig. 10) known as *La Schiavona* (National Gallery, London). Rembrandt's *Juno* indeed shares with the model of that picture the broad expanse of the body and the proportions of the face, and one could easily imagine that the arrangement of her hair was developed from the design of the hairnet of Titian's unknown lady. (The manner of painting, of course, differs greatly, being more in keeping with Titian's last pictorial manner.)

Rembrandt's *Juno* is not only reminiscent of Titian; one can safely say that it reflects a type of feminine portraiture frequently found in artists of the Venetian school, such as Licinio's portrait in the collection of Mrs. Edward D. Brandegee, Boston,[37] Palma Vecchio's unfinished *Portrait of Paola Priuli*, Pinacoteca Querini Stampalia in Venice,[38] or Paris Bordone's *Portrait of a Lady of the Fugger Family* of c. 1540 (where now?).[39] The most interesting analogy is perhaps offered by a portrait attributed to Bonifazio Veronese in the J. Paul Getty collection at Sutton Place. The young woman in that painting rests her left hand in a very similar manner on the corner of a table that juts into the picture in the lower right corner[40] (Fig. 11).

This raises, of course, the question whether Rembrandt really intended a table to appear in this corner. In the National Gallery in Washington, as part of the Widener bequest, there is a Rembrandt drawing of about 1640 in which a young woman rests her hand on a table in a manner somewhat similar (Fig. 12).[41] Yet one cannot entirely disregard the theory, expressed by Daan Cevat (see note 25), that Rembrandt had planned Juno to stand behind a ledge or balustrade. It is peculiar enough that Juno holds her scepter upside down, in a pose that has been compared, quite properly, with that of Flora leaning on her staff in the much earlier painting in the National Gallery in London (Bauch no. 261). This motif would be even more anomalous, if the scepter did not rest on anything solid; it certainly cannot have been meant to be supported by the peacock! A ledge running

[36] See Kenneth Clark, *Rembrandt and the Italian Renaissance*, The Norton Library, New York, 1968, p. 104. Clark stresses the point that of 155 Italian pictures of the Vendramin collection which were sold in Amsterdam in the 1640's, only four can be identified today so that "we are justified in assuming that many Venetian pictures were known to Rembrandt which are unknown to us."

[37] See Bernard Berenson, *Italian Pictures of the Renaissance, Venetian School*, II, London, 1957, fig. 851.

[38] *Ibid.*, fig. 928.

[39] *Ibid.*, fig. 1122.

[40] See J. Paul Getty, *The Joys of Collecting*, New York, 1965, pp. 100-1.

[41] Benesch, II, A 22, fig. 582. I cannot share Benesch's skeptical attitude toward this drawing.

across the entire lower end of the picture would have provided support for both Juno's hand and scepter; moreover, the somewhat amorphous form of the peacock would have been less disturbing than it is now.

4. "DIVITIARUM DEA"

We may finally ask what may have prompted Rembrandt to paint a picture of Juno in the first place. He was not in the habit of doing pictures of this kind and size for his own pleasure. Like the *Aristotle*, the *Alexander*, and the *Homer* painted for Don Antonio Ruffo, the *Juno* was probably also the result of a commission.

Before pursuing this question further, it will be necessary to inquire into the meaning of the picture—a problem hitherto completely neglected in the large literature about the painting. Since Juno is not rendered in any of the various incidents in which she was involved, according to ancient myths, she must be understood as an image expressing a specific quality characteristic of the goddess.

Like most Greek and Roman gods, Juno was not a fixed, immutable character of classical mythology. Even in ancient times she was venerated in different roles. She was particularly popular as Juno Pronuba, the protector of marriage. In this role she appears in Rembrandt's etching (Fig. 13) known as *Medea* (1648; Münz no. 270). Here Jason and Creusa, about to be married, kneel before the image of Juno, placed above the altar in a large temple. Juno, seen from the back, appears to be partly nude. She wears a crown[42] and holds a scepter in her right hand; her left arm and hand are in a position foreshadowing the pose of Juno in the New York painting.[43] The rather sinister appearance of the idol in this print may suggest the ill-fated nature of the marriage performed before it; indeed, vengeful Medea is already approaching in the shadow of the huge columns.[44]

[42] Rembrandt added the crown only in the second state. In the eighteenth century the print was actually known as "the little Juno" (*Junootje*); true connoisseurs, according to Houbraken (*op.cit.*, [28] p. 271), were not happy unless they owned the *Junootje* both with and without the crown!

[43] Rembrandt's teacher, Pieter Lastman, had painted in 1630 a *Sacrifice to Juno* (see K. Freise, *Pieter Lastman, Sein Leben und seine Kunst*, Leipzig, 1911, 79, no. 105, fig. 30). While Rembrandt surely knew this picture, Münz (*op.cit.*, II, p. 116) goes too far when he says that Rem-

brandt's *Juno* of the Medea print "may have been taken" from Lastman's picture.

[44] The only other rendering of Juno in Rembrandt's work is found in the drawing of *Mars and Venus Caught in a Net* of ca. 1638 (Fodor Museum, Amsterdam, Ben. 540) where she appears as one of numerous gods who watch curiously as Vulcan exposes the caught lovers—and his own shame. Accompanied by the peacock and completely nude, she is seen in lost profile sitting near the right edge. (I owe the reference to this drawing to Seymour Slive.)

Scepter and crown are standard attributes of Juno, identifying her as the queen of the Gods; they are sanctified, as Natale Conti tells us in his book on mythology,[45] by ancient custom: "Hanc Deam cum coelicolarum reginam putarent cum sceptro et diademate fingere mos fuit antiquorum" (This goddess whom they believed to be the queen of the heavens, the ancients customarily depicted with scepter and diadem). Yet Conti himself enlarges on her functions when he says: "Dicitur Juno . . . Reginaque esse Deorum et divitiarum Dea, partubus et matrimoniis praefecta"[46] (Juno is said to be the Queen of the Gods and the goddess of wealth, and to preside over births and marriages).

This phrase expresses a concept repeated over and over again in Renaissance writings about Juno: that she is the Goddess of Wealth. The popularity of this concept—aside from the passionate interest in material possessions characteristic of the early centuries of capitalism—was surely due to the eminence of the author who had first emphasized it: Boccaccio. He had called her *Divitiarum Dea*, explaining the scepter in her hand as a symbol of her power to grant wealth and authority to rule.[47] Wherever the various interpretations of Juno are discussed, as for instance in Vincenzo Cartari's Iconology of the Gods,[48] Boccaccio is cited as the authority for Juno's role as the "Dea delle ricchezze." And it was Boccaccio, too, who allegorized the peacock, traditional bird of Juno, as representing the pride and arrogance that go with wealth.

Boccaccio's characterization of Juno as Goddess of Wealth had, of course, earlier sources, including ancient ones. He was surely familiar with Alexander Neckam (d. 1217) who stated that those who had acquired wealth quickly, the *nouveau riches* owed their good fortune to Juno: "Dicitur autem fortuna Juno quasi juvans noves. Novus autem dicitur quilibet subito ditatus" (a *novus* is called he who became suddenly rich).[49] He surely knew also that one of Juno's Roman titles had been *Juno Moneta*. Originally this title had no reference to money but was apparently coined to express Juno's function

[45] *Natalis Comitis Mythologiae sive explicationum fabulorum libri X*, Venice 1581, II, ch. IV, p. 89. (The first edition was published in 1551.)

[46] *Ibid.*, p. 93.

[47] Giovanni Boccaccio, *Genealogie Deorum Gentilium Libri*, ed. by Vincenzo Romano (Scrittori d'Italia, 201), Bari, 1951, II, p. 436: "Eam preterea regnorum atque divitiarum faciunt deam"; p. 438: "Reginam et deam regnorum atque divitiarum insuper dixere Junonem. . . ." He further identifies Juno with Earth and rationalizes her role as Goddess of Wealth by saying that from the veins of the earth come all

the metals and precious stones.

[48] Vincenzo Cartari, *Le imagini colla sposizione degli dei degli antichi*, Venice, 1556: *Giunone*. Among the authors repeating Boccaccio's statements are Giacomo Zucchi, *Discorso sopra li dei de' gentili e loro imprese*, Rome, 1602 (see F. Saxl, *Antike Götter in der Spätrenaissance*, Leipzig-Berlin, 1927, p. 61); and Joachim von Sandrart, *Iconologia Deorum, Oder Abbildung der Götter . . .*, Nuremberg, 1680, p. 64.

[49] See Hans Liebeschütz, *Fulgentius Metaforalis*, Studien der Bibliothek Warburg, IV, Leipzig-Berlin, 1926, p. 19.

as a watchful deity (*monere*: to remind, to warn). A temple dedicated to *Juno Moneta* was erected in 344 B.C. on the *arx* of the Capitoline hill. It later housed the Roman mint and *Moneta* became the word for mint. This fact, however, may have been at the root of a story according to which Juno was surnamed *Moneta* because in the war against Pyrrhus she assured the Romans that money would never fail those who cultivated justice. First reported in the tenth century compilation known as Suidas, this story was generally known and appears, for instance, in Franciscus Sweertius' commentary to Abraham Ortelius' *Deorum Dearumque Capita* (Antwerp, 1602) at the end of the discussion of *Juno Moneta*. Conti, furthermore, makes a reference to Ovid when stating that the ancients already thought Juno to have been the goddess of wealth.[50]

It is tempting to consider Rembrandt's *Juno* as the image of the Goddess of Wealth, joined to that of Juno the Queen. Standing before us not only with scepter and crown, but also dressed in a splendid costume, with chains of pearls wound around her hair, pearl earrings, jeweled necklace, and a huge shimmering brooch attached to a pearl-adorned band holding her blue velvet, ermine-lined cape on her shoulders, she is the very image of proud opulence and conspicuous wealth. This surely is not a goddess assisting in marriage and childbirth, but a divinity who represents, and is capable of distributing, the treasures of this world.

Fortunately this interpretation of Rembrandt's *Juno* can be supported by pictorial evidence. In a series of engravings illustrating various allegorical concepts (*Amor, Dolor, Labor*) designed by Marten de Vos and engraved by Raphael Sadeler in 1591, Juno appears in a print entitled *Honor* (Fig. 14). A scholar dressed in a long fur-lined coat turns from his books to the rather seductive goddess, identified by the peacock standing beside her, who carries in her hands a box overflowing with precious objects (among them chains of honor! see p. 35 ff.). The foreground abounds with symbols of secular and ecclesiastical honor (crowns, scepter, miter, crozier, Cardinal's hat); most conspicuous, in the very center and lying directly below Juno's foot, is a large money purse, obviously full. The poem underneath identifies Juno as the goddess of wealth and honor: "Favor us, Goddess Juno, who rules those in places of honor and allows them to enjoy their illustrious condition. . . ." (Statues of Bacchus and Ceres, placed in niches, indicate some of the pleasures that can be derived from an exalted position, while Juno herself seems to hint at favors normally bestowed by Venus.)

As a munificent goddess who rewards with riches those whom she favors Juno appeared still earlier in Veronese's ceiling of the Sala del Consiglio dei Dieci in Venice, painted

[50] *Op.cit.*, p. 90.

probably as early as 1555, in a scene entitled appropriately *Juno Showering Riches over Venice*.[51] The same idea is expressed with almost prosaic directness in an engraving by Goltzius (Fig. 15) where Juno's golden gifts are decoratively displayed, with other attributes of honor and wealth, in marginal sections of the print.[52]

Still more important for Rembrandt's picture is a painting entitled *The Realm of Juno*, painted by Adam Elsheimer (1578-1610).[53] Rembrandt is known to have had great interest in Elsheimer's work, and Elsheimer's influence on Rembrandt is a well-documented fact of the history of art.[54] Elsheimer's painting, *The Realm of Juno*, formed part of a trilogy of *Juno*, *Venus*, and *Minerva*, which was owned by that great seventeenth century art patron (and, as Peter Paul Rubens called him, "art evangelist"), the Earl of Arundel. The original is lost, but luckily we know its composition from a print by Wenzel Hollar, dated 1646 (Fig. 16). In Hollar's print, Juno, seen *en face* and richly gowned, sits on a throne, in a relaxed attitude. In her right hand she holds a scepter, while her left, recalling Rembrandt's Juno, is resting on her thigh. On either side of her appear palatial structures, sumptuously decorated but apparently not connected structurally with each other. They look like interiors of temples; in the huge niches of the structure at the right stand full-length statues, probably representing gods, although they cannot be identified. Numerous small figures enliven this setting. H. Weizsäcker thought that the group at the left is taking wheat to market, the one at the right wool.[55] Neither explanation is completely satisfactory, but it is obvious that the artist intended to make references to commercial activities. Most important for Rembrandt's *Juno*, however, is a figured tapestry hanging directly behind Juno in Elsheimer's work. Here we do indeed discern a figure, though it is a bearded man, in complete frontality, with a crown on his head and chains draped across his chest. Two figures, also *en face*, stand on either side. Two others, in profile and on a lower level, are in front. The picture evidently renders a king seated in state, surrounded by counselors, in a compositional arrangement derived from the old type of the *Sacra Conversazione*. Placed as it is directly behind Juno, this tapestry brings out Juno's

[51] See Juergen Schulz, *Venetian Painted Ceilings of the Renaissance*, Berkeley and Los Angeles, 1968, pl. 22, cat. no. 35.

[52] I owe the reference to this print, and the photo, to Seymour Slive.

[53] This connection was first pointed out by Professor E. Haverkamp-Begemann, "Rembrandt's So-called Portrait of Anna Wijmer as Minerva," *Studies in Western Art*, III, Princeton, 1963, p. 63. For Elsheimer's composition see H. Weizsäcker, *Adam Elsheimer, der Maler von Frankfurt*, Berlin, 1952, pl. 48, fig. 57.

[54] See Kurt Bauch, 1960, pp. 129 ff. (29). Elsheimer's influence remained strong throughout Rembrandt's career; see, for instance, his *Rest on the Flight into Egypt* in Dublin (*Rider*, Fig. 11) of 1647, and *Jupiter and Mercury at the Home of Philemon and Baucis* in Washington (Bauch no. 106).

[55] Weizsäcker, *op.cit.*, I, p. 115.

function as that of a divinity granting power and wealth, while the activities on either side refer to the economic basis of this affluence.[56]

It can be safely assumed that Rembrandt was familiar with this composition by Elsheimer. He probably knew it from Hollar's print. In fact, in the present state of our knowledge, Elsheimer's *Realm of Juno* must be considered the chief source, iconographically and even formally, for the New York canvas. This does not rule out Rembrandt's having been familiar with, and possibly influenced by, still other formulations of the theme. He himself had owned, until it was sold in 1658, a painting of Juno by Pynas, a Dutch follower of Elsheimer's and probably one of Rembrandt's own teachers. (In one of his last attempts as collector, unsuccessful, as we know,[57] he had tried to buy three paintings by Lastman and Pynas.) Moreover, since Elsheimer's *Juno* was part of a set of three pictures, the other two representing Venus and Minerva, it is of considerable interest that a similar triad, also painted on individual panels by Frans Badens (1571-c. 1621), was listed in the inventory (July 7, 1632) of Pieter Lastman's estate.[58]

Rembrandt's Juno was painted at a time when the artist had suffered severe financial setbacks and was deeply in debt. A sentimental approach to art history might be tempted to interpret the painting as a work in which the impoverished master wistfully conjured up the resplendent goddess of wealth whose gifts had been denied to him in actual life. The truth, however, is probably different. As we have said, Rembrandt was not likely to have painted a picture of this size and importance without a commission. Fortunately, we know of one man who was eminently justified in asking for a painting of Juno, the goddess of wealth: none other than Harmen Becker, the rich collector and money-lender, who was so anxious to have Rembrandt complete the painting. Juno had indeed smiled on him and as a *nouveau riche* in Alexander Neckam's sense he had good reason to be grateful to her. It was probably not by accident, considering the relative rarity of single pictures of Juno, that Becker owned two representations of this subject.

Rembrandt, at any rate, was no favorite of the goddess. In his younger years he had indeed sought for, and in a measure achieved, both wealth and social status. But by the

[56] Elsheimer's triad, as Mrs. Kahr kindly reminded me, like that of Frans Badens mentioned below, may well have been connected with the old concept of the *vita triplex* (Fulgentius II, ch. 1) in which Juno represented the active life, while Minerva stood for the contemplative and Venus for the amorous or sensual (see H. Liebeschütz, *op.cit.*, p. 4, and p. 20, note 32, and Jean Seznec, *The Survival of the Pagan Gods*, Bollingen Series, XXXVIII, New York, 1953, p. 107 and fig. 32). The background scenes in Hollar's print are indeed excellent illustrations of the *vita activa*.

[57] See Hofstede de Groot, p. 298, no. 253.

[58] K. Freise, *op.cit.*, p. 19: "Drie tronien van Badens, als Venus, Juno en Pallas."

time he painted the *Juno*, he had long since abandoned such ambitions. The brazen display of opulence and wealth in the *Juno* in fact is an exception in a period when in his art he probed the emotional depths of tragic heroines and troubled men. Could it be that the subject may have failed to sustain the master's interest, as he increasingly turned to the moral and spiritual spheres as embodying the true values of man's existence? And if he indeed procrastinated in finishing this particular picture (and as we have seen, he may have never "finished" it at all)—was this possibly due, besides other factors, to a subconscious rejection of its very theme?

IV. REMBRANDT AND THE BOOK OF TOBIT

I. THE NARRATIVE

IT IS one of the commonplaces of the Rembrandt literature that the master took more subjects from the Bible than from any other written source. One curious fact, however, has not been considered worthy of comment. Rembrandt illustrated the Book of Tobit more often than any other biblical text of comparable length. The Book of Tobit, fourteen short chapters in all, occupies less than one half of one percent of the Bible that Rembrandt is likely to have used. Yet there are extant about fifty-five drawings, etchings, and paintings by Rembrandt illustrating scenes from Tobit, or approximately seven percent of all religious subjects found in his work, including even those of a non-biblical nature.[1] The purpose of the following pages is to present briefly the most important of Rembrandt's illustrations of the Book of Tobit, and then to explore the reasons for Rembrandt's interest in this text. If anything, this study bears out a truth well formulated as early as 1718 by Arnold Houbraken, an author who was hardly one of Rembrandt's greatest admirers: "In his art he was full of ideas, so that one sees not infrequently many different sketches made by him of the same subject, each one distinct from the other in expression, movement, and manner of clothing. . . . In this respect, indeed, he excelled all others, and I know of no one who made so many variations in rendering one and the same subject."

Tobit is one of the so-called apocryphal books of the Old Testament. Together with such popular books as Judith, the Wisdom of Solomon, Jesu Sirach, and the Maccabees, it had been included in the Vulgate, and in 1546 was accepted by the Catholic Church as part of the canon of the Bible. Newly translated from the Greek, it formed also part of the Dutch Bible as established at the Synod of Dordrecht of 1618, though in a preface the reader was properly warned of its untrustworthy nature.[2] It also formed part of Luther's

[1] I prefer to avoid a precise figure for the number of Rembrandt's illustrations for the Book of Tobit since there is disagreement among scholars whether certain drawings should be accepted. The problem involves subtle questions of connoisseurship not germane to the purpose of this study. For the same reason I have not tried to include all of Rembrandt's drawings dealing with Tobit, although I hope no major item is missing. Drawings and paintings omitted appear in the final note, along with a list of abbreviations for drawing numbers.

[2] The compilers of the Dordrecht Bible gave the following reasons for the untrustworthiness of the Book of Tobit: 1) it contains contradictions, and the Greek and Latin texts are at variance; 2) the angel tells a lie when he says his name is Azarias when in fact he is Raphael; 3) the story of the expulsion of the evil spirit sounds like a "Rabbinical fable"; 4) it is not likely that seven bridegrooms were killed by an evil spirit.

Bible but was not included in the King James version. Though much read in former times, it is little known today. Since Rembrandt's illustrations cannot be understood unless the main lines of the story are known, we shall begin with an abbreviated rendering of the narrative.

After the Kingdom of Israel had been invaded by the Assyrians, many Jews were carried into captivity, Tobit among them. Once rich, he had lost his fortune and for a while had hidden from the wrath of King Sennacherib. At the beginning of the story we find him living in Nineveh with his wife Anna and their son Tobias. Tobit is a pious man who keeps the laws of his religion even in exile. He feeds the hungry, clothes the naked, and buries the dead, even those killed by the king. One day his son tells him of a slain man lying in the street. Tobit buries the corpse at sundown. Since he feels unclean (or "tired," as the Vulgate has it), he lies down to sleep under a wall. During the night excrement from a swallow's nest falls on his eyes, covering them with a white film that blinds him. According to the version in the Dutch Bible, he visits doctors, but in vain.

Anna now supports the family by spinning. Satisfied with her work, her employer one day gives her a young goat in addition to her wages. But Tobit suspects her of having stolen it and commands her to return it. Seeing that he does not believe her repeated assurances, Anna grows angry and berates her husband. To Tobit this is a sign of God's wrath and he asks for death.

The same day, in faraway Ecbatana, a young woman also wishes to die. She is Sarah, daughter of Raguel. Married seven times, she has lost each husband on the wedding night before the marriage was consummated because of an evil demon who possessed her. Not surprisingly, no one else wanted to marry her. She is scolded by her maid—as Tobit is scolded by his wife—and accused of the murder of her husbands. Like Tobit, she too asks God for death. God hears the prayers of both these unfortunates and sends Raphael, the archangel, to help them.

Tobit now calls his son Tobias and admonishes him at length. He asks him for a burial when he is dead and urges him to honor his mother. He tells him to obey God's commands, to support the poor, to marry only a woman of his own people, not to get drunk, and to pay wages promptly. Remembering that a man in Media owes him some money, he asks Tobias to collect it. Urged by his father to find himself a traveling companion for greater security, Tobias goes out—and finds Raphael, who calls himself Azarias and whom he does not recognize as an angel. Tobit convinces himself in an interview with the youth of his reliability and agrees to pay him, besides his expenses, a drachma a day and a bonus upon safe return.

They leave, a little dog with them. At the River Tigris, Tobias tries to bathe but is attacked by "a fish." At the angel's command, he catches it and takes its heart, gall, and liver; they eat the rest. Heart and liver, so his companion informs Tobias, if laid on hot coals, will drive out evil spirits; the gall is a good remedy for blindness. The outcome of the story can now be guessed, especially as the angel suggests to Tobias that he ask for Sarah's hand. When Tobias, evidently aware of her seven previous husbands, is somewhat reluctant to take the advice, Raphael explains to him exactly what to do.

In Ecbatana they go straight to Raguel's house and after some exchange of news (for Raguel is acquainted with Tobit) Tobias is accepted as Sarah's eighth husband. The wedding is held the same day. When the newlyweds are alone, Tobias burns the liver and the heart of the fish and with their smell drives out the demon. Then they pray and finally go to sleep. Raguel, who—fearing the worst—had begun to dig a grave, is elated to hear from the maid that all is well. Now the wedding is celebrated in earnest. In order to save time, Tobias charges Raphael with the collection of the money and nothing is heard further of that old debt. At the end of two weeks of celebration Tobias receives one half of all of Raguel's property and they part with good wishes.

In the meantime, in Nineveh, Tobit and Anna have almost given up hope of Tobias' return. All the greater is Anna's joy when she sees the two youths returning, far in advance of their following. Blind Tobit tries to meet them but in his haste hits the door. Rushing up to the old man, Tobias spreads the gall of the fish on his eyes and, peeling off the blinding film, makes him see again. Then the marriage is celebrated for another week, at the end of which Tobit urges his son to pay his companion the wages agreed upon and to give him something extra. When Tobias generously offers one half of all his goods, the angel finally discloses himself, again stressing the importance of almsgiving. In the text Raphael addresses only the father and son; they fall to the ground, covering their faces in fear. When they get up, the angel has disappeared. The story ends with a prayer of thanks by Tobit, whose blindness, we are informed, has lasted for eight years, and a brief summary of the later life and eventual death of both father and son in ripe old age.

2. THE ILLUSTRATIONS

We need not concern ourselves with the origin or nature of this strange tale or how it came to be a part of the Bible. Suffice it to say that long before Rembrandt, and especially from the beginning of the sixteenth century, it had provided artists with material

for pictorial representation. Northern artists—Barent van Orley, Jan Swart, Cornelis Massys, Marten van Heemskerck, and Georg Pencz, among others—had selected the Book of Tobit for cyclical illustration. Scenes from the Book of Tobit are found in the works of many of Rembrandt's immediate predecessors, such as Adam Elsheimer, Pieter Lastman, Willem Buytewech, Paul Bril, and Jan van de Velde. Most common was the rendering of Tobias, walking in the company of the angel (already popular with Italian painters of the Quattrocento, whose pictures were probably intended as ex-votos for the safe return of traveling children), and the healing of old Tobit. Some incidents of the story, illustrated by earlier artists, do not appear in Rembrandt, such as Tobit burying the dead, and the collection by Raphael of the money owed by Gabel. Conversely, Rembrandt depicted aspects of the tale other artists had treated rarely, among them the long wait of his parents for Tobias, and Tobit walking to the door to greet his returning son.[3] The shift from scenes of objective action to those charged with subjective feeling is in itself significant, but beyond this Rembrandt stands alone by virtue of the sheer number of works inspired by the apocryphal book; moreover, his interest in the Book of Tobit manifested itself from the very beginning of his career and came to a climax in the 1640's and 1650's, abating only—if we can trust the evidence of his extant work—during the last ten years of his life.

The pathetic misunderstanding between Tobit and Anna about the little goat is the first incident of the story to appear in the work of the master, in a small painting in the collection of Baroness Bentinck-Thyssen, Paris, done in 1626 (Fig. 1), when Rembrandt was only twenty years old. The panel depicts the two old people facing each other in the foreground. Still clutching the goat in her arms, Anna looks in perplexed exasperation at her husband who, sitting on a low stool, his hands folded in a prayerful gesture, laments over his wife's "theft." The little dog cowers in the shadow between them, close to a fire burning on the floor. Like their wearer, Tobit's torn shoes and patched garments appear to have seen better days.[4]

[3] The wait of Tobit and Anna for their son's return had been treated before Rembrandt by Willem Buytewech in a drawing in Rotterdam, see E. Haverkamp-Begemann, *Willem Buytewech*, Amsterdam, 1958, p. 83, fig. 129. Unlike Buytewech's rendering of the story of the goat this drawing was apparently not turned into a print and since, in addition, it is very different from Rembrandt's treatments of the subject, there is no reason to assume that he knew it.

[4] Rembrandt's point of departure, as H. Jantzen first observed, may have been Jan van de Velde's print after Buytewech, see Kurt Bauch, *Die Kunst des jungen Rembrandt*, Heidelberg, 1933, pp. 21-22, fig. 11. See also E. Haverkamp-Begemann, *op.cit.*, p. 6 and fig. 126. Bauch stressed correctly the wide gap that separates the two works, both compositionally and as regards the expression of the figures.

Nineteen years later Rembrandt painted this scene again in a painting in Berlin (Fig. 2). In keeping with his general development Rembrandt now stresses mood more than action. Instead of juxtaposing the two figures in a sharp light in the foreground, he almost hides them in the shadowy recesses of a large barn-like room. A warming fire still burns close to the seated Tobit, while Anna stands near him, apparently more sad than angry; she holds the obstreperous little goat with a short rope. Her spinning wheel disappears in the shadow of one corner. Although the light of a bright day fills the large, partly open window, it fails to lift the gloom of this melancholy interior.

The story of the goat appears also in three of Rembrandt's drawings. In the sketchiest of them, drawn in a few harsh lines of the pen, the two figures face each other in a simple but telling confrontation (Berlin, Fig. 3). The pathos of the situation is slightly relieved by the surprisingly large goat turning in utter unconcern away from the harassed woman. The staging of the scene is similar in another drawing (Fig. 4), but the figures are sketched with gentler lines and Anna assumes a less aggressive pose. Rembrandt indicated the nature of the setting with a few sure strokes of the quill, including a fireplace behind Tobit. As in the Berlin painting, he emphasized the spinning wheel, which looms large also in the last drawing (Fig. 5). Here Anna pleads with her husband, whose blindness is made more poignant because he does not face his wife, standing behind him; his worried gesture is projected into empty space.

In the 1650's, when he occupied himself intensively with the story of Tobit, Rembrandt twice drew Tobit sleeping near a wall, beneath the fatal swallow's nest. The drawing in Rotterdam (Fig. 6) is the more explicit of the two, showing not only the nest above Tobit's head, but also the spade he had used to bury the dead man.

Tobit interviewing the angel was rendered by Rembrandt in two beautiful drawings. The earlier one (Fig. 7) resembles in some ways the Stockholm sketch of the incident with the goat. As in that sketch, Tobit sits with his back to the window and the spinning wheel stands before him at the left. Here, however, Anna sits at the wheel and continues working as she regards the stranger. At the right a sturdy, youthful Tobias turns his back to the scene. He looks down at the dog who, jumping up at his master, wags his tail eagerly, anticipating an outing. In the slightly later drawing (Fig. 8)[5] Tobias sits apart, putting on his boots, while directly in the center of the composition his father

[5] An almost identical drawing, until recently considered to be from Rembrandt's hand, is in the Rijksmuseum in Amsterdam (Ben. no. 870, fig. 1080). Although the Rotterdam version has evidently suffered and been cut above and below, I follow W. Sumowski (*Pantheon*, XXII, 1964, p. 20) in accepting it as Rembrandt's original.

earnestly talks with the angel. Holding the spindle under her arm, Anna sits on a low stool at the left. Thus a regular pyramid is formed of the three major figures.

The moment of actual departure appears in a drawing considered by Benesch as only a faithful copy (Fig. 9). The parents have accompanied the youths to the door, where the angel appears to talk reassuringly to Tobit as he shakes his hand in a last farewell. Tobias, bending down, makes a check of his shoelaces while the dog has already partly disappeared outside the door.[6]

It is worth noting that Rembrandt usually provided the angel with wings, despite the fact that until the very end of the story his divine nature is never suspected. Others know him as "Azarias" and only when he is about to disappear do they learn that in fact he is Raphael. Rembrandt had good reasons, beyond those of convention, for showing "Azarias" with wings. Just as the reader of the Book of Tobit knows from the outset the true nature of Tobias' traveling companion, so the viewer of Rembrandt's drawings and etchings need not be deceived; it is enough that the actors in the narrative are in the dark. (The problem must have been of some concern to the unknown author of the Book of Tobit, for in the end he lets the angel tell father and son that while they saw him eat and drink he never actually did so—that it was all an apparition.) Moreover, a wingless angel would have looked too much like Tobias himself, and might have been confused with him.[7] In two of his drawings, however, Rembrandt depicted Raphael without wings (Fig. 16 and Ben. no. 866).[8]

The largest number of drawings—about fourteen or fifteen—deal with the journey of Tobias with the angel and the incident of the fish. None of these dates from before 1640, or from after 1655, with the majority done in the years just prior to and shortly after 1650. One drawing (Fig. 10), according to Benesch only the copy of a lost original, shows the youths conversing as they walk side by side, paced by the little dog. In another (Fig. 11) they are at rest. Tobias loosens a boot before bathing in the nearby river, while Raphael sits and watches. On the far side of the stream one can distinguish small figures and cattle.

The encounter with the "fish" is depicted in two stages. In the more frequent of the

[6] Rembrandt dealt with this theme very differently in a slightly later drawing, which unfortunately has been badly disfigured. What originally was meant to be an indoor scene was changed by a later hand into a most incongruous open air event (Ben. no. 866). Only the figures are by Rembrandt, who also drew the spinning wheel and the chair. The landscape and the architecture are clumsy additions. The only drawing that shows Tobit actually embracing his departing son, it also is rather exceptional in that it depicts the angel as wingless and omits the dog.

[7] This idea was expressed by Miss Susan Silberman in a seminar report on this theme.

[8] See on this point also F. Lugt, "Man and Angel," *Gazette des Beaux-Arts*, 1944, pp. 324 ff.

two, Tobias, often shown rather young, draws back in fear when suddenly confronted with the aggressive creature. In what may be the earliest rendering of that moment (Fig. 12), the incident is set in a narrow, heavily wooded mountain gorge where the small figures of the scared Tobias and the watchful angel are almost lost in the jumble of broad quill strokes. In later drawings Rembrandt concentrates more on the figures. The angel generally assumes the role of mentor, reassuring the frightened boy, as for instance in the quick draft of the figures alone (Fig. 13), or in a drawing in Vienna (Fig. 14) with open scenery and distant mountains characteristic of the master's style of the mid-fifties. In the drawings showing him in the act of opening the fish, Tobias kneels on the ground, a knife in his hand; the angel calmly supervises the operation, occasionally bending down to keep a watchful eye on the proceedings (Fig. 15).

The events in Ecbatana Rembrandt told in two supremely beautiful drawings. The one in Amsterdam (Fig. 16) has occasionally been interpreted as a scene of departure, either Tobias' first leave-taking from his parents, or his second, from the family of his wife. The general mood of sadness and the (wingless) angel's turn towards the door might seem to support this theory. Yet most scholars appear to favor the thesis that it represents Tobias welcomed by Raguel.[9] The subdued mood of the drawing indeed reflects closely the text (7:7-8) which tells that when the young man had introduced himself, Raguel "got up and kissed him and cried . . . and when he heard that Tobit had lost his eyesight he became sad and cried, and Edna his wife, and Sarah, his daughter cried also." The angel's turn to the door may indicate that it was he alone who finally went to collect the money, though his departure took place only after the wedding night. And there is a rather meaningful differentiation between the two women: while Edna looks down, Sarah appears thoughtfully to examine the young stranger whom her father, a few lines further on in the text, accepts as his son-in-law. The clinching argument in favor of this interpretation is furnished by a drawing done by Marten van Heemskerck in 1555, now in the print room at Copenhagen (Fig. 17). It forms part of a set of ten drawings to the Book of Tobit—the most extensive set of illustrations of this book prior to Rembrandt.[10]

[9] Since the first appearance of this study Professor Seymour Slive has also come out in support of this identification (*Drawings of Rembrandt*, New York, 1965, 11, no. 320). He called attention to the fact that Wickhoff had been first to recognize the correct subject, followed later by Henkel and Benesch. A drawing by Bol (Ben. no. C 6, fig. 543) rendering the arrival of Tobias and the angel in the house of Raguel has been assumed to be a copy of a lost Rembrandt drawing. I cannot believe that Rembrandt invented the rather dull and psychologically shallow scene.

[10] Heemskerck's cycle consists of the following scenes: 1) Tobit blinded by the swallows' excrement. 2) The incident of the goat. 3) Tobias and the angel depart. 4) Tobias catches the fish. 5) Tobias welcomed by Raguel. 6) The marriage of Tobias and Sarah. 7) The incidents of the

Assembled on a platform in the foreground and arranged in the same sequence as in Rembrandt's drawing are the same five participants in the event. At the left is the angel, here still facing the other actors. Tobias and Raguel embrace each other in the center; Sarah and Edna stand attentively at the right. It is worth noting that in Heemskerck's interpretation, Sarah, too, looks at her future husband who in turn spies her across Raguel's shoulder. Heemskerck's drawing, made to be engraved, includes an elaborate background containing two subordinate scenes. At the left an animal is butchered in preparation of the wedding feast; at the right a few figures are seen at table, among them the bride (between her parents?) and the angel facing her from the other side.

The Dutch mannerist, making free use of his archaeological studies, was obviously interested in depicting his tall and slender figures as classical in costume, hair arrangement, and pose. Rembrandt's dominant theme, by contrast, was the emotions felt by the participants. Immobilized in their close embrace, Raguel and Tobias form a group in which—not unlike Rembrandt's later interpretation of the Prodigal's return—an old man's tender love for a younger one is movingly portrayed. The rather boyish youth, seen from the back, is completely enclosed in the arms of the old man, who kisses him in welcome, while the women, having just descended the spiral staircase at the right, watch from the landing that is one step higher than the actual floor. The emotional reticence of the scene is reflected even in the technical execution of the drawing. It was all done with the reed pen, a favorite tool of Rembrandt's later years, handled here with the greatest delicacy and economy.

The second drawing illustrates the events of the wedding night (Fig. 18). Done around 1650, it is only slightly earlier than the Amsterdam sketch of Tobias' welcome in Raguel's house, but the lines, drawn with the quill, rush across the paper like so many flourishes. As the heart and liver of the fish burn in a brazier on the floor, the grotesque demon—no

wedding night. 8) Tobias and Sarah take leave from Raguel and Edna. 9) Tobias returns and is greeted by his mother. 10) The angel departs. (Mr. Jan Garff is preparing a publication of the extensive collection of Heemskerck drawings in Copenhagen, and I am indebted to him for his assistance in examining them.) The scene of Tobias' arrival in Ecbatana appears also in a set of seven prints after Marten de Vos, but is depicted slightly differently: while Raguel embraces Tobias, Edna welcomes the angel and Sarah greets the little dog. There are two addi-tional figures watching the scene. The main scenes illustrated in Marten de Vos' cycle are: 1) Tobit buries the dead. 2) Tobit is blinded by the swallows' excrement. 3) Tobias and the angel depart. 4) The incident of the goat. 5) Tobias welcomed by Raguel. 6) Tobias and Sarah take leave from Raguel and Edna. 7) The angel departs. Several of Marten de Vos' prints have subsidiary incidents, among them Tobias catching the fish (on 3); the wedding feast and the prayer at the wedding night (on 5); the eye-operation (on 7).

more than a hasty scrawl of the pen—flies from the room. His departure goes unnoticed by the young couple devoutly praying for deliverance. Framed by large curtains, Sarah props herself up in bed; Tobias, in accordance with the biblical text, has risen from the bed and prays, kneeling on the floor. Through a partly opened door one sees a stooped elderly man, presumably Raguel, digging a grave. (It cannot be the servant sent into the bridal chamber to see how things were going, since this errand, as in other stories of this kind, was entrusted to a maid.)

The gist of this episode lies in its stress on conjugal chastity. Tobias told Sarah specifically that his main concern in taking a wife is not the gratification of sensual passion but the assurance of offspring. It is not the least of the merits of Rembrandt's drawing that the master was able to portray in it persuasively as delicate a relationship as continent love.

Rembrandt passed over the long celebration of the wedding, but he did devote one drawing to the homeward-bound travelers, who are now three: sporting the large-brimmed hat that often denotes foreign origin (Fig. 19),[11] Sarah rides on a donkey. The animal is led by Tobias, who walks ahead, still with Raphael by his side. The small caravan moves straight towards the foreground, sustained and almost propelled forward by a sweeping curve of buildings and trees. Bounded at the top, as are so many of Rembrandt's later drawings, by a shallow arch, this is one of Rembrandt's most "finished" compositions among his illustrations of the Book of Tobit.

Except for the incident of the goat, only the closing events of the story were depicted by Rembrandt in the more permanent media of painting and etching. He may have been the first artist ever to render the long and melancholy wait of the parents. It appears in a painting of around 1630 which one of Rembrandt's pupils, Gerard Dou, painted probably under Rembrandt's guidance and possibly with his aid (see below p. 127 and Fig. 48) We meet the subject again in a very late painting (1659, Fig. 20). In a dismal interior, barer still than the one in which, fourteen years before, Rembrandt had depicted the story of the goat, we see the elderly couple in their lonely vigil. Anna, the ever industrious, sits near the window and spins; Tobit, head sagging and hands idle, has drawn his chair close to the fireplace, as if to avoid an old man's chill.[12] The lonely couple appears to have

[11] Traditionally associated with gypsies (Egyptians), this hat is often worn by the Virgin Mary in renderings of the Flight into Egypt, see S. J. Gudlaugsson, *Ikonographische Studien über die holländische Malerei und das Theater des 17. Jahrhunderts*, Berlin, 1938, p. 21.

[12] The painting in the Museum van der Vorm has an undeniable similarity to emblem no. XLIV in Johan de Brune's *Emblemata of Zinne-werck*, Amsterdam, 1624. Accompanying a text in praise of humble industry, the true rewards of which will come only in the next world, the engraving

run out of words; neither a passing neighbor outside nor a bird twittering in a cage near the window are able to relieve the oppressive silence. This, undoubtedly, is one of Rembrandt's saddest pictures.[13]

At long last, the son arrives. The biblical text describes vividly how his mother greets him, but Rembrandt failed to depict this scene. Twice, however, he etched old Tobit, as he walks to the door to welcome his son.[14] In a very early and very small etching (Fig. 22), hardly more than a quick scribble, the stooped old man is seen shuffling towards the open door, beyond which are the vague indications of a landscape, possibly even of small figures. In the manner of the blind, he extends his right arm, but the indistinctly rendered hand may also convey a greeting.

More than twenty years later Rembrandt came back to the subject in another etching (Fig. 23). Not only is this print done in the lucid manner of etching often found in Rembrandt's later years but it describes the moment in terms of emotionally charged narrative details obviously derived from a long familiarity with the story. Tobit, who

shows an elderly couple in a modest interior. The woman sits at the left and like Anna she is spinning. The old man, like Tobit, sits near the fireplace at the right. The analogy thus extends both to the formal arrangement and to the sympathetic treatment of an elderly and poor couple. The only major difference is found in the fact that in the print the old man is busy also, whittling what looks like a spindle (Fig. 21).

[13] The surface of the painting in the Museum van der Vorm has a peculiar texture. It was painted on top of a still life executed in a rather heavy impasto, the brushstrokes of which look almost like foliage. According to Prof. H. Gerson (written communication) this still life, however, was painted by another hand.

[14] A painting given to Rembrandt by some scholars (Fig. 49) depicts the meeting between mother and son in a shadowy area outside the room where blind Tobit gropes for the door. (The picture was sold at Christie's April 1, 1960, no. 37, and for some time has been exhibited at the Museum Boymans van Beuningen in Rotterdam as the work of Rembrandt.) It was known until fairly recent times as a work of Gerard Dou, under whose name it was sold at the Braamcamp

sale of July 31, 1771, see J. G. van Gelder, "Rembrandt's vroegste Ontwikkeling," *Mededelingen der koninklijke Nederlandse Akademie van Wetenschapen*, N.R. XVI, 1953, pp. 273 ff., especially p. 292 and fig. 23 and the literature quoted there. More recently, however, it has been attributed to Jan Lievens, see Reiner Haussherr, "Zu einem Tobitbild aus dem Umkreis Rembrandts," *Schülerfestgabe für Herbert von Einem zum 16. Februar, 1965*, Bonn, 1965, pp. 88 ff. According to Haussherr, this attribution has also the support of Kurt Bauch and Werner Sumowski. The painting has some significance in our study since it was hardly painted without Rembrandt's knowledge. If by Dou (which still seems to me the more likely of the two attributions) it may have been done under Rembrandt's supervision and some passages may even have been touched up by the master. Yet it is precisely in the figure of Tobit that this picture differs from Rembrandt's own approach to the theme. Rembrandt's Tobit, even in his earliest renderings, is a heavy-set, slow-moving old man, bent by age and sorrow. The agile and vigorous figure in the Rotterdam painting is incompatible with this concept.

had been sitting, as always, near the fireplace, must have heard a commotion; rising excitedly, he rushes to the door, turning over the spinning-wheel. He is greeted affectionately by a shaggy mongrel who has run ahead (a detail mentioned in some versions of the text) and has been the first to enter the familiar room. Yet the old man pays no attention to the dog. His face is still marked by the long sorrowful wait, but his mouth is open as if voicing a silent welcome; he gropes with outstretched right arm for the door—and, pathetically, misses it. Rembrandt owed this idea to the Dutch Bible, which was more specific on this count than any other version, including the Vulgate: "Ende Tobias quam uyt na de deure ende stiet hem daer aen" (And Tobias went to the door and hit himself against it). Thus even in the moment when it is about to be ended, the old man's ordeal is once more vividly brought to our attention.

Almost as frequent in Rembrandt's work as the theme of the journey is that of the cure of Tobit's blindness. Contrary to the Dutch text, which says that as soon as he met his father Tobias rubbed the gall into his eyes and peeled off the covering film, Rembrandt invariably renders the event as a medical operation. The blind father always sits on a chair near the window, his head turned up towards the light. The son, in the manner of a surgeon, generally bends over him from behind, holding a needle-like tool in his hand, while the angel, Anna, and once Sarah, too, are watching.

Rendered in this manner, the subject first appears in a painting of 1636 (Fig. 24).[15] In a cavernous room (which originally may have been still larger since the painting is believed to have been cut down) the principal figures form a small group near the window, while two others, one of them surely Sarah, watch from the shadow near the left edge. Anna, seated in front of Tobias, consolingly holds her husband's hands; Raphael, standing behind him, leans forward to observe the action more clearly. Both figures watch intently as Tobias performs what Dr. Richard Greeff once termed a medically perfect rendering of the removal of a cataract.[16] Demonstrating in great detail that Rembrandt must have watched such an operation, Dr. Greeff calls attention to the fact that Dr. Job Janszoon van Meekren, a pupil of Dr. Nicolaas Tulp (whom Rembrandt portrayed in his famous *Anatomy Lesson* of 1632), had, since 1635, specialized in eye operations.

Although Dr. Greeff connected five of Rembrandt's drawings of the healing of Tobit's

[15] A slight drawing of young Tobias curing his father's blindness, now in the collection of Count A. Seilern (Ben. no. 131), if by Rembrandt at all, should probably be connected with this painting, as Benesch suggested. Its present owner proposed a date of c. 1630, which I feel is not tenable on stylistic grounds (*Paintings and Drawings . . . at 56 Princes Gate*, III, London, 1961, no. 179).

[16] Dr. Richard Greeff, *Rembrandts Darstellung der Tobiasheilung*, Stuttgart, 1907.

blindness with this painting of 1636, all of them are now dated later. Those done in the early 1640's (Fig. 25) crowd the figures and place the action asymmetrically to one side. Later drawings (Figs. 26 and 27) bring the action closer to the foreground and define the role of each figure more precisely. In the last two, for instance, Anna is holding a little bowl, presumably containing the gall of the fish. The Berlin drawing, probably dating from the early 1650's, differs from all previous ones in that Tobias is not caught performing the "operation" but examining closely his father's eyes, preliminary to the actual cure. In the Paris drawing, made interesting also by the watchful presence of Sarah and the humorous touch of Anna peering through eyeglasses from behind Tobias' back, the angel's head is so close that it almost touches the heads of both father and son. His role as divine protector is most strikingly expressed in the Berlin drawing, where he seems to hover above the group, his one visible wing spread wide like a blessing. He is drawn in softer lines than are the other figures, as if his dematerialization had already begun.

The actual disappearance of the angel is the final act of the drama as told by Rembrandt. According to the Book of Tobit, the event was witnessed only by father and son; in Rembrandt's interpretations, the whole family is present, occasionally even servants. He first treated the theme in the well-known painting of 1637 in the Louvre (Fig. 28). Both men are on their knees, but while old Tobit looks down, supporting himself on hands folded in prayer, Tobias watches the disappearance of the angel, his hands apart in the traditional gesture of surprise. The action of the men is echoed by that of the women, who stand in the doorway of the house. Like her husband, Anna averts her eyes, while Sarah, like Tobias, follows the flight of the angel. Yet Rembrandt skillfully concealed this basic parallelism in the action of the couples. Whereas Tobit is closer to the foreground and seen in strong light, it is Sarah who is placed and illuminated similarly; Anna, like her son, is farther back, and seen in the shade. The mother's hands, in addition, are spread apart like her son's, while Sarah's are folded in prayer, like Tobit's. Rembrandt's desire, so characteristic of this period, to vary and to dramatize the subject culminates in the figure of the angel, who rushes off, towards a bright opening in the clouds, propelling himself upward with arms, wings, fluttering draperies, and vigorous motions of the legs.[17]

[17] Rembrandt derived some of the ideas of this painting, especially in the poses of the angel and of Tobit, from a woodcut by Marten van Heemskerck (see F.W.H. Hollstein, *Dutch and Flemish Etchings, Engravings and Woodcuts, c. 1450-1700*, VIII, Amsterdam, 1949, pp. 234 ff., no. 6).

In an etching done four years later (Fig. 29), Rembrandt gave a very different interpretation to this subject. We see only the legs of the angel as he disappears in shafts of light, cutting through the smoke of a brazier. The members of the family are gathered closely together in an almost classical pyramid. Now it is Tobias and Sarah who avert their eyes; Tobit, at the extreme left, follows the flight of the angel with his eyes, while Anna—the only one standing—seems to look with astonishment at the spot from which he took off. In keeping with the prolix narrative style of the period of *The Night Watch*, Rembrandt included several servants both inside and out of the building and—as a reminder of the recent arrival of the young couple—a saddled donkey and an open trunk at the right. One servant in the center of the composition, carrying a bowl or a basket, seems to have Rembrandt's own features.

A drawing associated by Benesch (no. 492) with this etching may be only a copy; but Rembrandt treated the subject in at least three more drawings. The process of concentration, observed before, is manifest also in these sketches. The drawing at Oxford (Fig. 30) must have been done around 1650 or soon thereafter. The angel has almost disappeared, though one can still see his faintly drawn feet. Rembrandt again studied the effect the miracle has on the assembled members of the family. The young couple is near us, seen from behind. Tobias, on his knees, holds a large bowl; Sarah, standing at his side, raises her folded hands close to her face. She is richly dressed and still adorned with the broad-brimmed hat. The frightened dog hides behind her skirt as Tobit kneels opposite his son, averting his face and shielding it with his hands from the light; Anna stands next to her daughter-in-law, her hands again parted in amazement. Still farther back are a donkey and a man, arms raised, looking up in the direction of the disappearing angel. At the right a servant in the door completes the group.

Closely connected with this drawing is a very light sketch in the Budapest Museum (Fig. 31). It probably represents the first formulation of the idea which took its final shape in the drawing at Oxford. Sarah and Anna appear in almost identical poses and positions, but the two men are rendered very differently. The place of Tobit in the Oxford drawing is here occupied by a barely visible Tobias. The most dramatic figure is the father, who has fallen to the ground, and even in this prostrate position still folds his hands in prayer. Rembrandt here harks back to the Louvre painting of 1637, and the Heemskerck woodcut. The figure of Tobit must have given him some trouble, for he drew him in two positions, once very thinly and a second time in bolder lines. Even so, it is a disruptive element in the composition, both formally and emotionally, and for that reason was changed in the later and more finished version at Oxford. Being less dramatic,

and formally better integrated, the drawing at Oxford surely represents the more advanced formulation in the context of Rembrandt's stylistic tendencies of the early 1650's.[18]

The atmospheric lightness of the Budapest sketch forms a striking contrast to the severity of the final formulation, now in the Morgan Library (Fig. 32), drawn around or shortly after 1655. The elaborate narrative detail of the etching and of the earlier drawings has now been suppressed. Except for the shadowy, barely noticeable face of a maid-servant in the door, no one is present but the four principal figures. Even the dog, for once, is absent. Father and son, on their knees and very close to each other, avert their eyes from the heavenly light. Sarah, upright behind them, hides her face behind hands folded in prayer. Only doughty old Anna stands her ground, following the angel's flight with her glance. As in the painting of 1637, the angel is again rendered in full length. But instead of propelling himself vigorously into the depth of space, he now seems to be drawn upward by a superior power. Seen in side-view, he rises from the ground without visible effort. His outstretched arms indicate his yearning to return to his legitimate abode. Nor is he dressed, as he was in the earlier painting, in the apparel of mortals. The earthly wrappings have fallen away from him as he assumes his true angelic nature. A few bold diagonal lines suggest not only the direction of his flight but symbolize also the luminous emanation of the heavens at the moment of this miraculous assumption.[19]

3. THE THEMES

The large number of illustrations of the Book of Tobit made by Rembrandt, particularly in the highly personal media of drawing and etching, can clearly not be accounted for by commissions. Even if one or another painting might have been done on request, it is certain that in most cases Rembrandt dealt with the story on his own volition.

What was it, then, that drew the master again and again to this strange tale of magic and miracles? The relative frequency of one or the other incident may give us some

[18] The drawing, discovered by Ivan Fenyö, was published by Otto Benesch in an article discussing at considerable length Rembrandt's renderings of this particular subject (*Bulletin du Musée Hongrois des Beaux-Arts*, Budapest, 1963, pp. 71 ff.). Benesch believes that the Oxford drawing preceded the one in Budapest, a view which I feel presents more difficulties than the one proposed here.

[19] A pupil's drawing in Vienna (Ben. no. 1373), vigorously edited by Rembrandt, is based on the composition of the Morgan Library drawing and should not be considered as a kind of "trial run" for it. The student evidently tried to introduce a few personal ideas into Rembrandt's design, none of which is worthy of the master himself.

clues, yet Rembrandt was surely attracted by the basic message of the story.[20] The Book of Tobit is one of the greatest scriptural examples of piousness and complete confidence in God's unfailing wisdom. The story deals, as one commentator put it, "with God and man, and man's relationship with man; the problem of evil and the struggle against fate, the message of faith . . . God's mercy."[21] It may well have been "the author's sturdy belief in God's compassion"[22] that struck a responsive chord in Rembrandt, to whom the theme of God's charity and compassion—witness his interest in the parable of the Prodigal Son —was of profound significance. The longest passages, after all, of the Book of Tobit are prayers (Tobit praying for death, Tobit cured of his blindness, praising the Lord) and moral admonitions (Tobit instructing Tobias before his departure).

Moreover, throughout his career Rembrandt was fascinated by those biblical stories in which God's will was communicated to man through the visible intercession of angels. The angel's function as guide and guardian, so central to the story of Tobit, he found also in Lot's flight from Sodom, in Elijah's rest on Mount Horeb, in Joseph's dream, and in the liberation of Peter from prison. The angel as messenger and interpreter makes sudden and brief appearances in the story of Manoah's Sacrifice, Hagar in the Desert, Daniel's Vision, and the Annunciation to the Shepherds. In other incidents the angel plays an active and dramatic role, as when he stays Abraham's hand before it can slash Isaac's throat with the sacrificial knife, or wrestles with Jacob, or sword in hand, stops Balaam's ass, or sustains Christ in the Agony in the Garden. All these scenes appear in Rembrandt's work, several of them more than once.

Nor are subjects involving angels the only ones in which Rembrandt depicted mortals miraculously confronted with a supernatural presence. He rendered God's visit (in the company of two angels) to Abraham, and Christ's appearance to his disciples at Emmaus; he painted the moment when Philemon and Baucis suddenly become aware that the strangers they were entertaining were actually gods. The recognition in these themes of the divine nature of unsuspected visitors or companions parallels closely the final *dénouement* of the Book of Tobit.

We cannot, however, account for the frequency of Tobit illustrations in Rembrandt's

[20] It is not very likely, given Rembrandt's highly personal attitude toward religion, that he was interested in the allegorical and typological interpretations of certain incidents of the Book of Tobit such as those found in Isidore of Seville, St. Augustine, the Biblia Pauperum, and the Speculum Humanae Salvationis (see J.J.M. Tim-

mers, *Symboliek en Iconographie der Christelijke Kunst*, Roermond-Maaseik, 1947, *passim*).
[21] *The Book of Tobit*, translation and commentary by Frank Zimmermann, New York, 1958, p. 1.
[22] *Ibid.*, p. 2.

œuvre by pointing out features which the story shares with other subjects chosen by him from scriptural or classical sources. The narrative of the Book of Tobit evidently contained specific elements which never failed to occupy the master's mind—and hand. In the absence of documentary evidence, any effort to define these special features must remain conjectural. I should like, however, to point out some areas of thought and experience which may have led Rembrandt to an ever new consideration of the apocryphal tale.

The first has to do with Rembrandt's own religious sympathies. While officially "reformed," i.e. a Calvinist, he had close contacts with such dissident groups as the Mennonite Baptists, or the slightly more liberal Doopsgezinde or Waterlander Baptists.[23] The members of these religious splinter-organizations took great pains to distinguish themselves from the large congregation of the official Calvinist church; this they did by calling each other "brother" and "sister," thus stressing the "familial" ties that their common faith had established for them.

This is precisely what the characters of the Book of Tobit do: not only do Tobias and the angel address each other as "brother," but both Tobias and Raguel call their wives "sister." Tobias in turn is called "brother" by his parents-in-law. His marriage, indeed, fulfills a specific request Tobit made of him before sending him on his journey: do not marry a "strange" woman but remember that all the patriarchs—Noah, Abraham, Isaac, and Jacob—took their wives from their "brothers'" families. The social sphere of the Book of Tobit evidently resembles that of an exclusive religious sect such as those Rembrandt knew intimately, whether he belonged to one or not.

Menno Simons, the founder of the Mennonite sect, himself referred several times to the Book of Tobit as a model for a Christian education, singling out Tobit's patience, his piety, his charity, his concepts of sexual morality.[24] The Mennonites prohibited marriage with outsiders—and must have found comfort in Tobit's injunction to Tobias to marry a woman of his own people. Mennonites in general stressed strict honesty in business dealings. They certainly approved of Tobit's repeated concern with paying fair wages to those

[23] For Rembrandt's relationship to sectarian groups, see Hans-Martin Rotermund, "Rembrandt und die religiösen Laienbewegungen in den Niederlanden seiner Zeit," *Nederlands Kunsthistorisch Jaarboek, 1952-1953*, pp. 104 ff.; Jakob Rosenberg, *Rembrandt, Life and Work*, London-Greenwich, 1964, pp. 180 ff.; W. R. Valentiner, *Rembrandt and Spinoza*, London, 1957, pp. 50 ff.; Kurt Bauch, *Der frühe Rembrandt und seine Zeit*, Berlin, 1960, pp. 198 ff. For

Rembrandt's contacts with Socinians see H. van de Waal, "Rembrandt's Faust Etching, a Socinian Document, and the Iconography of the Inspired Scholar," *Oud Holland*, LXXIX, 1964, pp. 7 ff. See also below, pp. 143 ff.

[24] *The Complete Writings of Menno Simons*, Scottsdale, Pa., 1956, pp. 380, 389, 390, 620, 950. These writings were first published in 1541, revised in 1556.

in his employ. When various Mennonite groups united in West-Friesland in 1639, they agreed that "elaborate and expensive weddings are to be discouraged, after the example of Tobit."[25]

Whatever the Book of Tobit may have meant to his Mennonite friends, Rembrandt surely had his personal reasons for turning to it more often than to other sacred writings. To start with the least important though not insignificant point, I should like to mention Rembrandt's obvious interest in the dog that accompanied Tobias and Raphael on their trip. Tobit is the only book of the Bible in which the presence of a dog is specifically mentioned.[26] Its presence sanctioned by the text, Rembrandt took obvious pleasure in including the little creature in variations of its role. When the youths get ready to leave, the dog either jumps up eagerly at Tobias, or runs ahead; at the river he barks at the fish or drinks; he is the first to greet Tobit on their return, and he lies contentedly at his feet while Tobias performs the operation; when the angel disappears, he is as frightened as his masters. In short, his behavior, while perfectly normal for a dog, is always in accord with the activities of the human beings with whom he is associated.

Rembrandt, indeed, must have had a considerable interest in dogs. He included them in many compositions—among them *The Night Watch* and *The Hundred Guilder Print* —which did not specifically require the presence of the animal. Dogs appear frequently also in the works of Peter Paul Rubens, but always in appropriate contexts, primarily in the hunt, occasionally also as pure-bred specimens to enhance the majesty of a portrait model. Rembrandt's dogs are invariably mongrels—small, shaggy, undignified, and lovable (Fig. 35). The perfect companions of the common people who make up the cast of Rembrandt's characters, they help the master to achieve the air of simple domesticity that is so basic to his art.[27]

Granted, then, that the presence of a dog may have been a feature in the Book of Tobit that appealed to Rembrandt, yet its attraction was at best marginal. The central characters of the story—omitting the angel as outside the human sphere—are obviously Tobit, the father, and Tobias, the son. And if we look for a central theme underlying the actual "plot" of the story we find it in the abiding love of these two characters for each other.

[25] C. Henry Smith, *The Story of the Mennonites*, Newton, Kansas, 1957, p. 182.

[26] "Dogs" is used in a generic, and usually pejorative, sense in a few places and Luke 16:21 specifically mentions dogs licking Lazarus' sores.

[27] It should be recalled in this connection that the first of the few paintings by Rembrandt's son Titus which were listed in the inventory of Rembrandt's belongings drawn on July 25, 1656, was a painting of "Three little dogs, done from life" (Drie hondekens nae't leven van Titus van Ryn), see C. Hofstede de Groot, *Die Urkunden über Rembrandt (1575-1721)*, The Hague, 1906, p. 206, no. 298.

The father's concern for the well-being of his son dominates the beginning of the narrative. Tobit's long speech of advice is as telling as his careful examination of the youth "Azarias," who has offered to accompany his son. But as the story develops, the reader becomes aware how deeply this love is returned by the son. When Tobias first rejects the angel's advice to marry the woman whose previous husbands have all died, he does so because his death would be a blow to his father, whose only son he is (6:16). When, to speed up matters, he sends Azarias-Raphael to collect the money, he does so because he knows his father is counting the days and will be grieved if he tarries (9:4). When Raguel tries to persuade him to stay longer, he answers, "No, let me return to my father" (10:11). His filial piety culminates in the healing of his father's blindness as the very first act after his return.

Rembrandt's illustrations of the story show how well he understood the importance of this theme. In his renderings of the angel's disappearance, for instance, he always places father and son side by side, and generally so that they complement each other's actions. Both men kneel or fall to the ground, while the women stand behind them. (Only once—in the etching of 1641—is Sarah also on her knees; Anna always stands.) The most beautiful expression of the tender love between father and son is found in the last drawing (Fig. 32) where the two men practically form one silhouette, their heads appearing to touch.

Indeed, stories demonstrating the ties of affection between father and son always appealed to Rembrandt. He found a wealth of material in biblical narratives but often used his own imagination to make us strongly aware of this particular relationship. When he drew Jacob listening to Joseph's account of his dream, he rendered the patriarch holding little Benjamin protectively between his knees (Ben. no. 527). While Joseph, in the beautiful painting in Cassel (Figs. 33 and 34), in perfect accord with the wording of the Dutch Bible,[28] tries to correct what he thinks is a mistake of his father's, he does so ten-

[28] In the long-standing controversy about the precise meaning of this picture it has never been observed that Rembrandt followed literally the wording of the Dutch Bible (Genesis 48:17): "ende hy *ondervattede* sijnes vaders hant/om die van Ephraims hooft/op Manassehs hooft af te brengen" ["and he took his father's hand *from below*, to move it from Ephraim's head to that of Manasse"]. Nor can it be doubted that Jacob touched Manasse's head with his left hand, thus crossing his arms in keeping with an old iconographic tradition. Recently X-ray photos have shown that originally Rembrandt had painted Joseph's head leaning away from Jacob's, with an expression of displeasure. Only in the final version did Rembrandt soften this conflict and stress the fundamental harmony between father and son (see Ilse Manke, "Zu Rembrandts Jakobsegen in der Kasseler Galerie," *Zeitschrift für Kunstgeschichte*, XXIII, 1960, p. 252).

derly and with a son's complete love. In a drawing of the dismissal of Hagar (Fig. 36) Abraham seems to talk gently to the young woman, but his outstretched hand hovers for a moment—as if in blessing—above the head of Ishmael, who, after all, is his son, too. A father's sorrow for the lost son is depicted in the drawings where Jacob laments the death of Joseph upon seeing the bloody coat (Ben. nos. 95, 971) and Adam kneels in despair near the corpse of Abel (Ben. no. 955). Two subjects stand out as particularly significant of Rembrandt's interest in themes involving fathers and sons: Abraham's sacrifice of Isaac and the return of the prodigal son. Both appear in Rembrandt's work in several versions, the later ones invariably gaining in psychological depth. Of his renderings of the sacrifice of Isaac, only the etching of 1655 did full justice to the underlying pathos of the story (Fig. 37). It is beyond doubt the most moving rendering in art of the agony of a father whom God has commanded to sacrifice his only child.[29] None of his earlier illustrations of the return of the prodigal son equals the emotional density of his late painting in Leningrad, where in an almost audible silence the stooped father gathers to him the wayward yet still beloved child.

If Rembrandt's later works reveal an increased depth of interpretation of themes involving the relationship between father and son, this is probably due to something more specific than the master's general spiritual growth and maturity. Of the four children his first wife Saskia had given him, only a son, Titus, had survived. When Saskia herself died before the boy was a year old, the care of her child became a major concern of Rembrandt's private life. And since with Rembrandt all aspects of his private life found their echo in his work as an artist, the existence and development of Titus are clearly reflected in his works. The boy appears in a great number of actual portraits. He is observed as he ponders his work for school (Fig. 38), and as he writes and reads. We can follow the growth of the smiling child into a pensive, frail adult (Fig. 39). We may recognize Titus also in sketches of children whom an elderly nurse—perhaps the housekeeper Rembrandt hired after Saskia's death—teaches to walk (Ben. no. 706).

He appears, finally, as a model in paintings of a narrative context. It is little Titus, no doubt, with his high-curving eyebrows and golden curls who, in the role of Samuel, kneels at the feet of his mother Hannah (1650, Fig. 40).[30] Most meaningfully, however,

[29] In the first printing of this essay I had proposed that Rembrandt's emphasis on the sufferings of Abraham had been suggested to him by a passage in Menno Simons' *True Christian Faith* (*The Complete Writings*, p. 351). The founder of the Mennonites had indeed described the patriarch's agony in vivid and moving terms. Yet I now believe that another source may have been more important for Rembrandt: Theodore Beza's play, *Abraham Sacrifiant*. Beza (or de Bèsze, 1519-1605) had accepted Calvinism in 1548 and soon after (1549-1550) had written the

Titus appears as the inspiring angel in the painting of *St. Matthew* of 1661 (Aristotle, Fig. 4). Casting Titus in the role of the divine messenger, who with his luminous face and gently touching hand promises to clear the troubled mind of the evangelist, Rembrandt surely did not simply work from a convenient model. He acknowledged parabolically, as it were, the true place his son had come to occupy in his private scheme of things. We may also ponder the significance of the fact that Rembrandt, who had survived many severe blows, died within a year of the premature death of his son.

From Rembrandt's interest in the father-son relationship, reinforced as it was by his private experience, leads a clear path to his preoccupation with the story of Tobit and

play as a strong affirmation of faith in, and obedience to, God's word. The emotional climax comes in the long scene where Abraham steels himself to do the unnatural deed but hesitates again and again as he cries out in a father's anguish. When he finally decides to tell Isaac that he will be the victim, the son adds to his anguish by asking him to spare his young life. Abraham:

> O seul appuy de ma foible vieillesse!
> Las mon amy, mon amy, ie voudrois
> Mourir pour vous cent million de fois:
> Mais le Seigneur ne le veut pas ainsi.

Only when Isaac changes his mind in obedience to God does Abraham kiss him and, knowing that it will be his own death, proceeds to strike the fatal blow.

Rembrandt's first painting of this story is the large canvas of 1635 in Leningrad (Bauch, no. 13). Already here Rembrandt tried to show Abraham's mental pain by painting tears on the old man's face. The most striking detail in this picture is the knife dropping from Abraham's hand as the angel grips his wrist. It can hardly be a coincidence that in Beza's play the words

> Or est-il temps, ma main, que t'esvertues
> Et qu'en frappant mon seul fils, tu me tues

are followed by the stage instruction: *"Ici le cousteau tombe des mains"* (here the knife drops from his hands)! Admittedly, in Beza's play the knife falls not because of the angel's interference but due to Abraham's own weakness. Abraham continues with a brief, heartrending lament:

> Fut-il iamais pitié,
> Fut-il iamais une telle amitié?
> Fut-il iamais pitié? a, a, je meurs,
> Ie meurs, mon fils . . .

Only then does the angel, as the *deus ex machina*, arrive. (See Raymond Lebègue, *La tragédie religieuse en France*, Paris 1929, p. 294, and Gerard Dirk Jonker, *Le Protestantisme et le Théâtre de la langue française au XVIe siecle*, Groningen, 1939, pp. 98 ff. All quotations are from the Lyon edition of 1550, reprinted Geneva, 1920.) Aside from the general emotional intensity of Beza's play, the incident of the falling knife is such a special invention that it is hard to imagine that Rembrandt could have thought of it independently. This raises the question how Rembrandt could have learned about the play. It was apparently never translated into Dutch and was not performed on the stage in Amsterdam. Yet we know from a letter by J. J. Scaliger of December 13, 1595, that it had been performed in Leiden by "quelques enfans" and had made such an impression on the audience that several of the spectators actually cried (see Scaliger [J. J.], *Lettres françaises inédites*, par Philippe Tamizey de Larroque, Paris, 1879, pp. 311-12; the letter is addressed to Monsieur de Thou who was working on a "petite tragédie"). Moreover we know from Constantijn Huygens' autobiography that while still in school he had taken part in a performance of Beza's play in which his older brother had taken the role of Isaac. He, too, remembers that several people cried at the performance (J. A. Worp, "Frag-

Tobias—all the more clearly so as most of his renderings of the story belong to the years of Titus' youth and adolescence. The surprisingly youthful appearance of Tobias in some drawings of around 1650—when Titus was about eight years old—may indeed be due to this subconscious identification.

Yet I believe it was still another theme inherent in the Book of Tobit that touched Rembrandt's heart and roused his fantasy: the old man's blindness. The number of illustrations concerned with Tobit's loss and recovery of his eyesight is very large and some of these belong to the most beautiful among all the works based on the apocryphal text. This fascination with Tobit's affliction becomes all the more intriguing if we realize that blind people appear rather frequently in Rembrandt's work.[31] When in 1636 he painted—perhaps under the influence of Rubens or Van Dyck—a large canvas, *The Blinding of Samson* (Fig. 41), he deviated from the Flemish models by showing the actual blinding in crass and unsparing detail. In his picture of *Jacob Blessing the Sons of Joseph* (Fig. 34),

ment eener autobiographie van Constantijn Huygens," *Bijdragen en Mededeelingen der Historisch Genootschap te Utrecht*, XVIII, 1897, p. 30). In 1635, when Rembrandt painted the Leningrad canvas, he was still in close touch with Huygens (see Horst Gerson, *Seven Letters by Rembrandt*, The Hague, 1961). I consider it most likely that Huygens acquainted Rembrandt with the play or at least some of its main themes; it is even possible that he suggested the subject itself, as one involving the hero in an emotionally complex action. Huygens had approvingly described Rembrandt's handling of *Judas' Repentance* precisely because of the successful interpretation of Judas' emotions (see Kurt Bauch, *Der frühe Rembrandt und seine Zeit*, Berlin, 1960, pp. 7 ff.) and had recognized Rembrandt's gift for what he calls the *vivacitas affectuum*. It is surely no accident that the much debated word of the "meeste ende naetuereelste beweechgelickheyt" was used by Rembrandt in a letter to Huygens. Did he want to reassure Huygens that he had proceeded in accordance with aesthetic ideas the importance of which Huygens himself had emphasized in previous contacts?

[30] I owe to Mr. Colin Thompson, Keeper of Paintings, The National Gallery of Scotland, Edinburgh, the information that on the evidence of infra-red photography the date of this picture, generally cited as 1648, "can hardly be read as anything except 1650." Of the two interpretations of this painting found in the literature (*Timothy with his Grandmother Lois*, based on II Timothy 1:5, or *Samuel with his Mother Hannah in the Temple at Shiloh* according to the first book of Samuel) the latter and more traditional one is preferable. While the small group of figures in the background probably enacts the presentation of the infant Samuel (I Samuel 1:24), the main figures may allude more specifically to I Samuel 2:19: "Moreover his mother made him a little coat; and brought it to him from year to year, when she came up with her husband to offer the yearly sacrifice." See also L. Goldscheider, *Rembrandt*, London, 1960, p. 176, no. 79.

[31] Various scholars have been struck by Rembrandt's interest in blindness, among them Fritz Saxl (*Lectures*, London, 1957, p. 308, based on a lecture given in 1941); Emil Kieser, *Zeitschrift für Kunstgeschichte*, x, 1941-1942, pp. 129 ff.; Herbert von Einem, *Wallraf Richartz-Jahrbuch*, XIV, 1952, pp. 182 ff. I myself have commented on this aspect of Rembrandt's art in *Paintings by Rembrandt*, The Metropolitan Museum Miniatures, New York, 1956.

he obviously kept in mind the passage: "Now the eyes of Israel were dim for age so that he could not see" (Genesis 48:10). A drawing of the late 1650's renders Belisarius, the Byzantine general, who according to legend ended his life as a blind beggar (Fig. 42).[32] When he was commissioned to illustrate the Oath of Claudius Civilis for the Amsterdam town hall, Rembrandt made a point of showing that the Batavian hero had lost the sight of one eye. Most important for the aging artist was still another great figure of the past known to have been blind. Blind Homer appears first in Rembrandt's oeuvre in a drawing of 1652, dedicated to his young friend, Jan Six (Ben. no. 913). He is a commanding figure, reciting his poetry to a group of spellbound admirers. Homer's bust is included in the picture of *Aristotle* of 1653 (Fig. 1). Rembrandt returned to the theme of the Blind Homer once more in a late painting, done, like the *Aristotle*, for his Sicilian patron, Antonio Ruffo (Fig. 5). Homer's physical blindness is here beautifully set into contrast with his spiritual illumination. While the outer light is fading, the inner one shines all the more brightly and intensely.

In addition to these famous men who were wholly (or, as with Claudius Civilis, partially) blind, we find the theme of blindness in many variations in Rembrandt's work. He sketched Christ healing a blind man, probably illustrating the ninth chapter in John, in a drawing known to us only from a copy (Fig. 43). A blind man, and possibly a blind woman, hopefully join the throng around Christ in the etching known as *The Hundred Guilder Print*. A blind fiddler follows a mangy dog in an etching of 1631 (Münz, no. 122) and blind beggars appear in several drawings (Ben. nos. 749, 750; Fig. 44); the fiddling beggars (Ben. nos. 739, 740) are probably blind too, since they walk in the traditional manner of the blind behind a dog attached to them by a cord.[33] If we add to all these works the many renderings of blind Tobit, we can hardly escape the conclusion that physical blindness was of more than common interest to the master.

How can we account for this phenomenon? Rembrandt was surely aware of the tradi-

[32] The Dutch inscription Rembrandt added to the drawing of Belisarius reads, in translation: "Have pity for poor Belisarius who was once in great esteem because of his heroic deeds and who was blinded through jealousy." This is a free translation of a famous quotation: "Date obolum Belisario quem virtus extulit, invidia excaecatum afflixit," first found in Johannes Tzetze, *Historiarum variarum Chiliades*, ed.

Theophil Kiessling, Leipzig, 1826, p. 94. A painting of Rembrandt's school rendering Belisarius is listed by Hofstede de Groot (VI, p. 445, note 3) as in the Collection of the Earl of Lonsdale in Lonsdale Castle.

[33] For a discussion of Rembrandt's blind beggars in relationship to the tradition, see Bauch, *op.cit.*, [29] pp. 165-68.

tional view that of all the senses, sight was the noblest.[34] If our eyes are our foremost instruments for the perception of beauty and indispensable in a successful management of our affairs, loss of sight must be regarded as the worst tragedy that can befall man. This thought might easily occur to a painter whose entire activity is dependent on the proper functioning of his eyes. It is not inconceivable that Rembrandt was particularly conscious of this danger, and his interest in blindness—and its cure—may reflect the subconscious fear of an artist who, unlike the poet Homer, cannot turn such an affliction into a creative asset.[35] We may recall that in contrast to the biblical text, which simply says that the white film was peeled off Tobit's eyes "from the corners," Rembrandt always depicts the scene as the kind of cataract operation which he must have actually observed.[36]

A fascinating field of speculation is opened up if we turn to Freud's tentative explanation of any inordinate preoccupation with, and fear of, blindness.[37] Speaking of the deep involvement of the faculty of vision with sexual interests—the "lust of the eye"—Freud cites the case of the "peeping Tom" of Coventry who was punished with blindness as a retribution for a forbidden use of the eyes.[38] One could also refer to Tiresias who, according to one version, was blinded because he had seen Minerva bathing in the fountain of Hippocrene. The classical example, of course, is Oedipus who blinded himself as a symbolical act of self-castration. Was Rembrandt's preoccupation with sightless figures

[34] H. Kauffmann ("Die Fünfsinne in der niederländischen Malerei des 17. Jahrhunderts," *Kunstgeschichtliche Studien, Festschrift für Dagobert Frey*, Breslau, 1943, pp. 133 ff., especially p. 156) suggested that in Rembrandt's concern with blindness the concept of spiritual blindness played an important role. While this concept, common in theological writing, has indeed, as Kauffmann points out, biblical sanction (John 9:39-41), it hardly suffices to explain the many different themes involving blindness which Rembrandt depicted. It is purely the physical phenomenon of blindness which was of absorbing interest to the master, largely free, I believe, of moral metaphorical associations.

[35] William S. Heckscher connected with Rembrandt a passage from Dr. Tulp's writings about a famous artist who was convinced his bones were softening in his body like wax (*Rembrandt's Anatomy of Dr. Nicolaas Tulp*, New York, 1958, pp. 77-78). A morbid preoccupation with blindness would not surprise us in a painter who also suffered from neurotic delusions, but Professor Heckscher's theory, while fascinating, is hardly substantiated and, on the face of it, not very likely.

[36] One of his drawings (*Stockholm*, Ben. no. 1154), often associated with the Tobit legend, actually appears to depict some kind of eye surgery, though the patient, a young man, cannot be Tobit. Benesch's idea that the drawing is satirical in content seems to me unacceptable.

[37] I am indebted to Dr. Madlyn Kahr for bringing Freud's study to my attention. Mrs. Kahr also suggested that it was perhaps not accidental that in the painting of the Blinding of Samson (Fig. 41) Delilah has Saskia's features while those of Samson vaguely resemble Rembrandt's own.

[38] See Sigmund Freud, *Psychogenic Visual Disturbance according to Psycho-Analytical Conceptions* [1910], in *Collected Papers*, II, London, 1933, pp. 109-11.

prompted by subconscious feelings of guilt, which may be especially strong in a painter who by his very craft is a *voyeur*—an observer of the most private aspects of life? Did Homer turn, for Rembrandt, into an ideal figure—as he obviously did—precisely because his blindness protected him from defilement through visual contact with the world?[39]

In this connection it is of the highest interest that the only certain portrait we have of Rembrandt's father, a drawing in the Ashmolean Museum at Oxford (Fig. 45), suggests strongly that Harmen Gerrits van Rijn was blind or had, at any rate, lost his vision at the end of his life.[40] Rembrandt surely had no reason to draw his father asleep—especially in a sketch which has the nature of a formal portrayal—and the tensely contracted eyebrows and forehead are indeed more indicative of a man awake than asleep. K. Bauch[41] strongly maintained that the inscription giving the father's full name was written by Rembrandt himself, which makes it still less likely that the model was sleeping. Nor is there any reason to assume that the old man on the back of the Oxford drawing (Fig. 46) is rendered sleeping, as Bauch assumes: it is a figure leaning over forward as if in deep thought, but the pose is not at all characteristic of sleep. Another sketch (Fig. 47) also appears to be a portrait of the father, and again the pose with its lowered head and inactive hands raises the suspicion that we are faced with a sightless man.

Harmen Gerrits van Rijn died in 1630, when Rembrandt was only twenty-four years old. Many paintings of an elderly, beardless man, traditionally called portraits of Rembrandt's father, cannot, in fact, render him since some of them were painted years after his death. Bauch, however, correctly identified Harmen Gerrits' features in a painting in London which was largely, if not entirely, done by Rembrandt's first pupil, Gerard Dou (Fig. 48). Bauch follows Sir Charles Holmes in assuming that Rembrandt took part in the execution of the picture and that he is particularly responsible for painting the head of the old man.

The subjects of this London painting are Tobit and Anna! It shows the scene, later painted by Rembrandt himself, too, in which the two old people wait quietly if sadly, for the return of their child. Anna, seen from the back, pulls a thread from her distaff. Tobit, almost in profile, sits with his back to the window; his head is lowered and his idle hands are folded in his lap. A typical Dou still life fills the lower right corner.

Whether or not Rembrandt himself had a hand in the actual painting of this picture, he undoubtedly had a great deal to do with its conception. Dou had entered Rembrandt's

[39] For a moral interpretation of Homer's blindness, see Erwin Panofsky, *Studies in Iconology*, New York, 1939, p. 109, note 48.

[40] This observation was also first made by Mrs. Kahr.

[41] Bauch, *op.cit.*, pp. 172 and 220-21.

studio in 1628 at the age of fifteen, and he was hardly the artist to achieve such a work without Rembrandt's advice and close supervision. Thus, with some degree of justification, we can add this work, if only peripherally, to Rembrandt's own illustrations of the Book of Tobit.[42] What really is of importance, however, is that in a painting coming from the artist's closest circle, we find Rembrandt's father cast in the role of poor Tobit. If Rembrandt's father had lost his eyesight, his use as a model for the blind old man was obviously a "natural" choice. The London picture, indeed, to some extent supports the theory that Rembrandt's father was in fact blind.

In the light of these circumstances Rembrandt's early interest in the Book of Tobit gains one more dimension. Associating his sightless father with blind Tobit, Rembrandt may well have thought of himself—wishfully, perhaps, and possibly with a son's subconscious feeling of guilt—as Tobias, the beloved and loving son who travels to far lands and returns to restore his father's sight. This Rembrandt, of course, never accomplished, but his keen interest in eye surgery makes good psychological sense if understood as a posthumous tribute to his father and as a symbolical form of filial expiation.

We have seen before that in Rembrandt's later years the Tobit and Tobias story had a special meaning for the master because it touched on his affection for his and Saskia's son Titus. We now have reason to surmise that Rembrandt's original interest in the Book of Tobit had been stimulated by his emotional attachment to his own father.[43]

[42] The painting was engraved by Willem van der Leeuw as based on Rembrandt's invention ("Rembr. van Rijn inv. WPLeeuw fecit"). In his detailed discussion (*The Dutch School*, London, 1960, pp. 338-41) of the picture in the National Gallery Catalogue, Neil Maclaren concluded as likely that it was painted by Dou after Rembrandt's design, and retouched by the master.

[43] The following system of abbreviation has been used for the sources of Rembrandt's drawing numbers:

Ben. = Otto Benesch, *The Drawings of Rembrandt*, London, 1954-1957

Val. = Wilhelm R. Valentiner, *Rembrandt, Des Meisters Handzeichnungen*, Berlin-Leipzig, 1, n.d.

R. = Hans-Martin Rotermund, *Das Buch Tobias, Erzählt und ausgelegt durch Zeichnungen und Radierungen Rembrandts*, Stuttgart, 1964

Of the drawings omitted, some, though genuine, seemed of minor importance (Ben. nos. 131, 546, 608, 638, 881 (only in part by Rembrandt), 981, A1012). Others are either copies of lost originals or of doubtful genuineness, or both (Ben. nos. 130, 492, 497, 559, 573, 582, 639, C6, C24, C44, C61, C74, A26; Val. nos. 217, 220, 230, 237, 241, 249, 250; R. nos. 14, 18). A third group of drawings has been connected by some scholars with the Book of Tobit but almost certainly render incidents from other stories (Ben. nos. 127v, 167, 489, 544, 644, C15, C16; Val. nos. 228, 243, 245). Three of these (Ben. nos. 489, C15, C16) depict a bearded old man reading and an elderly woman listening to him. Since these figures look much like Tobit and Anna in other Rembrandt drawings, some scholars have called the subject: "Tobit reading to Anna from the Bible." No such incident, however, is described in the Book of Tobit and it is unlikely that Rembrandt would have invented a

scene neglecting what to him seems to have been its most important theme, Tobit's blindness.

Of the paintings listed in Hofstede de Groot's critical catalogue as representing incidents from the Book of Tobit, nos. 62, 67, 68, and 68a are not by Rembrandt; no. 66 is the picture of our Fig. 48. The painting in Turin of a sleeping man sitting in a chair has been called *Tobit Asleep* (Kurt Bauch, *Der frühe Rembrandt und seine Zeit*, Berlin, 1960, pp. 148-49). Yet except for the circumstance that the picture shows a man asleep, nothing in it fits the text of the story. It is an indoor rather than an outdoor scene (Tobit slept "aen de muer van de voor-plaetse"); Tobit's eyes are not exposed ("mijn aengesicht was ontdeckt," "mijne oogen obge-daen zijnde"); there is no reference to the swallow's nest in the wall, nor to the labor which Tobit had been doing and which had tired him out. Moreover, in the two drawings Rembrandt devoted to the subject, he followed the tradition —seen for instance in Heemskerck's drawing in Copenhagen (see above, p. 110)—of depicting Tobit lying on the ground. (As far as I can see,

a *seated* Tobit appears only in H. Holbein's woodcut for the *Icones Veteris Testamenti* [reprinted London, 1830] no. LXXXV, where the swallow's nest is shown directly above his head while Anna and Tobias stand at the right). From the very beginning, finally, Rembrandt characterized Tobit as an old man with a long white beard, while the man in the Turin picture is younger and has only a moustache. Realizing some, though not all, of these difficulties, Bauch still seems to favor the identification, see his *Studien zur Kunstgeschichte*, Berlin, 1967, p. 145. To me such a disregard for the text and the pictorial tradition of a story is incompatible with Rembrandt's practice. Since Bauch, however, may be correct when he maintains that the picture is more than a genre scene, the proper subject remains still to be found.

The so-called *Jewish Bride* (Aristotle Fig. 37) has occasionally been thought to represent Tobias and Sarah, a view apparently shared by E. Haverkamp-Begemann, see *Yale Review*, LVI, 1966-1967, p. 307. I cannot see how this identification can be substantiated.

V. REMBRANDT: TRUTH AND LEGEND (1950)

A FEW YEARS AGO I happened to be present when an English dealer tried to sell a Rembrandt to an American collector. As part of his sales talk he gave a short biography of the master, with all the authority a cultured British accent gives in such matters as art. I took it down afterwards as a prize item in my collection of Rembrandt legends. It ran something like this: "Rembrandt was no good in school, you know. He was kicked out when he made a caricature of his teacher. He was very attached to his mother; never allowed anyone else to paint her portrait. Later on he married his cook and took to drinking. He was so poor at the end of his life that he had to make his living by painting on pavements."

It is only fair to report that, despite the ingenious combination of the time-honored image of the starving genius with the specifically American virtue of mother-worship, there was no sale. The picture was not by Rembrandt.

This story of Rembrandt's life, which in part may have been made up on the spot (painting on pavements being to an Englishman a natural activity for a poverty-stricken artist), differs less from many popular Rembrandt biographies than one would expect. Thomas Craven tells us that Rembrandt was debt-ridden and toothless at the end of his life, and fat "from sitting down all day and too much Holland gin." Emil Ludwig, who gives to his last chapter on Rembrandt the title "The Beggar," tells us that Rembrandt was so poor in the 1660s that to earn some money he was forced to model for one of his own former pupils, Carel Fabritius. It is unfortunate for this touching story that Fabritius had already died in 1654. That Rembrandt was forgotten at the end of his life is a foregone conclusion. Wurzbach, who was, after all, a well-informed scholar, described Rembrandt's end like this: "Solitary and without friends, shunned by society, and forgotten, he languished and died in poverty." H. W. van Loon headlined one chapter of his fictionalized life of Rembrandt: "A Forgotten Man in a Lonely House Goes on Painting Pictures." Craven says that in Rembrandt's funeral procession there were "a number of curious idlers who had heard that his name was Rembrandt and that he had once been a famous man in Amsterdam." People with memories for films will remember Charles Laughton's old Rembrandt, a giggling, tippling, half-crazed bum who nevertheless could hush a gay crowd with his muttered biblical eloquence.

It is part and parcel of this popular Rembrandt myth that the great change in Rembrandt's career came with what is called the "scandal" of the *Night Watch*. The professional fiction writers have had a field day with this story, which tells that Rembrandt's

customers were dissatisfied with his work when they saw it. Van Loon, from whose text the Rembrandt movie took some of its most effective scenes, describes how at first sight of the painting "a gigantic roar of laughter" went up, but how the people soon became angry at the artist's "unseemly hoax." Had they not paid for their portraits to be seen clearly? From that moment, Van Loon continues, Rembrandt was doomed. Emil Ludwig goes him one better. He tells us that the *Night Watch* was considered "an insult. No city could suffer it patiently. They took the picture and instantly hung it on some obscure, half-forgotten wall." Craven informs us that, despite the fury of the soldiers, Rembrandt "stubbornly refused to alter the painting." So they "hung it in an anteroom," and cut it down to adapt it to a smaller space. Even a serious writer like Borenius, as recently as 1943, wrote: "It is on record that the people who ordered it were far from pleased."

Yet anyone who studies the records must come to the conclusion that, far from being a failure, the *Night Watch* was an extraordinary success. In a book published in 1678, the painter Samuel van Hoogstraten, who had been Rembrandt's pupil but who was by no means an uncritical admirer of the master, praised the *Night Watch* for giving unity to a theme which other Dutch painters had treated in a dull manner, putting one figure next to the other. "It will outlive all its rivals, being so original, artistic and forceful that others look like playing cards." Only a few years later, in 1686, F. Baldinucci begins his Rembrandt biography with a discussion of the *Night Watch*. "This picture," he says, "brought him such fame as was scarcely ever achieved by any other painter in those parts." He notes that Rembrandt was well paid for it because "luckily for him, his contemporaries greatly admired the work." Baldinucci's informant was a man who ought to have known, a Danish painter who for a number of years had studied with Rembrandt.

Indeed, far from being relegated to "some obscure half-forgotten wall," or "an anteroom," the picture was placed exactly in the spot for which it had been ordered, a large hall in the clubhouse (*Doelen*) of the chief military guilds of Amsterdam. There it remained until 1715, when it was transferred to the chamber of the War Council in the Town Hall, surely not a sign of lacking respect. It is true that it was cut down at that time, but Rembrandt's painting shared this fate with works of many other great artists. Applying Procrustes' methods to paintings to fit them into available wall spaces was a general practice in former centuries. In a guidebook to the Town Hall, published in 1758, it is described as one of the great attractions and it is interesting to note that in that year it was still known that the light in the picture is "strong sunlight," a fact which

only recently has been verified beyond all doubt by the successful cleaning of the *Night Watch* in 1944.

There is not a single record that tells us that Rembrandt's models were dissatisfied with the *Night Watch*. Some of the men who were portrayed in it declared a few years later that each one had paid 100 guilders "more or less, according to the place he received in the picture." Evidently each man knew well ahead where he would be placed. The captain of the company portrayed, Frans Banning Cocq, was so pleased with the result that he had two copies made, a watercolor for his family album and an oil, both of which give us a good idea of the original condition of the work. The little girl ("a female dwarf," according to F. J. Mather, Jr.), whom the Rembrandt legend asserts to have been an arbitrary and unwanted addition by the master, has been found to contain an emblematic significance and to be an integral part of the theme. The late Schmidt-Degener had proved, moreover, that the romantic character of the *Night Watch* reflects accurately the prevailing Amsterdam taste of the 1640s and it can be shown that there is a considerable "echo" of some of the ideas of the *Night Watch* in works of other artists. In short, nothing more remains of the "scandal" of the *Night Watch* than a faint criticism which Hoogstraten added to his praise, saying that he wished Rembrandt "had put more light into the picture," and Baldinucci's commentary that it was "difficult to distinguish one figure from the other" because of the "confusion" of the action.

If toward the end of Rembrandt's career there was a lessening of his popular acclaim and if financial difficulties threw their shadows over his life, it was not due to a failure of the *Night Watch*. In fact he received some important commissions in the late 1650s and in the 1660s. In 1660 a collection of poems was published which contained several in praise of some works of Rembrandt. His European fame was so great that the later Grand Duke Cosimo III of Tuscany, on a visit to Amsterdam in 1667, did not fail to look up Rembrandt in his studio. It was Rembrandt himself who withdrew from the world. Later critics almost invariably reproached Rembrandt, among other things, for having associated with plain people rather than with men of the upper classes. The German nobleman-painter, J. von Sandrart, seems to have been first (1675) to regret Rembrandt's keeping company with low-brows: "He did not know in the least how to keep his station." Baldinucci reports with obvious disapproval that Rembrandt wore "untidy and dirty clothes" because he "wiped his brushes on himself." R. de Piles (1699), French portraitist and writer, is the first to tell the story that Rembrandt, asked for reasons for keeping such company, answered: "If I want to relax my mind I do not seek honor, but freedom."

It is evident that whatever estrangement took place between Rembrandt and his

public, it was largely willed by Rembrandt himself. He did not want to "play the game." Nevertheless, there was not a moment during Rembrandt's life, nor afterward, that people were not aware of his existence. Rembrandt was never forgotten. He was not always equally appreciated. Praise of his art is often mixed with censure. Yet he was too big a figure ever to be overlooked. A. Pels (1681), Félibien (1684), and Houbraken (1718) call him "the great Rembrandt"; Walpole (1762) speaks of him as "the celebrated Rembrandt." One of his severest critics, the academic painter G. de Lairesse (1707), accompanied his criticism by the admission that the master was still greatly admired. It may be a dig at De Piles when he says: "There were and there still are many who maintain that Rembrandt was able to do anything that can be achieved in art and that he surpassed other artists in his naturalness, the force of his colors, his beautiful light, vivid harmonies, ingenious and uncommon ideas." He continues that he differs with that opinion even though he also had once greatly admired Rembrandt's manner (and let us not forget that he had been portrayed by Rembrandt in one of the master's most beautiful late portraits). In order to see the commentaries on Rembrandt in their proper light it is, of course, necessary to know exactly who the people were who wrote them and what axe they had to grind. When Hogarth described the parody of his picture *Paul before Felix*, published as a subscription ticket in 1748, as "scratched in the ridiculous manner of Rembrandt," he ridiculed not Rembrandt so much as his contemporaries who preferred old masters to moderns. That he used Rembrandt as a lever for his attack is only proof of the popularity which Rembrandt's work enjoyed at that time in England. Hogarth's joke was actually ill-received in the art world where Rembrandt was too sacred a name for such fooling. We may remember that Walpole reports (1762) that Rembrandt's works were "in such repute that his scratches sell for thirty guineas."

A study of the history of Rembrandt's fame shows plainly that almost to the end of the nineteenth century he was one of the great controversial figures. Even Fromentin was both attracted and repelled by the master. Rembrandt's greatness was always admitted, though sometimes begrudgingly. One can distinguish two lines of attack: one directed against his behavior, the other against his art. That he was untidy and associated with people from the "wrong side of the tracks" was not the only criticism of his personality. It was Houbraken who launched the story of Rembrandt's miserly disposition. He tells that Rembrandt lived frugally and spent little in taverns and that he was so money-mad that his pupils sometimes would paint silver and gold coins on the floor boards or other places to watch him try to pick them up. He also insinuated that the alterations which Rembrandt made in many of his etchings were due to his shrewd calculations that collectors would want to own every state of a print. Other stories were

added, for example that of describing Rembrandt's fake funeral and sale of his "estate." As late as 1857 an admirer of Rembrandt, Arsène Houssaye, still speaks of his *"folie de l'argent*. Yet there is sufficient evidence that Rembrandt was, if anything, too open-handed with money, and in some more recent commentaries he has been described as a veritable spendthrift whose love of collecting brought on his financial ruin. A. von Arnim, who devoted a long narrative in verse to Rembrandt's fake death announce-ment, makes him less a miser than a practical joker. Indeed, ever since Baldinucci, Rembrandt was believed to have been a whimsical and scurrilous character. When De Piles was in Holland he bought a painting by Rembrandt of a maid looking out of a window (it must have been a work like the pictures in Chicago and Baltimore) which Rembrandt is said to have placed in a real window to fool the people into thinking that the maid was actually there. This story is, of course, just another version of the many anecdotes by which an earlier art history demonstrated a painter's naturalism.

One anecdote told by De Piles was particularly shocking to a true academic mind and a definite proof of Rembrandt's bizarre and abnormal behavior. He was asked, it is said, if he studied the works of the ancients. In answer he pointed to a lot of old clothes, armor, and other paraphernalia and said: *"These* are my antiques." The parallel is evident with the story about St. Bonaventure who pointed to an image of Christ when St. Thomas asked him where he had his library; and there is little doubt that the story about Rembrandt, as so many others, is but new wine in old bottles. We know that Rembrandt *did* study Classical sculpture and that he owned some plaster casts of Roman heads. Yet the story of the rags, as we may call it, is revealing for a typical prejudice concerning Rembrandt's art. In the writings of most seventeenth- and eighteenth-cen-tury critics we find Rembrandt described as a man who followed only nature. This would have been a compliment in the early Renaissance. In the seventeenth century it was a serious reproach. Art was something which is produced according to rules, and Hoogstraten is clearly at a loss to understand why Rembrandt did not follow the rules which, after all, were so easy to learn. Since the academic tradition taught that real beauty is not found in nature, any emphasis by academic writers on an artist's uncritical imitation of nature implied that his works are ugly. This accusation is indeed repeated often, even where the power of Rembrandt's style is acknowledged. A. Pels, in his poem *The Use and Abuse of the Theatre*, 1681, started the ball rolling when he said that Rem-brandt's nudes were no Greek goddesses but laundry women with hanging breasts, ill-shaped hands, and that traces of lacings and garters showed on their bodies and legs. Even De Piles deplored Rembrandt's poor taste, which he "had sucked as a child," and

his ignorance of *"la belle proportion."* Lairesse warns artists not to paint with Rembrandt's heavy impasto. He describes Rembrandt's colors as having the appearance of a crust of mud. Lessing forgave Rembrandt his "wild and sloppy manner" of painting as long as he treated genre subjects, but he objects to it when it comes to noble themes except such that take place at night and in stables, like Nativities. The vulgarity of some of Rembrandt's themes has been decried ever since Hoogstraten. Two features were often quoted as particularly shocking: the inclusion of two copulating dogs in the *Preaching of St. John*, Berlin, and of a dog relieving himself in the etching of *The Good Samaritan*—both, incidentally, early works.

Yet while these guardians of the official taste expressed their disapproval of some of Rembrandt's practices as man and artist, Rembrandt's work never failed to attract attention and admirers. Visitors to Amsterdam went to see not only the *Night Watch*, but also the two *Anatomies* in the Surgeons' Guild. A German traveler records, in 1711, that a burgomaster had offered several thousand guilders for the *Anatomy of Dr. Tulp*. Rembrandt's works were collected in France. Rigaud, court painter to Louis XIV, owned some pictures by, and made copies after, Rembrandt, and De Piles had a collection of drawings and etchings, besides the picture of the maid looking out of the window. There is no evidence that Rembrandt's drawings were less appreciated by the connoisseurs than his other works; many of them still bear the marks of the great eighteenth-century collectors. It was Rembrandt's color which impressed De Piles more than any other aspect of his art: *"Il était maître de ses couleurs et il en possedoit l'art en souverain."* In De Piles' famous point system of rating, Rembrandt received seventeen out of nineteen possible points for color, as much as Rubens and Van Dyck, and fifteen for composition, as much as Leonardo da Vinci and Poussin.

With the theoretical justification of Watteau and Chardin, the estimation of Rembrandt shifted towards his simplicity of subject matter as well as his spontaneous technique. Like these artists, Rembrandt, too, achieved "the sublime" in subjects which were neither "noble" nor "heroic." It was Gersaint, Watteau's dealer, who made the first critical catalogue of Rembrandt's etchings (published in 1751)—on the basis of a collection which Jan Six had formed and which Houbraken had owned afterwards. Voltaire (1752) thinks that in his best works Raoux equalled Rembrandt. The Chevalier Marcenay de Ghuy, who had been rejected by the Academy and who thereupon had joined the "Maîtrise," declared in 1756: "No one has the right to consider himself a connoisseur who does not like Rembrandt with all his faults. What a touch, what a harmony, what resplendent effects!" A veritable Rembrandt vogue can be distinguished

among artists almost to the end of the eighteenth century, even though only the super-
ficial elements of his style, his exoticism, his picturesqueness and his chiaroscuro were
imitated. It was also the time when the famous Rembrandt collections of Dresden,
Cassel, the Hermitage, and of King Stanislaus Augustus of Poland were founded. One
of the German Rembrandt-imitators of the eighteenth century, Trautmann, acquainted
the young Goethe with Rembrandt's works. Goethe's conception of Rembrandt was
enriched by his association with J. H. Merck. Like Merck, he saw in Rembrandt a great
poet, a storyteller who characterizes each figure vividly, and he followed Lavater in
admiring both Hogarth and Rembrandt for their ability to render evil physiognomies
convincingly. De Piles had already extolled the "truth" of Rembrandt's works. Goethe
also liked to stress the *Wahrheit* of Rembrandt's stories and he gives to this term a strong
moral flavor. He described movingly a late etching by Rembrandt, the *Adoration of the
Shepherds with the Lanterns*, as a work which captured the humbleness of the Gospel
narrative by rendering the Biblical characters as Dutch peasants. Goethe collected Rem-
brandt's etchings and drawings (or what he considered as such), and he copied some of
Rembrandt's landscapes. As a frontispiece for his edition of 1790 of the *Urfaust*, he
ordered a copy of Rembrandt's etching then believed to be of Dr. Faustus. In his youth-
ful enthusiasm he had once written that three masters—Rembrandt, Raphael, and Ru-
bens—appeared to him like veritable saints, but a slight cooling-off in his estimate of
Rembrandt occurred in Italy under the impact of "Southern purity and clarity of form."

With the general reaction to the ideals of the *dix-huitième* in the course of Neo-
Classicism, a definite hostility toward Rembrandt can be noticed. It may suffice to quote
Blake (1809)—"Till we get rid of Titian and Correggio, Rubens and Rembrandt, we
shall never equal Raphael, and Albert Duerer, Michael Angelo and Julio Romano"—
and Ingres, who said, "Let us not admire Rembrandt and the others through thick and
thin; let us not compare them to the divine Raphael and the Italian school. That would
be blasphemy." In reality, of course, Blake protested against Reynolds and his school,
just as Hogarth had attacked the mania for old masters; and Ingres spoke against the
Romantics, to whom Rembrandt appealed with the rich somber textures of his colors
as well as the magic character of his light effects. Picking up Ingres' very word "blas-
phemy," Delacroix wrote: "It may sound like blasphemy, but people will perhaps dis-
cover one day that Rembrandt was as great a painter as Raphael." In 1857, Houssaye,
significantly comparing Rembrandt with Shakespeare, gave a succinct formulation of
all that the Romantics loved in Rembrandt: "Rembrandt est un poète sombre, étrange,
hardi, bizarre, romanesque. Il joue ses drames sur un fond noir; il aime le mystérieux
jusqu'a à la fantasmagorie." [Rembrandt is a somber, strange, bold, bizarre, romantic

poet. He stages his dramas against dark backgrounds, his love of mystery extends even to the phantasmagoric.] Our own Washington Allston expressed similar feelings in a poem "Occasioned by Rembrandt's Picture of Jacob's Dream." Rembrandt to him is the "strangest of all beings strange." Of his "visionary scenes," he says:

"That, like the rambling of an idiot's speech,
No image giving of a thing on earth,
Nor thought significant in Reason's reach,
Yet in their random shadowings give birth
To thought and things from other worlds that come,
And fill the soul, and strike the reason dumb."

Even the "ugliness" of Rembrandt's figures, which was so reprehensible in the eyes of the academic writers, is judged differently. Houssaye admits that Rembrandt "did not shy away from ugliness, but under his fertile hand everything assumed a fantastic and grandiose expression." For Taine, Rembrandt is "an eccentric genius." Taine develops Pels' description of vulgar forms but draws a very different conclusion. He lists: "begrimed visages of Jews and usurers, the crooked spines and bandy legs of beggars and cripples, slovenly cooks whose gross flesh still shows marks of the corset, bowed knees and flabby bellies, hospital subjects and shreds and tatters, Hebrew incidents which seem copied in a Rotterdam hovel, scenes of temptation where Potiphar's wife, jumping out of bed, makes the spectator comprehend Joseph's flight; bold and painful grasp of the naked reality however repulsive. Such painting, when it is successful, goes beyond painting . . . it is a poesy . . . the human form, the proper object of the plastic arts . . . is subordinated to an idea. . . . With Rembrandt, the chief interest of the picture is not man, but the tragedy of expiring, diffused, palpitating light incessantly competing with invading shadow."

To the Romantics, Rembrandt was a Romantic; to a man of Courbet's circle, like Jules Michelet (1858), Rembrandt was a partisan of the common man and of the people. Later on, Langbehn used Rembrandt to protest against the cultural shallowness of the Bismarckian empire. Down to our own day writers have continued to mirror themselves and their times in their interpretation of Rembrandt. Rembrandt legends and lies have continued to flourish and a good deal of writing will be necessary to overcome their stubborn longevity. Yet, after nearly a hundred years of serious research, the figure of Rembrandt has emerged in greater detail—just as his pictures, cleaned of their varnishes, are no longer seen only in contrasts of strong lights and deep shadows. Vosmaer was the first author to publish a well-founded biography (1868), and Thoré (Bürger)

and Fromentin have helped to give a deeper insight into Rembrandt's art. It is these men who established the new, critical approach to Rembrandt, which still bears fruit.[1]

[1] For the history of Rembrandt's reputation see also Seymour Slive, *Rembrandt and His Critics, 1630-1730*, The Hague, 1953; R. W. Scheller, "Rembrandt's reputatie van Houbraken tot Scheltema," *Nederlands kunsthistorisch Jaarboek*, XII, 1961, pp. 81-118; and J. A. Emmens, *Rembrandt en de Regels van de Kunst*, Utrecht, 1968.

VI. REMBRANDT'S INTEREST IN BEGGARS
(1984)

"What an amazing model!" whispered Hughie, as he shook hands
with his friend. "An amazing model?" shouted Trevor at the top of
his voice; "I should think so! Such beggars as he are not to be met
with every day. A trouvaille, mon cher, a living Velasquez! My stars!
What an etching Rembrandt would have made of him!"

(Oscar Wilde, The Model Millionaire).

THERE ARE SEVERAL WAYS in which to approach the art of a master like Rembrandt. Along with other scholars, Jan Bialostocki, to whom this essay is dedicated, has examined some of the recurrent themes found in his oeuvre.[1] These themes, which I call "core themes" are not necessarily the same as the concrete subject matter, though they may, at times, coincide. To the extent that they seem to have occupied the artist's mind at different times of his life, these themes may furnish opportunities to penetrate to the center of Rembrandt's thoughts and emotions. In the essay on Rembrandt and the Book of Tobit I had tried to identify some of these "core themes" (see above pp. 134-40). Focusing now on Rembrandt's frequent renderings of beggars, I try to demonstrate that the theme of the beggar may reveal an unexpected psychological aspect of the master's personality.

I have been aware of the importance of the beggar in Rembrandt's art ever since a fellow student in Freiburg wrote her dissertation on the portrayal of the beggar from the fifteenth century to Rembrandt.[2] To the best of my knowledge, her book has remained the only monographic treatment of the subject by an art historian. Students of literature and of socio-economic conditions, however, have not neglected to examine the phenomenon of beggary in the late Middle Ages and the Renaissance.[3] Unfortunately, the ten pages Sudeck devoted to Rembrandt deal chiefly with the difference between

[1] Jan Bialostocki, "A New Look at Rembrandt's Iconography," *artibus et historiae,* x, 1984, pp. 9-19.

[2] Elisabeth Sudeck, *Bettlerdarstellungen vom Ende des XV. Jahrhunderts bis zu Rembrandt,* Strasbourg, 1931.

[3] See for instance Erik von Kraemer, *Le type du faux mendiant dans les littératures romanes depuis le moyen âge jusqu'au XVIIème siècle,* Helsingfors, 1944. See also the literature listed in Sudeck's bibliography.

his beggars and those by Callot, while leaving aside the question of what the beggar theme may mean in the context of Rembrandt's total oeuvre.

To understand Rembrandt's attitude towards the subject of the beggar it is necessary to consider briefly the role beggars played in the works of earlier artists, as well as the attitude society had taken to beggary as a mode of existence. I shall not dwell on subjects which require the attributive presence of a beggar, such as renderings of saints—like St. Elizabeth of Hungary or St. Martin—who demonstrate their charity by clothing or giving alms to beggars, though Rembrandt in fact occasionally depicted such figures. Rather I want to concentrate on those images in which the beggar himself is the chief personage.

Living, as we do, in a society at least theoretically committed to the proposition that no one should fall through the social safety net, we have difficulty realizing how ubiquitous beggars were in former centuries (though there are parts of the world where we still can see such a state of affairs). Birth defects, illness, accidents, and war, at an age when medical skills were primitive and for most of the indigent unavailable, left many people in a condition where they could not, or could no longer, be active in gainful occupations. The *Bettelstab* (beggar's staff) was taken up also by people reduced to indigence by economic reversal, when all other hope was gone. Yet society had good reason to suspect that among the hordes of beggars were many fraudulent ones; that the bodily defects, so insistently displayed, were not always genuine; that some of the self-styled "pilgrims" were shiftless vagrants, and that dependency on charity was a career chosen, rather than a necessity imposed by adverse conditions.[4] In fact, many communities distinguished between local beggars, who had a municipal license to ask for alms, and drifters from outside, and even the latter could obtain some kind of insignia that attested to the truth of their condition. On the one hand there was the Christian injunction that it was a duty of those who had the means to help the poor; and yet by and large, beggars were generally looked at with suspicion, sometimes with ridicule, and in any case considered fit subject for all sorts of moralization. A good example is Barthel Beham's large woodcut of twelve beggars (Fig. 1), each one accompanied by a four-line verse explaining why he or she had been reduced to that miserable state.[5] The first is the Alchemist, a forerunner of Pieter Bruegel's mad experimenter, who also ends in poverty; we see further a gambler, a swashbuckling swordsman, a glutton, a prosti-

[4] See the *Liber Vagatorum, Der Bettler Orden*, Basel. The book was published in 1528 with a preface by Luther and subtitle, *Von der falschen Bettler Büberei*, and was widely distributed.

[5] See Max Geisberg, *Der deutsche Einblatt-Holzschnitt in der ersten Hälfte des XVI. Jahrhunderts*, Munich, 1923-1930, no. 159; see also *Bilder-Katalog zu Geisberg*, Munich, 1930, p. 42.

tute, and a lecher; there are also a disobedient servant and a lazy school boy. The last, incidentally, is a beggar who has inherited the profession from his parents. Only one of these beggars is crippled (the swordsman who has lost part of his leg) but, as the captions say, all have deserved their fate. Yet when we come to the long poem at the bottom of the sheet, we are told that one should be kind to beggars and that it is still better for the poor to beg than to turn to crime.

In a drawing, now in Brussels (Fig. 2), Hieronymus Bosch scattered a large number of badly crippled beggars all over the sheet; and a similar drawing (in Vienna) with 31 cripples and blind beggars may be the copy of another such drawing by Bosch, done by Pieter Bruegel the Elder.[6] Neither artist betrays any feeling of compassion for the wretched creatures they draw. This is certainly true for Bruegel's own inventions. Displayed mercilessly in all its grotesqueness, the crippled condition of beggars in his small panel in the Louvre is a metaphoric reference to human greed, falsehood, and hypocrisy (Fig. 3); and his famous canvas of the Blind leading the Blind (Naples) castigates the misplaced confidence in flawed—probably religious—leaders.

When Cornelis Metsys depicted twelve pairs of dancers, among them some blind and crippled beggars (1538) who nevertheless dance merrily, the artist obviously considered beggars a suitable object for humorous treatment.[7] In the early seventeenth century Van de Venne used the beggar subject as a convenient device for social moralizations in the manner of Jacob Cats, stressing their deformities, ragged and patched clothing, and brutish manners, but without a spark of sympathy with their fate.[8] Like Bellange and Georges de la Tour he depicted brawling beggars, some of them blind. There seems to have been indeed a popular entertainment where blind beggars were made drunk and set up, like gladiators in a Roman arena, to fight each other. Even where one might suspect a modicum of compassion, the inscription on a scroll *Armoe soeckt List* (Poverty looks to Cunning) clearly implies that the old couple's blindness is faked (Fig. 4).[9] The

[6] An engraver who printed this group of beggars turned the sheet into an anti-clerical propaganda, referring to the Roman pope as "the bishop of the cripples" whose servants live by sloth and deceit, and therefore are comparable to the deformed creatures drawn by the artist.

[7] See F.W.H. Holstein, *Dutch and Flemish Etchings. Engravings and Woodcuts, ca. 1450-1700,* Amsterdam, 1955, pp. 203, 138-49.

[8] See Laurents J. Bol, "Adriaen Pietersz. van den Venne, schilder en teyckenaer, VIII: Grisaille-schilderingen," *Tableau,* 1983, pp. 53-63.

For a scurrilous series of beggars drawn "from life" by Pieter Quast, see Dieuwke de Hoop Scheffer, "Een serie bedelaars door Pieter Quast," Bulletin van het Rijksmuseum, XXII, 1974, no. 4, pp. 166-72. In the engraved title-page of the set, the subjects are characterized as "vermomde Bedelaaren en andere Gespuis" (masqued beggars and other rabble).

[9] Like other such inscriptions on Van de Venne's moralistic painting this, too, sums up what appears to have been a proverbial saying. See the Dutch edition of Ripa's *Iconologia,* Am-

impressive renderings in large paintings (Georges de La Tour!) of blind hurdy-gurdy players (the hurdy-gurdy being the traditional instrument of blind beggars) fascinating as they may be, were hardly intended to evoke feelings of pity.

It is well known, and indisputable, that in his renderings of beggars Rembrandt was indebted to Callot's series of twenty-five etchings known as *Les Gueux* or *Les Mendiants*. Yet Callot's prints, in a sense, are only Bosch brought up to date. True, in the Frenchman's etchings there is none of Bosch's wicked, almost diabolic delight in human monstrosities. Some of his beggars are identified as hypocrites, displaying too obviously the rosaries in their hands. In his renderings of cripples Callot gives us clinically precise delineations of the shapes and movements of sadly handicapped people (Fig. 5). Removed from any identifiable environment, Callot's beggars are drawn as emotionally indifferent as handbook illustrations. The artist's graphic technique, not surprisingly, is as spare as his approach is cold. Confronted with one of Rembrandt's beggars, the impersonal quality of Callot's is perceived with utter clarity. When Rembrandt drew the heavy-set beggar of Figure 6, he obviously wanted us to notice that in that human being, no matter how afflicted and deprived, there is still a remnant of human dignity. Likewise, in an etching of 1648 (Fig. 7) a group of beggars, perhaps a family, stands quietly at the door of a house whose owner places a coin into the outstretched hand of a woman carrying a child on her back. Her husband, if that's what he is, plays the hurdy-gurdy as an indication that he is blind. It is a scene without words, but of great dignity—on both sides. The poor receive gratefully what the old man, almost smilingly, gives, and in a moment they will again be on their way. Scorn, ridicule, satire or shallow moralization—attitudes that had dominated the rendering of beggars and are found even in works of his contemporaries—are never encountered in Rembrandt's drawings and prints. He may, in fact, have been the first artist to see beggars as unfortunate fellow human beings, marked in shape, dress, movements, and expression by suffering and privation. This has evidently not been overlooked entirely.[10] What is less well known is

sterdam, 1644, pp. 25-26, under *Armoede*: ". . . en gelijckmen gemeenlijck seyt, *soo maeckt d'Armoede den Mensch kloeck en listigh*."

[10] Remarks about Rembrandt's renderings of beggars abound of course in the literature on the master. Carl Neumann (*Rembrandt*, 3rd ed., Munich, 1922, II, p. 404) saw emotional intensity only in beggars drawn in the 1640s; for the younger Rembrandt they were no more than (as he says) "interessante Kerle und malerische Objekte."

Weisbach, too (*Rembrandt*, Berlin, 1926), credits Rembrandt with feeling for beggars only in his later portrayals. Speaking about an early etching (to which we shall return) he writes that "the face, framed by bristly hair and beard, the mouth torn open, is half wild-animal (*tierischwild*), half idiotic, without evoking any sympathetic feeling." Hamann (*Rembrandt*, Berlin, 1948) also seems to be repelled by the unkempt appearance of these figures. The beggar with the wooden leg

how frequently Rembrandt turned to the subject of beggars and how much he stands alone in Dutch seventeenth-century art in his preoccupation with the homeless men, women, and even children who live—precariously—on charity.[11] Occasionally we can recognize in Rembrandt's renderings of beggars some older representational patterns, such as the blind beggar led by a child, a formula which has a long history in Flemish art.[12] Examples are drawings in Berlin, 1633-1634, Vienna, 1647-1648 (Tobit, Fig. 44, and Stockholm, 1655-1656.)[13] Traditional, too, is the transient beggar family, where the wife may sometimes take the role of guide, though she may also collect—as in an early etching—the alms doled out at the door of a house while her fiddling husband walks on, trusting the lead of a little mutt. There are several drawings of such couples, one actually seen from the back, expressing with particular poignancy the rootless nature of their existence (Figs. 8-10).

Studies of single beggars can occasionally be seen in earlier works, such as a woodcut by Hans Weiditz (?) where a solitary beggar hobbles off in the distance.[14] The single figure occurs again in a late drawing in Berlin (Fig. 11). While most of his beggars are

"rather than appealing to our pity evokes our fear as he extorts our gifts" (der "durch das wüste Gesicht Furcht erregt und Gaben erpresst"). Even Rosenberg (*Rembrandt*, London, 1964) believes that Rembrandt "had an eye for the picturesque and comical side of the beggars' appearance" while being also aware of "their loneliness, exhaustion, and tragic degradation to an animal-like state." None of these writers goes beyond a recording of their subjective reactions to individual prints or drawings. The most thoughtful passages on Rembrandt's interest in beggars, though limited to the master's youthful works, have been written by Kurt Bauch (*der Frühe Rembrandt und seine Zeit*, Berlin, 1960, pp. 153-61). Bauch is primarily concerned with Rembrandt's relationship to contemporary artistic trends and how far he shared in or broke with them. Recognizing Callot's seminal role, Bauch lays stress on Rembrandt's independence as he describes eloquently the early etchings of beggars. Following Hind, he also believes that the beggar in the etching B. 174 of 1630 bears Rembrandt's own features, but did not find the artist's self-identification with a ragged beggar deserving of any further comment.

A distant tribute to Rembrandt's interest in beggars—and not only as a picturesque model—

was paid in Alexander Korda's Rembrandt movie, when Charles Laughton, as Rembrandt, picked up and conversed with a beggar who greets him with the words, "You are the artist who paints beggars."

[11] While Dutch cities, above all Amsterdam, maintained several institutions for their indigenous poor (the *Weeshuis* for orphans, the *Leprozen Huis* for sick and insane, the *Oude Vrouwen Huis* and the *Aalmoezeniers Huis* for poor women and men, respectively, they locked up beggars caught thieving, and put them to work in the *Rasphuis* if they were men, the *Spinhuis*, if women. Local beggars often were licensed and provided with a badge for identification. See J. Landwehr, *De Nederlander uit en thuis*, Alphen, 1981.

[12] See Kahren Hellerstedt, "The Blind Man and his Guide in Netherlandish Painting," *Simiolus*, XIII, 1983, pp. 163–81.

[13] No effort is made here to enter problems of attribution or dating. For convenience sake, these data are taken over from Benesch's monumental catalogue *Rembrandt Drawings*.

[14] See Walther Scheidig, "Von dem harten Weg," *Die Holzschnitte des Petrarca-Meisters*, Berlin, 1955, p. 254.

homeless migrants, he also etched one sitting by the wayside, warming his hands over what may be a chafing dish or simply a bowl of hot soup (Fig. 12).

Even this selection from a much larger group of works demonstrates Rembrandt's persistent interest in the appearance of people who live insecurely at the fringes of established society, subsisting on handouts as they go from one place to another. In fact, it is the beggars' homelessness, the curse of their existence, which Rembrandt appears to have recognized clearly, but it is also worth noting that whenever he depicted people approached by beggars, he shows them responding without hesitation.

What does it mean in the context of his art as a whole that Rembrandt treated this particular subject as often as he did, and with an attitude so contrary to what had been the custom up to his own time? One might ask, for instance—though it is not a question I intend to pursue—whether his interest in beggars is related to his interest in the Polish Jews, most of them poor, who had found in Holland a refuge from persecution at home, but who, not unlike the beggars (which they were not), remained largely outside the social establishment of their new environment. There is still another question: scholars have increasingly paid attention to the roles Rembrandt gave himself to play in some of his narrative subjects. He appears as a bystander in an early painting, the *Stoning of St. Stephen* (Lyon); he is one of the helpers in a print *Christ's Descent from the Cross*; and he portrayed himself also as the prodigal son from the famous biblical parable (Dresden), carousing with two women (one of whom is no longer visible but has been discovered in an X-ray photograph of the canvas), a picture whose meaning, as we now realize, is much deeper than being only, as was formerly believed, the exuberant testimony to a happy marriage.

Rembrandt, we begin to see ever more clearly, must have been a very complex human being. On the one hand he tried to create for himself an ambience intended to support a claim to social and intellectual distinction.[15] Yet he was anything but a conformist, either artistically or in his dealings with the world around him. In an earlier study I have tried to suggest that he was not unfamiliar with the conflict between artistic integrity and social rewards (see above, pp. 55-58). Thanks to J. A. Emmens we know that the romantic notion of Rembrandt being out of step with artistic theories of his time has no basis in fact.[16] He certainly was, as Emmens put it, in perfect agreement with the pre-classical theory of art when he rendered "old men and women, beggars, peasant, huts, and ruins," yet what he made of such conventional subjects is quite different from

[15] See R. W. Scheller, "Rembrandt en de ency-clopedische Kunstkamer," *Oud Holland,* LXXXIV, 1969, pp. 81-147.

[16] J. A. Emmens, *Rembrandt en de Regels van de Kunst,* Utrecht, 1968.

their treatment in the works of Bloemaert or Jan van de Velde. There seems to be, in fact, a trend, especially among Dutch art historians, to stress Rembrandt's involvement in the broad structure of life in the Holland of his time, in an understandable reaction to the poetic phantasies with which earlier biographers had beclouded the artist's life. Yet the more we are told that Rembrandt was not very different from other Dutch burghers, that in his day-by-day existence he was—how could it have been otherwise—subject to various public and private conditions, the social stresses, the rules and regulations of an active commercial society, the more we run the danger of forgetting that as an artist, Rembrandt was like no other Dutch artist. His life may have been a conventional and "normal" one; his art was not.

No other Dutch painter of his time, for instance, left behind anything near the large number of self-portraits—drawn, etched, and painted—that we have of Rembrandt. Was he aware of his own complexities? Did he try to plumb his own nature as he scanned his features in front of the mirror? Could it be that he felt himself different from the people around him and tried to understand what set him apart?[17]

There are early self-portraits in which he frowns or laughs, but I suppose these were essentially attempts to study on his own face how some basic human emotions affect physiognomy. In general, his self-portraits are serious, and increasingly somber. Yet even among the earlier ones there are some that seem to be curiously revealing. In imitation of two engravings by Hans Sebald Beham (Fig. 13) he etched two shabby peasants who exchange a few words about the cold weather (Fig. 14). [18] One—and he has Rembrandt's features—states morosely, "It's awfully cold." The other laughs and replies, "That's nothing."[19] Except for the words of the brief conversation, Beham's and Rembrandt's prints have nothing in common. Beham's peasants, one almost the mirror image of the other as they turn towards each other, are short, stocky characters, impassively facing the iniquities of the weather. Given Beham's political convictions and seeing that both peasants wear swords, one even holding an additional "weapon"— a pitchfork—their conversation about the weather which does not affect them one way or the other may well have been understood by Beham's contemporaries as a sly reference to the political climate rather than to the meteorological one.[20]

[17] For a very different interpretation, see Svetlana Alpers, *Rembrandt's Enterprise: The Studio and the Market*, Chicago, 1988, see above p. 5.

[18] The texts in Beham's engravings, inscribed on scrolls, are "Es ist kalt weter" and "Das schadet nit." Rembrandt's words are " 't is vinnich koud" and "Dats niet."

[19] I do not know on what basis Christopher White (*Rembrandt as an Etcher*, University Park and London, 1969, 1, p. 156) twice avers that Rembrandt's etchings "illustrate an old saying."

[20] See Herbert Zschelletzschky's stress on the "revolutionary" significance of many of Beham's works; he remains silent on the meaning of the prints of the "Wetterbauern."

Whereas Beham stressed the similarity in shape and attitude of the two peasants, Rembrandt made the two a study in contrast, in shape, dress, and above all mood. They also turn their backs to each other. The one who shivers—though more warmly dressed than his opposite—looks at us with a grim, pessimistic expression. The other, who also looks out, grins merrily and is completely unconcerned. What we are facing here, I submit, is a translation into the popular genre of the old contrast between two philosophical modes, exemplified by Democritus and Heraclitus, the laughing and the crying philosophers. If so, it is significant that Rembrandt gave his own features to the incorrigible pessimist whose unhappiness with the weather is but the manifestation of a somber, in fact melancholy, disposition. Even as a young man he found it more natural to identify himself with a man whose outlook on the world (including the weather) was clouded rather than happy-go-lucky, as was that of his companion.[21]

What these etchings tell us about Rembrandt's concept of himself brings us back to, and is reinforced by, one of his etchings of beggars. Four years before the unhappy "weather-peasant" he had, in fact, portrayed himself in the guise of a beggar (Fig. 15). This is unquestionably the same person as the tousle-headed youth whom Rembrandt saw in the mirror when he etched one of the well-known self-portraits of *ca.* 1630 (Fig. 16), a fact that was recognized by several scholars, among them Hind and Bauch.[22] Yet what in the straight portrait etching is hardly more than the record of a face he "made" before the mirror, in order to study varieties of physiognomic expression, assumes a very different psychological significance when he gave this face to a ragged, ill-shod beggar, sitting forlornly by the wayside, miserably aware of his existence at the fringes of society. Thus I wonder whether this early etching may not provide a clue for a deeper understanding of Rembrandt's life-long interest in beggars. I find it very unlikely that portraying himself as a visibly unhappy beggar should be no more than a bit of whimsical role-playing by the young master. He may have overdramatized—at age 24—his sense of alienation, of not fitting smoothly into the world in which he lived. But there are many indications, in his art as well as his life, that psychological difficulties as much as religious sensibilities predisposed him to sympathize with those rejected by society.

There is still more. Not enough attention seems to have been paid to three etchings, belonging to a group of prints, containing in the most informal arrangement figural

[21] The last study dealing with the theme of Democritus and Heraclitus in art, including its possible appearance in Rembrandt's works, is by Herbert von Einem: "Festschrift für Gert von der Osten," Cologne, 1970, pp. 177-88. Most of the previous literature is referred to in the foot-notes of that article.

[22] A. M. Hind, *A Catalogue of Rembrandt's Etchings, Chronologically Arranged and Completely Illustrated*, 2d ed., London, 1923; Kurt Bauch, *op. cit.* (note 9), p. 157. [9]

sketches of the kind an artist would normally sketch with pen or pencil on a sheet of paper. (In the Rembrandt literature they are indeed listed as study sheets or *Studien-blätter*, with all too little stress on the novelty of the phenomenon and the fact that only a master who etched as he drew would have used a copper plate the same way he did a sheet of paper.) Almost as if he wanted to call attention to the casual nature of such products, Rembrandt turned the plate at least once, and in one case even twice, as he worked, thereby forcing the beholder to do the same with the prints pulled from those plates. The three discussed here, however, form a small group by themselves. Two of them are self-portraits, done twenty years apart (B. 363 and B. 370, Figs. 17, 18). The third has two sketches of Saskia resting in bed (B. 369). But in addition to these "main" subjects, all three have small sketches of other figures distributed arbitrarily over the surface of the plate, some recognizable only if the print is turned by 90 degrees. In the earliest of these prints, generally dated 1632, the self-portrait occupies the upper right area; quick sketches of the heads of a haggard old woman and an old man are at the lower left and right corners, and a still more fragmentary sketch, noticed only when the sheet is held upside down, is seen in the upper left. The only two fully developed figures, directly under but at right angles to the self-portrait, are a shuffling old man and—in the opposite direction—an old woman leaning on a cane. Both these figures are typical of Rembrandt's cast of beggars. The same thing is true of the later self-portrait, of 1651. That self-portrait is a particularly searching one, the strands of hair (is it prematurely white?) playing loosely around the broad forehead. Here, too, other figures have been added: one is a man with a high cap often seen with Rembrandt's beggars, but more striking still, as we turn the sheet, is the figure of a poor woman, bundled up in patched garments while her feet are unprotected in open sandals. She is preceded by a small child. If their appearance does not clearly enough identify them as beggars, the little basket the woman carries does: it is standard equipment for begging women (see Fig. 7). And it is a pair of old beggars whom Rembrandt sketched using the most delicate lines drawn with the needle on the sheet on which he had first recorded the ailing(?) Saskia. Could it be accidental, and hence meaningless, that in three etchings, done many years apart (1632, 1638, and 1651) but linked in a personal way with Rembrandt himself, he added poverty-stricken people, people who are clearly representatives of the "family" of beggars that seem to have aroused his interest and sympathy? Nor is it likely that their poverty as such or their picturesqueness alone attracted his interest. Did he understand, perhaps only subconsciously, their social estrangement as a facet of his own mental condition?

Seen in this light, Rembrandt's interest in beggars may help us to understand other

subjects he dealt with at different times in his career. Foremost among them is the parable of the Prodigal Son (Luke 15:11-24). Through his own wilfulness, the Prodigal placed himself outside the established order of society and in the end was reduced to the state of a beggar. Ragged and destitute he appears in several of Rembrandt's drawings and etchings, as he returns remorsefully to his father. The greatest of these scenes is the celebrated canvas in Leningrad, and it is surely significant that in that painting special emphasis is given to the worn-out shoes, the mark of the poor migrant. I am not overlooking the profound religious meaning of the subject, the welcome given to the errant child by a loving and forgiving father—a transparent allusion to God's mercy. Nevertheless, it seems to me perfectly legitimate to conjoin two of Rembrandt's favorite subjects, the beggar and the Prodigal Son, since both deal with the theme of the social outsider, if not outcast. It may not be farfetched to think that Rembrandt was attracted to that theme, and was able to deal with it so understandingly, because it struck in him a familiar chord.

The first version of this essay was delivered in a short talk as part of a Rembrandt symposium at Wellesley College, December 3, 1982, held in honor of Jan Bialostocki. It was developed subsequently into a full lecture (New York, March 1984, and Berlin, June 1984). An abbreviated version, published in *artibus et historiae*, no. 10, 1984 ("A Rembrandt 'Theme' ") forms the basis of the present study. A different approach to the subject has since been taken by Robert W. Baldwin (" 'On earth we are beggars, as Christ himself was': The Protestant Background of Rembrandt's Imagery of Poverty, Disability, and Begging," *Konsthistorisk Tidskrift*, LIV, 3, 1985, pp. 122-35). Supporting his thesis with abundant references to religious, chiefly Protestant, literature—the quotation in his title is from Luther's writings—Baldwin interprets Rembrandt's interest in beggars (or "vagabonds") as a projection of his personal "seeking of Christ among the rags and poor people of Amsterdam." Thus Rembrandt's renderings of beggars are (I assume peripherally) linked to the Protestant stress on "the sublime lowliness and poverty of the incarnate Christ" which throughout informs Rembrandt's religiosity. That such a tradition, traceable even in pre-Protestant, potentially heretical literature, dominated much Protestant (including Calvinist) thinking cannot be doubted, nor that it plays an important role for the interpretation of many of Rembrandt's christological subjects. But I prefer to see in Rembrandt's preoccupation with beggars a highly personal approach to a traditional subject, whereas for Baldwin beggars, along with sick people and sinners, remain, what for Christian and especially Protestant interpreters of Christ's humanity they had been for centuries: metaphors for the pervasive misery of the human condition. Rembrandt alone of Dutch artists rejected the picto-

rial tradition of ridiculing or satirizing beggars; only he appears to have sympathized with their rootlessness and understood the hardship of their existence. Whether he turned to the theme because "on earth we are beggars, as Christ himself was," or because he felt a psychological sense of affinity with their estrangement, or possibly both, is beyond our power to know.

A very different interpretation of the beggar theme with Rembrandt was given by Suzanne Stratton ("Rembrandt's Beggars: Satire & Sympathy," *The Print Collector's Newsletter*, XVII, no. 3, 1986, pp. 77-82). In direct contrast to Baldwin (whose piece she apparently did not know) she blamed Protestantism (the "protestant work ethic") for the hostility to mendicants whom the Catholic Church had tolerated. Rembrandt, she avers, did not differ much from his contemporaries and, like them, stressed "comic effects," relying more on Callot's etchings than on real models (?). Only in his later work does she discover a more sympathetic view and connects it with a general trend in Dutch society which, so she says, had—under the influence of Dutch Pietism—increasingly accepted a social and moral obligation towards the poor. Even if there were reliable evidence for such a view, which I am inclined to question, the singularity of Rembrandt's approach to the theme is evidently not accounted for by it. I regret that Stratton, in her thoughtful and well-documented historical outline, failed to recognize how profoundly Rembrandt's etchings of beggars differ from Callot's renderings, a difference all the more striking as Callot's prints may in fact have triggered Rembrandt's interest in the theme.

The reference to the Heraclitus and Democritus analogy, first suggested in my talk of 1982, appears in an exhibition catalogue by Ben Broos (*Rembrandt en zijn Voorbeelden—Rembrandt and his Sources*, Rembrandthuis, Amsterdam, 1985-1986), but he mentions it only in passing and without any commentary on its possible psychological significance.

VII. REMBRANDT AND THE SPOKEN WORD
(1970)

THE INTENSITY of the recent discussions of Rembrandt's life and work, outlined in the introductory remarks to this collection of essays, was not entirely unprecedented. Sporadic efforts had been made for some time to redraw the image earlier generations had formed about the great Dutch master. Questions about the stylistic coherence of the works attributed to him led to a drastic reduction in the size of his oeuvre.[1] More attention than before has been paid to Rembrandt's acquaintance with, and dependence on, the traditions of Netherlandish, German, and Italian art. Archival studies revealed new data about his private life and helped to define his place in the contemporary social scene. More specifically scholars examining the subject matter of some of his works, succeeded in providing new interpretations at variance with what had been assumed about them before.[2] In most of these studies, the uniqueness of Rembrandt's art was treated as a given fact. Admittedly, attempts were occasionally made to put it into words. But not all scholars felt obliged to define the specific qualities and characteristics of Rembrandt's art or to make appropriate observations to distinguish it from that of his contemporaries. Yet unless we succeed in recognizing in Rembrandt's work the manifestation of a unique and uniquely creative artistic temperament, we will be hard put to understand why for centuries he has been hailed as one of the most original masters in the entire history of art.

One of the earliest formulations, still widely repeated, to characterize Rembrandt's art concerns his highly personal handling of light and dark, his chiaroscuro. Avoiding this purely formal approach, some scholars have stressed Rembrandt's deep but undogmatic commitment to biblical narratives. Still others have singled out his humanity, his poetic handling of landscape subjects, or the variety and psychological subtlety in his observation of emotional situations. Art historians have also pointed to his astonishing development, as the manifestation of an incomparable power of self-education, perhaps even self-transformation. Indeed, it is hard to think of any other artist, except perhaps Goya, where the early works prepare us so little for the depth and power of those done late in life. Yet no matter how different the emphasis may have been, there was hardly ever disagreement among commentators that Rembrandt's art is so rich and complex

This paper was first given as a lecture in Berlin in 1969.

[1] H. Gerson, ed. A. Bredius, *The Complete Edition of the Paintings of Rembrandt*, 3d. ed., London, 1969.

[2] C. Tümpel, "Studien zur Ikonographie der Historien Rembrandts," *Nederlands Kunsthistorisch Jaarboek*, xx, 1969, pp. 107-98.

that it is a hopeless task to find a formula encompassing it all. We have to be content with investigating individual problems and—going beyond them—to make observations which, despite their fragmentary character, may have claims to a broader validity.

More recently, attention of several scholars has been directed towards particular kinds of "themes" in Rembrandt's art. These themes are different from the normal categories of subject matter—sacred or secular—which provide the material for the conventional researches in iconography. As referred to here, these themes are more comparable to musical themes which remain recognizeable even when reappearing in different contexts and in formal variations. (Leitmotive). Twice before I have called attention to some such themes (see above, pp. 97-98, 134-40), and other scholars have followed similar tracks, too, as H. van de Waal did in his study on Hagar[3] or Jan Bialostocki in a summary of recent Rembrandt studies.[4] Even Kurt Bauch, who objected to some of Bialostocki's formulations, singled out some such themes of his own.[5] I came back again to this line of reasoning in my paper on the beggars in Rembrandt's work (see above, p. 153). The "theme" I am about to describe here has been touched upon briefly by Bauch in a sentence worth repeating: "Activity" (with Rembrandt) "consists in the exchange of words, in conversation. Human speaking and listening are the specific actions" (die eigentlichen Handlungen) "of his dramas."

No matter how right and important these observations are (with the qualification that they apply only to a particular group of works) they are insufficient to do justice to Rembrandt's highly personal treatment of subjects involving verbal exchanges. It is easy to see that these indeed form a special category. Leaving aside categories like landscape, still life, or pictures with single figures, including portraits, we can distinguish three types of multi-figural compositions. One is characterized by an assembly of stationary figures, typically represented by the *Sacre Conversazione* of the Italian Renaissance, or other groupings without visible action, such as the unforgettable painting known as *Pan* by Signorelli which was destroyed in the grievous fire in the Flak-tower in Berlin-Friedrichshain (1945). The second type involves figures in actions, be they restrained, as in an *Adoration of the Magi* or a scene in a tavern, or agitated and full of excitement as in pictures of battles or hunts. No matter whether the actions are calm or violent, the personages in such paintings are mute or inarticulate. Even if we see that in the moment of her abduction Proserpina opens her mouth in a scream, or that Samson does likewise

[3] H. van de Waal, *Steps towards Rembrandt*, Amsterdam, London, 1974.

[4] J. Bialostocki, "Ikonographische Forschungen zu Rembrandts Werk," *Münchner Jahrbuch zur Bildenden Kunst*, 8, 1957, pp. 195-210.

[5] K. Bauch, *Ikonographischer Stil, Studien zur Kunstgeschichte*, Berlin, 1967, pp. 123-51.

when he is brutally blinded, these (imagined) sounds belong essentially to the realm of bodily motions, mere side-effects of physical exertions or sufferings, audible (if we could actually hear them), but definitely non-verbal. It is only the third category, clearly distinguishable from the first two, where the actions involve speech, that is, words formed and guided by a human (or humanized "celestial") intellect. And it is of course precisely this kind of subject that poses considerable difficulties for the artists, be they painters or sculptors. We can "hear" Laocoön's scream, seeing his squirming body and facial contortion, even if we are unfamiliar with the myth and the reason for his punishment. But there are subjects that even in their title make reference to words spoken, such as the *Noli me tangere*—the words with which the risen Christ keeps Magdalen at a distance. The classic example for this kind of subject is evidently the *Annunciation to the Virgin*. Strictly speaking, it is a conversation between the archangel Gabriel and the Virgin Mary. The words and the sequence of their conversation are predetermined in every detail. We may think also of the formalized exchange of words between the *Quick and the Dead*, so frequent in late medieval art, the interpretations of dreams, as in the story of Joseph, not to mention all the subjects where people "speak" even though they do not follow a fixed literary text.

Thus, subjects in which words, by their nature invisible, play a central role were depicted in art long before we encounter them in Rembrandt's work. Yet it cannot be denied that this kind of subject appears in his oeuvre more often than in the works of earlier or even contemporary artists. Nor is there any evidence that this preference appeared only at a certain stage of his development. Although at first he had difficulties with such subjects and fell back on conventional patterns, and only later developed effective devices to bring them to life, his interest in actions involving words spoken by one or more actors was there from the beginning. The fact that in his first group-portrait, the *Anatomy of Dr. Tulp*, the central motif is the spoken explanation of the anatomical structure of the corpse's hand might well indicate that the problem of speech in the visual arts had occupied and fascinated Rembrandt well before that time (1632).

The aim of this study, however, is not simply to call attention to Rembrandt's interest in themes involving the spoken word, but to examine the way he visualized them. For I believe one can demonstrate that in dealing with these themes, Rembrandt broke with an old tradition. Even though his manner of dealing with the problem had been anticipated by others to some degree, there is no evidence that artists before Rembrandt had given serious attention to the difficulty of dealing visually with actions the essential nature of which consisted in verbal expression. In the following remarks, I depend on our familiarity with gestural and facial motions that artists have used as their "vocabu-

lary" to indicate that a person is speaking and to show the degree of the speaker's involvement in that act.

Already in ancient art, certain characteristic "speaking gestures" had been developed and these recur, with various modifications, in the Renaissance and the Baroque. To some extent, they were standardized as part of the rules of Rhetoric, formulated particularly by Quintilian.[6] The artists of the later Middle Ages enlarged this silent vocabulary with other formulas which soon also congealed into fixed patterns with accepted values. In Jan van Eyck's *Annunciation* in the National Gallery in Washington, Gabriel greets the Virgin with a smile, while one hand points up to where his message comes from. Mary answers with two raised hands which accompany and support the modesty of her words and may also express her surprise. The artist, however, went beyond these gestural devices. As he did in the Ghent Altarpiece, he added the very words of the brief conversation between the divine messenger and the shy handmaiden of the Lord. And he did it in such a manner, that the beginning of each phrase is next to the mouth from which the words are issuing, which resulted in inscribing the Virgin's words upside down.

If we take this painting as the rendering of an exchange of words verbatim recorded in the first chapter of the Gospel of St. Luke, it is obvious that this dialogue appears here only in a very condensed form. In the Gospel, the angel begins his greeting—AVE GRATIA PLENA—in verse 28. It is followed by an account of the disturbed reaction of the Virgin, upon which the angel explains more fully the nature of his mission. He reassures her—after she sensibly asks how she could conceive a child, having never "known" a man—that with God "nothing shall be impossible." Only after hearing these words from the angel, the Virgin accepts her destiny, responding, in verse 38, with the humble words, ECCE ANCILLA DOMINI.

It does not concern us here to what extent Jan van Eyck, despite his revolutionary style and technique, follows established patterns. What I want to stress is that in his painting two short phrases, spoken one after the other, and in fact separated from each other by other words also spoken by the two participants, are inscribed side by side; and this device, given the persuasive power of the painted image, virtually suggests that both phrases are spoken simultaneously.

[6] G. Heinz, "Realismus und Rhetoric im Werk des Bartolomeo Passarotti," *Jahrbuch der Kunsthistorischen Sammlungen in Wien*, LXVIII, 1972, pp. 151-69. The importance for the orator of the gesticulation of the hands was pithily expressed by Quintilian (see Heinz, p. 161): *Nam ceterae partes loquentem aiuvant, hae [manus], prope est ut dicam, ipsae loquuntur* (While the other parts [of the body] help the speaker, they [the hands], if I may say so, speak by themselves).

I hardly need stress that no one was ever in doubt which words were spoken first, and which followed. No beholder in the fifteenth century could ever have entertained the grotesque idea that the angel and the Virgin could have talked at the same moment. The painting in the eyes of the contemporary beholder was not, after all, to be read realistically as the visual equivalent of a recorded conversation, but as the symbolic condensation of the first phase in the divine plan of human salvation.

For the artists of a later period, the possibility of including several moments of a continuing story into one unified action, and particularly one involving specific spoken words, offered welcome opportunities. In Tintoretto's *Announcement of the Betrayal*[7]— going considerably beyond Leonardo—we see not only Christ as he makes the fateful announcement, but also the reaction to that announcement by the apostles, excitedly discussing it among themselves. In his *Calling of Matthew*,[8] Caravaggio did not hesitate to combine in one well thought-out composition Christ's call *"Follow me"* (Matthew 9:9)—memorably carried by his outstretched hand, bridging the interval between the two groups of figures—and also the publican's astonished response, that seems to ask, *"Do you mean me?"* Although in reality these words (if so spoken) could only have followed each other no one was (or could be, even today) disturbed that the artist made it appear as if they were spoken simultaneously.

Nor has Rubens ever been faulted, to quote one more example, for showing, in one closely knit composition, the commanding figure of Christ as he *"cried with a loud voice, Lazarus come forth"* (John 11:43) and simultaneously the fully "recovered" Lazarus, already partially freed of his "graveclothes" approaching his Savior with humble gratitude and devotion.[9] In fact, such condensation of several instances of time in one suggestive compositional arrangement has always, and justly, been considered a major challenge and, when successful, a praiseworthy achievement of the artist.

At least since Lessing's *Laocoön* critics have been aware of a problem facing painters and sculptors alike: to render an ongoing action in a medium that can show only one moment of time. That artists developed skills to suggest phases of the action that preceded or followed the one represented need not concern us here, nor need we think of paintings like Memling's *Seven Joys of the Virgin* (Munich), where one large—if wildly heterogeneous—landscape contains, as in medieval Passion plays, important incidents

[7] Venice, Scuola di San Rocco; see H. Tietze, *Tintoretto, The Paintings and Drawings*, London, 1948, pl. 208.

[8] Rome, S. Luigi dei Francesi, Contarelli Chapel; see H. Hibbard, *Caravaggio*, New York, 1983, pl. 52.

[9] Formerly in Berlin, Kaiser-Friedrich-Museum, and destroyed in 1945 in the fire in the Flak-tower in Friedrichshain.

of an entire life. It was Rembrandt who more than any other painter not only was attracted to subjects involving verbal exchanges, but also developed devices to give them convincing representation.

I should like to begin my examination of Rembrandt's approach to these themes with an etching of 1645 which demonstrably deals with a "conversation" between two figures (Fig. 1). In the several renderings by Rembrandt of the dramatic story of Abraham's willingness to sacrifice his only son at God's demand, the etching of 1645 occupies a special place. In contrast to all his other renderings of the event, which concentrate on the climax—the interference of the angel who stays the patriarch's hand—the etching shows father and son quietly standing side by side, evidently engaged in a conversation. One scholar, Ludwig Münz, identified a woodcut by Lucas van Leyden[10] as a possible source for Rembrandt, but the sixteenth-century artist was within an iconographic tradition according to which Isaac carries the firewood for the burnt offering, an old typological prefiguration of Christ carrying the Cross for his own supreme sacrifice. Rembrandt's chief source, was, as usual, the text of the Bible itself (I Moses 22). On the way to "one of the mountains" in Moriah, where in accordance with God's command the sacrifice should take place, Isaac asks his father where is the lamb for the planned ritual, since fire and wood were there. "And Abraham said, My son, God will provide himself a lamb for a burnt offering: so they went both of them together." This is the situation depicted—a short but highly significant conversation. The entire attitude of Abraham, with his raised hand pointing to heaven (still reminiscent of the Eyckian angel in the Annunciation) leaves no doubt that it is the moment when he reassures Isaac with his trust in God. The more interesting part of Rembrandt's etching, however, is not Abraham but his young son. From what we know about the traditional rendering of such scenes, we would expect that the artist would also suggest the question that preceded and triggered the answer. Yet we see nothing of the kind. Isaac stands still, his hands keeping the bundled logs upright, but he no longer speaks. He has put his question and now listens to what his father has to say. The moment is precisely fixed, the sequence of question and answer carefully observed.

We shall see that this is not an accident. Rembrandt dealt with another such verbal exchange between two figures, also illustrating a biblical passage, the nocturnal visit of Nicodemus who came to put some earnest questions to Christ (John 3:1). The "interview" is of major importance since Christ most willingly considers the frank questions by the "master of Israel" and delivers one of the longest statements about his mission.

[10] L. Münz, *Rembrandt's Etchings*, London, 1952, under no. 180.

This meeting had been depicted by Marten de Vos, in a composition preserved in an engraving by Jacob de Bie (Fig. 2). De Vos gave to both figures conventional speaking gestures, since he could rely on the willingness of the beholder to resolve the seeming simultaneity of the words spoken into the natural, and intended, sequence—one following the other. Nevertheless, the visual evidence gives the impression that both Nicodemus and Christ are talking at the same moment—not the best way of carrying on a conversation. This is precisely what Rembrandt avoided when he drew the same subject in a beautiful drawing, now in Vienna (Fig. 3).[11] Here, too, the two participants in the conversation are seated, facing each other, but only one of them speaks. While Christ with a raised hand addresses his visitor, Nicodemus, sitting with crossed legs and with hands resting in his lap, appears to be pondering the message he hears. Like any good participant in a dialogue, he is ready to listen to what the other has to say, and it is his thoughtful silence that intensifies immeasurably the effect of the words spoken by Christ. It is likely that Rembrandt intended to evoke here the end of the conversation, before Nicodemus departed. After the inspired words of Christ, Nicodemus apparently left, without responding again, but what he had heard affected him deeply. He defended Christ before the Pharisees (John 7:50-51) and he participated in Christ's burial (John 19:39).

We owe to the late Professor Emmens' penetrating study of Rembrandt's portrait of the Mennonite preacher Anslo (Berlin) the information that it was painted in answer to the challenge contained in Joost van den Vondel's (rhymed) critique on the master's etched portrait of Anslo of 1641.[12] In his paraphrase of an old literary topos, Vondel had expressed doubt that the artist could render the essential quality of his model, his voice: "Hey, Rembrandt, paint Cornelis' voice. / The visible is the least of him: / We know the invisible only with our ears. / He who wants to see Anslo must hear him." In the etching Rembrandt showed Anslo alone, sitting behind a table, holding one book and pointing at another. In the painting, Rembrandt gave not only much greater emphasis to the "speaking" hand but he added a second figure, most likely the preacher's wife, who listens quietly to his words. And this listening itself is made "visible" by the turn of her head: it is the organ of hearing, her ear, that is turned towards the speaker.

The silent partner in a conversation appears early in Rembrandt's work. In the painting of 1628 in Melbourne of two elderly men (Peter and Paul?)[13] in intense conversation

[11] O. Benesch, *The Drawings of Rembrandt. A Critical and Chronological Catalogue*, London, 1954-1957, v, no. 889.

[12] J. A. Emmens, "Ay, Rembrandt, maal 'Cornelis' stem," *Nederlands Kunsthistorisch Jaarboek*, VII, 1956, pp. 133-65.

[13] Gerson-Bredius, p. 339 [1].

(Fig. 4), it is only one of the men, facing his partner (and us), who is caught, as it were, in mid-speech. The other, seen from the back and holding the volume to which his companion points, appears to be listening quietly. It is worth noting that in a print by Lucas van Leyden, which according to Tümpel was Rembrandt's source, both figures are rendered with speaking gestures.

In the equally early picture (Tobit, Fig. 1), where Tobit and his wife Anna confront each other (1626, Amsterdam), the pathos of the situation (Tobit wrongly suspecting his wife of the theft of the little goat) grips us because our attention is led towards Anna who, perplexed and visibly upset, mutely listens to the reproaches of her blind husband. The misunderstanding between Tobit and Anna appears several times in Rembrandt's illustrations of the book of Tobit (see pp. 121-22) with the artist concentrating on the moment when Tobit berates Anna for having, as he thinks, stolen the animal. In a drawing in Berlin, the artist may have chosen the passage where Tobit urges his wife to return the kid, while Anna stands before him apparently in silent protest (Tobit 2:21). Although the attitudes change from case to case, with more attention sometimes given to the setting, the format remains the same: Tobit is the one who speaks; Anna stands before him, almost helplessly listening to the accusation.

It suffices to select a limited number of dialogues where only one partner is shown in the act of speaking from the large number found in Rembrandt's work. In the Berlin drawing of Jacob and Esau (Fig. 5),[14] it is Esau who, sitting at the table, beckons Jacob to approach. His gesture is so eloquent that one has no difficulty linking it to his actual words: "Feed me, I pray thee, with that same red pottage, for I am faint." (We know that he was seated, since after he had eaten the pottage of lentils he "rose up and went his way"). Only after Esau has spoken does Jacob reveal his condition, "Sell me this day thy birthright." As Rembrandt draws him, he stands silently, carrying the platter with both hands. The same scene had been drawn by Marten de Vos (known from a print) where, less faithful to the text, Jacob sits and Esau stands, and where, characteristically, both figures appear to be talking at the same time, with their mother, too, taking part in the conversation.

Two Rembrandt drawings are particularly revealing: they depict the visit of the prophet Nathan with King David (II Samuel 12). The prophet came to chastise the king for having engineered Uriah's death so as to be able to marry Bathsheba. In the drawing in Berlin (Fig. 6)[15] the two men are at a considerable distance from each other. The prophet appears to be talking quickly albeit respectfully, while the king, ensconced on

[14] Benesch, III, no. 647 [11]. [15] *Ibid.*, V, no. 947.

his throne, shows little concern. The second drawing (in New York)[16] reads like a continuation in time, and at the same time like a "correction" of the first (Fig. 7). The prophet is more intense; his outstretched hand now comes so close to the king that it appears to be in contact with David's arm. David, in turn, inclines towards the prophet. His right hand, which before had held the scepter, now supports the pensive head. Nathan's reproaches have evidently been driven home. What in the first drawing had been merely a confrontation has now become a true interaction, in which an intensely presented argument (possibly the prophet's prediction of the death of Bathsheba's child) has visibly shaken the listener, who remains silent.

The last examples of a conversation between two people are of secular subjects. In the first (Fig. 8), in the collection of the late Van Regteren Altena, Vertumnus, disguised as an old woman, ardently addresses Pomona while keenly watching for the effect of his words.[17] Sitting before him, in a thoughtful pose (a pose, in part derived from Roman statuary), Pomona remains silent but nevertheless appears to be listening to the god's smooth talk. In the other drawing (Fig. 9), formerly owned by Curtis Baer, it is a veiled woman who listens, with hands crossed, to an eagerly speaking man.[18] For want of a better interpretation, the drawing is generally referred to as *The Matchmaker*.

Mention ought to be made, in this connection, of the etching of 1648, known by the title *Jews in a Synagogue*.[19] This print demonstrates once more Rembrandt's recognition of the fact that a meaningful conversation between two people requires one of them to listen while the other speaks. On either side of the composition are two men engaged in talk. The speaker on the left is an elderly man seen from the back. His partner bends forward to hear better what he has to say. At the right it is again the man closer to the edge whom we see leading the conversation as he turns to his companion walking quietly at his side. It may not be accidental that the two clearly visible speakers frame the composition; between them the eye loses itself in the darkness of the silent space. (Two men in conversation can also be seen frequently in Rembrandt's drawings.)

To summarize what we have seen so far: in most of the situations where Rembrandt chose to render a dialogue between two people he permits only one to talk; the other is there to listen. This mute presence serves, thanks to the precise fixing in time and the differentiation of individual attitudes, to sharpen the psychological effect of the action. Before turning to other applications of this principle in Rembrandt's work it may be useful to speculate here how Rembrandt may have come to discover the effectiveness of this narrative device. Since it was rarely seen before and never applied systematically,

[16] *Ibid.*, v, no. 948.
[17] *Ibid.*, iii, no. 553.
[18] *Ibid.*, ii, no. 397.
[19] Münz, no. 273 [10].

he hardly could have derived it from traditional models alone. Nor can I see any reason why it should have developed from theoretical speculations—about the relative nobility of the senses of sight or hearing, for example. (Emmens, in his paper on the Anslo portrait and Vondel's quatrain, has made reference to this fashionable controversy among seventeenth-century theoreticians.) Because of the somewhat one-sided perspective I have chosen in this essay, one might be tempted to conclude that Rembrandt aligned himself with those who gave the palm to hearing. It hardly needs to be said that one could easily demonstrate what one would expect from a painter anyhow, that the intense gaze of the human eye was for Rembrandt one of the most effective devices to characterize his actors and dramatically visualize the chosen narrative. Yet cold theoretical speculation does not seem to have been of major interest to the master; nor was the desirability of determining precisely a sequence of time, as far as I know, ever examined in the art-theoretical writings that Rembrandt may have known. The postulation of the three unities—time, space, and action—of the French classical drama, which marginally may offer some analogy, had not been formulated at the time Rembrandt developed his method of rendering figures caught in the act of conversing with each other.

Rembrandt's inspiration, if we may call it so, to treat verbal exchanges in the manner here described, may have come from a very different area: the theater. We know that the artist was very interested in the performances in the Amsterdam *schouwburg*. Already in the 1630s he made many drawings of actors in their costumes. Elsewhere (see note on p. 137). I have tried to show that the idea of the knife falling from Abraham's hand in the Leningrad canvas of the *Sacrifice of Isaac* may have its origin in a staging device in Theodore Beza's popular play *Abraham Sacrifiant*, and that Huygens, who as a pupil had himself acted in it, may have suggested the dramatic motif to the young artist. Still other connections of Rembrandt's art with plays performed have been pointed out (among them the *Medea* of Jan Six, even if the etching of 1648 does not render an event occurring in the play),[20] though not always convincingly (see note on pp. 6-7). Essential for any successful performance on the stage is clarity of speech; the simultaneous speaking of two actors, unless introduced for special dramatic effect, must be avoided, even though, in conventional discourse, speaking and listening are rarely kept separate. The attention paid to the speaking actor by others on the stage is closely linked to the attention expected from the audience. The colloquy of actors on the stage is comparable to a tennis game where the ball wanders from one player to the other but

[20] *Ibid.*, no. 270.

can never be hit by both players at the same moment. The *Medea* etching, which is believed to contain structural elements of the Amsterdam theater, is significant precisely from this point of view. It contains approximately thirty-five figures assembled to attend the celebration. But only one of them is unmistakably rendered with a speaking gesture—the high priest who addresses, with his right hand raised, the young couple kneeling before him. In the background at left we see a father who points out the action to his small son, and below him another man who turns his head towards a neighbor. Everyone else pays wordless attention to the ceremony and it is evidently this impression of silence, preserved by a large number of people, that contributes to the solemn mood of the print, but also, associated with the ominous appearance, in the right foreground, of Medea, to its dramatic tension.

Rembrandt had achieved a similar effect several years before in the painting (1644) of *Christ and the Woman Taken in Adultery* (Fig. 10, London).[21] The biblical source (John 8:3-11) does not identify an individual accuser, stating only that "the scribes and Pharisees" brought the woman to Christ to see how he would act ("tempting him, that they might have to accuse him"). Visualizing the event in terms of the theater, Rembrandt singled out one man, who acts as the spokesman for the many who came along and who now wait silently and with palpable tension for the outcome; one figure, in fact, puts his finger to his mouth to admonish the crowd to silence, a truly eloquent gesture, adopted already in ancient times for Harpocrates, the god of silence. Christ himself stands and listens quietly to the accuser who points at the crying woman kneeling before him; yet by his size and place in the composition he is clearly identified as the spiritual center of the action. He evidently will speak only when the outraged Pharisee has had his say. (We know that he will shame them when he says, "He that is without sin . . . let him first cast a stone at her.")

The same incident—the accusation of the adulteress by one man, while Christ as well as a large gathering of curious people watch in silence—is found in the powerful drawing in Munich dating from 1659 (Fig. 11).[22] Conscious of their sequence in time, Rembrandt again makes a clear distinction between the Pharisees' accusation and Christ's reply, unlike older renderings of the story, where no such differentiation was made and both were combined in one composition, as in paintings by Lotto (Paris), Rocco Marconi (Venice) and Tintoretto (Dresden and Copenhagen). Rembrandt's inscription on the Munich drawing, although still not completely deciphered, seems to indicate that Christ hesitated with his answer.

[21] Gerson-Bredius, p. 480 [1].

[22] Benesch, v, no. 1047 [11].

The same respect for the words spoken by any individual (we could perhaps call it the "let-him-have-his-say" principle) is shown in the drawing (Fig. 12) formerly with Victor Koch, London, where Abigail begs David to return good for evil and not to take revenge on her husband, Nabal (I Samuel 25:23-31).[23] The subject was painted by Rubens as an animated action, in the center of which David rushes to lift up the beautiful woman kneeling before him.[24] In Rembrandt's drawing, David stands motionless, one hand holding a lance, the other on his hip. Although angry—for good reason—he is willing to listen to what Abigail has to say. According to the biblical text, he waited a long time, since Abigail had prepared a clever as well as moving speech, which had the desired effect. (When Nabal died soon thereafter, David asked her to be his wife). The impression of a patiently listening king is reinforced by the stationary poses of all the other figures, from the horsemen in David's entourage to the maidservants behind the kneeling Abigail.

A sizeable group of people paying close attention to a single speaker, is a subject encountered frequently in Rembrandt's work. Obviously, it is hardly a novel theme. It is known, for instance, in Italian art in the form of a preacher—often a member of an order fond of sermonizing, like the Dominicans—speaking from a pulpit. It is so found, for instance, in a Florentine woodcut of 1495, dedicated to Savonarola.[25] The monk of San Marco, gesticulating excitedly, addresses a large audience assembled in the nave of a church, men and women separated from each other by a curtain. Yet there is not the slightest indication of an interrelation between the speaker and his public; the intense effort of the preaching monk does not seem to have an echo in the multitude sitting at his feet. The same, and possibly even more markedly, is true for Pieter Bruegel's allegory *Fides* (Fig. 13).[26] What we see are anonymous figures huddled beneath the pulpit, giving no visible sign of any response to the words of the speaker. (I hardly need to point out that this may very well be the point Bruegel tried to make.) In his painting of the *Sermon of St. John the Baptist* (Budapest) Bruegel assembled a large and colorful crowd that occupies the foreground and attracts our interest.[27] We have trouble locating the speaker, small in the distance. The effect of the words spoken is seen here as little as in the *Fides* allegory or in the Florentine woodcut.

A preacher addressing a large number of people is the subject of a Rembrandt draw-

[23] *Ibid.*, v, no. 1013.

[24] J. S. Held, *The Oil Sketches of Peter Paul Rubens*, Princeton, 1980, no. 315 (and the two other versions mentioned there).

[25] See A. M. Hind, *An Introduction to a History of Woodcut*, Boston and New York, 1935, ii, fig. 309.

[26] See R. van Bastelaer, *Les Estampes de Peter Bruegel l'Ancien*, Brussels, 1908, no. 132.

[27] See F. Grossmann, *Bruegel, The Paintings*, Complete Edition, London, 1955, no. 122.

ing in London (Fig. 14, *St. Paul Preaching in Athens*)[28] and in the Berlin painting of the *Sermon of St. John* (Fig. 15).[29] In both compositions the speaker dominates by virtue of his placement and emphatic gesticulation. The Baptist in the Berlin painting is neither singled out from the crowd nor does he disappear into it. His public is not an anonymous mass of figures but one rather remarkably heterogeneous in appearance and behavior. Nevertheless, with one characteristic exception, they are all depicted in attitudes of close attention. This eagerness to hear the Baptist's words is underscored still further by a father who is vexed by two fighting children, a mother who admonishes her child to be silent, and similar groupings. Only the three Pharisees in the foreground, by ostentatiously turning their backs, express their disapproval. And even this group exhibits what I have been claiming for Rembrandt: of the three men, only one speaks; the two others are listening to his words.[30]

Although Rembrandt returned to the subject of a solitary speaker addressing a larger number of people throughout his career, it is above all his later works that stress the binding and compelling function of the spoken word. How the master handled the subject during his earlier period can be shown in a drawing (Fig. 16) in which Joseph recounts his second dream to his father and assembled brothers (I Moses 37:9-10; the entire family was present only on this occasion).[31] The youthful speaker is on one side, his audience, caught in a variety of poses, on the other. The noticeable tendency to animate and vary the listeners' attitude, perhaps inspired by his study of Leonardo da Vinci's *Last Supper*, is characteristic of Rembrandt's earlier work; he surely was also guided by the knowledge that the speaker's words aroused his audience's disapproval and scorn. When at a later date Rembrandt drew the twelve-year-old Jesus before the "doctors" in the temple (Luke 2:46-47)[32] he rejected the chance that Dürer had taken in his famous *opus quinque dierum* to hint at the learned men's hostility; what he gave was a youth, in the center of the composition, whose words radiate from this center and visibly affect all that are reached by them (Fig. 17). In ever new variations Rembrandt explores the states of sympathetic attention and thoughtful absorption of the listeners, with not one straying from the spiritual focus.

[28] Benesch, I, no. 138 (London) [11].

[29] Gerson-Bredius, p. 469 [1].

[30] The concentrated attentiveness of the many listeners to St. John's sermon has already been noticed and admired by Samuel van Hoogstraten (*Inleyding tot de Hooge Schoole der Schilderkonst*, Rotterdam, 1678, p. 183); " 't Gedenkt my dat ik ... [in Rembrandt's 'Johannes Predicatie'] ... een wonderlijke aendacht in de toehoorderen van allerleye staeten gezien hebbe" (I remember that I have seen in Rembrandt's *Sermon of St. John* a marvelous attention of all kinds among his listeners).

[31] Benesch, III, no. 527 (London, Coll. P. Hatvany) [11].

[32] *Ibid.*, v, 885 (Paris).

This power of the spoken word was most memorably formulated by Rembrandt in the celebrated drawing of Homer reciting his poetry (1652, Amsterdam, Collection Six)[33] where a motionless group of people sit or stand all around the majestic poet; even the scribe seems to have stopped as he looks up while holding his pen in readiness (Fig. 18). Variety is guaranteed not by a diversity of action but by a most skillful and imaginative arrangement of figures in space. Much less known than the drawing of Homer, but equally significant for Rembrandt's fascination with the effect of the spoken word, is a still later drawing in the museum at Rennes (Fig. 19).[34] As Livy tells it in the forty-fifth book of his Roman history, Lucius Popilius, the Roman Consul, trying to obtain an answer from Antiochus Epiphanes of Syria whether he would withdraw from Egypt, drew a circle around the king with a rod (*virga*) and demanded his answer before he stepped out of the confining line. The king yielded. In Rembrandt's drawing, Popilius, as Rome's ambassador, still holds the rod he had used a moment before to trace the circle in the sand; his raised left arm gives emphasis to his stern command. And again it is only one person, Popilius, who speaks. The scene is watched in total silence by the king's soldiers, transfixed in their poses by the power of the spoken word, here reinforced by the magic of the circle.

Admittedly, the theme of an orator emotionally stirring his audience was by no means unprecedented. One of its most famous visualizations was Raphael's cartoon (and tapestry) of *St. Paul Preaching in Athens*, occasionally claimed even to have influenced Rembrandt.[35] Still, what Rembrandt made of this theme was something fundamentally different. A good comparison can be made between Raphael's composition and Rembrandt's etching of *Christ Preaching* (Fig. 20), known as *La Petite Tombe*.[36] To begin with, Christ's listeners remain completely silent; they crouch on the floor, sit on benches, or stand. Lost in deep thought, they put hands to chins or mouths. A small boy, neglecting the top at his side, traces imaginary lines on the pavement—he, too, silent. By contrast, in Raphael's composition, some figures play roles of their own: in the right foreground a man exclaims in astonishment, both hands raised in a conventional gesture of surprise; another turns back in order to call the speaker to the attention of his neighbor who—perhaps only momentarily—had looked backwards, away from the Apostle. (It is a device already recommended by Alberti.) More important, still, is the difference in the two compositions. In Rembrandt's rendering, Christ is not just placed in the center, he *is* the center. What he has to say touches everyone assembled around him, old and

[33] *Ibid.*, v, no. 913.
[34] *Ibid.*, v, no. 1014.
[35] Kenneth Clark, *Rembrandt and the Italian Renaissance*, New York, 1966, p. 185.
[36] Münz, no. 236 [10].

young, poor and rich, men and women. The setting contributes to this centralization. Raphael's Paulus is an orator whose message is directed not only to those before him, though even they are noticeably at some distance. Appearing relatively small and striking conventional attitudes, they are rather a symbolic audience; the Apostle's words are meant to resonate in distant spaces and for a larger congregation. And the function of the architectural setting is the very opposite of Rembrandt's: the sound of Paulus's voice is released into the distance. In the Rembrandt etching, Christ's voice is reflected back by the confining walls upon the people gathered in their shadow. Only with Rembrandt do we find the spoken word used as an agent to link a speaker intimately with his audience.

The several examples discussed here (being by no means all that could have been cited) should suffice to demonstrate that the spoken word, as dialogue or as address, not only occurs frequently in Rembrandt's art but plays an important role in his interpretation of religious subjects. Needless to say, the intimacy here established between Christ and the humble people whom he addresses is as much part of Rembrandt's Protestant heritage as Rubens' miracle-performing, suffering, and triumphant Savior is the focus of the religiosity of the Counter-Reformation. Yet it was only Rembrandt who discovered, in terms of the visual arts, how to give to the spoken word an unmistakably clear and leading role.

If it is justifiable to maintain—as I have done elsewhere—that another theme of Rembrandt's art is the existential loneliness of human beings, one could postulate an additional reason for the master's interest in themes involving verbal communication. Is not speaking, and the willingness to listen, one of the ways by which we hope to break out of our isolation and to build bridges from one to another? We might perhaps consider, in this context, some works where silence itself has been made part of the narrative. On the one hand we have pictures like the *Prodigal Son* (Leningrad),[37] or even the *Claudius Civilis* (Stockholm),[38] where silence is the final confirmation of unity—in the former, in a father's love for an errant child; in the latter, between a band of patriotic conspirators. But the abandonment of speech may also be the ultimate expression of estrangement and psychological isolation. The oppressive character of some of Rembrandt's late works may well be due to the impression that the people portrayed have stopped talking. This is surely true of the late picture of *Tobit and Anna* in the Museum Boymans-Van Beuningen in Rotterdam where the two old people, with no hope of seeing their son again, sit far apart (Tobit, Fig. 20). In their silent despair they have no words

[37] Gerson-Bredius, p. 503 [1]. [38] *Ibid.*, p. 391.

left, not even the angry ones they had exchanged when Anna came home with the little goat (see above, p. 121-22).

I could hardly think of a better example in Rembrandt's oeuvre to demonstrate the artist's expressive use of silence than the painting of *The Dismissal of Haman* in the Hermitage of Leningrad (Aristotle, Fig. 35).[39] The action of the picture has been interpreted in many different ways (see above, p. 3), with some authors even denying any connection with the Book of Esther.[40] Yet even those who believe that the principal figure is indeed Haman (Kahr, Tümpel, van de Waal, and Bialostocki, among others) vary greatly in their reading of the action, not to mention subsidiary meanings associated with it.[41] Differences concern the precise moment chosen here from the Book of Esther and the identity of the old man at the left, in whom van de Waal saw the prophet Elijah assuming the guise of the chamberlain Harbonah, while Kahr called him a "servant." To see in him Esther's father Mordecai, as many earlier scholars had done, is incompatible with any part of the biblical narrative. He may be the reader who called the king's attention to the unpaid debt of gratitude he owes to Mordecai. (No one seems to have followed up Kahr's suggestion that some clues may be found in one of the several seventeenth century plays about the Book of Esther.)

What should not be in doubt, however, is the fact that the oppressive mood of the picture derives from its total silence. Although the pertinent sections of the Book of Esther offer sufficient opportunities to depict verbal actions, Rembrandt here eschewed any gesture or expression that would have characterized one figure as engaged in the act of speaking. Each one is alone with his thoughts, disengaged from the others even though close in space. No matter how one may account for it, Rembrandt leaves no doubt that we are faced with a human situation where language—the bridge we throw from one to another—has lost all meaning. (We have seen such situations dramatized in movies by Ingmar Bergman.) Compositionally, the three men belong to different

[39] *Ibid.*, p. 442.

[40] I. Linnik, "Sur le sujet du tableau de Rembrandt dit la Disgrace d'Aman," *Bulletin du Musée de l'Ermitage,* xi, 1957, pp. 8-12; A. Bader, "A New Interpretation of Rembrandt's 'Disgrace of Haman'," *The Burlington Magazine,* cxiii, 1971, p. 473; S. Nystad, "Haman of Jozef," *Oud Holland,* lxxxvi, 1971, pp. 32-41.

[41] M. Kahr, "A Rembrandt Problem: Haman or Uriah?," *Journal of the Warburg and Courtauld Institutes,* xxviii, 1965, pp. 258-73; *idem,* "Rembrandt's Meaning," *Oud Holland,* lxxxiii, 1968,

pp. 63-68; *idem,* "On the Evaluation of Evidence in Art History," *The Burlington Magazine,* cxiv, 1972, pp. 551-53; Christian Tümpel, "Ikonographische Beiträge zu Rembrandt," i and ii, *Jahrbuch der Hamburger Kunstsammlungen,* xiii, 1968, pp. 95-126; xvi, 1961, pp. 107-98; H. van de Waal, "Rembrandt and the Feast of Purim," *Oud Holland,* lxxxiv, 1969, pp. 199-223; J. Bialostocki, "Der Sünder als Tragischer Held bei Rembrandt," *Neue Beiträge zur Rembrandt-Forschung*, Berlin, 1973, pp. 137-50.

layers in space, just as they seem to occupy sealed-off psychological spaces. The only discernable gesture is made by Haman's right hand, a gesture of deep concern, that may indeed reveal his awareness of imminent doom.

In another of Rembrandt's late paintings the spoken word plays once more a central role—and the word "role" is not inappropriate since it evokes a well-known convention of plays portraying the suicide of the hero or, as the case may be, the heroine. It can hardly be doubted that Lucretia, in the Washington painting of 1664 (Juno, Fig. 3),[42] as she is about to die, pronounces some last-minute words. Her parted lips and her raised left hand make this perfectly clear. But her words are not addressed to another person: Lucretia, in the solitude of her decision, speaks to the agent of her death, the dagger, poised in her right hand. In the face of death, the spoken word is no longer an instrument of communication with other human beings. In this situation, it is tragically cast in the form of a monologue.

At the outset I have mentioned that certain formulas Rembrandt used in giving visual form to the spoken word can occasionally be noticed in works of an earlier date. It remains for us to examine to what extent Rembrandt may have been able to profit from those earlier works, and whether it is possible to establish actual sources. His principal teacher, Pieter Lastman, can safely be omitted, despite the fact that for a long time, as Stechow has pointed out,[43] he exercised a considerable influence on Rembrandt's development. It is very instructive to compare Rembrandt's copy (done in red chalk) of Lastman's *Susanna*[44] with the original. The chief difference is found in the "speaking" gestures. In Lastman's painting Susanna has raised her right hand and, in doing so, responds to the wicked proposal of the Elders. The brief but important time interval has not been observed. This is what Rembrandt changed. In his drawing, Susanna's hands are lowered and it is only the lewd men who "speak." The chaste young woman remains literally "speechless."

The masters of the Utrecht school by and large follow the old convention of visualizing dramatic events by introducing a maximum of gesticulating figures. A good example is Baburen's canvas of *Christ among the Doctors* (Oslo)[45] where not only the precocious boy argues, with a gesture of both hands the artist had borrowed from Caravaggio, but where at least two and possibly three of the older men harangue him

[42] Gerson-Bredius, p. 442 [1].

[43] W. Stechow, "Some Observations on Rembrandt and Lastman," *Oud Holland,* LXXXIV, 1969, pp. 148-62.

[44] Rembrandt's copy: Benesch, II, no. 448 [11], Lastman's painting of 1614. Both works are in Berlin.

[45] See L. E. Plahter, "The Young Christ among the Doctors by Teodoer [*sic*] van Baburen," *Acta ad archaeologiam et artium historiam pertinentia,* III, 1983, pp. 183-230.

at the same moment. All the more surprising then is a painting by Honthorst (Fig. 21).[46] Painted before 1620, it depicts, as a night scene, Christ's examination by the high priest (presumably Caiaphas, though it also might be Annas) and seems indeed to anticipate an approach we have recognized as characteristic of Rembrandt's narrative style: only one person talks—the High Priest. All the other participants, Christ included, stand silently. This painting is unquestionably an impressive achievement, by a master of the second rank, but it is important to note that the biblical text illustrated here specifically tells us that Christ, confronted by hostile witnesses, remained silent (Matthew 26:62-63; Mark 14:60-61: "But he held his peace and answered nothing"). Moreover, the London painting remains an isolated case in Honthorst's oeuvre. Several years later he painted Solon before Croesus (Hamburg) where, in the time-honored manner, both figures appear to be talking simultaneously.

More important, and more likely as models for Rembrandt, could have been some sixteenth-century graphic works. But surely not an artist like Heemskerck, despite the fact, well taken by Tümpel,[47] that Rembrandt occasionally derived compositional as well as iconographic ideas from engravings based on Heemskerck's design. Het Heemskerck adhered clearly to the tradition of "universal gesticulation." We find, however, in Iost Amman's biblical illustrations single figures, chiefly prophets, in animated attitudes addressing a group of people, who listen in silence. Yet the best and most interesting analogies are found in the small but admirably precise woodcuts after Holbein, first printed in the 1538 (Lyons) edition of the Old Testament.[48] Thus the woodcut of the *Reckoning of the Genealogies* (I Chronicles 9:1 ff.) (Fig. 22) has undeniable similarities with Rembrandt's drawing of Joseph's brothers (Amsterdam) asking Jacob to let them take Benjamin with them (see Genesis 43:1-10).[49] Not only is there only one speaking person in each of the works, but there is a quite comparable distribution of clusters of listeners. Other scenes with a single speaker before a group of people are found in the woodcuts for II Moses 5:2, V Moses 1:3 and 4:1, II Samuel 14:4; II Kings 23:2; Amos 1:1, and Hosea 1:1. And while the Bible does not mention any words spoken before David by Abishag the Shunamite, the "fair damsel" picked by David's servants to warm the aging king's blood (I Kings 1:1-4), Holbein illustrated the story as a conversation in which one person, the kneeling Abishag, speaks, while David listens (Fig. 23). (The

[46] See J. Richard Judson, *Gerrit van Honthorst*, The Hague, 1959, pp. 164-65, no. 44 (frontispiece).

[47] See above, note 41. See also Tümpel, *Rembrandt, Mythos und Methode*, Königstein im Taunus, 1986, esp. p. 171.

[48] *Historiarum ueteris instrumenti icones ad uiuum expressae*, Lyon (Melchior and Gaspar Trechsel), 1538. The illustrations here are taken from the fairly reliable copies in *Icones Veteris Testamenti*, London (William Pickering), 1830.

[49] Benesch, III, no. 542 (Paris) [11].

mission, though faithfully executed by Abishag—she "cherished the king and ministered to him"—was unsuccessful: "the king knew her not.")

If we look for "sources" for Rembrandt's handling of the spoken word in earlier works of art, they are indeed found at best in the modest woodcuts of the Holbein Bible. Yet it is precisely in this perspective that we recognize in how much more penetrating and psychologically differentiated ways Rembrandt dealt with the difficulty of translating a verbal action into a visible form. This, I believe, is one of Rembrandt's major achievements.

That brings me to a last question, too broad to be more than adumbrated in this context: what about Rembrandt's pupils? Without exploring the question systematically, I could not help noticing that they appear to have ignored Rembrandt's deliberate and clear distinction between figures who speak and those who listen. Thus, when Ferdinand Bol painted the negotiations between Julius Civilis and Quintus Petillius Cerealis, facing each other across the gap of the broken bridge (Amsterdam),[50] he gave to *both* generals animated "speaking" gestures; nor can we be astonished that none of the many accompanying figures pay them any attention. In Karel van der Pluym's canvas of the parable of the laborers in the vineyard (Matthew 20:1-16; Collection Russel, Amsterdam),[51] two figures are shown in conversation, but since both of them are talking, neither listens to the other. Occasionally we find examples that seem to echo Rembrandt's ideas about the rendering of verbal exchanges but these appear to be accidental rather than intentional, since the same artists also painted pictures that run counter to anything we have observed for their master. If anyone, Art de Gelder, Rembrandt's last disciple, seems to have understood, or at least tried to adopt, Rembrandt's way of dealing with such subjects.

If we are correct in this observation about Rembrandt's pupils, we are faced with a curious question: to what extent was Rembrandt conscious of his own principles of interpretation? Do we have to assume that he withheld from his students the knowledge of a narrative device he had developed and had consistently applied in his own compositions? It seems to me more likely that Rembrandt failed to instruct his students about this particular aspect of his art because he himself had not provided it with a theoretical underpinning; in fact, he may not have been fully aware of the significance of his personal approach to the problem of the "spoken word."

With this question we are touching on a problem of a more general nature, one that

[50] See W. Sumowski, *Gemälde der Rembrandt-Schüler,* I, Landau (Pfalz), 1983, p. 341, no. 102.
[51] See *Rembrandt and His Pupils*, Exhibition Montreal Museum of Fine Arts and Art Gallery of Ontario, Toronto, 1969, *Catalogue* no. 99, Coll. Dr. Willem M. J. Russell, Amsterdam.

goes far beyond the framework of this study. To what extent were the great poets, musicians, and artists of the past conscious of their own personal thematic preferences and of the characteristics in technical, stylistic, and interpretative respects that mark their works as unmistakably their own? Is it not only with the benefit of hindsight and the total oeuvre of these artists before us that we can draw conclusions about the specific individuality that distinguishes them from their contemporaries and enables us to define their place in history.

Some masters—one thinks of Poussin—may indeed have thought about the theoretical foundations of their craft and tried to pass them on to their pupils. The few pronouncements by Rembrandt that have been reported or the much debated passage from one of his letters to Huygens (1639) about his effort to catch the most natural expression (die naetuereelste beweechgelickheijt) are not of the kind to make us think that he had formulated theoretical statements which have been lost.[52] The famous Goethe words "Bilde Künstler, rede nicht" might well have been Rembrandt's motto, too.

[52] This was observed by Anthony Bailey (*Rembrandt's House*, London, Melbourne, Toronto, 1978, pp. 98-99) in his well-written, occasionally fictional but basically sound story of Rembrandt's "house" and life.

NOTES TO THE 1969 EDITION

pp. 17-18 I am grateful to The New Yorker for the permission to reproduce here George Price's 1980 cartoon whose caption fits nicely an argument I have made early on in my study of 1969. While most cartoons of Rembrandt's painting (I understand the Metropolitan Museum has assembled a huge collection) have taken the picture itself for their point of departure, Price's target has been the painting's popular title. The shallowness of its formulation, which I had questioned half mockingly, half seriously, is hilariously revealed when quoted by one of Price's lovable, pot-bellied, beer-guzzling working men. The gist of my paper has been, of course, that the painting can be given a more precise and more substantial reading.

p. 18, note 8 Emmanuel Berl (*Rembrandt, Collection Génies et Réalités*, Paris, 1965, p. 130) similarly misread the action when he said, "... le philosophe regarde le poète aveugle avec une intensité qui teinte ce tableau paien de christianisme."

p. 26, lines 11-13 The size of 8 by 6 palmi ought to be calculated differently, as has been pointed out in *Art and Autoradiography*, The Metropolitan Museum of Art, 1982, p. 99, note 46. Although the exact correspondence cannot be established, the size of Ruffo's painting was ca. 176 by 132 cm. The loss in height, therefore was about 37 cm, not as I had it, 53 cm.

p. 40, line 5 The painting given here as "anonymous" has been identified by St. Roettgen as a work of A. R. Mengs, portraying the artist's son Moritz Mengs (*Paragone*, July 1968, fig. 52). It was sold at Christie's, Rome, on October 15, 1970 (lot 134).

pp. 50-51 Many more artists than I listed in 1969 were honored and rewarded with golden chains to which a portrait medal of a ruling monarch was attached. The younger Matthaeus Merian, so Sandrart tells us, received from Emperor Leopold "grosse güldene Ketten, Gnadenpfennige und Verehrungen" (A. R. Peltzer, *Joachim von Sandrarts Academie der Bau-, Bild-, und Mahlerey-Künste von 1675*, Munich, 1925, p. 200). Sandrart himself "ward neben mildreicher remuneration mit einer schönen güldenen Kette samt der Käyserlichen Medaglie beschenket" (*Ibid.*, p. 39). Artus Quellinus, the great Flemish sculptor, according to Sandrart, was honored "mit sehr grossen Schätzen, Medaglien und güldenen Ketten" (p. 236). The golden chain that Rubens received from King Christian IV of Denmark, still preserved in the Rubenshuis in Antwerp, has the king's portrait medal attached to it. For the manner of wearing such chains Kneller's self-portrait in the National Portrait Gallery, London

"I'll be in the den, contemplating the bust of Homer."

Drawing by Geo. Price; © 1980 The New Yorker Magazine, Inc.

(the so-called Kit-cat portrait), is of interest. He wears the chain, given to him by William III in 1699, draped diagonally across the body, just as does Aristotle in Rembrandt's painting (see J. Douglas Stewart, *Sir Godfrey Kneller and the English Baroque Portrait*, New York, 1983, p. 16). Walter Liedtke called my attention to the fact that as shown by X-ray evidence, the medal worn by Aristotle had originally been suspended further down. Rembrandt may have moved it higher up, to place the image of the helmeted monarch more directly opposite the bust of the poet. The suggestion made by Margaret Deutsch Carroll (see below p. 191-93) that the head on the medal is of Pallas Athena rather than Alexander makes no sense if the chain is understood

as an "Ehrenkette." For the problem of the fusion of the imagery of Alexander and Pallas Athena, see above, p. 23 and note 25.

p. 53, note 138 The lecture by H. van de Waal was published first in *DELTA*, XII, no. 2, 1969, pp. 74-88, and again in the author's book *Steps towards Rembrandt*, London, 1974, pp. 13-17.

JUNO

p. 99, lines 1-3 The happy juxtaposition of the *Aristotle* and the *Juno* at the Metropolitan Museum unfortunately lasted only a few years.

p. 107, line 17 The museum where the painting was deposited during the war years was the Detroit Institute of Arts, not the "Detroit Art Museum."

p. 111, line 12 The reference to the Portrait by Licinio should read *"formerly* in the collection of Mrs. Edward D. Brandegee, Boston."

REMBRANDT AND THE BOOK OF TOBIT

p. 126, after line 12 Christian Tümpel has called attention to a painting by Pieter Lastman (1611, Boston Museum of Fine Arts) depicting the same subject. (He considers the New York drawing to be a copy of Rembrandt's original drawing, now lost, a view I find hard to follow; see "Studien zur Ikonographie der Historien Rembrandts, Deutung und Interpretation der Bildinhalte," *Nederlands Kunsthistorisch Jaarboek,* XX, 1969, pp. 175-78, and again in *Rembrandt, Mythos und Methode*, Antwerp, 1986, p. 391, no. 23.) On the basis of the Boston panel Tümpel interpreted a powerful, if enigmatic, painting in Edinburgh as *Sarah Expecting Tobias*. The painting depicts a buxom young woman in bed; only the upper part of her body—one breast uncovered—is seen, as she lifts the bed-curtain with one hand and intently looks at something or somebody outside the picture. K. Bauch (*Rembrandt Gemälde*, Berlin, 1966, no. 266) had called it simply "A Woman in Bed"; H. Gerson (*Rembrandt Paintings*, Amsterdam, 1968, no. 227) more specifically identified it as "Hendrickje Stoffels in Bed." Yet the work surely has a narrative content, and the title given to it by Tümpel points in the right direction, though it might be preferable to call it *Sarah Watching Tobias as He Burns the Heart and Liver of the Fish*. For Tümpel this would be another example of Rembrandt's practice of "Herauslösung" (isolation) of single figures or small groups from a more complex overall action. For the identification of the model with Geertje Dircx see note on p. 9.

p. 138, note 30 The subject of the Edinburgh painting was discussed at length by Christian Tümpel, pp. 187–94). Rejecting both interpretations discussed in note 30, Tümpel identifies the old woman as the Prophetess Hanna (Luke 2:36-38) and the boy as a "youthful servant." He retained this interpretation in his 1986 Rembrandt book, (p. 420, no. A9). Although acute in many of his interpretations of biblical scenes, Tümpel fails to proceed, as one ought to, from the character of the scene depicted. A little boy, prayerfully kneeling at the side of an elderly woman who holds a book in her lap, must be more than a servant who, according to Tümpel, appears (not always very clearly) in some scenes of the *Presentation of Christ*. Nor is the prophetess ever rendered seated and removed from the event that alone placed her into the sequence narrated in Luke's gospel. Tümpel's chief argument against interpreting the scene as the one described in I Samuel 2:19, while the *Presentation of Christ* is shown in the background, rests on his belief that Rembrandt never connected—in the manner of medieval typologies—Old and New Testament actions in one composition. Even if this is the case with the works we have (we must remember that we do not have all of Rembrandt's works anymore) there is always the possibility of an exception, for instance due to a special commission, perhaps from a Catholic patron. The beautiful painting, unfortunately, stands not only in the center of discordant interpretations, it is now also doubted as Rembrandt's work. Gerson (1968, p. 497, no. 223) suggested van Hoogstraten or Abraham van Dijck as its author. Tümpel lists it simply as "Rembrandt-Workshop."

p. 141, after line 17 That towards the end of his life Rembrandt's father may have lost part, or all, of his eyesight can not be confirmed from the few documents at our disposal. Yet one observation, not previously made (except in the Leipzig edition, in German, of this book) seems to lend strong support to such an assumption. Three times in his life Rembrandt's father made a will—in 1600, in 1614, and in 1621 (see *The Rembrandt Documents*, edited by Walter L. Strauss and Marjon van der Meulen, New York, 1979, pp. 37-38 |1600|; pp. 24-26 |1614|, and p. 51 |1621|, see Fig. A). His signature in the earlier ones is written in a strong, clear hand and in a straight line: *Harmen gerret molenaer*, and *Harmen gerretsz vanden rijn* (variations in spelling of names, even by the people themselves, were very common at the time). In 1621, however, when he wrote only *Harmen gerretsz*, his script is shaky and uncertain. It does not look like the writing of someone whose muscular control is affected (as by trembling) but rather as though he had trouble seeing what he was doing. (I owe to Professor Werner Jaeger, of Heidelberg University, the information that an inability to write in a straight line is characteristic for people suffering from impaired eye-

1600

1614

1621

sight.) We do not know what happened to Rembrandt's father between 1621 and 1630, when he died, but it is perfectly possible that he suffered from cataracts (*grauer Star*) and underwent a cataract operation. This certainly would explain Rembrandt's interest in, and obvious familiarity with, the technique of these operations, in which the surgeon stands behind the patient. Unfortunately, as Professor Jaeger has pointed out, such operations in Rembrandt's time, did not always bring a lasting improvement in sight (see Wolfgang Jaeger, *Die medizinhistorische Bedeutung der Tobiasheilungen Rembrandts*, Vorwort to Julius S. Held, *Der blinde Tobias und seine Heilung in Darstellungen Rembrandts*, Heidelberg, s.d. 1980).

A final piece of evidence supporting the same thesis is provided by a small panel (24 x 20.3 cm.) in the collection of Dr. A. and Mrs. Bader, Milwaukee (Fig. 50). It is signed with the early form of Rembrandt's signature, *RHL*, and was etched by J. G. van Vliet in 1634. Rejected as Rembrandt's work by the authors of the Rembrandt *Corpus* (C 22), it was strongly defended by P. Schatborn (*Oud Holland*, c, 1986, p. 62). Tümpel (1986) listed it as an authentic work (no. 128) and reproduced it in color, p. 57). It was K. Bauch (*op. cit.* 1966, no. 343) who first recognized it as a portrait of Rembrandt's father, a fact that can hardly be denied. The troubled expression and the curious, sideways, and unfocussed glance of the old man strongly convey the impression that the model had largely lost his ability to see.

APPENDIX

ARISTOTLE: POSTSCRIPT (1990)

WHILE ALL the authors aiming at an overall discussion of Rembrandt's work have written about Rembrandt's *Aristotle* (and happily no one has questioned its authenticity), they have concentrated generally more on its history and less on its meaning. Only one author, Margaret Deutsch Carroll, has tried to replace the interpretation I gave in 1969 with a completely different one.[1] I ought to mention, however, that a prominent literary figure has taken the painting as the point of departure (and continued point of reference) for an ironic, pseudo-historical smorgasbord of fact and phantasy.[2] Drifting back and forth between the historical Aristotle, Rembrandt's Aristotle, and the contemporary art market, Joseph Heller scatters some mordant commentaries on art, collecting, the value of money, and the vanity of all things. I suppose we should be grateful for the fact that he had no intention of making a contribution to our understanding of the picture itself.

In a shorter study, published in a somewhat out-of-the-way place, Michael Platt[3] discussed the relationship between seeing and thinking, as it applies not only to Aristotle, who gazes away from the bust of Homer while presumably thinking about it, but also to Platt himself who can think about the painting without actually looking at it. Platt's further speculations on the relationship of art, poetry, and philosophy involve other works by Rembrandt and have no special bearing on our understanding of the *Aristotle*. When he finally turns to the golden chain he takes the position that it has here a meaning slightly different from the chains of honor (and financial reward) so commonly encountered in seventeenth-century portraiture. It is his opinion that in this case—since it is presumably a gift from a pupil to his revered master—it has none of the connotations of bondage that go with the conventional meaning of such chains. I consider it moot to argue whether Rembrandt used the chain in the sense familiar from his seventeenth-century experience, or in a way that was valid only in this special instance—particularly since the chain, like the rest of the picture, is a pure poetic invention. Contrary to Carroll, Platt accepts my thesis that the chain must be understood as a gift from a prince, and that the portrait medal attached to it shows the face of the only prince Rembrandt could have had in mind—Alexander the Great.

Calling her paper an "essay on the philosophical value of looking at art" (p. 56),

[1] Margaret Deutsch Carroll, "Rembrandt's Aristotle: Exemplary Beholder," *artibus et historiae*, no. 10, 1984, pp. 35-56.

[2] Joseph Heller, *Picture This*, New York, 1988.

[3] Michael Platt, "Aristotle Gazing," *The College*, Annapolis and Santa Fe, XXXI, no. 2, 1980, pp. 68-74 (published by St. John's College).

Carroll bases her interpretation on two assumptions, either of which is highly debatable. Accepting the popular title of the work as a correct summing-up of its theme and as an equally correct reflection of Rembrandt's intentions, she takes it for granted that Aristotle does contemplate the bust of Homer and—probably compelled by the modern and fully justified admiration for the particular Hellenistic marble depicted by Rembrandt—she is convinced that Aristotle here "contemplates" the bust *qua* work of art. There is but one step from here to Neoplatonic notions about the spiritually uplifting effect of contemplating beautiful things, and also to the Aristotelian admission of the pleasure that artful imitation (even of revolting subjects) can give to the beholder. The arbitrariness of such a reading becomes obvious if we substitute equally arbitrary, but not impossible titles, such as "Aristotle Contemplating the Vanity of All Things," or "Aristotle Contemplating the Greatness of Homer's Poetry." In fact, while we know that in the seventeenth century busts were collected for their historical and iconographic significance, there is no clear evidence, as far as I know, that their appeal was chiefly aesthetic, even though a man like Rembrandt (or Rubens for that matter) was surely not insensitive to the excellence of their craftsmanship.

Carroll's second assumption introduces the idea (which H. von Einem had very cautiously hinted at and which I had rejected) that the golden chain worn by Aristotle stands for the so-called "golden chain of Homer," better known now as "the great chain of being," a concept derived (see above, p. 47) from a curious passage in Homer's *Iliad*. Despite all the learned references to the symbolic meaning of Homer's "chain" standing for the interconnectedness of all things, Carroll can not show one single example where that symbolic object is transformed into a real chain, worn decoratively by an individual and further embellished by a medal attached to it, as with most chains of honor.

The problem with such readings (and that goes also for some on the *"Polish" Rider*) is ironically one shared by Rembrandt's painted Aristotle, insofar as he behaves as these theories propose: that he is engaged in interesting philosophical constructs without actually looking at the object that supposedly triggered these thoughts. When I developed the notion of a conflict depicted in the *Aristotle* between the world of spiritual things (symbolized by the bust of Homer) and of worldly success (suggested by the chain), with the significant distinction between the philosopher's right and left hands, I remained close to what any viewer can see. And while I could make no more than a stab at explaining why Rembrandt's Aristotle appears to be possessed by melancholy reflections, Carroll—though accepting the idea when she calls Aristotle a "melancholy philosopher" (inevitably calling up Dürer's *Melencolia I*)—fails to give any reason why this "exemplary beholder" and champion of the concatenation of all things should be mired

in rather bleak thoughts, a notion even less understandable since she even thinks that in the figure of Aristotle, Rembrandt may have depicted "the ideal prototype" of his Sicilian patron, Don Antonio Ruffo.

While in Carroll's interpretation of the painting the central concept is *sight*, in Svetlana Alpers' much shorter discussion it is the sense of *touch*. Yet because of this stress on touch, the picture assumes for her considerable significance, since the entire chapter—the first of her book—is devoted to and indeed titled "The Master's Touch." Her concern in that chapter is with Rembrandt's craftsmanship, his heavy application and the substantiality of the pigments used, and the central role played by the artist's hand. In this connection she turns to Rembrandt's interest in blindness, to which I had first called attention in 1964 (see also above pp. 138-41), but gives to it a very different interpretation. She links Aristotle's right hand to the use blind people make of their hands, the organs with which they "see." And in an almost paradoxical reversal—since it is Homer, after all, not Aristotle, who is blind—she interprets the role of Aristotle's right hand as helping him to "know" the bust; she even uses the word "probing" (the way in Ribera's painting—see p. 40, note 89—the factually blind Gambazo, or Carneades "probes" the bust in his hands). The entire meaning of Rembrandt's painting is thus reduced to the hardly original notion that *touch* is "the means" (not the only one, of course) "by which we apprehend the world." Since Alpers apparently is satisfied with the conventional title according to which Aristotle "contemplates the bust of Homer," his contemplation in this context can only be of the physical piece of marble, and Rembrandt's purpose in painting it was no more than to remind us of the role touch plays "in our experience of the world." I find such a view too shallow for one of Rembrandt's major artistic statements.

THE "POLISH" RIDER: POSTSCRIPT (1990)

My ARTICLE on the "Polish" Rider, written in 1942-1943 and published in 1944, was the first comprehensive analysis devoted to that celebrated canvas. For the historical data (from its first appearance in the late eighteenth century to its acquisition by Henry Clay Frick in 1910)[1] I had to rely on a variety of sources, many of them Polish. Yet despite some subsequent clarification the general outlines of that history have remained unchanged. When that article was incorporated in the first edition of this book (1969) I added some new material (for instance some quotes from Vondel's poetry that seemed to me relevant) and in an Appendix surveyed the critical literature that had appeared on the picture up to that time. A similar addition was made to a German translation that appeared in Leipzig in 1983. I shall try to summarize here and examine critically the various opinions published on the picture during the last forty years, and I shall list them by "categories" rather than in a chronological sequence. (Since the Dutch scholars who claim that the picture was not painted by Rembrandt at all have not, so far, come forth with concrete arguments in support of their view, I prefer to let that sleeping dog lie.)

All studies have in common a keen desire to clear up the "mystery" of a work whose artistic merit and emotional appeal have never been in doubt. Yet one can not help reflecting on the reliability of interpretative art history when so many learned and well-intended scholars arrive at meanings as radically different from each other as those suggested for this particular painting. Moreover, it seems to me, that the "simpler" the proffered explanation, the more vulnerable it appears when submitted to critical examination.

The questions, overriding all others, have always been: Who is the rider? What is his name? as if, Rumpelstiltskin-like, a name would instantly break the spell and uncover the "real" meaning of the picture. Some scholars have looked to the theater to find a name and role for the young soldier, not unreasonably so, since we know that Rembrandt had contact with actors and once even made an etching linked to a play by Jan Six. The earliest of these attempts to link the picture with a play performed in Rembrandt's time was made by W. R. Valentiner who identified the rider as Gysbrecht van Amstel, the hero of an eponymous play by Vondel.[2] This suggestion loses all cred-

[1] The most authoritative account of the physical condition of the painting, based in part on X-ray evidence, is found in *The Frick Collection, An Illustrated Catalogue,* 1, New York, 1968, pp. 258-60. The text for the Dutch paintings was edited by John Walsh, Jr.

[2] W. R. Valentiner, "Rembrandt's Conception of Historic Portraiture," *Art Quarterly,* xi, 1948, pp. 117-36.

ibility as soon as we realize that Gysbrecht was an old man when he fled to Poland (as he is supposed to be doing in the picture) and that he was accompanied on that flight by his family and some servants.

Gary Schwartz (1985)[3] thought he found the identification in an equestrian soldier in the play *Tamerlane* by Joannes Serwouters (1623-1677). Since that play was first performed in 1657 Schwartz was forced to date Rembrandt's painting to that year—later than it had ever been placed. (Even so, Rembrandt must have been in a hurry to use the latest hit for a painting.) Tamerlane (modern Timur) was a Mongol prince who late in life made war against and conquered the Turkish Sultan Bayazet. Although there is no such scene in Serwouters play, Schwartz interpreted the "Polish" Rider as *Tamerlane in Pursuit of Bayazet*. For a man in pursuit of a deadly enemy Rembrandt's young man is rather nonchalant; one might be tempted to advise him to have at least one of his several weapons ready for action.

No more likely is a suggestion made in a short paper by J. Z. Kannegieter (1970)[4] who discovered a "bley-eyndigh treurspel" *Sigismundus van Poolen* that was performed in 1647 and was available in print in 1654 (no author given). His candidate, however is not the titular hero but a martial maiden in soldier's attire; yet it is nowhere in the play stated that she went into battle all alone.

Some scholars have found what they thought were plausible links to definite historical personalities. Zdzislaw Zygulski, for instance,[5] while essentially concerned with the geographic localization of the rider's outfit and armament, revived once more the old idea (see above, p. 65-66) that Rembrandt painted an officer of the legendary Lisowski regiment. In that opinion he remains alone, even though other scholars, especially Polish ones, agree that not only the rider, but his horse as well, are demonstrably and unmistakably Polish.

Seemingly better founded was a study by Jan Bialostocki[6] who had discovered a Socinian pamphlet, pleading for tolerance in matters of faith, whose author identified himself only as "Eques Polonus" (A Polish Knight). Actually he was a prominent member of a Polish Socinian group in Holland and about sixty years of age at the time the picture is believed to have been painted. His name was Jonasz Szlichtyng. Unable evidently to consider the rider in the Frick canvas a "true" portrait of Szlichtyng, Bialo-

[3] Gary Schwartz, *Rembrandt, his life, his paintings*, New York, 1985, pp. 273, 277-78.

[4] J. Z. Kannegieter, "De Poolse Ruiter, II," *Kroniek van het Rembrandthuis,* xxiv, 1970, pp. 85-88.

[5] Zdzislaw Zygulski, "Lisowćzyk Rembrandta," *Nadbitka z Biuletynu Historii Sztuki,* xxvi, 1964, pp. 83 ff., reprinted in English in *Bulletin du Musée National de Varsovie,* vi, 2-3, 1965, pp. 43-67.

[6] Jan Bialostocki, "Rembrandt's Eques Polonus," *Oud Holland,* lxxxiv, 1969, pp. 163-76.

stocki claimed for it the status of a "spiritual portrait" of the Polish nobleman. It remains unclear why a member of a faith profoundly opposed to war should be portrayed armed to the teeth, with saber, sword, war-hammer, and bow and arrow. Sectarian doctrine (such as the Socinians' denial of the trinitarian dogma) is hardly anything one would connect with the confident young soldier, riding alone in a romantic setting.

In the context of an important analysis of Rembrandt's painting of *Jacob Blessing the Sons of Joseph* in Kassel, Reiner Hausherr[7] floated—very tentatively to be sure—the theory that the "Polish" Rider might have been painted for a Jewish patron, or one close to Jewish messianic thinking. If so, he says, it might be an image of the *Messiah "ben Ephraim"* who, according to the eschatological-messianic writings by Menasseh ben Israel is the "first" Messiah, who will gather the ten tribes in preparation for the coming of the final Messiah who shall reign forever. Rembrandt knew Menasseh ben Israel and even made etchings for one of his books, which were not used in the end. The print, however, that Hausherr introduced, depicting the self-claimed Messiah Sabbatai Zevi on horseback, is not only considerably later (dated 1666), which Hausherr acknowledges, but is actually only a copy of an etching by Stefano della Bella (the *Moorish Rider*, see "Polish" Rider, Fig. 9) and hence hardly adds a significant piece of evidence.

Yet with this suggestion we come to still another sphere from which names and characters were picked to help the rider out of his anonymity. For a while Colin Campbell's thesis[8] that in the Frick picture Rembrandt had painted the Prodigal Son, riding out into the world after having received his "portion" (Luke 15:11-13) found several "converts" (Tümpel, in his 1986 book, declared it "the most convincing" interpretation). Since Rembrandt's horseman carries nothing that might indicate his new affluence, Campbell ingenuously suggests that the abundance of weaponry attests to his fortune which, as we know, he will waste with "riotous living." Nor is it clear why Rembrandt, who several times indeed depicted some of the standardized incidents of the parable, should have chosen to dedicate a large canvas to a moment of no significance to the message of the story, and one not legitimized by an established iconographic tradition.

The Prodigal Son was not the only character from scripture to have found a kind of

[7] Reiner Hausherr, *Rembrandt's Jacobssegen*, Abhandlungen der Rheinisch-Westfälischen Akademie der Wissenschaften, Opladen, 1976, pp. 55-56.

[8] Colin Campbell, "Rembrandt's 'Polish Rider' and the Prodigal Son," *Journal of the Warburg and Courtauld Institutes,* XXXIII, 1970, pp. 293-303. Campbell read a version of this paper at the meeting held in connection with the Rembrandt-Year in Berlin (1969) which was published, together with excerpts of the discussion that followed, in *Neue Beiträge zur Rembrandt-Forschung,* ed. Otto von Simson and Jan Kelch, Berlin, 1973, pp. 126-36. A Dutch version of Campbell's paper was printed in the *Kroniek van het Rembrandthuis,* XXVI, 1972, pp. 51-66.

reincarnation in the figure of the "Polish" Rider. In a slim volume investigating Rembrandt's familiarity with things Persian (and incidentally questioning, not without reason, some of Zygulski's pronouncements on the Polishness of the rider's weapons) Leonard Slatkes[9] offers the young David (as described in I Samuel 18) as a likely candidate. He arrives at this notion by way of the Christian Knight, a familiar figure since Erasmus's *Enchiridion militis christiani*. Vondel had taken up that theme and in that connection cited young David as its Old Testament prefiguration.[10] Despite the fact that I can see in Slatkes's assertion a welcome echo of a concept introduced in my original paper (one almost universally misinterpreted, as if I had identified the "Polish" Rider himself as a *Miles Christianus*),[11] I can not accept his thesis. What he introduces as concrete evidence (when he says for instance that "oriental costumes" were used by Rembrandt generally for Old Testament figures) unfortunately is no more compelling than the arguments Campbell had used to identify the rider as the Prodigal Son. And there is no iconographic precedent for David on horseback, riding alone.

It was almost inevitable that another possibility which I had considered and rejected would again be revived: that Rembrandt's painting is an actual portrait. Giving credit to suggestions by Bialostocki, B.P.J. Broos[12] first had to affirm that the painting is not different from certain Dutch types of equestrian portraiture (an argument Slatkes has rightly questioned). Nevertheless, Broos introduced a new and interesting element into the discussion. What had escaped me when I checked the names of Polish students inscribed in Dutch universities (pages 144-45 in my 1969 book) was that several members of an Ogiński family had studied in the Netherlands. A Theodor Ogiński, age 20, was inscribed in Leiden in 1636. Two Ogiński brothers, Jan and Szymon Karol, studied

[9] Leonard J. Slatkes, *Rembrandt and Persia*, New York, 1983, pp. 60-92.

[10] "HYMNUS OF LOFZANGH Vande Christelycke Ridder," *De Werken van Vondel*, Amsterdam, 1927-37, I, pp. 447-58.

[11] It is difficult for me to understand how the concept of the *Miles Christianus* (even put in quotes in the chapter heading where I introduced it) could be taken as the "key" to my interpretation of the painting. Even a distinguished scholar like Horst Gerson crudely reduced my discussion of the painting to one sentence (*Rembrandt, Gemälde*, Amsterdam, 1968, p. 106): "Julius Held . . . sees the horseman simply [!] as a *miles christianus*, a Christian soldier, the matter of the Polish character being quite irrelevant" [!]. This statement has been repeated, in varying degrees of bluntness, in many other publications, few authors evidently taking the trouble to read my own version. My summing up of that chapter should make clear that while I believe that Rembrandt's martially handsome rider derives some of his appeal from the old concept of the *miles christianus*, I never claimed that Rembrandt intended him to personify such an allegorical character, and always admitted the possibility that "he may have called him by a definite name." Nor did I ever say or imply that the question of the rider's costume was irrelevant.

[12] B.P.J. Broos, "Rembrandt's Portrait of a Pole and his Horse," *Simiolus*, VII, 1974, 4, pp. 192-218.

in Franeker in 1641, and Marcyan Aleksander Ogiński, 19, was inscribed in Leiden in 1650. Since, as we know (see above pp. 62-63) two members of the Ogiński family had been involved with the painting in the last decade of the eighteenth century (though the role of Michael Casimir Ogiński is not clearly established), Broos was fully justified in speculating on the possibility that the painting by Rembrandt was somehow connected with one of the four young Ogińskis known to have been in Holland at Rembrandt's time. Without considering other scenarios, Broos chose the simplest: that the Frick canvas is nothing other than a straightforward portrait of one of these men, comparable to the equestrian portraits of Dutch cavaliers in fancy oriental outfits, as seen for instance in several portrayals by Aelbert Cuyp. Broos's candidate was Szymon Karol who had settled in Holland, married a Dutch woman and fathered three children. In 1655 (the date generally given to the picture) he was 34 years old. Actually he is the least likely candidate since it is hard to understand why the father of a family, approaching middle age and presumably happily settled in the Netherlands (he lived in Groningen), should have wanted to be portrayed in such a romantic fashion. A more likely candidate (as I had stated in 1981)[13] was the youngest of that group, Marcyan Ogiński. Juliusz A. Chroscicki had come independently to the same conclusion.[14] Quoting from a Polish biographical dictionary, Chroscicki traces Marcyan's military career as follows: around 1651 he entered military service, served in Pawel Sapieha's Lithuanian army around 1656, and in 1657 had reached the rank of colonel in the Royal army fighting against Jerzy II Rakoczy. He later became one of the wealthiest Lithuanian magnates, was involved in anti-royalist conspiracies but, tried in 1687, he again became a royalist. He died in 1690.

What might be no more than an attractive possibility—that it was Marcyan Ogińsky through whom Rembrandt's painting entered the family from whose possessions it first emerged in the seventeen nineties—Chroscicki tries to make into a certainty with the help of a painting by Ferdinand Bol, which he introduces as a documented portrait of the young Polish gentleman.[15] According to Chroscicki the letters "M.O." which appear

[13] Julius S. Held, *Rembrandt Studien*, Leipzig, 1983, p. 69: "Unter den von Broos zitierten Mitgliedern der Ogiński-Familie gibt es in der Tat einen—aber eben nur diesen einen—dessen Daten in eine solche gedankliche Konstruktion passen würden: Marcyan Ogiński ..." (Nachwort zum "Polnischen" Reiter, 1981).

[14] Juliusz A. Chroscicki, "Rembrandt's Polish Rider, Allegory or Portrait?" *Ars Auro Prior, Studia Ioanni Bialostocki Sexagenario Dicata*, War-

saw, 1981, pp. 441-48. Chroscicki deserves credit for having discovered the lithograph by Karol Auer (Fig. 24) which, in contrast to the claim made for the illustration in the 1934 *Encyclopedia* (see Fig. 2) is clearly based on Rembrandt's painting, then making part of the Tarnowski collection at Dzykow.

[15] This portrait was formerly in the A. L. Wenner-Gren collection, Stockholm.

at the lower right identify the model as Marcyan Ogiński, and the additional letters "T.R." or "S.T.R." indicate Ogiński's "earlier rank" (*stolnik trocki*). Since the present whereabouts of the picture is unknown, the originality of these inscriptions can not be tested, but I am willing to accept them, as well as the meaning the author has given them. I doubt, however, that everyone will agree with him when he tries to establish with the help of "anthropometrical analysis" a physiognomic similarity, sufficient for portrait-identification, between Bol's young man and Rembrandt's rider. Yet I noticed with pleasure that Chroscicki sees more in the painting than a mere portrait; coming back (though it seems somewhat grudgingly) to some of my old formulations, he wonders whether the picture, besides being a portrait, is not also an "allegory of a soldier riding to defend his fatherland, . . . confident of his approaching heroic deeds." Do I hear an echo here of my words, at the end of my paper, written almost fifty years ago, calling the picture "a glorification of youthful courage and dedication to a worthy end" while admitting that "Rembrandt may have called him by a definite name"? And if Marcyan Ogiński was indeed the youth who commissioned the work, could he not have wished to be seen as a reincarnation of one of the heroic figures of his own national past? If so, he was lucky. His dreams of future glory would hardly have been realized pictorially—or certainly not in a manner that would still stir the beholders centuries later—had he not found a master, one of whose greatest gifts was to transfigure prosaic reality by the poetic magic of his brush. Thus, while it is hard to see a true physiognomic similarity between Bol's portrait of Marcyan Ogiński and the young soldier in the *"Polish" Rider*, that does not necessarily prove that they are two different people. The face of Rembrandt's rider with the extreme symmetry and regularity of his features has shed the marks of a specific individual, perhaps better to convey the romantic ideal that the young Pole may have wished to represent.

Will it ever be possible to close the gap between the 1650s when Rembrandt presumably painted the *"Polish" Rider* while a young member of the Ogiński family studied in Leiden, and the 1790s when the picture emerged in the collection of another member of that clan? Whatever attractive theory we may develop, we must remember that it is no more than that. The Rider still withholds much from our ever-questioning minds.

JUNO: POSTSCRIPT (1990)

IN MY 1969 VOLUME the brief second chapter of the essay on *Juno* ended (p. 93) with the statement, that the painting had been "entrusted" to the Metropolitan Museum by its then owner, J. William Middendorf II. It did not stay there very long: in 1977 it was acquired by Armand Hammer who asked me to prepare a short version of my earlier study.[1] The following sections taken from this abbreviated text will show why I welcomed the opportunity to deal once more with that painting:

> As if the picture had not been full of surprises before, a new aspect has been revealed in a thorough technical examination which has recently (1977) been made by the technicians of the Center for Conservation and Technical Studies of the Fogg Art Museum, Harvard University. Although in 1966 the painting had been cleaned in New York and treated for some abrasions and relatively minor losses no X-ray photographs had apparently been taken at that time. This omission was rectified in the Cambridge laboratory (where the picture was also examined by infra-red and under ultra-violet light). [See Juno, Fig. 17.] It appeared that contrary to a statement I had made in 1969 ("the picture shows few pentimenti and certainly no major revisions") there is indeed a most interesting change to be seen in the X-ray; originally Juno's right arm had been painted in virtually the same position as her left, it resting too, like the other, on what may have been conceived as the ledge or a banister in the foreground. Its execution may have been less detailed (the strongly decorative accents on the lower sleeve are absent), but otherwise the treatment corresponds completely to the one still visible on Juno's left arm. It also appears from the technical report signed by Greta M. Anderson, Associate Conservator of Paintings, that the bodice *decolléte* was changed from a narrow deeper ... to a wider, more shallow outline. The report states further that the present right hand, holding the sceptre, is painted more thinly and less spontaneously, with more extensive glazing, and warmer tones than the left hand. This, I may add, is not surprising in a revision painted over previously established parts of a design.

The discovery of an extensive pentimento has a direct bearing, I believe, on the early history of the painting. As has been pointed out above Harmen Becker, who had lent some money to Rembrandt, refused to return to the master a number of paintings,

[1] Julius S. Held, "Rembrandt's Juno." *Apollo,* cv, 1977, p. 478-85.

[200]

prints, and drawings given to him as security for the loan, declaring that Rembrandt should first finish the *Juno*. (The details of this transaction and its amicable settlement are reported above on pp. 100-103.) The *Juno*, which in the spring of 1664 was still unfinished, was completed (at least to Becker's satisfaction) by October 6, 1665. Thanks to the evidence revealed by the X-ray photographs, we are no longer in the dark regarding the nature of the "incompleteness" of the picture when Becker set his condition. Rembrandt, as we saw, had begun to show Juno with both arms lowered in a nearly symmetrical fashion, but her right arm and especially right hand were less finished than her left. Moreover, the identity of the goddess, while adumbrated by her crown, was not clearly indicated, even if her attribute, the peacock (which remains none too visible) formed part of the original design. The iconography of Juno, as we can tell from other seventeenth-century renderings required the inclusion of a scepter, and this detail, quite clearly, belongs only to the final state of Rembrandt's painting, when Juno's right arm was raised to rest—I feel somewhat incongruously—an the upturned scepter as if on a cane.[2] I would not go as far as Hubert von Sonnenburg,[3] who believes that the change from a lowered to a raised hand is the work of a follower, since it is hard to understand what could have motivated a later artist to make such a far-reaching change.

[2] The connection between Rembrandt's *Juno* and Hollar's print after Elsheimer (above, p. 102) has also been noticed by Keith Andrews in his book *Adam Elsheimer*, New York, 1977, p. 152, under no. 22.

[3] Hubert von Sonnenburg, "Maltechnische Gesichtspunkte zur Rembrandtforschung," *Maltechnik/Restauro,* LXXXII, 1976, p. 12, and p. 21, note 2.

THE BOOK OF TOBIT: POSTSCRIPT (1990)

REMBRANDT's illustrations for the Book of Tobit have been the subject of a recent publication: *The Book of Tobit*, Preface by Christian Tümpel and Notes by Peter Schatborn, Zeist, 1987. Tümpel's text deals exclusively with the theological aspects of the apocryphal book. Schatborn uses the opportunity to deal critically with the problems of attribution of many of the drawings. Although I do not intend to involve myself in such questions, I would like to point out that Schatborn believes that several of the drawings illustrated here are either copies or works independently produced by pupils. (He mentions Bol and Drost as possible authors.) Since none of these drawings could have been done without models by or the influence from Rembrandt, my essential argument about Rembrandt's fascination with the Book of Tobit remains valid. Schatborn, however, returns to the older interpretation of the Amsterdam drawing (Fig. 16) as depicting the departure of Tobias from the house of Raguel, an interpretation I consider completely untenable. Schatborn does not mention my analysis, nor the Copenhagen drawing by Heemskerck which I consider an important piece of evidence in deciding this question.

INDEX

PLATES

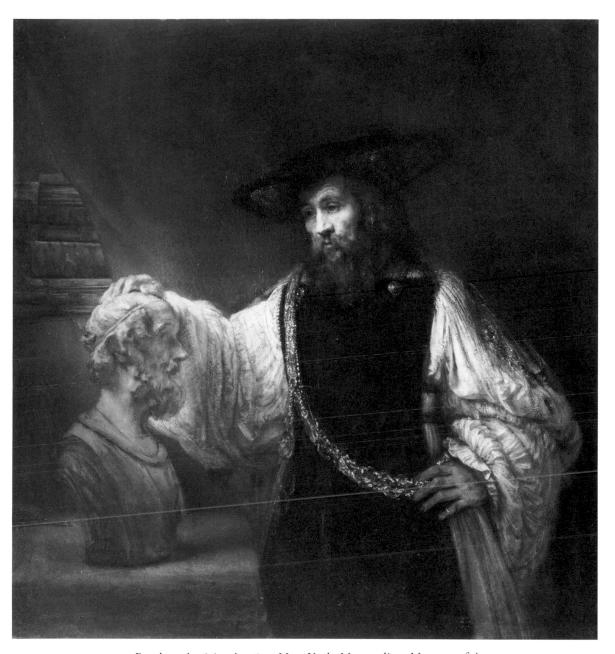

1. Rembrandt, *Aristotle*, 1653. New York, Metropolitan Museum of Art

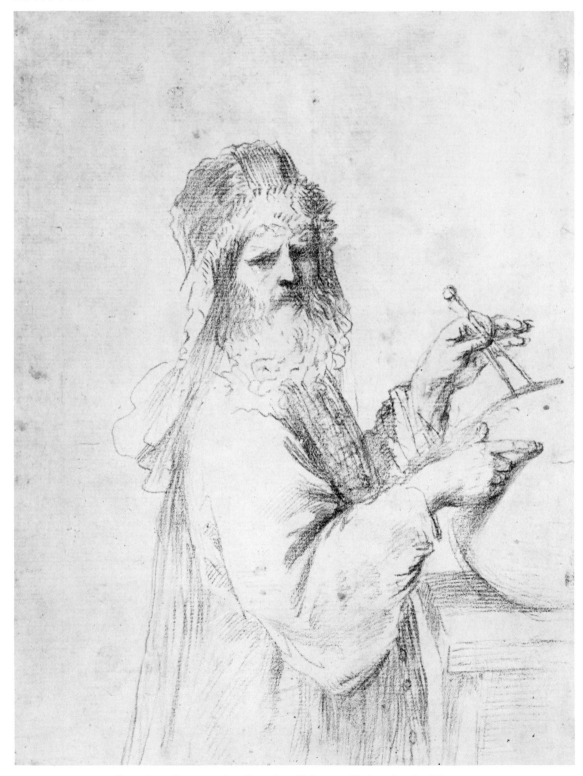

2. Guercino, *Cosmographer*, Drawing. Princeton University Art Museum

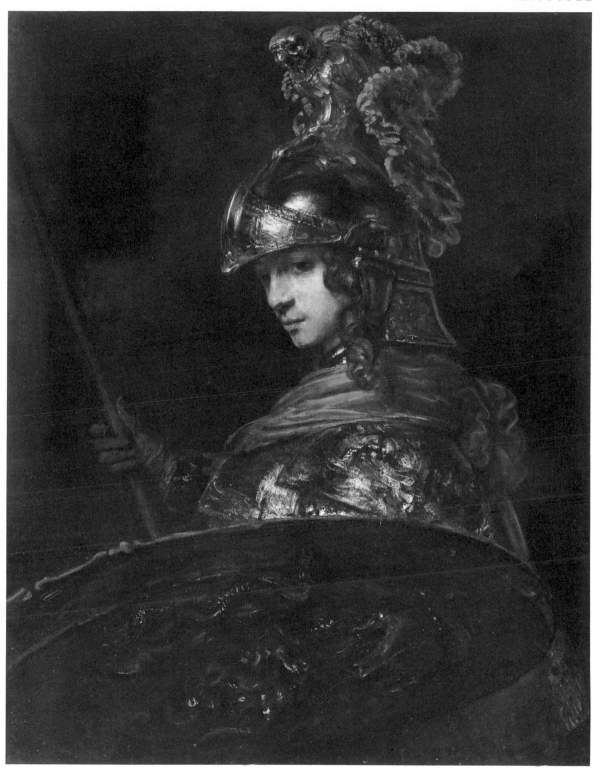

3. Rembrandt, *Alexander the Great* (?). Lisbon, Gulbenkian Foundation

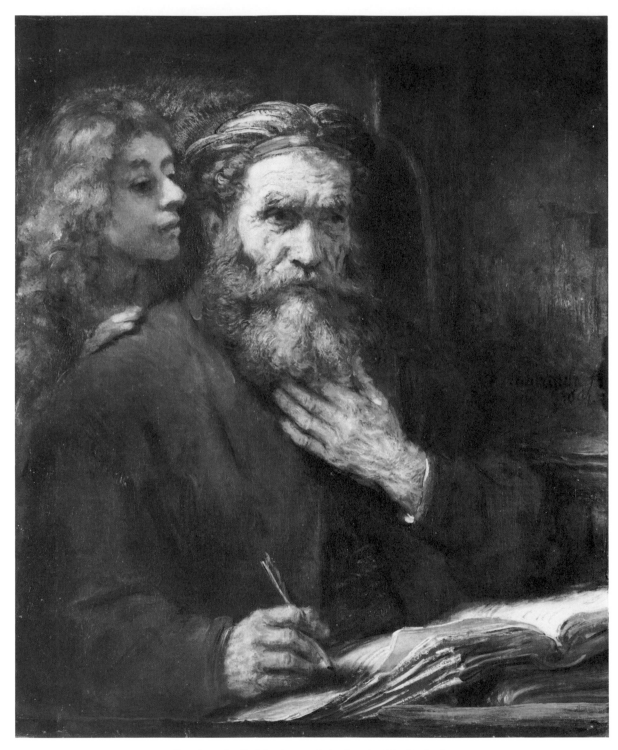

4. Rembrandt, *St. Matthew and the Angel*, 1661. Paris, Louvre

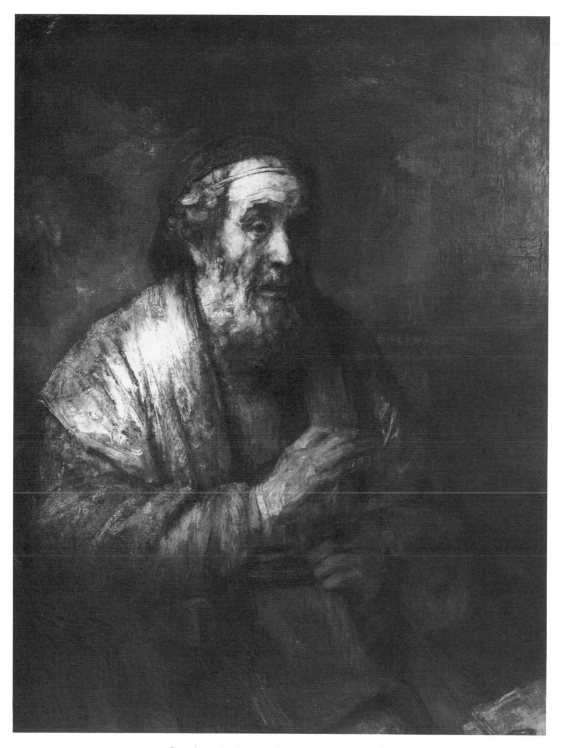

5. Rembrandt, *Homer*. The Hague, Mauritshuis

6. Theodor (Dirk) Galle, "*Aristotle*," Drawing.
Rome, Vatican (Cod. Vat. Capp. 228)

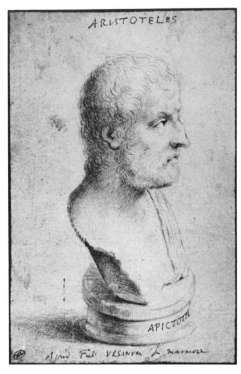

7. P. P. Rubens, *Aristotle*, Drawing.
Paris, Louvre

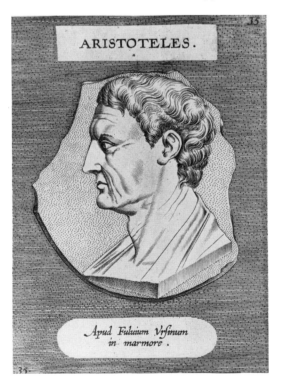

8. Theodor (Dirk) Galle, *Aristotle*, Engraving

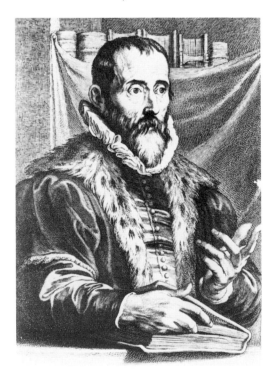

9. Schelte a Bolswert, *Portrait of Justus Lipsius*,
after Van Dyck. Engraving

10. Rembrandt, *Aristotle*, Detail

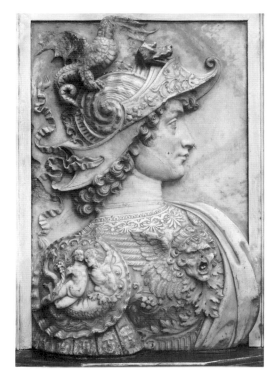

11. Attributed to Verrocchio, *Alexander the Great*, Marble. Washington, National Gallery of Art

12. *Alexander the Great*, Anonymous Woodcut (from Gio. Batt. della Porta, *Della Celeste Fisonomia*, Venice, 1644)

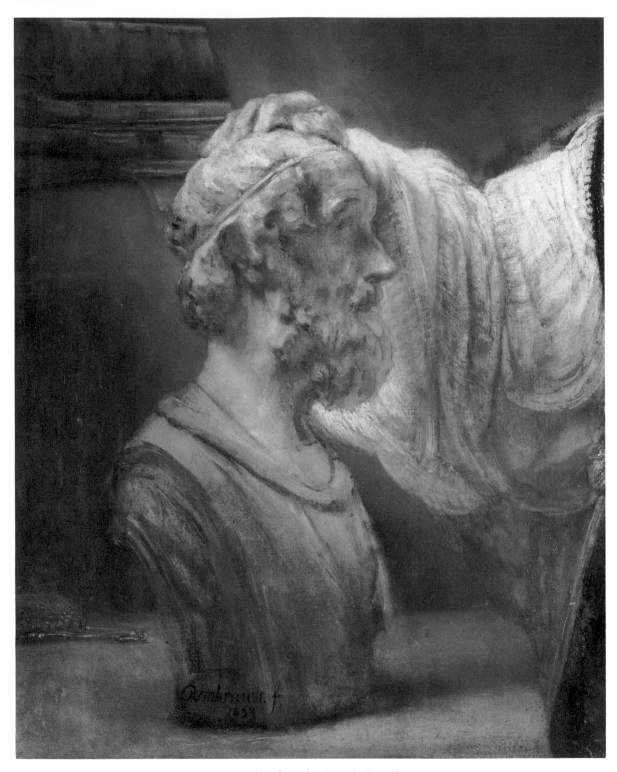

13. Rembrandt, *Aristotle*, Detail

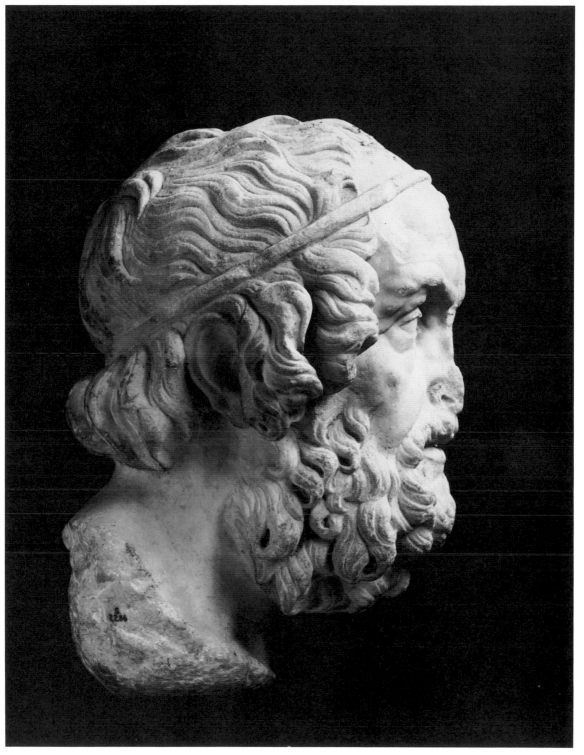

14. Hellenistic Artist, *Homer*, Marble. Boston, Museum of Fine Arts

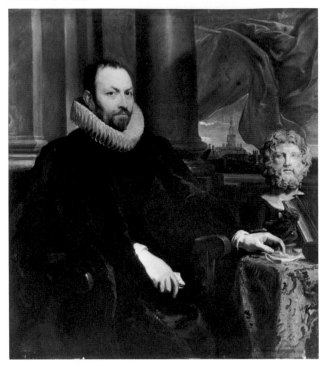

15. A. Van Dyck, *Portrait of Nicolaas Rockox.*
Leningrad, Hermitage

16. P. P. Rubens, *Portrait of Dr. Ludovicus
Nonnius.* London, National Gallery

17. Arnoldus van Ravesteyn, *Portrait of Jacob Cats.* The
Hague, Dienst voor s'Rijks Verspreide Kunstvoorwer-
pen (On loan to the Catshuis)

18. P. P. Rubens, *Portrait of Caspar Gevartius.*
Antwerp, Koninklijk Museum

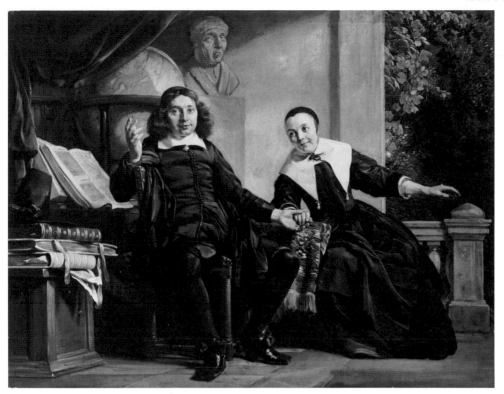

19. Jan de Bray, *Portrait of Abraham Casteleyn and His Wife.* Amsterdam,
Rijksmuseum (photo: Courtauld)

20. Anonymous Artist (A. Houbraken?), *The Industrious
Scholar*, Engraving (from "Stichtelyke Zinnebeelden,"
Amsterdam, 1723)

21. Hans Holbein, *Erasmus of Rotterdam*,
1535, Woodcut

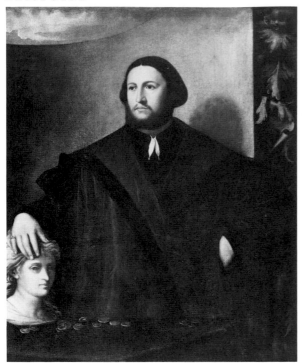

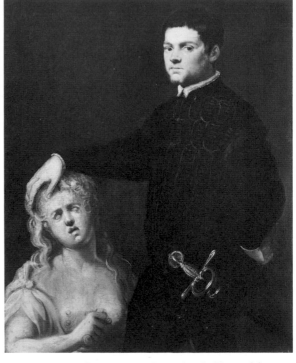

22. Sebastiano Florigerio, *Portrait of Raffaele Grassi*.
Florence, Uffizi

23. Studio of Tintoretto, *Portrait of a Young Man*.
Munich, Alte Pinakothek

24. Nikolaus Brucker, *Portrait of Duke Albrecht V
of Bavaria*, Munich, Graphische Sammlung

25. Peter de Iode, *Portrait of A. Colyns de Nole*,
after Van Dyck, Engraving

26. R. Ch. F. Lisiewsky, *Portrait of P. Ch. Zinck.* Leipzig, Museum der Bildenden Künste

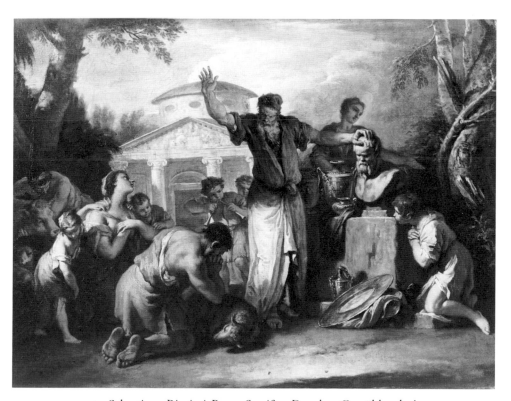

27. Sebastiano Ricci, *A Pagan Sacrifice.* Dresden, Gemäldegalerie

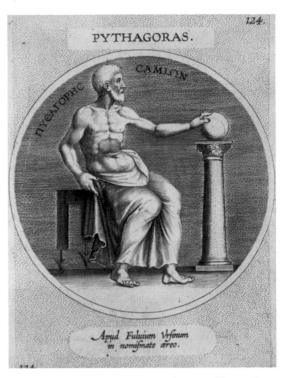

28. Jean Daret, *Self-portrait*. Leningrad, Hermitage

29. Theodor (Dirk) Galle, *Pythagoras*, Engraving after a bronze coin in the collection of Fulvio Orsini

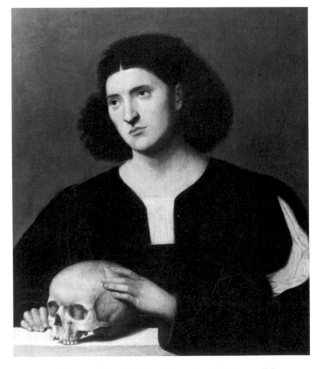

30. Dirck Jacobsz., *Portrait of Pompejus Occo*. Amsterdam, Rijksmuseum

31. Bernardino Licinio, *Portrait of a Young Man*. Oxford, Ashmolean Museum

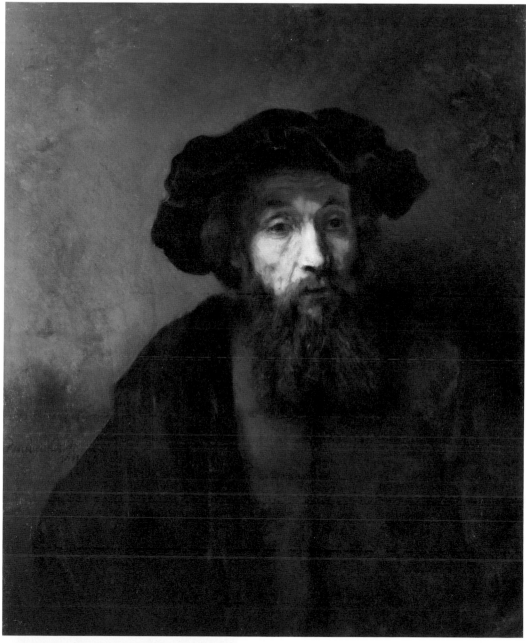

32. Rembrandt, *Portrait of a Man*. London, National Gallery

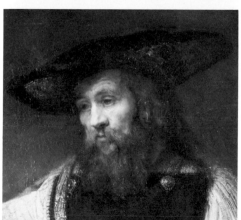

33. Rembrandt, *Aristotle*, Detail

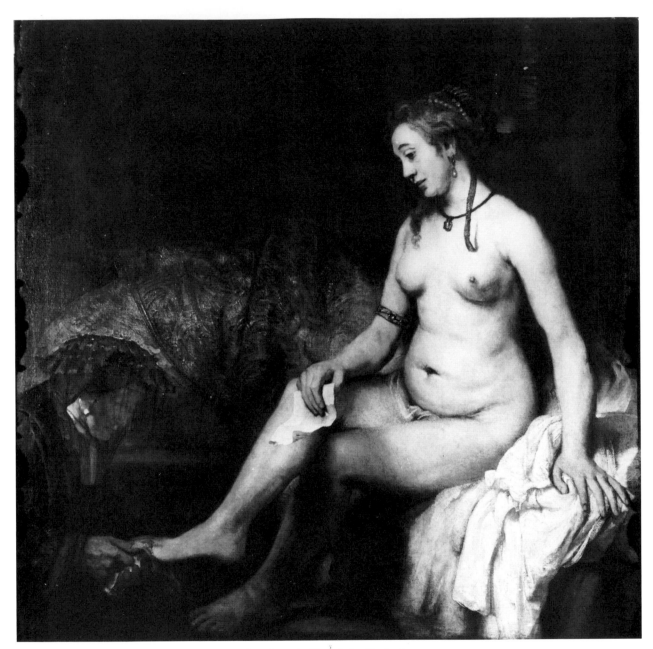

34. Rembrandt, *Bathsheba*. Paris, Louvre

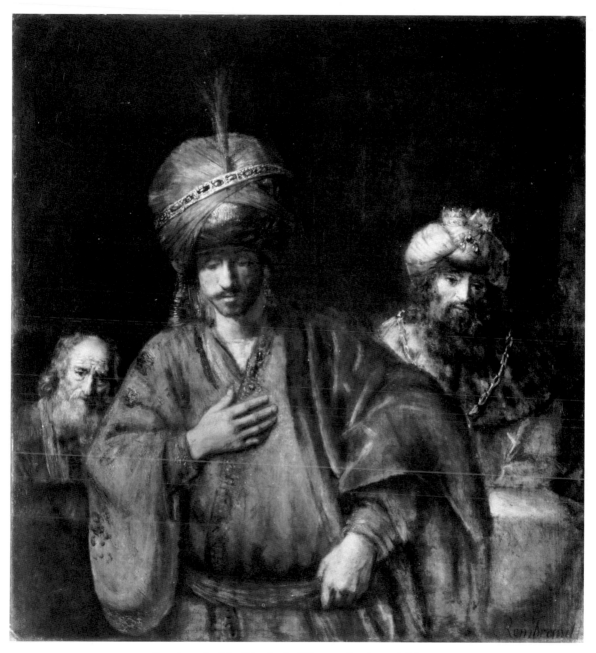

35. Rembrandt, *The Dismissal of Haman.* Leningrad, Hermitage

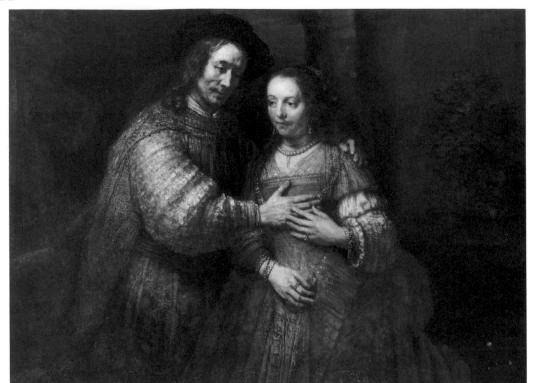

36. Rembrandt, *"The Jewish Bride."* Amsterdam, Rijksmuseum

37. Rembrandt, *Isaac and Rebekah,* Drawing. New York, Collection S. Kramarsky

38. Georges de la Tour, *Magdalen with the Mirror*, Detail. Paris, Private Collection

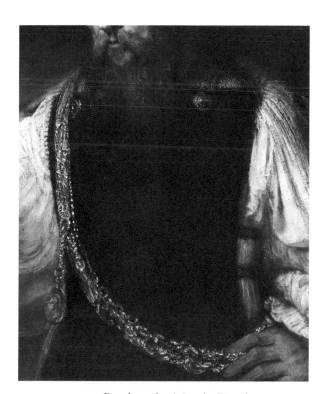

39. Rembrandt, *Aristotle*, Detail

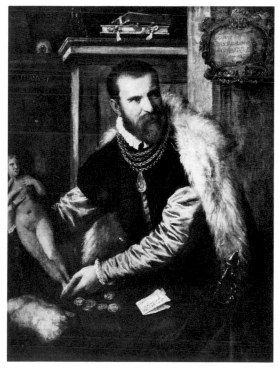

40. Titian, *Portrait of Jacopo de Strada*. Vienna, Kunsthistorisches Museum

41. Paul Pontius, *Portrait of Caspar Gevartius*, after Rubens, Engraving

42. David Beck, *Self-portrait*, Engraving by A. Cognet

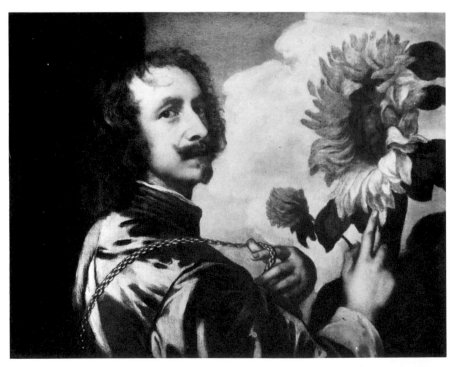

43. A. Van Dyck, *Self-portrait with Sunflower*. London, Duke of Westminster

44. Paris Bordone (attributed to), *Portrait of Gian Jacopo Caraglio*. London, Collection of A. S. Ciechanowiecki

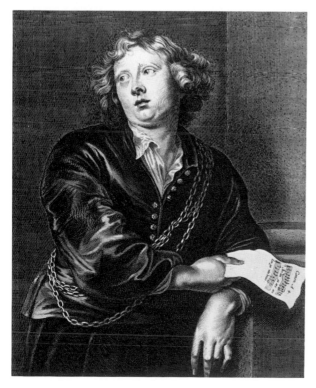

45. Peter de Iode, *Portrait of Liberti*, after Van Dyck, Engraving

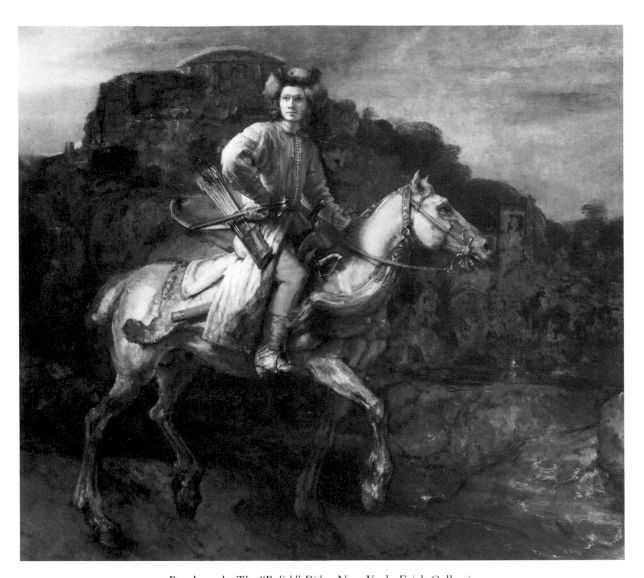

1. Rembrandt, *The "Polish" Rider*. New York, Frick Collection

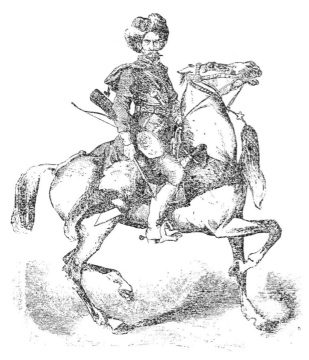

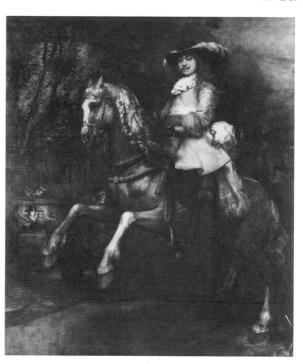

2. Anonymous Artist, *"Lisowski Officer after Rembrandt,"* Wood-engraving, 19th cent.

3. Rembrandt, *Equestrian Portrait* (Frederik Rihel?). London, National Gallery

4. Paul Potter, *Portrait of Diederick Tulp*, 1653. Amsterdam, Six Collection

5. Thomas de Keyser, *Equestrian Portrait*. Frankfurt, Städelsches Kunstinstitut

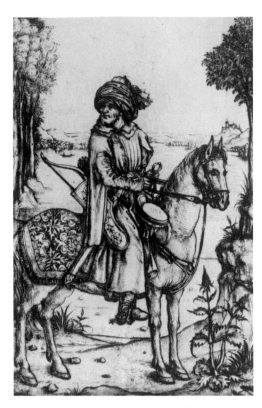

6. Master of the Hausbuch, *Turk on Horseback*, Drypoint

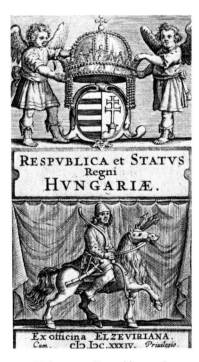

7. Title page, *Respublica et Status Regni Hungariae*. Leiden, 1634

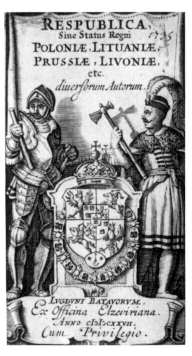

8. Title page, *Respublica sive Status Regni Poloniae*. Leiden, 1642

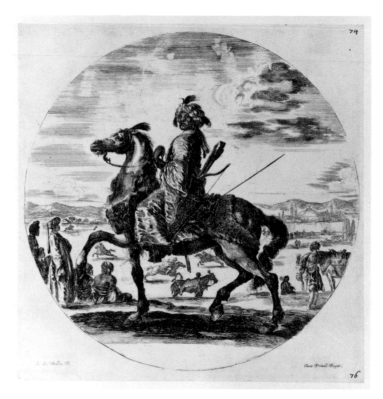

9. Stefano della Bella, *Moorish Rider*, Etching

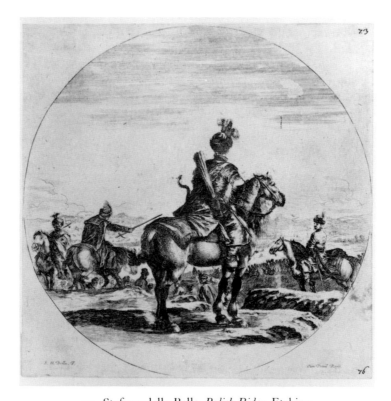

10. Stefano della Bella, *Polish Rider*, Etching

11. Rembrandt, *Rest on the Flight into Egypt.* Dublin, Museum

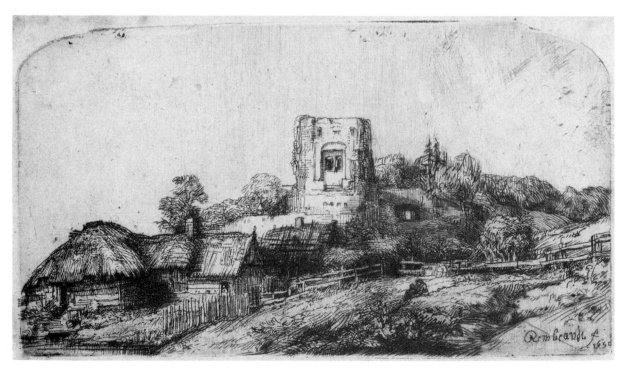

12. Rembrandt, *Landscape with a Square Tower*, 1650, Etching

13. Rembrandt, *The "Polish" Rider*, Detail

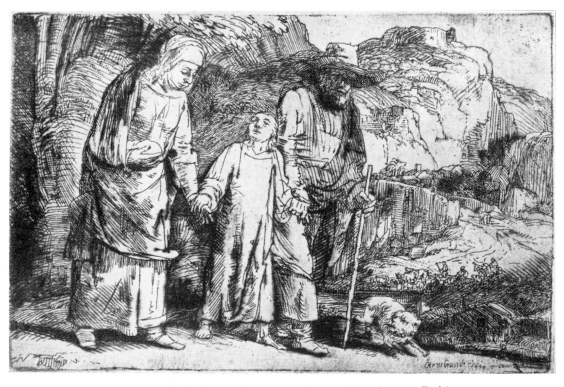

14. Rembrandt, *Holy Family Returning from the Temple*, 1654, Etching

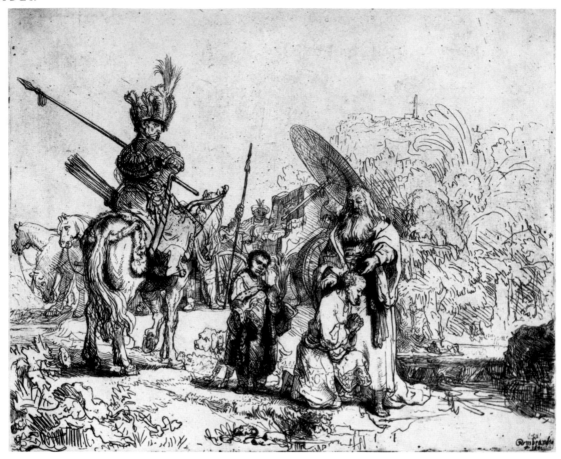

15. Rembrandt, *Baptism of the Eunuch*, 1641, Etching

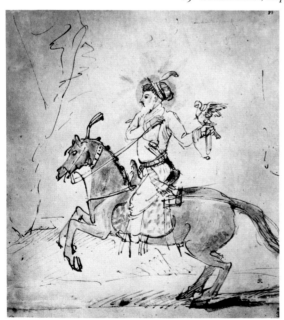

16. Rembrandt, *Shah Jahan*, Copy of a Mughal
Miniature, Drawing. Paris, Louvre

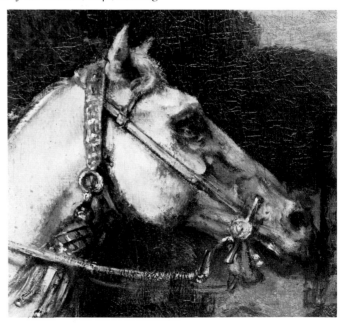

17. Rembrandt, *The "Polish" Rider*, Detail

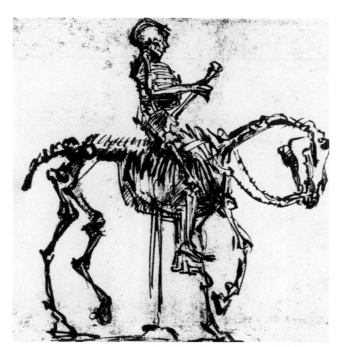

18. Rembrandt, *Skeleton Rider*, Drawing. Darmstadt, Museum

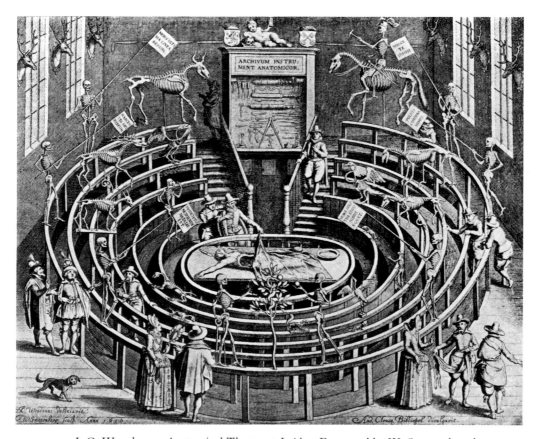

19. J. C. Woudanus, *Anatomical Theater at Leiden*, Engraved by W. Swanenburgh

20. Rembrandt, *Anatomy of Dr. Deyman*, Drawing. Amsterdam, Rijksprentenkabinet

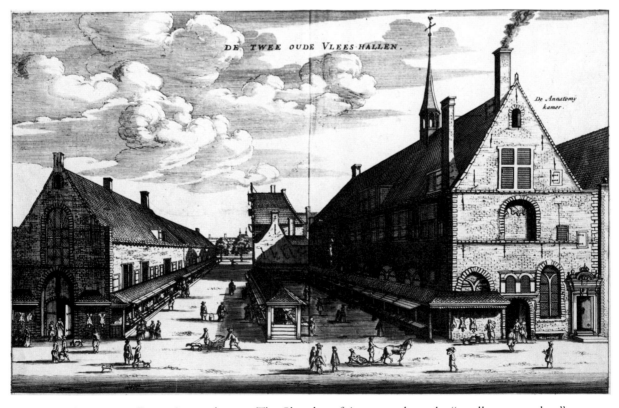

21. Anonymous Engraving, 17th cent., The Chamber of Anatomy above the "small meat-market."

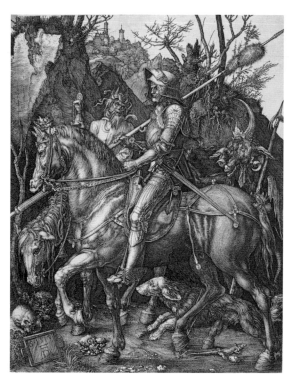

22. A. Dürer, *Knight, Death, and the Devil*, 1513, Engraving

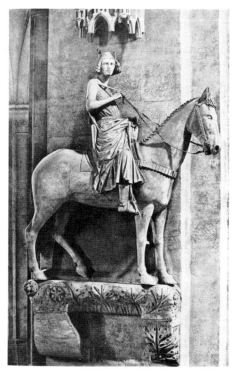

23. Unknown Master, 13th cent., *King on Horseback*. Bamberg, Cathedral

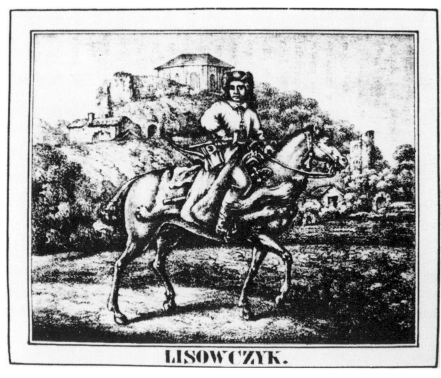

24. Karol Auer, *Lisowczyk*, 1841, Lithograph

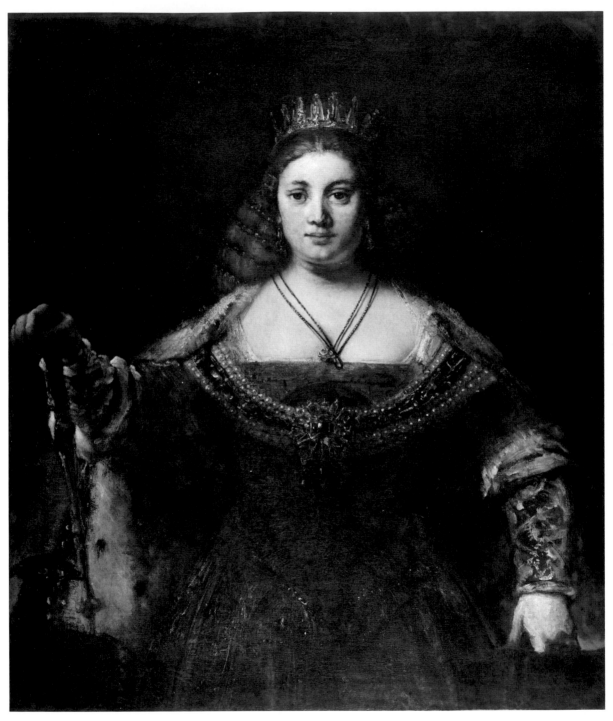

1. Rembrandt, *Juno*. Los Angeles, Armand Hammer Collection

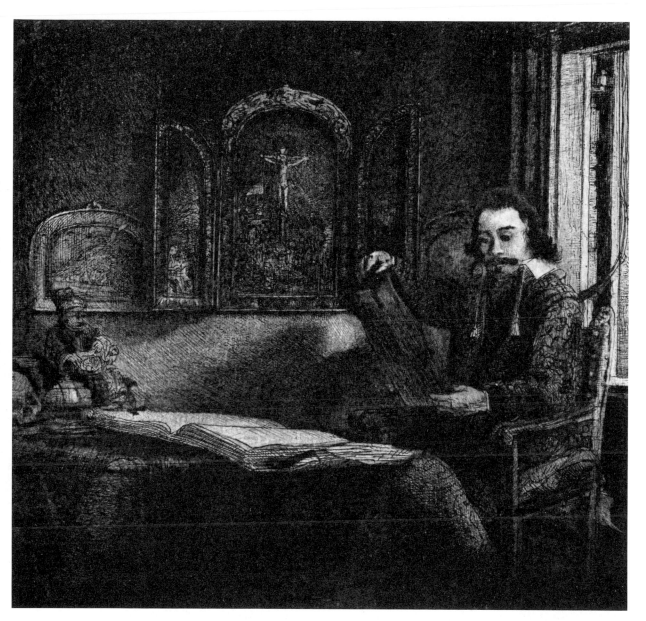

2. Rembrandt, *Portrait of Abraham Francen*, Detail, Etching

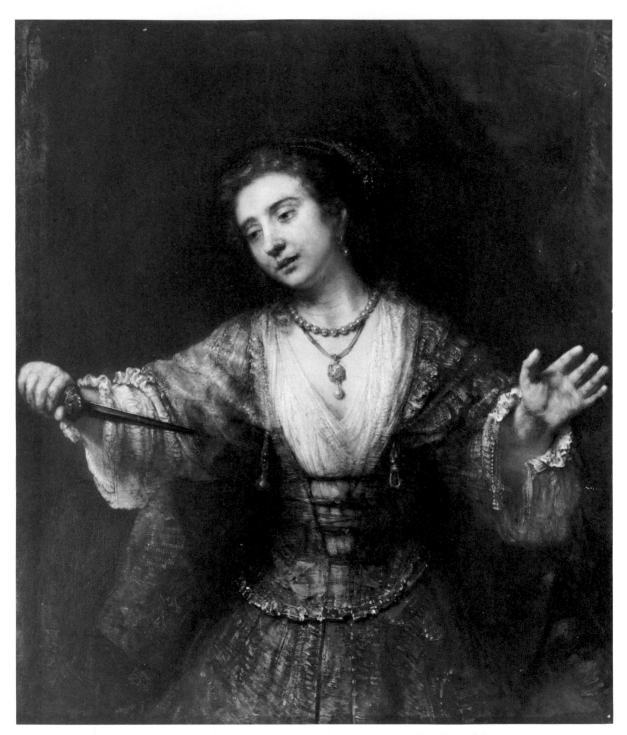

3. Rembrandt, *Lucretia*, 1664. Washington, National Gallery of Art

4. Rembrandt, *Juno*, Detail

5. Rembrandt, *Lucretia*, Detail

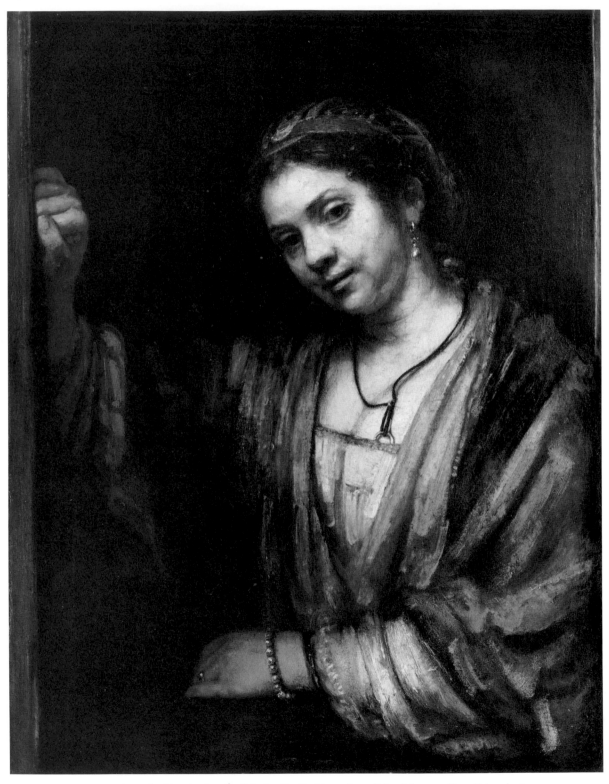

6. Rembrandt, *Hendrickje Stoffels*. Berlin-Dahlem, Staatliche Museen, Gemäldegalerie

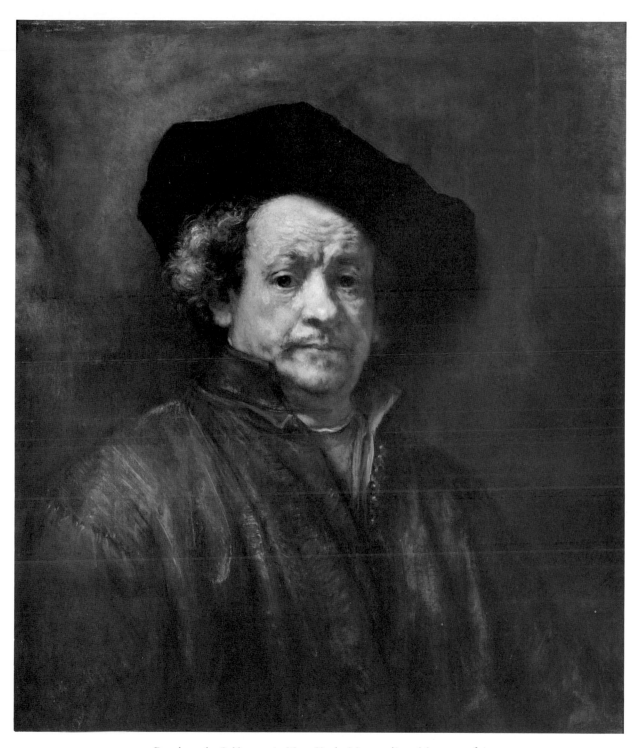

7. Rembrandt, *Self-portrait*. New York, Metropolitan Museum of Art

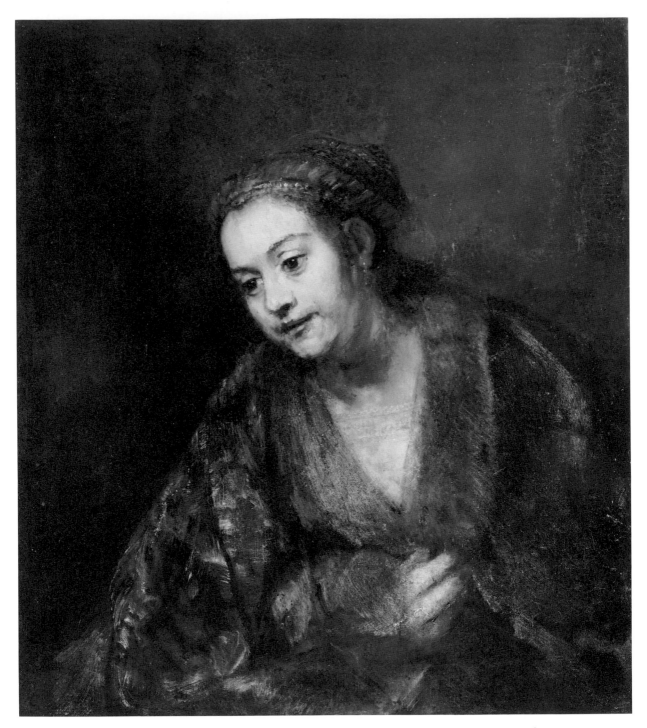

8. Rembrandt, *Portrait of Hendrickje Stoffels*, 1660. New York, Metropolitan Museum of Art

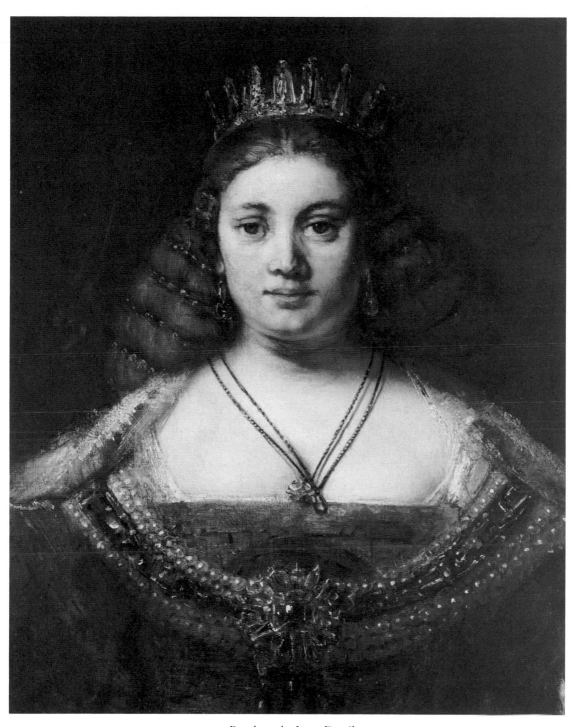

9. Rembrandt, *Juno*, Detail

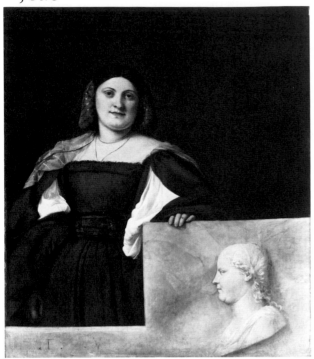

10. Titian, "*La Schiavona*," London, National Gallery

11. Bonifazio Veronese, attributed to, *Portrait of a Lady*. Malibu, J. Paul Getty Museum

12. Rembrandt, Figure Studies, Drawing. Washington, National Gallery of Art

13. Rembrandt, *Medea*, 1648. Etching

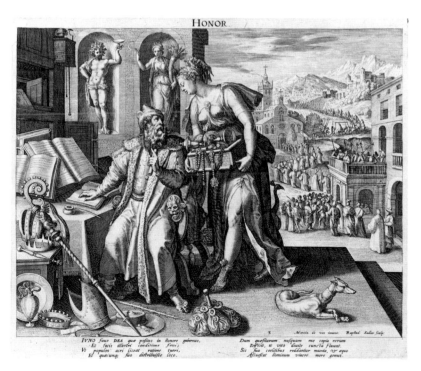

14. Raphael Sadeler, *Honor*, Engraving after Marten de Vos

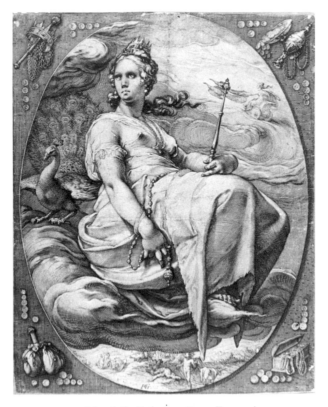

15. Hendrik Goltzius, *Juno*, Engraving

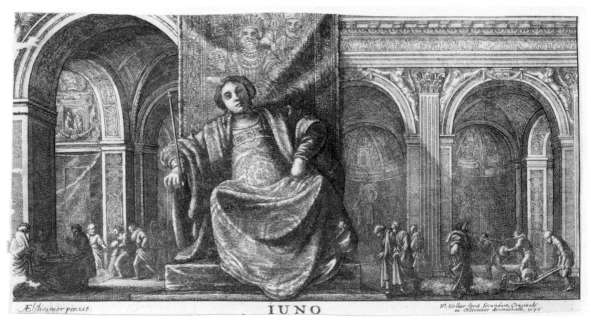

16. Wenzel Hollar, *Realm of Juno*, 1646. Etching after Adam Elsheimer

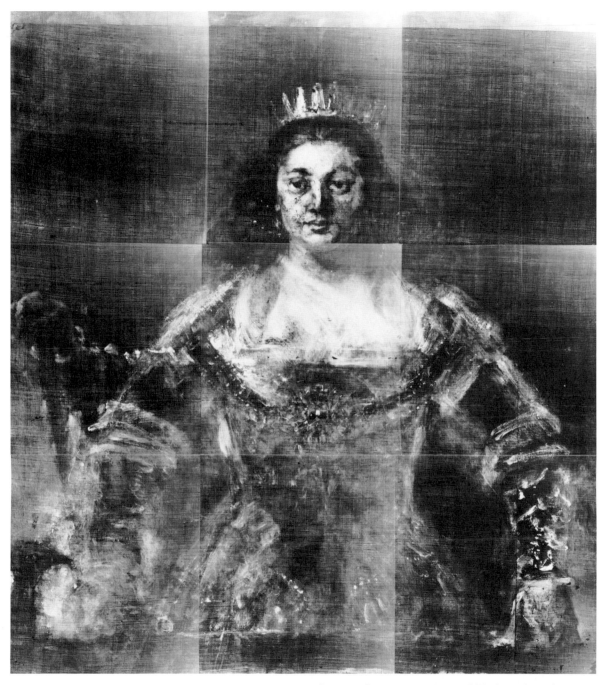

17. Rembrandt, *Juno* (X-ray photograph), Courtesy of Center for Conservation and Technical Studies, Cambridge, Fogg Art Museum, Harvard University

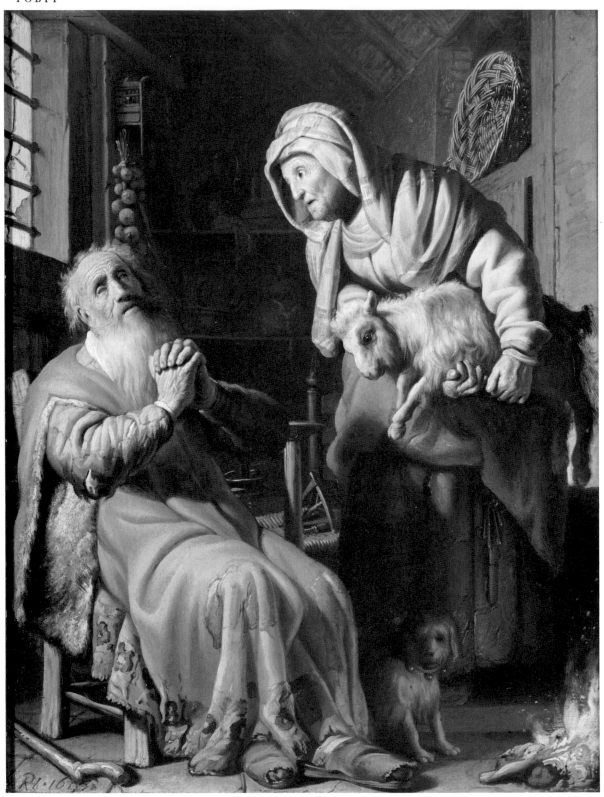

1. Rembrandt, *Tobit and Anna*, 1626. Amsterdam, Rijksmuseum

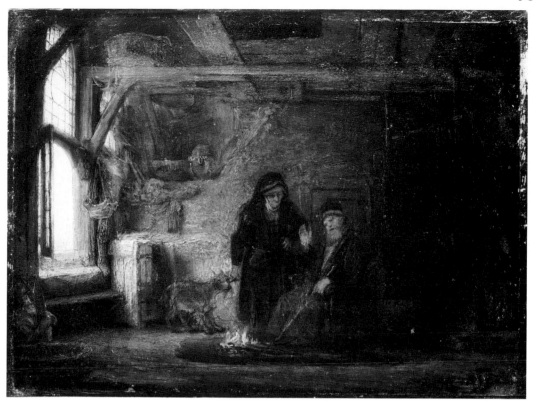

2. Rembrandt, *Tobit and Anna*, 1645. Berlin-Dahlem, Staatliche Museen, Gemäldegalerie

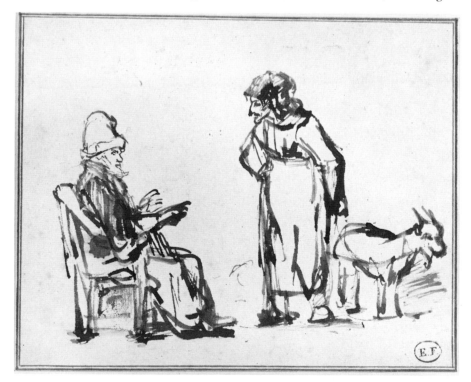

3. Rembrandt, *Tobit and Anna*, Drawing. Berlin-Dahlem, Kupferstichkabinett

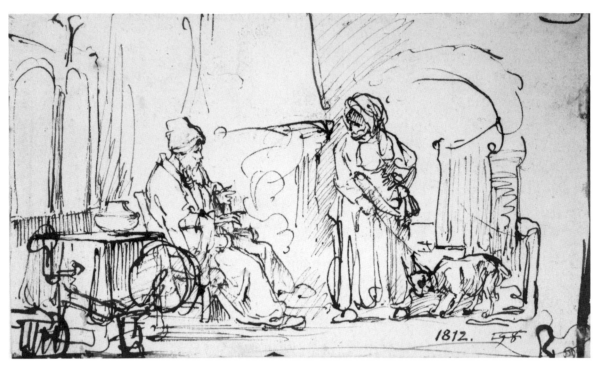

4. Rembrandt, *Tobit and Anna*, Drawing. Stockholm, Nationalmuseum

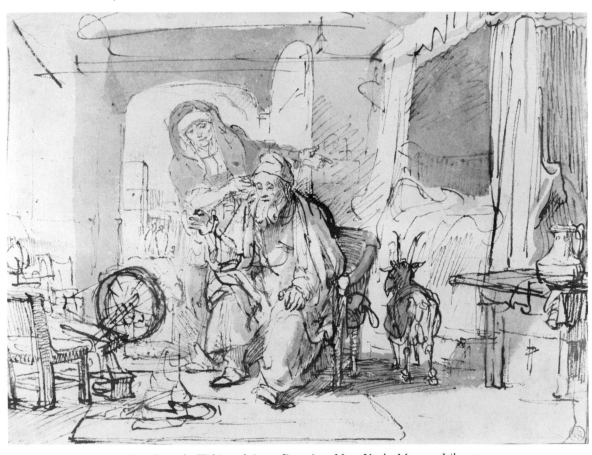

5. Rembrandt, *Tobit and Anna*, Drawing. New York, Morgan Library

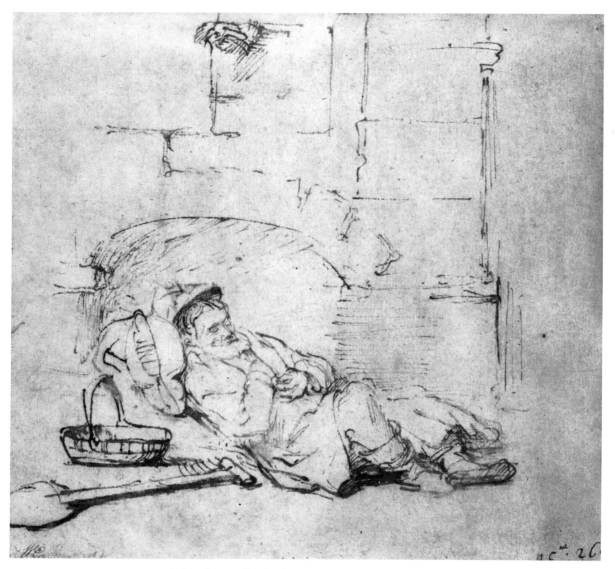

6. Rembrandt, *Tobit Sleeping below the Swallow's Nest*, Drawing. Rotterdam, Museum Boymans-Van Beuningen

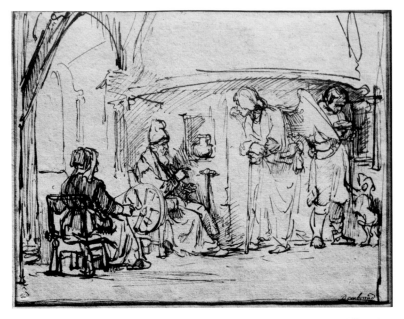

7. Rembrandt, *Tobit Interviewing "Azarias,"* Drawing. Vienna, Albertina

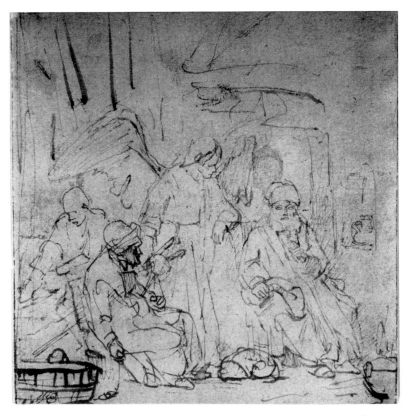

8. Rembrandt, *Tobit Interviewing "Azarias*," Drawing. Rotterdam,
Museum Boymans-Van Beuningen

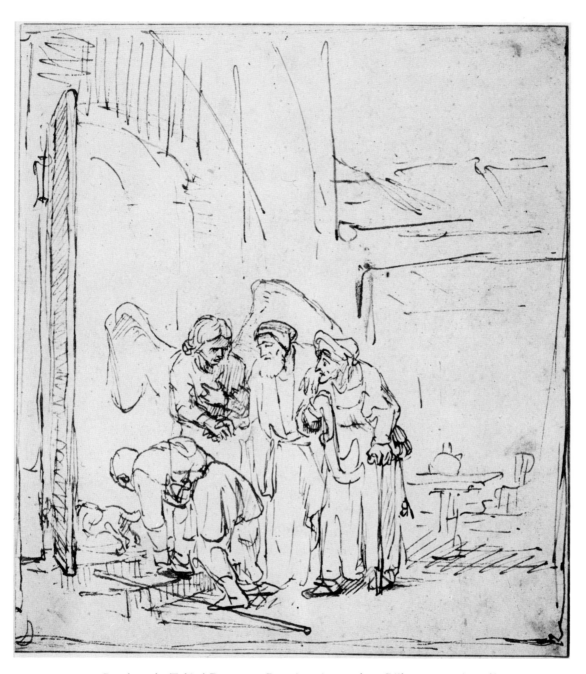

9. Rembrandt, *Tobias' Departure*, Drawing. Amsterdam, Rijksmuseum (copy?)

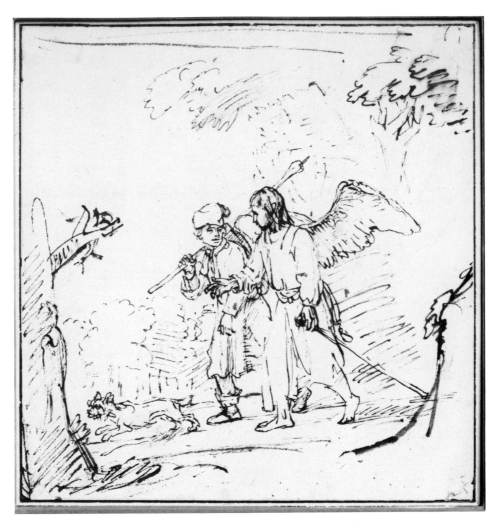

10. Rembrandt, *Tobias and "Azarias" Walking*, Drawing. Vienna, Albertina

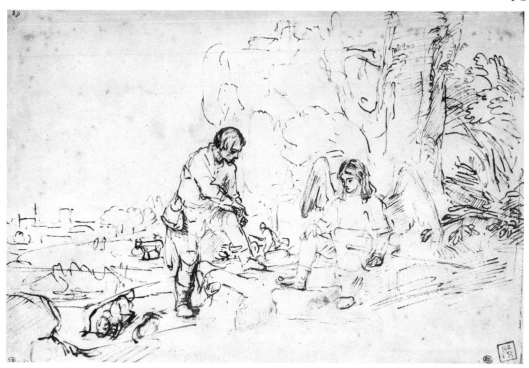

11. Rembrandt, *Tobias and "Azarias" Resting*, Drawing. Paris, Louvre, Cabinet des Estampes

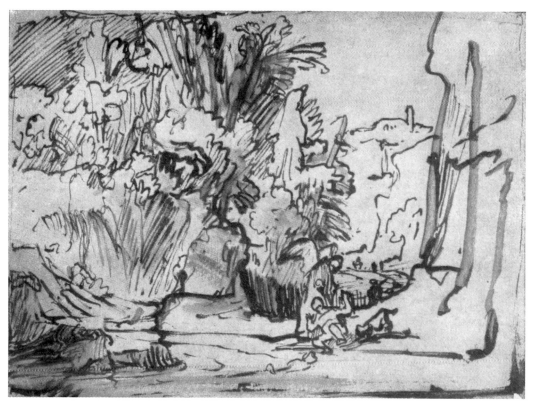

12. Rembrandt, *Tobias Frightened by the Fish*, Drawing. Paris, formerly Collection Mme. V.

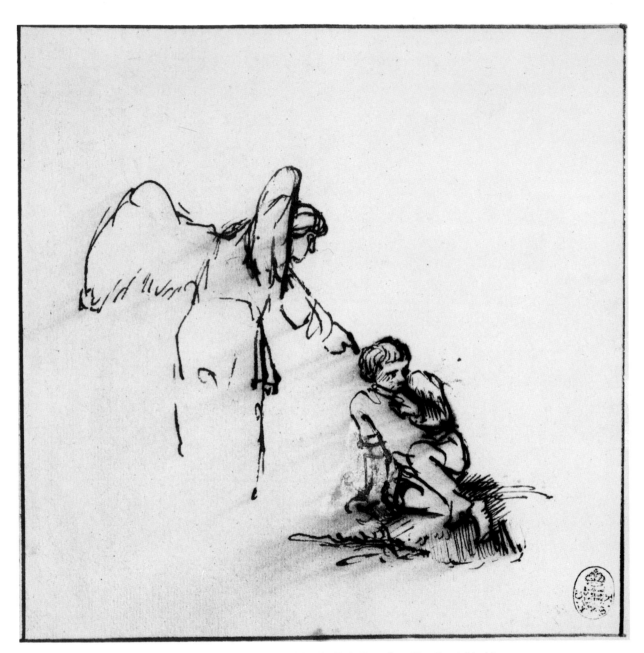

13. Rembrandt, *Tobias Frightened by the Fish*, Dresden, Kupferstichkabinett

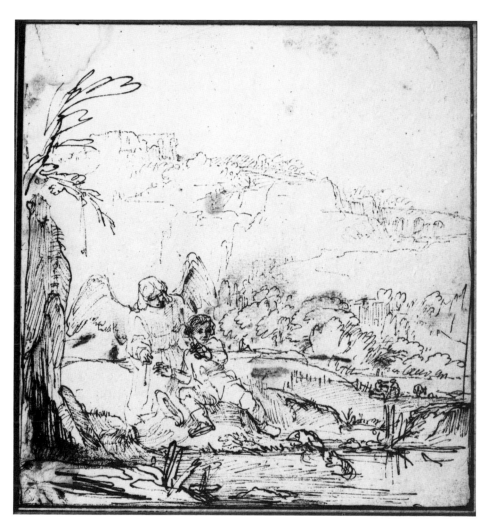

14. Rembrandt, *Tobias Frightened by the Fish*, Drawing. Vienna, Albertina

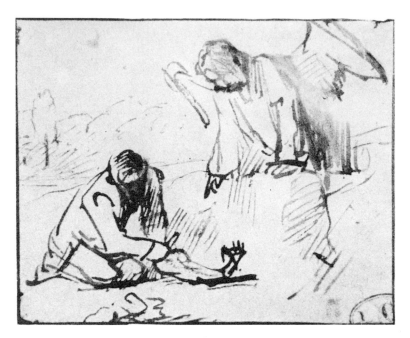

15. Rembrandt, *Tobias Disemboweling the Fish*, Drawing.
New York, Private Collection

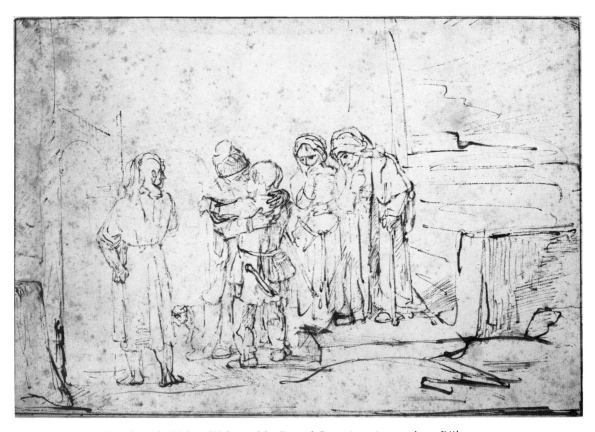

16. Rembrandt, *Tobias Welcomed by Raguel*, Drawing. Amsterdam, Rijksmuseum

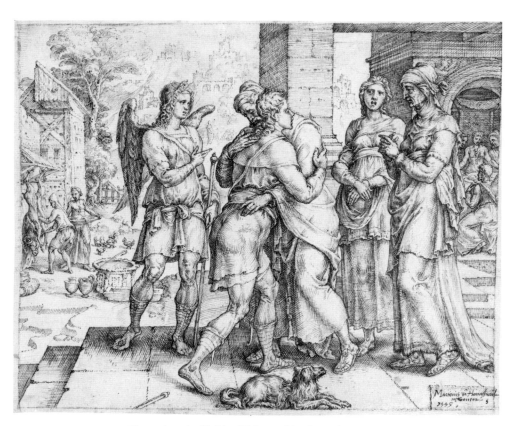

17. Marten van Heemskerck, *Tobias Welcomed by Raguel*, Drawing. Copenhagen,
Kobberstiksamling

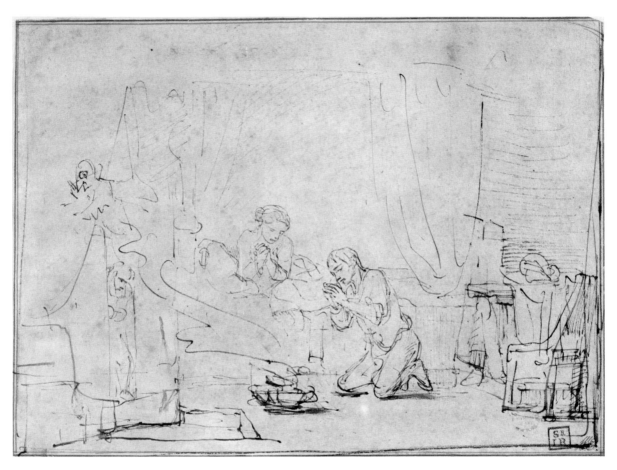

18. Rembrandt, *Tobias and Sarah Praying*, Drawing. New York, Metropolitan Museum of Art

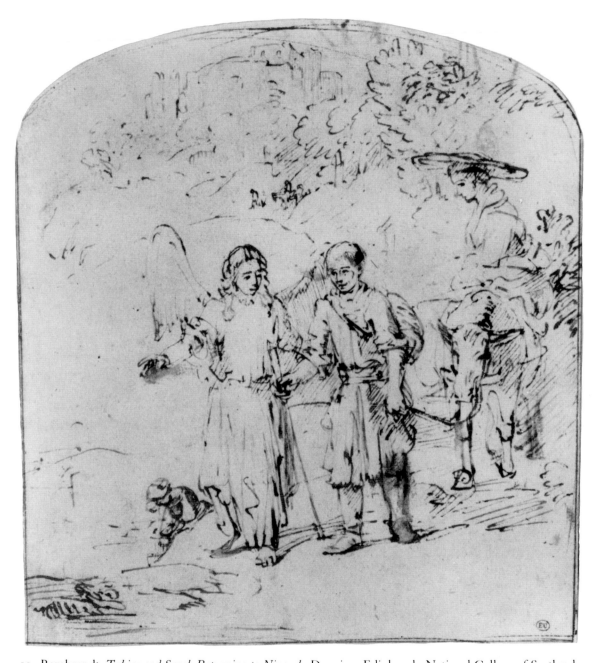

19. Rembrandt, *Tobias and Sarah Returning to Nineveh*, Drawing. Edinburgh, National Gallery of Scotland

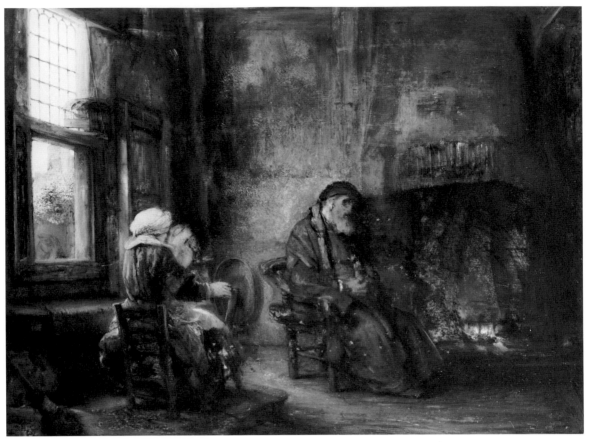

20. Rembrandt, *Tobit and Anna Waiting for Tobias' Return*, 1659. Rotterdam, Museum Boymans-Van Beuningen

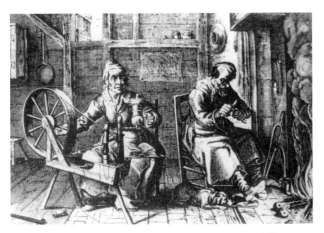

21. Johan de Brune, *Emblemata . . . ,* no. XLIV, Allegory
of Industry, Engraving

22. Rembrandt, *Tobit Advancing to Welcome
His Son*, Etching

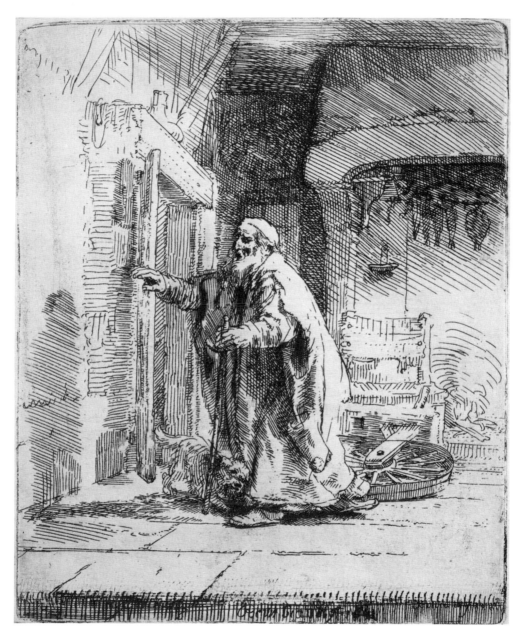

23. Rembrandt, *Tobit Advancing to Welcome His Son*, 1651, Etching

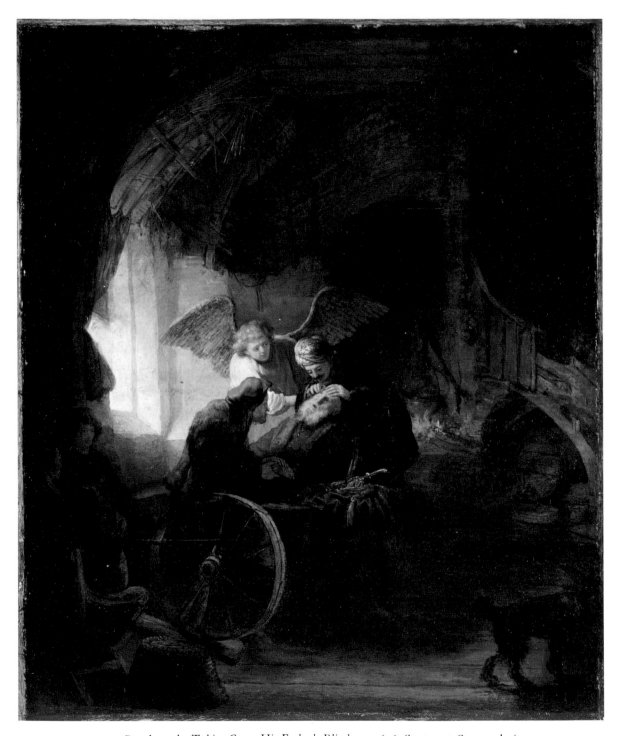

24. Rembrandt, *Tobias Cures His Father's Blindness*, 1636. Stuttgart, Staatsgalerie

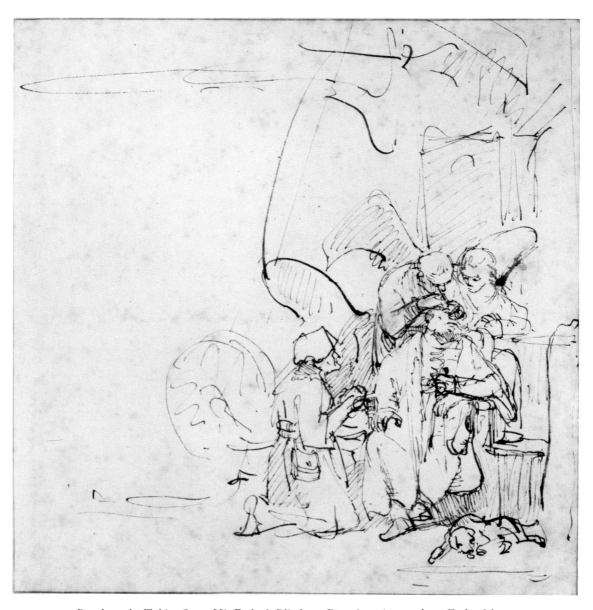

25. Rembrandt, *Tobias Cures His Father's Blindness*, Drawing. Amsterdam, Fodor Museum

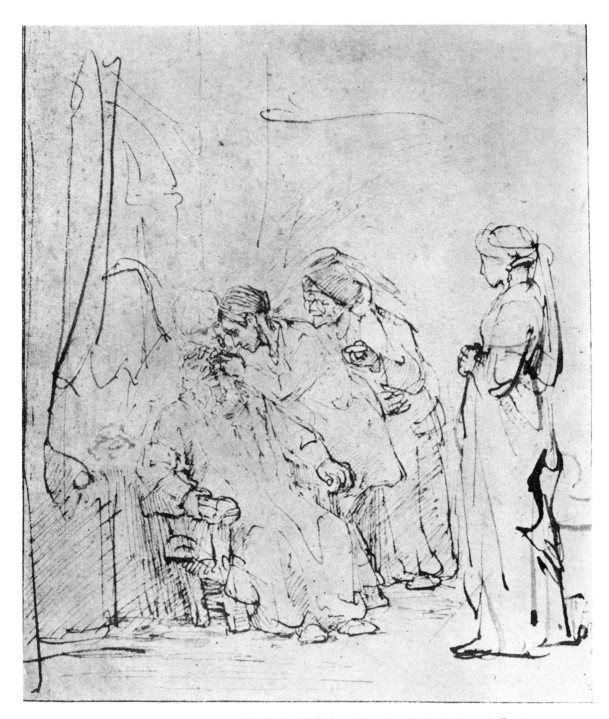

26. Rembrandt, *Tobias Cures His Father's Blindness*, Drawing. Paris, Private Collection

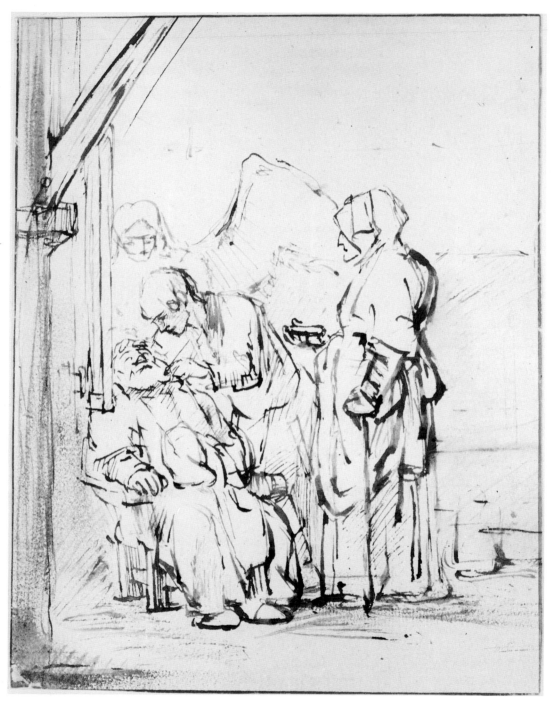

27. Rembrandt, *Tobias Cures His Father's Blindness*, Drawing. Berlin-Dahlem, Kupferstichkabinett

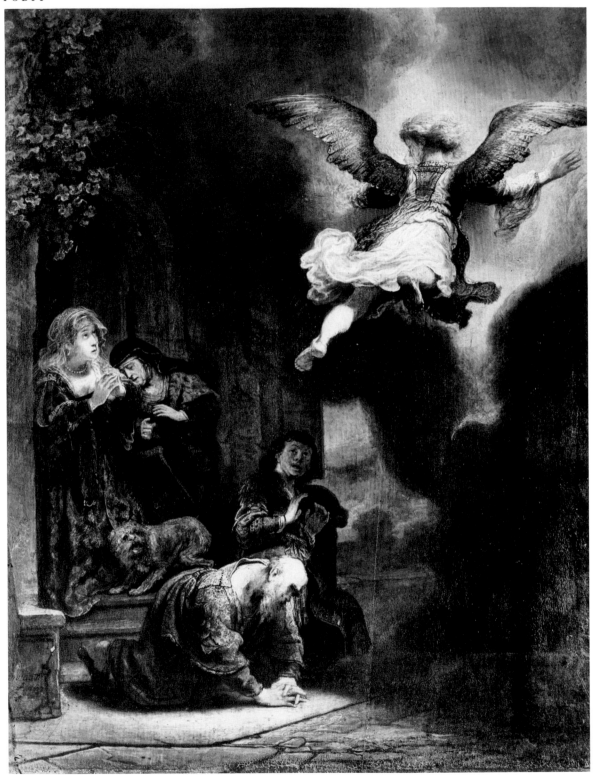

28. Rembrandt, *Departure of Angel*, 1637. Paris, Louvre

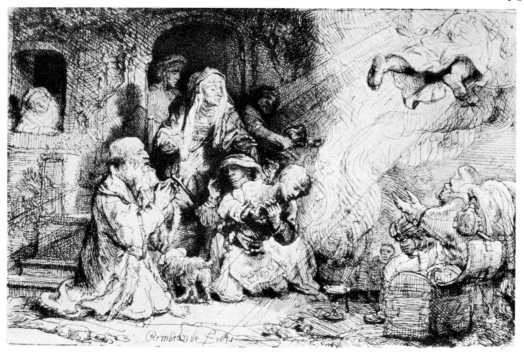

29. Rembrandt,
Departure of Angel,
1641. Etching

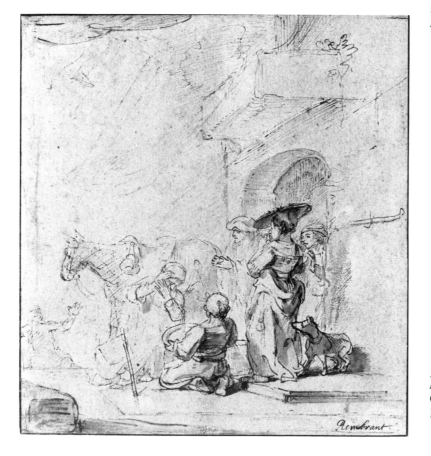

30. Rembrandt,
Departure of Angel, Drawing.
Oxford, Ashmolean
Museum

31. Rembrandt, *Departure of Angel*, Drawing. Budapest, Museum of Fine Arts

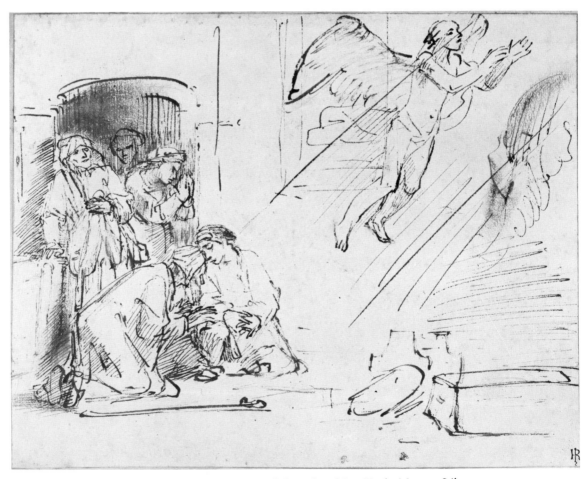

32. Rembrandt, *Departure of Angel*, Drawing. New York, Morgan Library

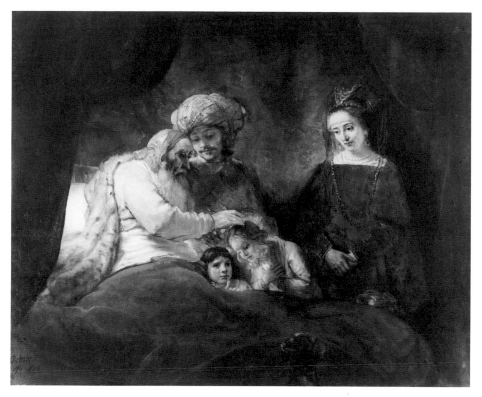

33. Rembrandt, *Jacob Blessing Sons of Joseph*, 1656. Cassel, Staatliche Kunstsammlungen

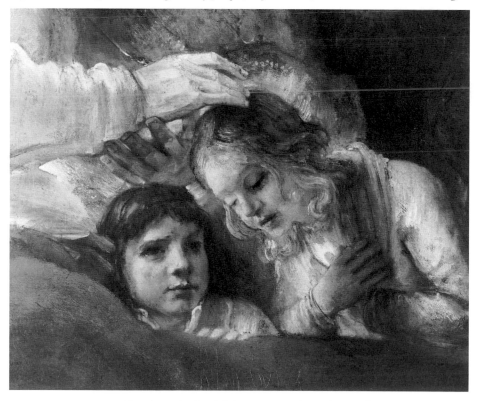

34. Rembrandt, *Jacob Blessing Sons of Joseph*, Detail

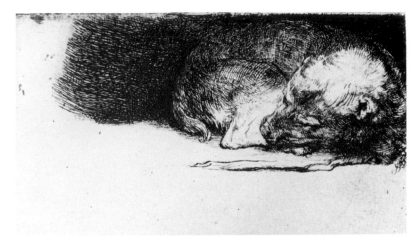

35. Rembrandt, *Sleeping Dog*, Etching

36. Rembrandt, *Abraham Dismisses Hagar*, Drawing. Amsterdam, Rijksmuseum

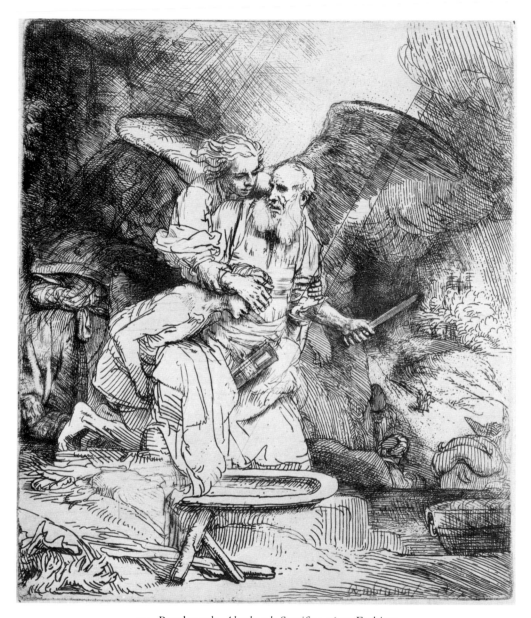

37. Rembrandt, *Abraham's Sacrifice*, 1655, Etching

38. Rembrandt, *Portrait of His Son Titus*, 1655. Rotterdam, Museum Boymans-Van Beuningen

39. Rembrandt, *Portrait of His Son Titus*. Paris, Louvre

40. Rembrandt, *Hannah and Samuel*, 1650. Edinburgh, National Galleries of Scotland

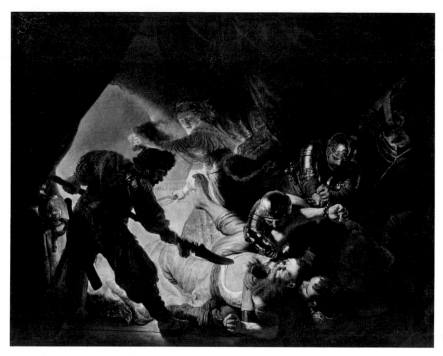

41. Rembrandt, *Blinding of Samson*, 1636. Frankfurt, Städelsches Kunstinstitut

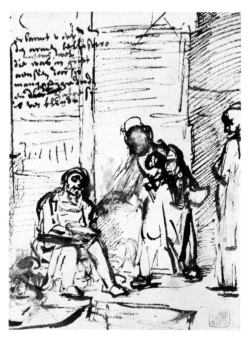

42. Rembrandt, *Blind Belisarius Begging*,
Drawing. Berlin-Dahlem, Kupferstichkabinett

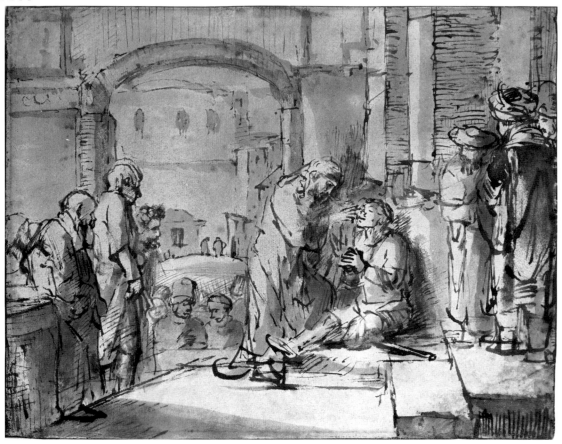

43. Copy after Rembrandt, *Christ Healing Blind Man*, Drawing. Rotterdam, Museum Boymans-Van Beuningen

44. Rembrandt, *Blind Beggar*, Drawing. Vienna, Albertina

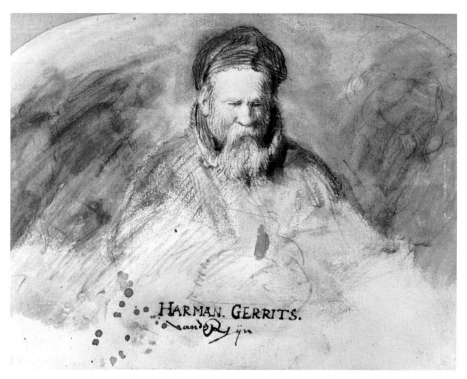

45. Rembrandt, *Portrait of His Father*, Drawing. Oxford, Ashmolean Museum

46. Rembrandt, *Old Man Seated*, Drawing. Oxford, Ashmolean Museum
(Reverse of Fig. 45)

47. Rembrandt, *Old Man Asleep* [Rembrandt's Father?], Drawing. Paris, Louvre

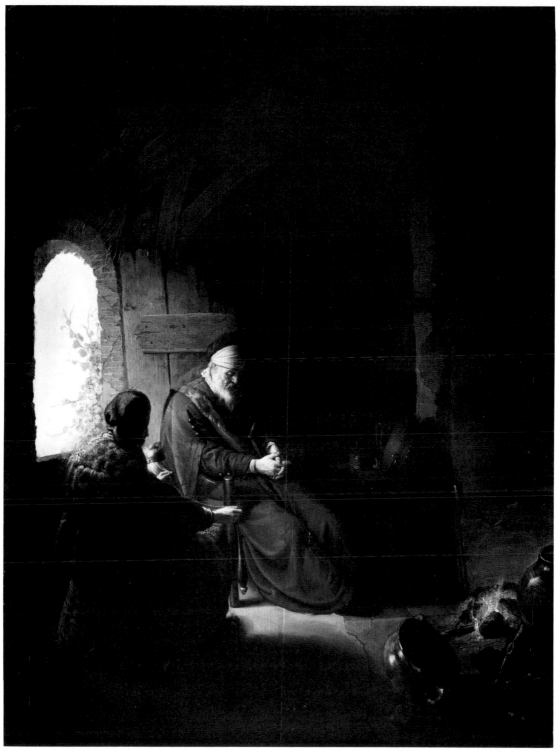

48. Gerard Dou (and Rembrandt?), *Tobit and Anna Waiting for Tobias' Return.* London, National Gallery

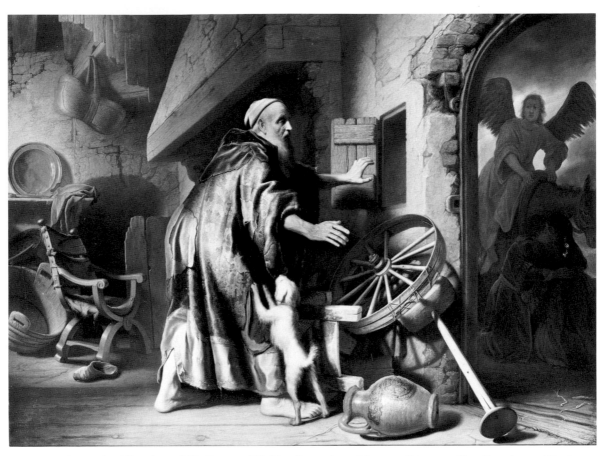

49. Gerard Dou (and Rembrandt?), *Return of Tobias*. Rotterdam, Museum Boymans-Van Beuningen (On Loan from a Private Collection)

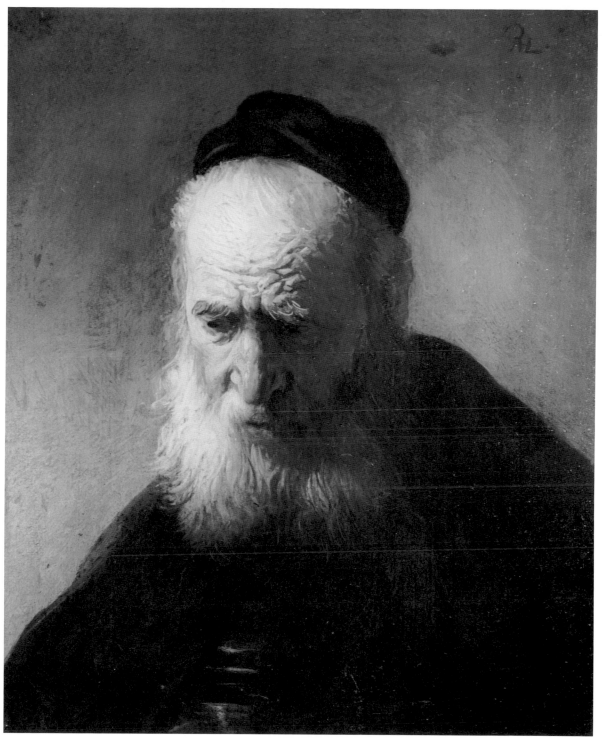

50. Rembrandt, *Head of an Old Man* (Rembrandt's Father?), Milwaukee, Collection Dr. A. and Mrs. Bader

1. Barthel Beham, *Twelve Beggars.* Woodcut

2. Hieronymus Bosch, *Cripples and Beggars*, Drawing. Brussels, Cabinet des Estampes

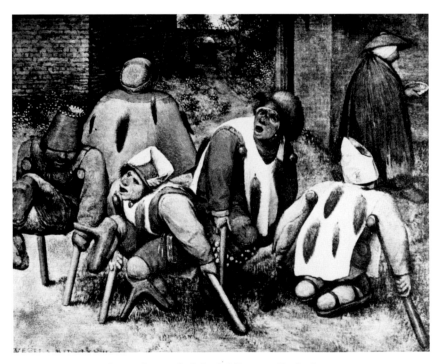

3. Pieter Bruegel, *Crippled Beggars.* Paris, Louvre

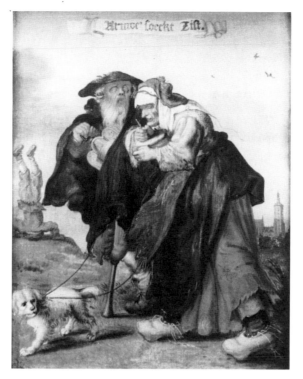

4. Adriaen van de Venne, *"Armoe soeckt List"*

5. Jacques Callot, *Two Crippled Beggars.* Etching

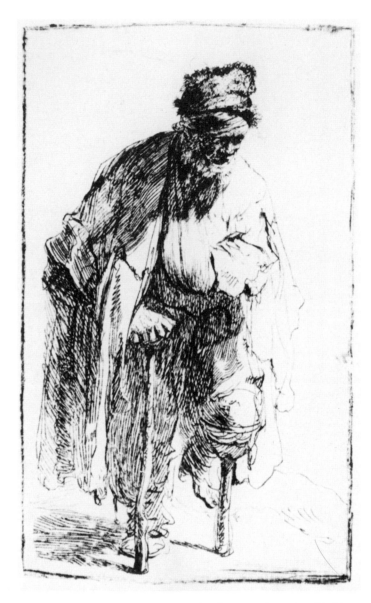

6. Rembrandt, *Beggar with a Wooden Leg, ca.* 1630-1631. Etching

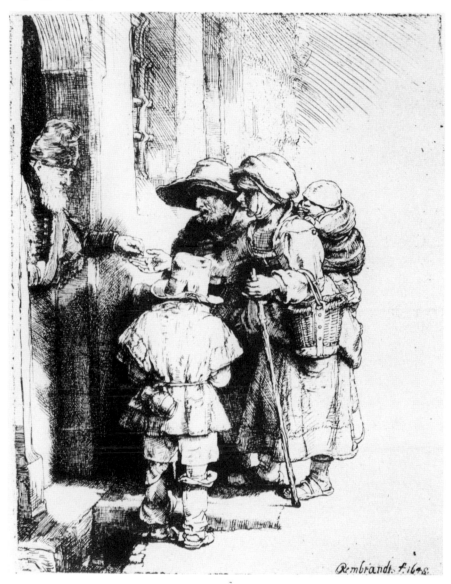

7. Rembrandt, *Beggar's Family Receiving Alms*, 1648. Etching

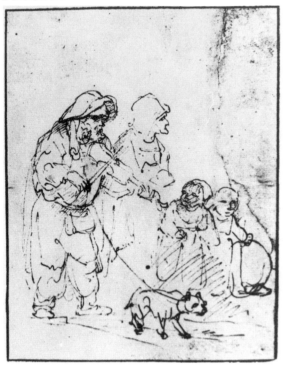

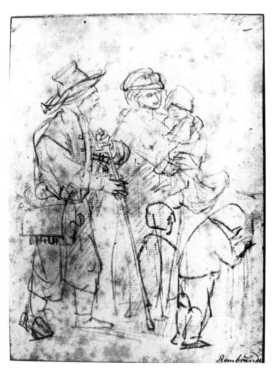

8. Rembrandt, *Fiddling Beggar, with Wife, Two Children Watching, ca.* 1642-1643. Drawing. University Library, Warsaw

9. Rembrandt, *Beggar Family with Three Children, ca.* 1647. Drawing. Amsterdam, Museum Fodor

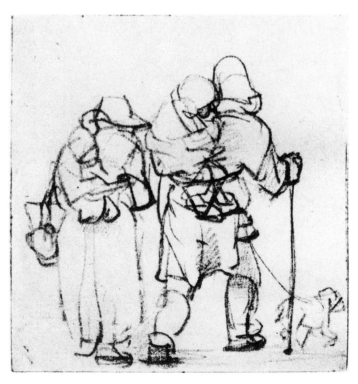

10. Rembrandt, *Beggar Family, Seen from the Back, ca.* 1648. Drawing. Vienna, Albertina

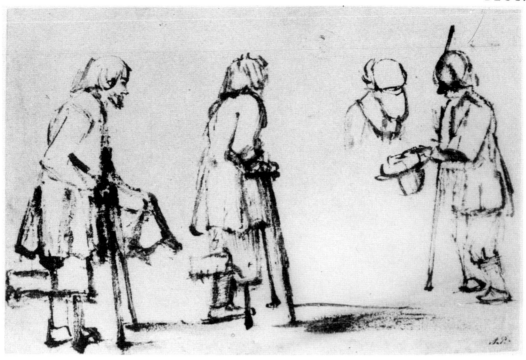

11. Rembrandt, *Three Studies of a Single Beggar, ca.* 1659-1660. Drawing. Berlin-Dahlem, Kupferstichkabinett

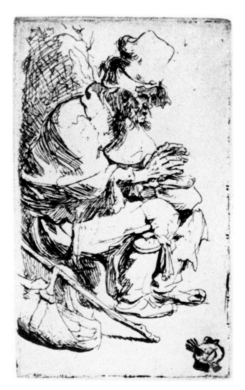

12. Rembrandt, *Beggar Warming His Hands at a Chafing Dish, ca.* 1630. Etching

13. Hans Sebald Beham, Two Peasants Conversing about the Weather, 1542. Engravings

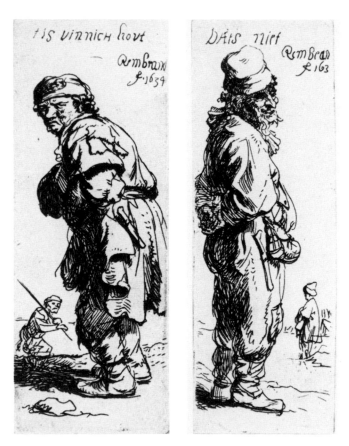

14. Rembrandt, Two Peasants Conversing about the Weather, 1634. Etchings

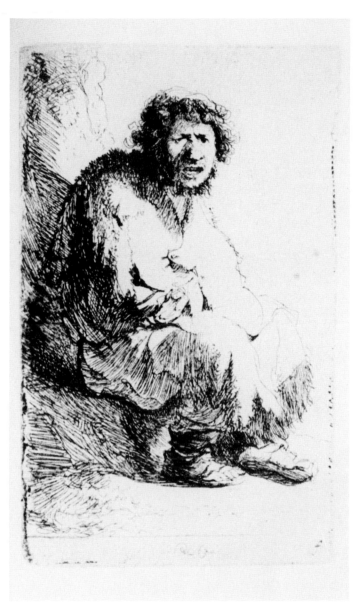

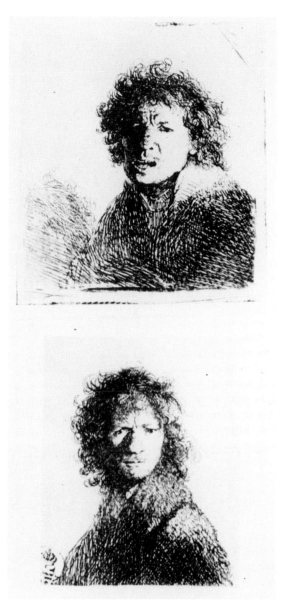

15. Rembrandt, *Beggar at the Wayside, with Self-portrait,*
ca. 1630-1631. Etching

16. Rembrandt, Two Self-portraits,
ca. 1630. Etchings

17. Rembrandt, *Self-portrait* (with Figure Studies), *ca.* 1632. Etching

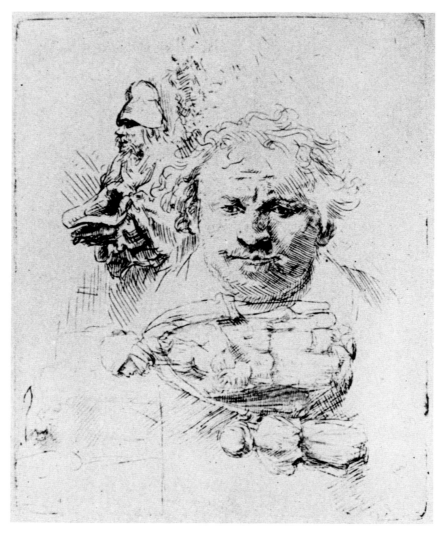

18. Rembrandt, *Self-portrait* (with Figure Studies), *ca.* 1651. Etching

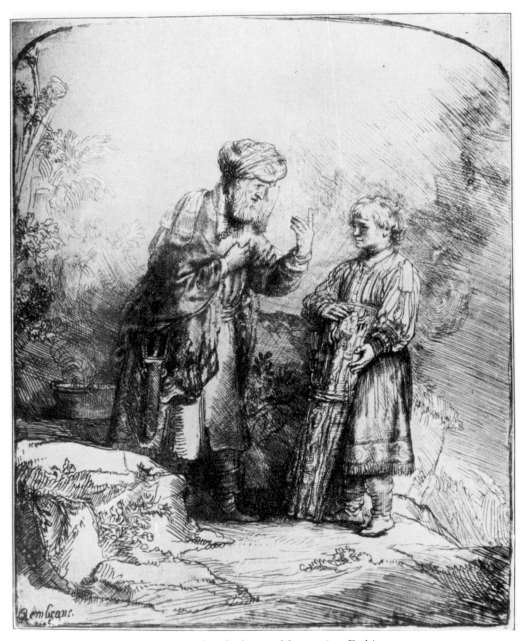

1. Rembrandt, *Abraham and Isaac*, 1645. Etching

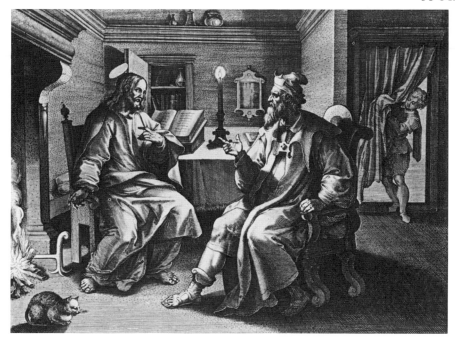

2. Marten de Vos, *Christ and Nicodemus.* Engraving by J. de Bie

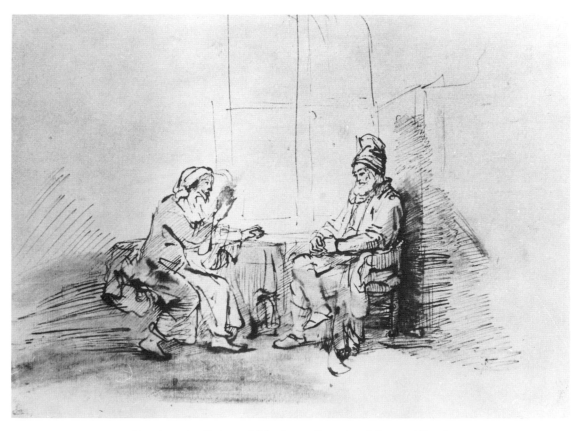

3. Rembrandt, *Christ and Nicodemus*, Drawing. Vienna, Albertina

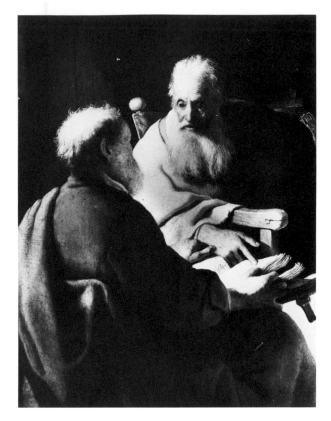

4. Rembrandt, *Peter and Paul*, Detail. Melbourne, National Gallery of Victoria

5. Rembrandt, *Jacob and Esau*, Drawing. Berlin-Dahlem, Kupferstichkabinett

6. Rembrandt, *Nathan and David*, Drawing. Berlin-Dahlem,
Kupferstichkabinett

7. Rembrandt, *Nathan and David*, Drawing. New York, Metropolitan Museum of Art

8. Rembrandt, *Vertumnus and Pomona*, Drawing. Amsterdam, Collection of the late Van Regteren Altena

9. Rembrandt, *The Matchmaker*, Drawing. Formerly New Rochelle, Collection Curtis O. Baer

10. Rembrandt, *Christ and the Woman Taken in Adultery.* Detail. London, National Gallery

11. Rembrandt, *Christ and the Woman Taken in Adultery*, Drawing. Munich,
Bayerische Staatsgemäldesammlungen, Graphische Sammlung

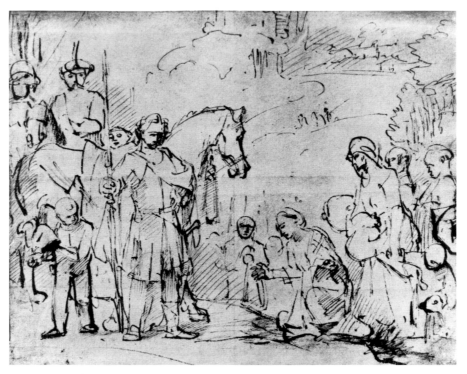

12. Rembrandt, *David and Abigail*, Drawing. Formerly London, Collection Victor Koch

13. Pieter Bruegel, *Fides (Faith)*, Drawing. Amsterdam, Rijksprentenkabinet

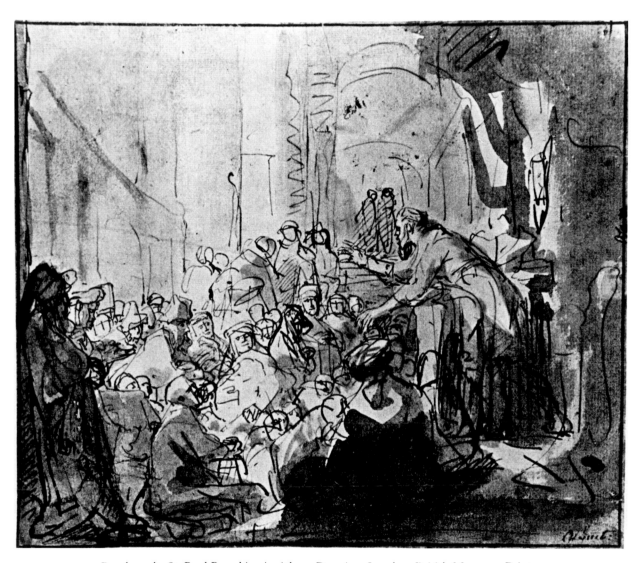

14. Rembrandt, *St. Paul Preaching in Athens*, Drawing. London, British Museum, Printroom

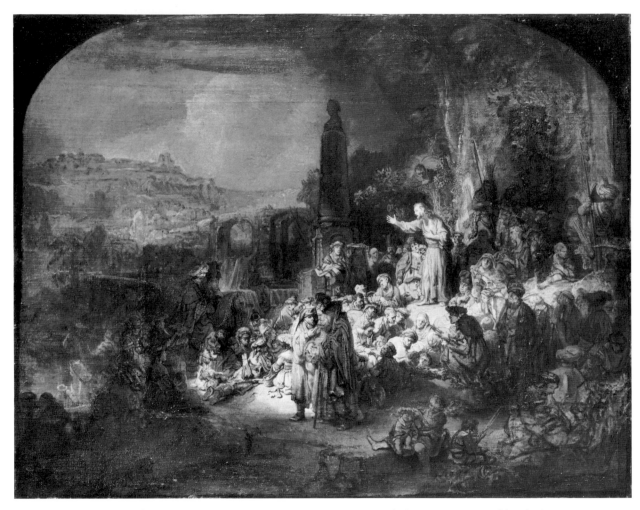

15. Rembrandt, *St. John Preaching*. Berlin-Dahlem, Staatliche Museen, Gemäldegalerie

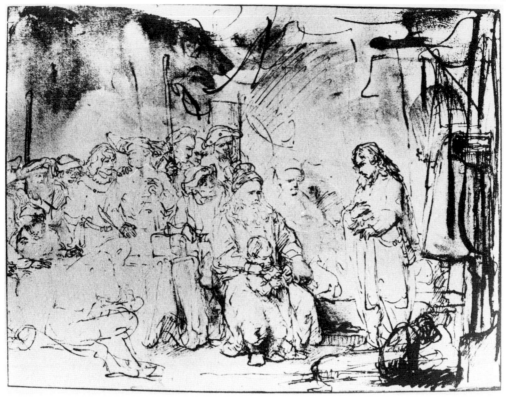

16. Rembrandt, *Joseph Tells His Dream*, Drawing. Formerly London, Collection Baron Paul Hatvany

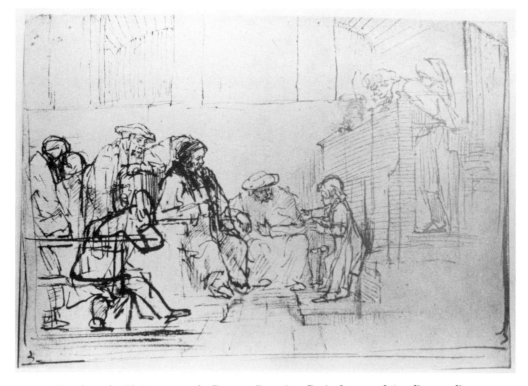

17. Rembrandt, *Christ among the Doctors*, Drawing. Paris, Louvre, Léon Bonnat Bequest

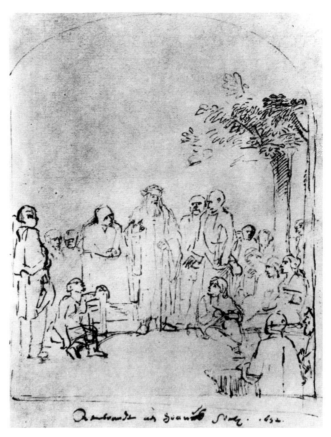

18. Rembrandt, *Homer Reciting His Poetry*, Drawing.
Amsterdam, Collection Six

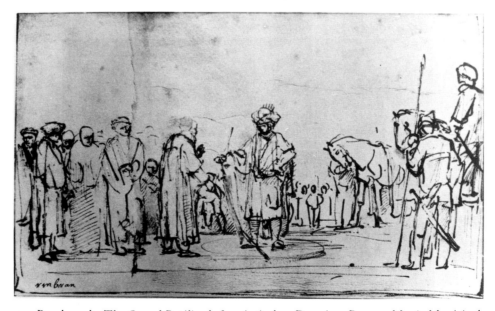

19. Rembrandt, *The Consul Popilius before Antiochus*, Drawing. Rennes, Musée Municipal

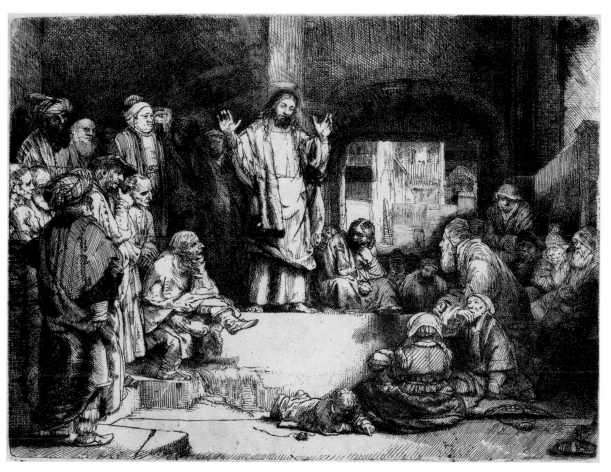

20. Rembrandt, *Christ Preaching*. Etching

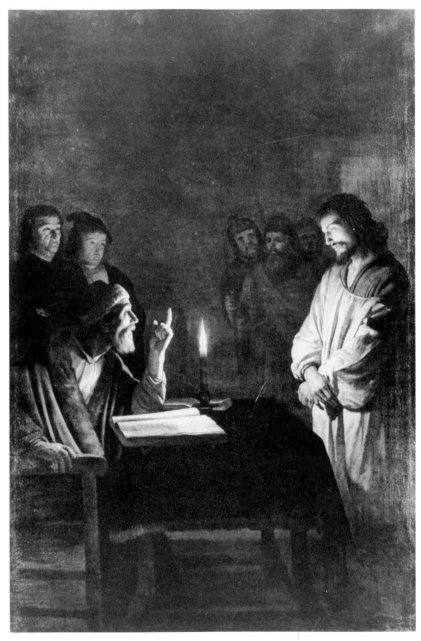

21. Gerard van Honthorst, *The Interrogation of Christ*. London, National Gallery

22. Hans Holbein, *The Reckoning of the Generations*. Woodcut

23. Hans Holbein, *David and Abishag*. Woodcut